ART FOR THE NATION

Art for the nation

Exhibitions and the London public
1747–2001

BRANDON TAYLOR

Rutgers University Press
New Brunswick, New Jersey

First published in the United States 1999
by Rutgers University Press, New Brunswick, New Jersey

First published in Great Britain 1999
by Manchester University Press,
Oxford Road, Manchester M13 9NR, UK

British Library Cataloguing-in-Publication Data
A catalogue record for this book is available upon request

Library of Congress Cataloging-in-Publication Data
Taylor, Brandon.
 Art for the nation : exhibitions and the London public, 1747–2001
/ Brandon Taylor.
 p. cm.
 'First published in Great Britain 1999 by Manchester University
Press' – – T.p. verso.
 Includes bibliographical references and index.
 ISBN 0–8135–2702–3 (cloth : alk. paper). – – ISBN 0–8135–2703–1
(pbk. : alk. paper)
 1. Art exhibition audiences – – England – – London – – History. 2. Art
patronage – – England – – London – – History. I. Title.
N4396.5.T38 1999
708.2´1 – – dc21 99–10170

Printed in Great Britain

Contents

List of illustrations		*page* vi
Preface and acknowledgements		xiv
1	In the image of the King: towards the Royal Academy of Arts	1
2	Publics for Trafalgar Square: the National Gallery	29
3	Instructing the whole nation: South Kensington to St Martin's Place	67
4	A national gallery of British art: the Millbank Tate	100
5	Managing 'modern foreign' art: an extension at the Tate Gallery	132
6	Post-war positions: Arts Council, LCC and ICA	167
7	For an international public: the Hayward Gallery	203
8	Coda: Bankside and beyond	237
	Notes	243
	Bibliography	287
	Index	303

Illustrations

Plates

1 Richard Wilson, *View of the Foundling Hospital*, c. 1746. Thomas
Coram Foundation for Children, London. *facing page* 30

2 William Hogarth (attrib.), *A Man loaded with Mischief, or Matrimony*,
c. 1762, signboard (from J. Larwood and J. C. Hotton, *History of Signboards,
from the Earliest Times to the Present Day*, 1867, frontispiece). 30

3 J. Zoffany, *Dr William Hunter delivering a Lecture on Anatomy at the Royal
Academy*, c. 1772 By kind permission of the Royal College of Physicians, London. 31

4 F. Mackenzie, *The National Gallery when at Mr J. J. Angerstein's House,
Pall Mall, prior to 1834*, c. 1834. Board of Trustees of the Victoria and Albert
Museum, London. 31

5 *Cross Readings at Charing Cross*, c. 1836, aquatint by Charles Hunt, originally
published by W. Soffe. By kind permission of the Bridgeman Art Library,
London. 62

6 A. Hoven, *A Room hanging with British Pictures*, after 1856 (showing Turner's
Dido building Carthage and *Ulysses deriding Polyphemus*, and Hogarth's
The Painter and His Pug). Photograph National Gallery, London. 62

7 W. Mulready, *Interior with Portrait of John Sheepshanks*, 1832–34. Photograph
Victoria and Albert Museum, London. 63

8 Hubert von Herkomer, *Sir Henry Tate*, 1897. Courtesy the Tate Gallery, London. 63

9 G. Scharf, *National Portrait Gallery at the South Kensington Museum*, c. 1885.
By Courtesy the National Portrait Gallery, London. 126

10 Sir William Orpen, *Homage to Manet*, 1909. Copyright Manchester City Art
Galleries. 127

11 John Lavery, *King George accompanied by Queen Mary at the Opening of
the Modern Foreign and Sargent Galleries at the Tate*, 1926. (also shows Phillip
Sassoon, D. S. McColl, J. B. Manson, Charles Aitken), oil on canvas. Courtesy
the Tate Gallery, London. 158

12 Alfred Munnings, *Does the Subject Matter?*, 1956. With permission of the Sir
Alfred Munnings Art Museum, Norwich. 158

13 Festival of Britain, 1951. By permission of the Central Office of Information
and the Festival of Britain Society. 159

14 John Hilliard, *Ten Runs past a Fixed Point (3), 1/500 to 1 second*, 1971,
photographs, and *Sixty Seconds of Light*, 1970–71, 'The New Art', Hayward
Gallery, 1972. Courtesy of the Hayward Gallery, London. 159

Figures

Map of London, showing sites of principal art institutions. *page* xviii

1 James Thornhill's Academy in St Martin's Lane, London, c. 1735, from
 C. Knight (ed.), *London*, vol. III, 1842, p. 209. 3

2 General Court Room of the Foundling Hospital. Photo courtesy Paul
 Mellon Centre for Studies in British Art and Thomas Coram Foundation,
 London. 5

3 Francis Hayman, *The Artists presenting a Plan for an Academy to Frederick,
 Prince of Wales and Princess Augusta*, c. 1750. Courtesy Royal Albert Memorial
 Museum, Exeter. 6

4 George Smith, *Landscape*, about 1760. Courtesy Sotheby's London and Witt
 Library, London. 8

5 Charles Grignion after William Hogarth, frontispiece to the catalogue of the
 exhibition of the Society of Artists of Great Britain, May 1761. Courtesy
 British Museum, London. 12

6 William Hogarth, *Beer Street* (proof state, February 1750/51). Courtesy
 Master and Fellows of Christ's College, Cambridge. 16

7 T. Bowles, *Cheapside, with Bow Church and the Old Signs to the Shops*, c. 1751.
 Courtesy British Museum, London. 17

8 View of the Old Royal Academy in Pall Mall (from the extra illustrated edition
 of W. Sandby's *The History of the Royal Academy of Arts from 1768 to the
 Present Time*, 1862, p. 125, and from a drawing in the British Museum).
 Courtesy British Museum, London. 23

9 Giovanni Cipriani, *'The Arts': Illumination for the King's Birthday*. Oppé
 collection, by permission of the Tate Gallery, London. 25

10 Richard Earlom, after Charles Brandoin, *The Exhibition of the Royal Academy
 of Painting in the Year 1771*, 1771. Courtesy Yale Centre for British Art, Paul
 Mellon Collection. 26

11 James Stephanoff and F. P. Stephanoff, The British Institution in 1816, 1817.
 Courtesy Board of Trustees of the Victoria and Albert Museum, London. 31

12 John Chessell Buckler (attrib.), *The Picture Gallery of Sir John Fleming Leicester
 at 24 Hill Street, London in 1806*, 1806–7. Courtesy the Tabley House
 Collection, University of Manchester. Photograph courtesy the Courtauld
 Institute of Art, London. 32

13 Sir T. Lawrence, *Portrait of John Julius Angerstein*, about 1823. Courtesy
 National Gallery, London. 35

14 John Jackson, *Portrait of William Seguier*, 1830. Courtesy National Gallery,
 London. 36

15 Charles Hullmandel, *The Louvre or the National Gallery Paris, and No. 100
 Pall Mall or the National Gallery of England*, c. 1830. Courtesy Trustees of the
 National Gallery, London. 38

16 John Nash, Plan of the Proposed Improvements at Charing Cross, St Martin's
 Lane, and Entrance to the Strand, from *Fifth Report of the Commissioners of
 Woods, Forests and Land Revenues*, 1826, p. 12. 42

17 After R. Shepherd, *The King's Mews, Charing Cross*, engraving by J. Tingle,
 n.d. Courtesy National Gallery, London. 42

18 Lighting scheme at the Munich Pinakothek. Source: *Report of the Select Committee on Arts and their Connexion with Manufactures*, 1836, Evidence of Baron von Klenze, p. 196. 48

19 'A Court for King Cholera', *Punch*, vol. XXIII, July to December 1852, p. 139. Photograph courtesy the Illustrated London News Picture Library, London. 49

20 *Grand Procession of the Metropolitan Temperance Society passing Charing Cross, 8 June 1840*. Courtesy National Gallery, London. 50

21 Richard Doyle, 'In the National Gallery', 1840, from *A Journal Kept by R. Doyle in 1840*, Smith Elder and Co. London, 1885. Courtesy National Gallery, London. 54

22 Henry Gritten, *View of the National Gallery and the Royal Academy*, 1838. Courtesy Williams and Son, London. 55

23 Chartist demonstration in Trafalgar Square, from *Lady's Newspaper*, 1848, pp. 214–15. Courtesy National Gallery, London. 56

24 Charles Compton, *A Study in the National Gallery*, 1855. Courtesy National Gallery, London. 56

25 'The Triumph of History' (Westminster Hall Exhibition of Cartoons), *Illustrated London News*, 8 July 1843. Courtesy Illustrated London News Picture Library. 57

26 John Leech, 'Substance and Shadow', *Punch*, vol. 5, 15 July 1843, p. 23. Courtesy Illustrated London News Picture Library. 58

27 Henry C. Selous, *Opening of the Great Exhibition by Queen Victoria on 1 May 1851*. Courtesy Victoria and Albert Museum, London. 68

28 South Kensington Museum, general view, *Illustrated London News*, 27 June 1857, p. 635. Courtesy Illustrated London News Picture Library. 72

29 Anon., The Vernon Gallery in the National Gallery, Trafalgar Square from *Illustrated London News*, 4 November 1848, p. 284. Courtesy Illustrated London News Picture Library. 72

30 Sir J. Tenniel, 'The Sunday Question: The Public-House, or, the House for the Public?', *Punch*, 17 April 1869. Courtesy Illustrated London News Picture Library. 74

31 'The South Kensington Museum on a Whit Monday', *The Graphic*, 3 June 1871. Courtesy Illustrated London News Picture Library. 80

32 E. J. Brewtnall, 'A Party of Working Men at the National Gallery', *The Graphic Supplement*, 6 August 1870. Courtesy National Gallery, London. 81

33 'Holiday Folks at the National Gallery', *The Graphic Supplement*, 3 August 1872. Courtesy Illustrated London News Picture Library. 82

34 J. W. Wild, design for Bethnal Green Museum. 83

35 Opening of the Bethnal Green Museum by the Prince of Wales, *Illustrated London News*, 29 June 1872. Courtesy Illustrated London News Picture Library. 83

36 'Art Connoisseurs at the East End: A Study at Sir Richard Wallace's Loan Collection in the Bethnal Green Museum', *The Graphic Supplement*, 19 April 1873, pp. 368–69. Courtesy Illustrated London News Picture Library. 86

37 'A Sunday Afternoon in a Picture Gallery, Drawn from Life' *The Graphic*, 8 February 1879. Courtesy Illustrated London News Picture Library. 87

38 'A Sunday Afternoon in a Gin Palace, Drawn from Life', *The Graphic*, 8 February 1879. Courtesy Illustrated London News Picture Library. 87

39 'Sunday Afternoon in the Whitechapel Picture Gallery', from Henrietta
 Barnett, *Canon Barnett, His Life, Work and Friends*, vol. II, London, 1918,
 opposite p. 154. 90
40 The National Portrait Gallery at Bethnal Green, after 1885, photograph by
 Emery Walker showing seventeenth century portraits. Courtesy National
 Portrait Gallery, London. 95
41 National Portrait Gallery from St Martin's Place, c. 1896, from *A Popular and
 Pictorial Guide to London*, Ward Lock and Co, London, 1898, p. 88. Courtesy
 City of Westminster Archives Centre, London. 97
42 'Welcome!', *Punch*, 11 April 1896. Courtesy Illustrated London News Picture
 Library. 98
43 Henry Tate's Collection at Park Hill, Streatham (billiard room), c. 1892.
 Courtesy Tate Gallery Archive, London. 103
44 Edwin Douglas, *Alderneys (Mother and Daughter)*, 1875. Courtesy Tate Gallery,
 London. 106
45 Dendy Sadler, *Thursday*, 1880. Courtesy Tate Gallery, London. 107
46 Sidney R. J. Smith, proposed design of the Tate Gallery for Exhibition Road,
 London, published in *The Builder*, 19 March 1892, p. 226. Courtesy Tate
 Gallery Archive, London. 111
47 'Tate-à-Tate', *Fun*, 16 March 1892. Courtesy Tate Gallery Archive, London. 112
48 Millbank Penitentiary (copied from a model by the Clerk of the Works),
 Westminster City Libraries (E. 137, Millbank, pp. 3-5). 113
49 Sidney R. J. Smith, project for the facade of the Tate Gallery, Millbank,
 Magazine of Art, June 1893. Courtesy Tate Gallery Archive, London. 115
50 Tate Gallery, Millbank, front facade, *Daily Graphic*, 22 July 1897. Courtesy
 Tate Gallery Archive, London. 116
51 'A Gallery for Pictures: The Tate Gallery Interior', *The Graphic*, 17 July 1897.
 Courtesy Tate Gallery Archive, London. 118
52 'Opening of the Tate Gallery, 1897', *The Graphic Supplement*, 31 July 1897,
 pp. 4-5, drawn by H. M. Paget. Courtesy Illustrated London News Picture
 Library, London. 119
53 'Royal Academicians at Millbank', *Punch*, 17 December 1892. Courtesy
 Illustrated London News Picture Library, London. 120
54 'The Site of Old Millbank Prison: Ground Plan of the Projected Workmen's
 Dwellings', *Daily Graphic*, 21 October 1897. Courtesy Tate Gallery Archive,
 London. 123
55 'Inspecting the Pictures at Millbank', *Daily Graphic*, 24 August 1897. Courtesy
 Tate Gallery Archive, London. 125
56 'Mr Henry Tate's Gift to the Nation', *Penny Illustrated Paper*, 24 July 1897.
 Courtesy Tate Gallery Archive, London. 126
57 Tate Gallery interior, showing Galleries 4 and 5, British School pictures from
 the National Gallery and Vernon Collections, *St James's Budget*, 16 July 1897.
 Courtesy Tate Gallery Archive, London. 128
58 W. Goscombe John, *Boy At Play*, c. 1895. Courtesy Tate Gallery, London. 128
59 Frank Dicksee, *Two Crowns*, 1900. Courtesy Tate Gallery, London. 138
60 Sir Joseph Duveen (1869-1939) and his wife Elsie, née Salamon (1881-1963),
 photographed by Kazamian, c. 1912. Courtesy National Portrait Gallery, London. 142

61 Samuel Courtauld IV, July 1936. Photograph by Barry Finch, courtesy
 Courtaulds plc. 145
62 Georges Seurat, *Bathers at Asnières*, 1883–84. (Courtauld Fund). Courtesy
 National Gallery, London. 146
63 James Bolivar Manson, *Self Portrait*, 1912. Courtesy Tate Gallery, London. 147
64 Opening of the Modern Foreign and Sargent galleries, Tate Gallery, 1926:
 the King and Queen, accompanied by Lord D'Abernon. Courtesy Illustrated
 London News Picture Library. 149
65 Plan of the Tate Gallery, main floor, 1921. Source: *National Gallery Millbank,
 Illustrated Catalogue, British School*, London, HMSO, 1921, pp. ii–iii. 151
66 Tate Gallery: Modern Foreign and Sargent galleries (Sargent Gallery, Room
 XIV, looking towards the Modern Foreign galleries), 1926. Courtesy Tate
 Gallery Archive, London. 152
67 Plan of the Modern Foreign, Sargent and Turner galleries, Tate Gallery, 1926.
 Source: *National Gallery Millbank, Illustrated Guide, British School*, University
 of Glasgow Press, 1926, pp. iv–v. 153
68 Sir Frank Dicksee, President, speaking at the Royal Academy Dinner, 2 May
 1925. Courtesy Royal Academy, London. 157
69 'Some of the Sights and Sounds that liven London Streets', from A. St John
 Adcock (ed.), *Wonderful London*, 3 vols, 1926–27, vol. I, p. 221. 160
70 New Duveen Wing: Modern French gallery, *The Builder*, 9 July 1926. 162
71 New Duveen Wing: South Pavilion, *The Builder*, 9 July 1926. 163
72 Vincent Van Gogh, *The Yellow Chair*, 1888–89, purchased by the Courtauld
 Fund, 1924. Courtesy National Gallery, London. 164
73 The Thames at Millbank during the flood of January 1928, photograph.
 Courtesy Tate Gallery Archive, London. 165
74 Pictures being taken to safety following the flood at the Tate Gallery, London,
 January 1928. Courtesy Tate Gallery Archives, London. 166
75 The 'Unprofessional Painting' exhibition, 1938–39: Green line bus-driver
 Henry Stockley with an example of his work. Photograph courtesy Mass-
 Observation Archive, University of Sussex. 169
76 The Tate Gallery following a bombing raid in September 1940. Courtesy Tate
 Gallery Archive, London. 171
77 Rembrandt's *Portrait of Margaretha de Geer*, 1661, on show as the first Picture
 of the Month at the National Gallery, London, January 1942, *Illustrated
 London News*, 24 January 1942, p. 101. Reproduction courtesy Illustrated
 London News Picture Library, London. 171
78 Paintings by Matisse, the 'Picasso–Matisse Exhibition', Victoria and Albert
 Museum, 1946. Courtesy Public Record Office, Kew. 177
79 Viewing paintings by Picasso, the 'Picasso–Matisse Exhibition', Victoria and
 Albert Museum, 1946. Courtesy Public Record Office, Kew. 178
80 Pablo Picasso, *Woman with a Fish Hat*, 19 April 1942. Reproduction courtesy
 Stedelijk Museum, Amsterdam. 182
81 Lee cartoon, 'Willy! Did you do that?', *Evening News*, c. 1936. 183
82 'The Joy of Modern Art', *Punch*, 9 November 1938. Courtesy Illustrated
 London News Picture Library. 184
83 Hayland cartoon, *Lilliput*, October 1943. 185

84 Members of the Ashington Group outside the Tate Gallery, 1948. Courtesy
 Trustees of the Ashington Group. 186
85 Lee cartoon, 'Don't be a cad, sir!', *Evening News*, 26 February 1948. 187
86 Lee cartoon, *Evening News*, 24 March 1948. 188
87 F. E. McWilliam, *Kneeling Woman*, 1947. Photograph courtesy Scottish
 National Gallery of Modern Art, Edinburgh. 191
88 Guide–lecturers showing visitors Henry Moore's *Three Standing Figures* at the
 'Open Air Exhibition of Sculpture', Battersea Park, May 1948. 194
89 '40,000 Years of Modern Art', Institute of Contemporary Arts, 1948–49,
 Academy Cinema basement, London. Photograph courtesy Tate Gallery
 Archive, London. 197
90 Shoppers in Oxford Street looking at J. Lipchitz, *Figure*, 1926–30, exhibited
 as part of '40,000 Years of Modern Art', London 1948–49, from *The Star*, n.d. 198
91 The Royal Academy Dinner, 1949 (the Duke of Gloucester speaking). Courtesy
 News International Photographic Archive (photograph Royal Academy,
 London). 199
92 Henri Matisse, *Trivaux Pond (La Forêt)*, 1916 (Stoop Bequest, 1933).
 Courtesy National Gallery, London. 200
93 David Low cartoon, 'Art War News', *Evening Standard*, London, 4 May 1949. 201
94 Strube cartoon, 'The Moderns present a Farewell Gift to the President of the
 Royal Academy', *The Tatler*, 11 May 1949, p. 182. Reproduction courtesy
 Illustrated London News Picture Library, London. 201
95 Scully cartoon, 'It Says "Air-Conditioning by Ajax"', *The Sketch*, 7 May 1952. 204
96 The South Bank before the Hayward: the Lion Brewery and Waterloo Bridge,
 March 1930. Reproduction courtesy of the London Metropolitan Archives. 205
97 'Great South London Scheme', *The Star*, late 1930s. 207
98 Festival of Britain: Queen Elizabeth and King George VI passing the Sea and
 Ships Pavilion, 4 May 1951. By permission of the Central Office of Information
 and the Festival of Britain Society. 208
99 Visitors looking at F. E. McWilliam's *Head in Green and Brown*, Battersea Park
 Sculpture Exhibition, 31 July 1951. Photograph courtesy London Metropolitan
 Archives. 210
100 Willi Soukop, *The Pied Piper*, 1959. Reproduction courtesy of the London
 Metropolitan Archives. 212
101 Hayward Gallery exterior, 1968. Photograph courtesy London Metropolitan
 Archives and Hayward Gallery, London. 216
102 Queen Elizabeth II speaking to Mme Duthuit at the opening of the Matisse
 exhibition, Hayward Gallery, 1968, *Daily Telegraph*, 10 July 1968. Photograph
 courtesy Tate Gallery Archive, London. 217
103 Matisse exhibition, Hayward Gallery, London, 1968, installation view.
 Photograph courtesy London Metropolitan Archives and the Hayward Gallery. 218
104 'New Generation' sculpture exhibition, Whitechapel Gallery, 1965. Photograph
 courtesy John Goldblatt, London. 221
105 Barry Flanagan, *ring n*, Rowan Gallery, London, 1966. Photograph courtesy
 Waddington Galleries and Cavendish Photographic Ltd, London. 222
106 Poster designed by students of Hornsey College of Art, London, 1968.
 Photograph courtesy BBC Publications, London. 223

107 Anthony Caro exhibition, Hayward Gallery, 1969, installation view. Photograph
 courtesy Hayward Gallery, London. 225
108 'When Attitudes Become Form', Institute of Contemporary Arts, London,
 1969. Photograph courtesy Tate Gallery Archive, London. 227
109 Tate Gallery staff with Robert Morris sculptures, 1971. Photograph courtesy
 Tate Gallery Archive, London. 229
110 Michael Craig-Martin, *Assimilation*, 'The New Art', Hayward Gallery,
 London, 1972. Photograph courtesy Hayward Gallery, London. 232
111 Barry Flanagan, *Hayward II*, 'The New Art', Hayward Gallery, London 1972.
 Photograph courtesy Hayward Gallery, London. 233
112 M. de St Croix, The National Gallery, 1839. With permission of the National
 Museum of Photography, Film and Television, Science and Society Picture
 Library, London. 239
113 Tate Gallery of Modern Art, Bankside during conversion. Photograph courtesy
 Tate Gallery, London. 240

Tables

 1 Visitors to the National Gallery, London, 1826–54. Source: *Reports* of the
 National Gallery, 1826–54. 53
 2 Quantities of provisions sold in the refreshment courts during the Great
 Exhibition of 1851. Source: *First Report of the Commissioners for the
 Exhibition of 1851* (1852), Appendix XXIX, p. 150. 69
 3 Visitors to the major museums and other facilities, Whitsun 1863. Source:
 Return of Number of Visitors, Whitsun 1863, 1863. 79

Preface and acknowledgements

ART EXHIBITIONS FOR THE GENERAL PUBLIC have for over two hundred and fifty years played a significant part in British social life. Originating in the second third of the eighteenth century and burgeoning remarkably in the nineteenth, public art galleries have been a major preoccupation of the state in the fields of culture and education and in the formation of national identity. This book is about how visiting art galleries became one of the privileges and duties of the citizen.

Just how those privileges and duties have been envisioned by patrons, parliament, the monarch and the 'public' itself has been more frequently investigated by social scientists than by art historians. Important studies such as Janet Minihan's *The Nationalisation of Culture* (1977) or Nicholas Pearson's *The State and the Visual Arts: A Discussion of State Intervention in the Visual Arts in Britain, 1760–1961* (1982) have sketched the outlines of state involvement in visual culture, followed more recently by Marcia Pointon's edition of essays *Art Apart: Art Institutions and Ideology across England and North America* (1994) and Carol Duncan's *Civilizing Rituals: Inside Public Art Museums* (1995). What issued from these and other studies is the realisation that art institutions termed 'national' are highly complex objects, whose histories can be told in many ways: at the very least, they are by no means exhausted by 'official' accounts written within the institutions themselves. Entire networks of social, aesthetic and political relationships can be unearthed, running between the institutions and the patrons (both private and governmental) who provided buildings, works of art or financial power; back and forth amongst the institutions themselves; and between all these agencies and what we can discover of actual audiences for art within the viewing space.

Moreover these relationships present no simple pattern. Even in the case of London – the single city I examine in this book – the reader will find it difficult to discern a continuous narrative stretching between bodies as diverse as the Royal Academy of Arts in the 1760s, the National Gallery in the 1820s and 1830s, the National Gallery of British Art (Tate Gallery) from the 1890s onwards, the Arts Council in the 1940s and the Hayward Gallery in the 1960s. Each came into being out of unique combinations of governmental thought, private initiative and public debate. Such is my general scepticism about a comprehensive 'theory' of the field.

For all that, a number of ideas stand out with some clarity. An overriding concern of art professionals throughout the period from the 1740s to the 1960s was

that of public or civic 'improvement': improvement of judgement, of discrimina-
tion, of morality, of that general posture and attitude that marks out individuals as
participants in the nation's culture and saves them from becoming mere onlook-
ers, or, even worse, dissenting outsiders. For a national gallery to be made freely
open was an achievement. For it to become coercive in establishing alignment with
the manners and attitudes of a particular class was an aspect of the social life of the
whole nation. From the early identification of the Royal Academy of Arts with the
authority of the King, through to the government reports on the health and behav-
iour of the urban public flocking through the doors of the National Gallery in mid-
nineteenth-century London, the dominant idea was that exposure to the fine arts
would be good for the people and conduce to their participation in the 'progress'
of the polity to which they were being bound. Which is to admit that the identity
of 'the people' or 'the public' was always a subject of anxiety; its definition and
refinement always a matter of the highest concern.

That reference to 'progress' is well meant; the interval from the 1740s to the
1960s, at least, was deeply imbued with a sense of historical unfolding in the form of
a movement towards an end state or goal. In most of the European states a public
culture of the arts provided a moral rhetoric, a theatrical repertoire, a secular equiv-
alent for religion that linked the experience of works of art to the promise of liberty.
And yet – this is the second theme that impels my argument – such onrushing
'progress' showed subtle signs of change, even of decay, as the twentieth century wore
on. It remains a matter of speculation as to how or why this happened. My general
argument is that the exhaustion of nineteenth-century ideals of public improvement
through art exhibitions – even of moral redemption – can be traced to changes in the
make-up of British society between about 1890 and the end of the First World War.
This was not only the period in which, to repeat Virginia Woolf, human nature
changed; but that in which major art institutions in London began to respond to
'progressive' enthusiasm for French Impressionism and Post-Impressionism in ways
that would shift the centre of discussion to the cognitive pleasures and dangers of
'modern' art, to ideals of personal emancipation and expressive action, and to cer-
tain myths and ideals about self-actualisation through the very experience of art.

This shift was undoubtedly a complex one. For a time the debate was conducted
by professionals and centred upon the virtues and potential vices of modern art;
talk (and planning) was of the progressive enthusiasms of the Tate Gallery versus
the stable (or moribund) traditions of the Royal Academy. What had disappeared,
at any rate, by about 1920 was an aesthetic outlook that could or even attempted
to embrace the urban poor. Nor did the management of the art museums any longer
require or gain validity from the authority of the monarch. The more or less imme-
diate result was to fracture and problematise the identity of a 'national' culture,
alter the composition of the audience for art in London and lead to the eventual
remaking of the concept of the viewing public *per se*.

In social terms the arrival of modern art took the form of a cultural revolution
of the middle classes against themselves. The formation of the Arts Council of

Great Britain in 1946 under the patrician hand of Lord Keynes announced the final demise of the idea of 'improvement' at the level of the disenfranchised or the working poor and the promotion of very different ideals and values throughout an even more inclusive middling social order. The virtues of particular forms of cognition were now claimed by at least two very different social and educational groups. The 'moderns', now powerfully represented by institutions such as the British Council, the Arts Council, the Tate Gallery, the Institute of Contemporary Arts and the Whitechapel Gallery, came to bitter blows with the anti-moderns or traditionalists, championed by the Royal Academy of Arts, the Royal Society of Arts, the Royal Watercolour Society, and other bodies. The early exhibitions of the newly formed Institute of Contemporary Arts and the open-air sculpture shows mounted by the London County Council from 1948 fanned the war of values still further; yet the context was now that of the welfare state, the British Broadcasting Corporation (BBC) and mass-circulation magazines, new technologies and an evolving freedom to consume after the austerities imposed by war.

It goes almost without saying that London as a city underwent profound changes over the course of the period from the 1740s to the 1960s, but particularly in terms of sheer population size. London in the early 1700s was perhaps 600,000 souls, by 1800 a million, by 1900 up to three million and so on upwards to its post-war total of some six million persons or ten times its eighteenth-century size. What is striking retrospectively is how over that period the national art institutions produced (and then reproduced) a culture of centralisation gathered around a restricted geographical area that also encompassed the court, the monarchy and the law. Appearing first in Bloomsbury, the Strand and Charing Cross, the exhibitions took place in Pall Mall and Trafalgar Square, before rushing for a while to South Kensington in the west and then moving back to the West End. The short excursion over the river to the South Bank and more recently to Bankside, opposite St Paul's, seems to complete a circle of little more than a mile in radius in which the symbolic circus of national culture in the British capital has been performed.

Yet that centralisation may be deceptive too. Looking back to the post-war period today, it is hard not to recognise other forces which would soon render the very concept of a specifically London public for art a severely attenuated or weakened one. Already by the 1950s the growth of journalism and broadcasting was beginning to consolidate audiences for art in stereotypes of participation according to age, education and class. Already the arena of participation in visual culture was becoming an informational and media rather than a geographical space, at the same time as the growth of transatlantic travel and communications has made that space increasingly an international rather than a national one. Art exhibitions and their audiences were henceforward *in* London, not *of* it; *in* the nation's capital, but decreasingly *of* it as a place. With the further proliferation of life styles and available goods, the idea of 'the London public' became hardly feasible any longer except as a statistically differentiated body of consumers; certainly no longer structured by ideals of engagement or discrimination resembling those

that prevailed in the turbulent but close-knit exhibition world of the 1760s. The inauguration of the Hayward Gallery on London's South Bank in 1968 – on the site cleared for national celebrations in 1951 that themselves echoed those of 1851 – provided an almost perfect architectural and curatorial setting for a new public culture based on mobility, spectatorship and consumer choice. Notwithstanding a brief, late flowering of the idea of participation, the linkage of 'art' to 'citizenship' was about finally to disappear.

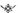

I first embarked on a study of relations between national art museums and their publics in London following a visit to the rehang of the Tate Gallery in 1989 by its then new Director, Nicholas Serota. That modest epiphany opened on to others; and in subsequent years I found myself spending more time in archives than in the galleries themselves. My second debt therefore is to the writers of these archives, whose secretarial and epistolary remains form the main basis of this book. Over the years I have received intellectual and practical advice from a large number of people: Rhian Harris at the Thomas Coram Foundation; Susan Bennett at the Royal Society of Arts; Patricia Eaton, Colin Penman and Nicholas Savage at the Royal Academy of Arts; Jacqui McComish, Simon McKeon, David Carter and Jessica Chitty at the National Gallery; Anthony Burton at the Victoria and Albert Museum; Ruth Baker at the Bethnal Green Museum of Childhood; Charles Saumarez Smith, Jill Springall and Francesca O'Dell at the National Portrait Gallery; Nicholas Serota, Robin Hamlyn, Anne Beckworth Smith, Jennifer Booth, Louise Ray, Krysztof Cieskowski and James Armstrong at the Tate Gallery; Marjorie Allthorpe-Guyton at the Arts Council of England; Dorothy Sheridan and Joy Eldridge at the Mass-Observation Archive, University of Sussex; Lucy Whetstone at Bolton Metropolitan Museum; Henry Meyric Hughes and Pam Griffin at the Hayward Gallery; Eleanor Gawne at the R.I.B.A.; Mik Flood at the Institute of Contemporary Arts; Isobel King at the Camden Arts Centre; Ann Simpson at the Scottish National Gallery of Modern Art, Edinburgh; Edward Morris at the Walker Art Gallery Liverpool; John Newman at the Whitechapel Art Gallery; R. J. Holder of the Victorian Society; Veronica Burtt, Clive Phillpot and Victorine Martineau of the British Council; David Tate and Bill Rusby of Tate and Lyle Limited; Daphne Hayes-Mojon of the Streatham Society; Jean Goodman and Stanley Booth of the Alfred Munnings Museum; Ian Barker of Annely Juda Fine Art; Catherine MacMahon of Leeds University; Fred Peskett of the Festival of Britain Society, Portsmouth; Catherine Moriarty of the Design Council Archive, University of Brighton; Michael Paraskos of University College Scarborough; Simon Bradshaw and John A. Walker of Middlesex University; Menai Jones of St Martin's School of Art; Eileen Carnaffin of Gateshead Central Library; Helen Atkinson of the London Metropolitan Archive (formerly the Greater London Archive); and Jeff Walden at the BBC Written Archives Centre. I am also grateful to the staffs of the National Art Library, the London Library, the Illustrated London News Archive, the Public Record Office, the British Library, the Courtauld Institute

and Witt Library, and the BBC Sound Archive. I am also indebted to many friends and collaeagues, including Allan Bullock, Kenneth McConkey, Christine Boyanoski, Hilary Gresty, Marcia Pointon, John House, Sir Adam Butler, Hope Kingsley, Gordon Fyfe, Sue Malvern, Lara Perry, John Gillett, Tim Barringer, William Feaver, Kirk Martinez, Caroline Worthington, Richard Humphreys, Charles Harrison, Tom Paxton, Michael Doran and Saxon Tate.

Much of what is now Chapter 2 was prepared for an inaugural lecture at the University of Southampton in September 1993. An early version of Chapter 4 was read to the 1991 Annual Conference of the Association of Art Historians, London, and published in revised form in M. Pointon (ed.), *Art Apart: Art Institutions and Ideology across England and North America*, already mentioned. Chapter 5 first surfaced as a paper presented to a post-graduate seminar held at the Courtauld Institute, University of London under the generous auspices of John Murdoch, in 1995, and had a second airing at the conference '*Rethinking Englishness: English Art, 1880-1940*', organised by David Peters Corbett at the University of York in July 1997. Early drafts of all or part of the text were read by Carol Duncan, Andrew Stephenson, Frances Spalding, Giles Waterfield, Diana Donald, Shearer West, Pam Griffin, Margaret Garlake, Annie Richardson and Elisabeth Billington, all of whom saved me from error. I must particularly mention Tim Barringer, my editor at the Barber Institute, who read the whole text with great thoroughness and offered me invaluable editorial advice. My students Jean MacDonald, Michael Gray, Claire Armstrong and Alan Dyer were generous enough to supply me with new material. Finally I must mention my wife Lucia and our growing children without whose support I should never have finished the book.

Map of London, showing sites of principal art institutions

In the image of the King:
towards the Royal Academy of Arts

THE FIRST HALF OF THE EIGHTEENTH CENTURY saw the emergence in London of a new type of society. England's capital city was a unique combination of forces; a major port, the centre of the country's financial institutions and its legal system, the home of its Parliament and its court, the centre of influence of the new line of Hanoverian kings. From it emerged a culture of prosperity, self-confidence, artistic invention and commercial dynamism – commerce particularly providing the basis of a new regime of manners and consumption habits among a broadly based middle and mercantile class. Now known as the period of the emergence of the 'public sphere', the decades between the accession of George I in 1714 and that of George III in 1760 witnessed a metropolitan boom in books, newspapers and luxury goods; in shopping; in fashionable assemblies and pleasure gardens; in clubs, coffee houses and theatres; and notably, at the end of that period, an efflorescence of public exhibitions of art.[1]

The last of those developments is our subject here. In the 1760s several types of public exhibition took place in the capital, each vying for the approval of those who increasingly interested themselves in art, but also for the approbation of the press, the City, the court and ultimately the King. Private ventures based on commercial capital, these early exhibitions projected very different conceptions of the social and aesthetic functions of art, largely by gathering to themselves elements of a purported 'Britishness' or 'Englishness' – the terms were often interchangeable – that they hoped would help define a set of values for visual culture.

Before the earliest public exhibitions it had been the Grand Tour to Italy that had defined the values of aesthetic pleasure and erudition in art. This in turn had fed the expansion of a market for Italian and continental paintings and soon stimulated patriotic anxieties about the relative invisibility of a British 'school'. Yet in Britain, the habit of travel for those with learning and curiosity spread: in the early part of the eighteenth century it was the country-house collection above all that played a vital role in preparing the ground for the new public institutions. The practice of visiting such collections had already underlined a network of distinctions between 'noteworthy' and unexceptional objects and delineated the competences necessary to appreciate them. Guidebooks like the modern Michelin guides,

often with strip maps which took the traveller along a given route, pointed to places of cultural interest while omitting reference to farms, workplaces, asylums, prisons, fairs, and other less cultivated human spaces and resources.[2] It is as if 'the country' had by mid-century already become a storehouse of objects deemed valuable by a relatively well-educated and adventurous elite, a kind of permanent outdoor museum or exhibition.

The picture galleries added to country houses and collections in the early Georgian period were laid open to inspection by certain categories of visitor (predominantly the aristocracy and the educated gentry) by written application or by invitation of the owner. Once inside, the visitor would be provided with a printed list of the objects on view, with their descriptions, origins, dates and original locations. The architecture, the gardens, the furniture and particularly the paintings (often with separate printed guides) soon became the sights that the visitor principally wanted to see. The same process was unfolding in London itself, where a new concern with British art in particular helped elevate the very production of paintings, especially, from being a mere job or craft, to becoming a serious affair involving knowledge, discrimination and a sense of the differences between the schools of the European nations.

This new emphasis on art as a 'serious' activity, superior to the frivolous pleasures of the street or fair, was meanwhile becoming integral to the style of the mercantile middle class. The metaphors of art appreciation were increasingly closely allied to those of business and trade: a comparison between the early language of commerce and that of the art market would reveal a lexicon of overlapping and partially synonymous terms. Indeed the burgeoning machinery of the art market in the first half of the eighteenth century had already upheld, though not without difficulty, a group of persons known as *cognoscenti* or *dilettanti* who purported to be able to perform judgements of taste. *Connoisseur* then became the term self-applied by those of classical and historical learning who purported to continue the task of discrimination which the *dilettanti* had begun. The activity of judgement presupposed that there was something out of the ordinary to judge, and historically the emergence of the public exhibition coincided with a rise in the status of the painter from a skilled executor of commissions to a person (almost always a man) who could operate with more ambitious social or aesthetic ideas – the source of the major disagreements to come. Secondly, it was increasingly recognised at least by 1720 that good art in England presupposed good training, as well as the evolution of standards of approbation, not to mention the journalistic space in which to broadcast them. The very concept of a 'public' as opposed to a private exhibition grew out of all these factors, combined with the perceived insufficiency of the solitary studio showing as the best or only means of viewing art.[3] Above all, the question of the distinction between British art and that of the continent burned ever brighter in the minds of connoisseurs and artists alike. The Protestant succession following the Revolution of 1688, the anti-Catholic Act of Settlement (1701), the Act of Union with Scotland (1707) and the beginning of the Hanoverian succession in 1714 had

after all intensified the latent patriotism of British subjects and cast into some doubt the inevitable superiority of the art of the Catholic countries of Europe. Rivalry with France in particular – for trade, for land, for culture – became a serious preoccupation in England,[4] and helped produce cultural institutions whose clients, patrons and subjects perceived themselves to be 'national' in character: English, but also British and freqently francophobic to boot. This chapter is concerned with how the earliest of London's exhibitions would interpret this patriotic demand.

The Foundling Hospital and its consequences

Private teaching academies implying the holding of occasional 'private' views were established in the metropolis from the second decade of the eighteenth century by Sir Godfrey Kneller, in Great Queen Street (from 1711), and by Sir James Thornhill in Arundel Street, Covent Garden (from 1724). Both proved short-lived, as did the academy set up in St Martin's Lane in 1720 by Louis Chéron and John Vanderbank. Thornhill with the painter William Hogarth's assistance founded a second and more durable academy in St Martin's Lane in 1735 (Figure 1),[5] and with a group of artists at various times attempted to establish more permanent working premises.[6] The association is important, since some of the Thornhill group were among those who donated paintings to Thomas Coram's orphanage known as the Foundling Hospital shortly after it received royal approval in 1737 and opened in its first home two years later: first Hogarth in 1740 (by then already a governor), and then Hayman, Highmore, Wills, Wilson, Haytley, Wale and Gainsborough in 1746.[7] These paintings formed a scheme of decoration in the Hospital's new buildings in Bloomsbury Fields when they were finished in 1747 (Plate 1): a scheme that was on view all the year round, and '[was] permitted to be seen by any visitor, upon proper application. The spectacle was so new, that it made a considerable impression upon the public, and the favourable reception these works experienced impressed the artists with an idea of forming a public Exhibition'.[8]

The paintings, in the words of a later account, 'being exhibited to the public, drew a daily crowd of spectators in their

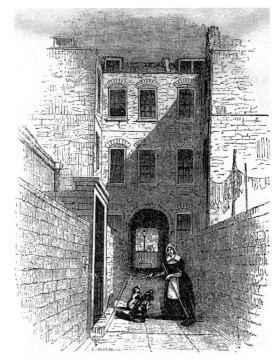

1 James Thornhill's Academy in St Martin's Lane, London, c. 1735.

splendid equipages, and a visit to the Foundling became the most fashionable morning lounge of the reign of George II'.[9] As Linda Colley has observed, the two decades following the defeat of the Jacobite rising at the Battle of Culloden in 1746 became 'an infinitely creative period in terms of patriotic initiative and discussion of national identities'.[10] Thomas Coram's hospital was an expression of just such an initiative: Coram was the son of a Dorset ship's captain, a merchant's agent and a sea-faring trader who turned to philanthropic work for destitute children, caring for them when young and rehabilitating them as servants or sending them to sea when older. The hospital that bore his name was a voluntary corporate body with its own directors and legal identity, and its own board of governors approved by George II, most of them merchants in Coram's mould. Hogarth, himself a mercantilist and a patriot of Coram's type, painted his patron's portrait in 1740 and designed a uniform for the foundlings as well as a coat of arms.[11]

Aside from self-advertisement, several other factors played a part in motivating the Foundling organisers to exhibit high-quality paintings to the considered view. Attracting a regular crowd of well-to-do visitors would increase the visibility, the reputation and ultimately the annual budget of the institution. Secondly, four history paintings presented – Hogarth's *Moses Brought Before Pharoah's Daughter*, Francis Hayman's *The Finding of Moses in the Bullrushes*, Joseph Highmore's *The Angel Appearing to Hagar and Ishmael* and James Wills' *Little Children Brought Unto Christ*, all of 1746 (Figure 2) – underscored through their biblical subjects the Hospital's wider mission of caring for destitute or distressed children. Thirdly, the Foundling exhibition, in so far as it elicited qualities of sympathy and cultivated awareness, contributed to the wider ordering of metropolitan society by helping to mark out the differences between aspects of that society's morals and behaviour. As David Solkin shows in detail in the case of the contemporaneous shows and manifestations at Vauxhall Gardens on the south side of the river, the opportunity was now present in the middle ranks of British society to deploy the arts to establish markers of distinction between 'polite' behaviour and its 'impolite' or 'vulgar' counterparts – a major cultural distinction not only of the eighteenth century but of the modern British nation-state. 'What is it that gives either Grace, or Dignity, or Relish to human Life, but the ingenious Arts?' a contemporary writer asked in 1740. 'What else is it that raises Society to true Grandeur? Take away the virtues and Arts, and what remains but merely sensual and animal Gratifications? What remains that is peculiar to Man, that exalts him above the Brutes, or entitles the Society of Man to the Character of a Rational Society?'[12]

A year later David Hume had proposed that 'a cultivated taste for the polite arts ... improves our sensibility for all the tender and agreeable passions'.[13] By the time the Foundling Hospital was thrown open as a public space for the viewing of British pictures, aesthetic theory and particularly the genteel aesthetics of the 3rd Earl of Shaftesbury had simultaneously defined the 'cultivation of taste' for art as an aspect, perhaps a necessary one, of the morally benevolent character.

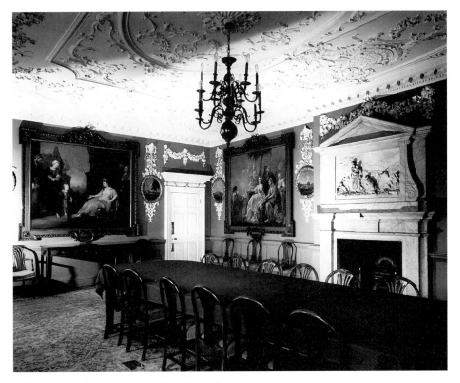

2 General Court Room of the Foundling Hospital.

The history paintings by British artists on show at the Foundling Hospital represented an important stage in the development of the concept of a public culture in eighteenth-century London. First, a set of important polarities was in the making: history painting versus portrait or genre; elevated subjects versus popular themes; British art emerging from the domination of continental and specifically Catholic traditions. The latter antagonism is particularly clear: the Foundling pictures were painted by British artists, which for a profession used to hearing that continental painting was superior was a major triumph. Secondly, the well-presented General Court Room at the Foundling was an elegant space that conveyed to a central London milieu an early yet clear association between the ambitions of contemporary British art and the virtues of the liberal humanitarian outlook.

At the same time, it had to be admitted that displaying history paintings in a charitable hospital still tied British pictorial culture to non-aesthetic ends. A series of initiatives now emerged to generate patronage for a national academy of art. Hayman, of the St Martin's Lane group, sketched a large painting on the subject of an academy and addressed it to Frederick Prince of Wales (Figure 3):[14] as oldest son of George II and already an ardent patron of the arts, Frederick was a likely target until his untimely death in 1751.[15] Hayman was also a leading signatory of a circular issued by the St Martin's Lane group in October 1753 broadcasting a scheme

'set on foot for erecting a public academy, for the improvement of the arts of paint-
ing, sculpture and architecture', and chaired a meeting of the interested parties.[16]
Hogarth himself was dissatisfied with the scheme on suspicion it might resemble
the French model; he was by now perhaps the most famous artist in London, with
a reputation as a great comic moralist, yet by instinct a patriot; he had recently pub-
lished *The Analysis of Beauty. Written with a View of Fixing the Fluctuating Ideas of
Taste*, and had well-known anti-academic views both on art and institutional struc-
ture. By the time of the 1755 pamphlet from Hayman's group entitled *Plan of An
Academy for the Better Cultivation, Improvement and Encouragement of Painting,
Sculpture, Architecture and the Arts of Design in General*, envisaging royal patronage
and a president yet stressing that the undertaking would be 'of a public nature', with
a 'yearly exhibition of pictures, statues and models, and designs in architecture' as
well as a public subscription, Hogarth's disaffection was complete.[17] The plan had
been discussed within a social club for wealthy young men known as the Society of
Dilettanti, and also within the Society for the Encouragement of the Arts,
Manufactures and Commerce (also known as the Society of Arts), founded by
William Shipley in 1754 as a spur to national refurbishment and self-recognition –
but nothing had resulted.[18]

Hogarth's disagreements with the St Martin's Lane group precipitated him in
turn into the arms of Shipley's Society of Arts later in 1755. William Shipley
(1715–1803) was a painter with antiquarian and scientific interests who from 1753
had developed a school to teach drawing, primarily as a skill useable in recording
and documenting 'Machines, Buildings, or Pieces of Antiquities'.[19] Both Shipley's
school and the St Martin's Lane Academy supplied students to the early Society

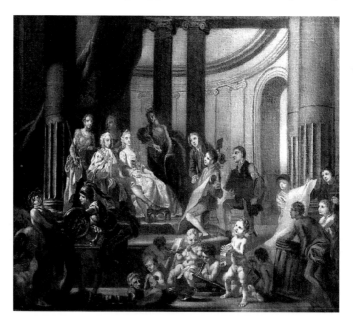

3 Francis Hayman,
*The Artists presenting a
Plan for an Academy to
Frederick, Prince of
Wales and Princess
Augusta*, c. 1750, oil
on canvas, 63.8 x 76.5
cm.

of Arts, which trained children from a young age in scientific and manufacturing skills and awarded prizes for such patriotic purposes as the growing of oaks for the navy and the dyeing of textiles. 'Profit and honour are two sharp spurs', Shipley had written in his proposals for his Society. It was to cover 'the liberal sciences, the polite arts, and every useful manufactory', and, kept afloat by public subscription, would be 'an effectual means to embolden enterprise, to enlarge science, to refine Art, to improve our Manufactures, and extend our Commerce; in a word, to render Great Britain the School of instruction, as it is already the centre of traffic to the greatest part of the world'.[20]

Drawings, in particular, were exhibited to the view of members of the Society and their friends, and it was hoped that the plaudits of onlookers and judges would stimulate the making of even better work. Hogarth himself was a judge. Yet the Society in those years was dominated by merchants who wanted quick profits from new designs and, viewed objectively, was unlikely to form the basis of an adequate patronage system for artists of all ranks. Although the Society of Arts expanded its range of drawing subjects and pupils in the later 1750s, Hogarth became disillusioned and drifted away in weariness and disappointment.[21]

By the late 1750s a desire for some form of regular exhibiting structure for drawings and paintings was being expressed in different ways. The Foundling Hospital exhibitions and the Society of Arts competitions had established an appetite for visual display; yet the purposes of exhibition and the consitution of an audience were still both contested and confused. In March 1759 the painter Robert Pine had proposed an exhibition to the Society of Arts but had been turned down for lack of room. Frustration at the delays finally prompted Hayman, who belonged to both groups and was well liked, to propose at the annual meeting of the Foundling Hospital artists on 5 November 1759 a further discussion to found 'A great Museum all our own'[22] – though by this time it was known that the Society of Arts had moved into spacious premises in the Strand and had become the obvious location for such a show. The Foundling group referred the idea to a committee of over 30 artists, including Hayman, Ramsay and Reynolds, to work out the details: this was the meeting of 12 November 1759 at the Turk's Head tavern, Gerrard Street, Soho. Hayman proposed an annual exhibition as a 'public receptacle to contain the work of artists for the general advantage and glory of the nation and satisfaction of foreigners'; it was to 'encourage Artists whose Abilities and Attainments may justly raise them to Distinction who otherwise might languish in Obscurity and that their several Abilities may be brought to Public View'.[23] A further proposal was to form a fund for improvident artists and their families by charging a shilling at the door. Two further meetings were held in December 1759 before the proposal was put before the Society of Arts in February 1760 and accepted in March, 'under such Regulations and Restrictions as the Society shall hereafter prescribe'.[24] Reynolds, who headed the painters on the committee, was influential in securing advantagous positions for the works of senior artists – Hayman, Richard Wilson, Samuel Wale, Richard Dalton and Francis Newton – alongside the Society's prize-winners, with

whom they were exhibited at the first event.[25] Though the Society of Arts turned down the proposal to impose an entrance fee, the artists introduced a sixpenny catalogue. The first temporary art exhibition in London opened, for a period of a fortnight, on 21 April 1760.

Exhibitions of 1760–62

Here at last was a group of paintings – 74 in all – by the likes of Cozens, Hayman, Haytley, Highmore, Pine (3 works each), Reynolds (4), Sandby and Richard Wilson (both 3), with sculptures by Roubiliac and engravings by Yeo, plus drawings, that were not only available for public inspection but which for the first time sought to mould that public in its behaviour and assumptions, at the same time as it witnessed the first onslaught of printed criticism of art in the periodical press. To add to the cacophony of voices, the Society had its own patriotic priorities: its very sizeable premium of 100 guineas 'for the best original Historical Picture' was awarded to Robert Pine's *The Surrender of Calais to Edward the Third* (no. 42), a clearly francophobe representation of an important English event, while the 50-guinea second prize went to the Italian painter Andrea Cassali's *The Story of Gunhilda*. The 'best landscape' prizes went to George Smith's *Landscape* (Figure 4) and his brother John Smith's work of the same title, both Claudian ideal landscapes of a distinctly English appearance.

The awards sparked off what must be one of the earliest public controversies over the values of art; an anonymous correspondent to the *London Chronicle* complaining of a 'deficiency of knowledge' in the Society's sections on painting and sculpture. Claiming that these arts had been cultivated 'in all polite countries and in all ages' and that 'next to poetry and history [they] are the most improving and entertaining', the critic tried to drive a wedge between intentions and results.

4 George Smith, *Landscape*, about 1760 (a version of the landscape with which Smith won the Premium at the Society of Arts, 1760), oil on canvas, 75 x 100 cm.

I fear we must not hope to see it established in any great degree of perfection till peo-
ple have acquired a better taste, and shall become more capable of distinguishing the
ore from the dross. For what encouragement is there for an ingenious artist … when
the very worst things are preferred to the best? When a set of tawdry, dissonant and
flaring colours, which have nothing in them but distraction and confusion, can so
easily influence the judgement of Connoisseurs? … When a laboured and painful
neatness, not painted but dotted and fiddled out with a pencil, gives more pleasure
to judges (if such are to be called judges) than an easy freedom and firmness of hand,
capable of determining all the several parts with an infallible precision which is alone
to be found in the great masters?

Maintaining that 'there are as fixed and certain rules for painting and judging of
a fine picture as for erecting or judging of an elegant and noble piece of architec-
ture', the writer is advancing elite standards of judgement rich in connotations of
aristocratic culture and clearly intended to be recognised as such. He commends
a work known as *Evening* (though there is nothing in the catalogue by that name),

which was rejected by the majority of gentleman Connoisseurs [but in which] the
water forwards … was so artfully and masterly managed as to receive, with great
clearness, the reflection of the broken grounds, bridges, &c. The foliage of the trees
was of a proper breadth in their masses of light and shade, and expressed with a free
and easy pencil. At the same time a great certainty and firmness of hand manifested
a master.

The writer's emphasis on 'easy freedom and firmness of hand' is at the same time
an attribute of the gentlemanly manners of the old aristocracy that is becoming
increasingly attractive to a British mercantile bourgeoisie; 'certainty', 'firmness'
and 'masterly managed' resonate with similar meanings. The writer spoke of
'rules' and 'principles' which would combine these virtues with those of clarity
and control.[26]

In the following issue of the *London Chronicle* the argument was robustly con-
demned as 'flourishing, pungent, puritanick'; as 'party uneasiness' in the service
of a particular group of friends. The standard now defended was nature herself.[27]
What is happening in this debate – conducted in the public medium of a tri-weekly
paper – is a contest of two standards of judgement: an aristocratic regard for prin-
ciples derived from the past, against a specifically British attention to patriotic
detail and local circumstance; a confident yet fluent technique against evidence of
hard descriptive labour; of abstraction against particularity.[28] Conducted in an
idiom of personalised invective mixed with generalities and tendentious detail,
such debates served to articulate critical opinions and the moral claims that went
with them, and to divide the reading public interested in art along similar lines. It
was a critical contest that would animate the reception of art in England at differ-
ent intervals over the next two hundred years.

In tandem with the growing volume of public criticism, the 1760 exhibition at
the Society of Arts was well attended. A profit of £165 came from an audience of

over 6,500 who bought the catalogues, the actual number of visitors being as high as perhaps 20,000.[29] By the same calculation, the show attracted many visitors who did not buy a catalogue and who to that extent supplied neither endorsement nor cash. The author John Gwynn, in an epochal book on the replanning of central London of 1766, put the matter succinctly in what may have been an eye-witness report:

> as every member of the society was at liberty to distribute what numbers of tickets for admittance he thought fit, that which was intended only as a polite, entertaining and rational amusement for the publick, became a scene of tumult and disorder; and to such a height was the rage of visiting the exhibition carried, that, when the members themselves had satisfied their own curiosity, the room was crowded, during the hours allotted for the exhibition, with menial servants and their acquaintance; this prostitution of the polite arts undoubtedly became extremely disagreeble to the professors themselves, who heard alike, with indignation, their works censured or approved by kitchen-maids and stable-boys.[30]

A powerful sense of the social status of the show is contained in an order of the Society 'to exclude all persons whom [the officers] shall think improper to be admitted, such as livery servants, foot soldiers, porters, women with children, etc., and to prevent all disorders in the Room, such as smoking, drinking, etc., by turning disorderly persons out'. Although the exhibition room was large – at 10 by 40 feet large enough to accommodate up to a hundred people for meetings – and although windows were broken and there were some scuffles, probably not serious, the clear intention was that art could and did provide experiences unlike those of the fair or the street. To the artists particularly, the danger was that the wrong people would judge the work; hence they complained of 'the intrusion of persons whose stations and educations disqualified them for judging of statuary and painting, and who were made idle and tumultuous by the opportunity of a show'.[31]

This was a key moment in the definition of works of art as objects of a specific kind of attention. Above all, the painters wanted approbation from those whose patronage would do them some good in the circle of their profession; and that excluded the majority. Gwynn himself suggests that one consequence of mixing the more eminent painters with the Society's prize-winners was that some visitors concluded that the prize-winners were the best *of all*: 'Had it been possible to have confined this injurious decision to the vulgar spectators, it would have been a thing of no consequence; but unfortunately for the arts, many in a higher sphere of life were liable to be led away by the same opinion'.[32] Or as Gwynn's contemporary Edward Edwards puts the same problem:

> As soon as it was known which performances had obtained the premiums, it was naturally supposed, by such persons who were deficient in judgement, that those pictures were the best in the room, and consequently deserved the chief attention. This partial, though unmerited selection, gave displeasure to the artists in general.[33]

Therefore when the Society turned down the artists' requests for even tighter con-
trol over the exhibition the following year, Reynolds and his group rented alter-
native premises at Cock's Auction Room in Spring Gardens, near Charing Cross.
The Society of Arts held its usual exhibition in the Strand, but without the dis-
tinguished painters who had been there the year before, save for Cosway and
Nollekens, who remained loyal to Shipley's cause.

The background to this shift of allegiance by the Reynolds group was almost cer-
tainly the accession to the throne of England in October 1760 of the 22-year-old
George III, a figure who had very different attitudes to both art and its national uses
than either of his Hanoverian predecessors. Unlike the somewhat peripatetic George
I and George II, George III spent most of his time in London, and displayed an inter-
est in the arts just as his father, Frederick the Prince of Wales, had done. Yet as Linda
Colley notes, George III was 'different': as his long reign unfolded he developed the
confidence to indulge his tastes and to surround the image of the monarchy with
emblems of national culture and display. Further, he was British born and bred, and
identified from the outset with the destiny of his country.[34]

Reynolds and his group knew that they stood a chance of royal patronage even
at the time of preparations for their Spring Gardens show in the spring of 1761 –
some five months before the new King's coronation in Westminster Abbey. In a
conspicuous gesture they now called themselves the Society of Artists of Great
Britain to emphasise their identity with the 'nation' and to announce a clear split
from Shipley's faction. Reynolds and his group were joined by Hogarth and
Gainsborough, and admission was by catalogue only, one that 'would admit a
whole family in succession'.

Contemporary reports attest to the immense popularity of both exhibitions –
though distinctions between them were becoming noticeable and important. Back
in the Strand, 'the Crowd was so great … by People pressing into the Exhibiting
room … that a deal of Mischief was done; one of the Porters, who was employed
by the Society to see Decorum observed, was knocked down, and otherwise greatly
abused'.[35] At Spring Gardens, thirteen thousand catalogues were sold, and profits
were high, though Edwards states that the new method of admittance 'was still
productive of crowd and disorder, and it was therefore altered the next year'.[36]
Hogarth's own position was interesting. With five paintings in the show, the same
number as Reynolds, he was a prominent contributor. At the same time he took
the opportunity to protest the influence of auctioneers, dealers and connoisseurs
– which he now associated with the Strand exhibition – and bemoaned the mar-
ket's habit of favouring pictures only by deceased foreign artists at the expense of
the British and the living. For the tailpiece to the Spring Gardens catalogue he
drew a one-eyed monkey (clearly a connoisseur) watering 'exotiks' in the form of
dead trees. The design for the frontispiece (Figure 5) purportedly shows George
III's patronage of the arts, though it in fact reveals Hogarth's true attitude to royal
patronage. The image of the King's benevolence flowing first into Britannia's
watering-can appears a little absurd. Secondly, close inspection shows that the tree

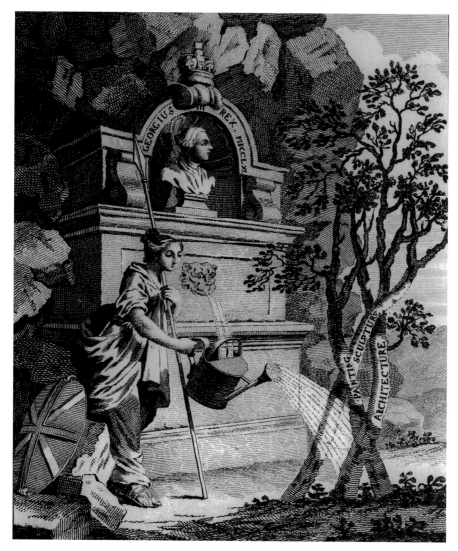

5 Charles Grignion after William Hogarth, frontispiece to the catalogue of the exhibition of the Society of Artists of Great Britain, May 1761, etching 16.2 x 14.3 cm.

of Painting, unlike Architecture or Sculpture, is half dead, though that condition is cleverly disguised: only the branch billowing towards the King himself seems alive.[37]

Taken together the two images summarise Hogarth's fears for the new style of royal patronage – already visible in the first year of the King's reign and the second in which exhibitions were publicly seen in the capital. On the one hand a competitive commercial culture, especially the trade in old masters, threatened to obscure the vitality of painting and sculpture based in the detail of the

contemporary. For Hogarth himself, as an artist and patriot, how could the blandishments of royal patronage of British art be reconciled with the rights of citizens to engage in social and therefore political expression? How was the monarch's 'protection' of the arts to lead to the flowering of visual culture unfettered by hierarchies and rules?

In the face of such questions, the years between 1762 and 1768 were to see a virtually permanent schism between the different factions of the painting profession in England. In 1762 itself three exhibitions – at least – were held within a geographical area comprising the half-mile between the Strand and St James's Park. The remaining artists of the Society of Arts grouped themselves under the philanthropic title 'Free Society of Artists associated for the Relief of Distressed Brethren, their Widows and Orphans'. Awarding prizes for work, their exhibition took place from 20 April in the 'Great Room' of Old Beaumont House on the south side of the Strand.[38] Four weeks later the Society of Artists of Great Britain's second exhibition, headed this time by Hayman but significantly without Hogarth, opened in Spring Gardens on 17 May 1762, preceded by resolutions in the artists' meetings that concentrated even greater power over selection and hanging in a smaller committee; 'the resolutions of the committee', according to a contemporary account, 'shall be kept a profound secret'.[39] The Society's previous philanthropic commitments were now dropped. Admission to the show for 1 shilling per person – a big increase over the previous year – was partly to ensure that only 'the highly respectable' got in.[40] The catalogue, written by Samuel Johnson or Reynolds or more likely both, contained a 'conciliatory preface' which sought to excuse and explain the terms of access against the accusation that the show was too expensive and select. 'The purpose of this exhibition is not to enrich the artist', the preface says a touch disingenuously, 'but to advance the art'. Above all, it claimed that 'discrimination' was called for of a kind which rose above the personal rivalry between artists (rivalry that public exhibitions were nonetheless bound to accentuate):

> It cannot be denied or doubted, that all those who offer themselves to criticism are desirous of praise; this desire is not only innocent but virtuous ... [in those who], already enjoying all the honours and profits of their profession, are content to stand candidates for public notice ... [and who] without any hope of increasing their own reputation or interest, expose their names and their works only that they may furnish an opportunity of appearing to the young, the diffident and the neglected.

That statement – an important one in the evolving conception of a public for art in London – claimed to transfer the terms and rewards of approbation from the painters, their groups and societies, to at least a section of the public at large. 'The eminent are not flattered with preference', the authors continue, 'nor the obscure insulted with contempt. Whoever hopes to deserve public favour, is here invited to display his merit.' Yet the preface was equally clear about the need to limit visitor numbers and to raise profits – two aims that could be achieved simultaneously with the higher entrance charge: 'We know ... what everyone knows, that all cannot be

judges or purchasers of works of art.' Indeed it justified confining the audience to the wealthy and educated in two ways. The desire of an artist to attract a large crowd 'defeats its own end, when spectators assemble in such number as to obstruct one another' – this was the first and weakest of the preface's two arguments. The second appealed directly to a measure of discernment and taste: 'When the terms of admission were low, our room was thronged with such multitudes, as made access dangerous, and frightened away those whose approbation was most desired.'[41]

Here was a contradiction that would repeat itself endlessly in the evolution of a discriminating public for art: the incompatibility of large numbers with physical comfort in the viewing space, and the need to ensure 'correct' judgement by admitting only the discrimating few. The fear, if not the reality, was of contamination by an undiscriminating mass. It turned out however that the Society's visitors in 1762 were 'highly respectable ... [and] also perfectly gratified with the display of art, which, for the first time, they beheld with ease and pleasure to themselves' (the witness is again Edwards),[42] suggesting that optimal viewing and judging conditions had been achieved at last. Optimal, that is, for artists and audience alike if adequate discernment and exclusivity were the criteria being deployed. But the *desiderata* imposed by such statements are equally revealing for what they do not say. 'Approbation', 'ease' and 'pleasure' were terms of gentlemanly refinement indicative of relaxed absorption in works of serious import. Admittedly some amateurs were also on display, and not every work could be described as 'high art'. Yet here in its formative stage was a culture of, and a public for, art considered largely self-justifying and frequently elevated in content; above the common weal and definitive of a group of artists increasingly ambitious for identitification with the nation and the King.

Signs in public

The third exhibition of 1762 was very different. Held almost simultaneously with those of the Free Society of Artists and the Society of Artists of Great Britain, in Bow Street, Covent Garden, in the house of Hogarth's and David Garrick's friend the journalist Bonnell Thornton,[43] it was, perhaps improbably, an exhibition of the work of sign-painters that had been postponed from the previous year. Here was a very different exercise in patriotic culture. Trading heavily on the humorous and the burlesque, the Signboards Exhibition – as we may call it – launched an effective criticism of the high pretensions of the two other shows.

Signs in city streets in early eighteenth-century London had been numerous, colourful and essential for a largely illiterate and innumerate population (houses had yet to be numbered) and often projected far into a crowded alleyway or street. They were also humorous: according to one account, 'we meet very heterogeneous objects joined together' (the reference is to language and visual construction) to the point where a puzzled correspondent to *British Apollo* for 1710 had written a poem:

I'm amazed at the Signs
As I pass through the Town
To see the odd mixture:
A Magpie and Crown,
The Whale and the Crow,
The Razor and Hen,
The Leg and Seven Stars,
The Axe and the Bottle
The Tun and the Lute,
The Eagle and Child,
The Shovel and Boot.[44]

Yet by mid-century, incongruity and improbability had become established as aes-
thetic principles in satirical literature and in some quarters of the visual arts. In
The Analysis of Beauty of 1753 Hogarth implies that they were consonant with vari-
ety and tolerance, and as such were characteristics of 'Britishness'. He himself
painted signboards early in his career: while preparing to write *The Analysis of
Beauty* Hogarth is reported to have visited Fleet Market and Harp Alley 'which
were in those times the great marts, and indeed exhibitions, of signs, of various
descriptions, barbers'-poles, etc. etc. … in these places it was the delight of
Hogarth to contemplate those specimins of genius emanating from a school which
he used emphatically to observe was truly English'.[45]

Perhaps he was the author of *A Man loaded with Mischief, or Matrimony* for an
alehouse at 414 Oxford Street (Plate 2). The sign shows a man around whose neck
is a chain fastened by a 'Wedlock': he carries a woman, who holds up a glass of gin.
A sow is asleep below, with a label 'She is drunk as a sow'; while two cats make love
an a roof, and a pub in the background has a pair of horns as a finial with 'Cuckolds's
Fortune' inscribed above. The inscription below reads 'A Monkey, A Magpie, and
Wife; Is the true Emblem of Strife'. Sign-painting was a genuinely popular art, and
Hogarth was obviously alive to its capacity for visual and verbal incongruities, puns,
emblems and wit (Figure 6).[46] This interest in signs was far from unique: Bonnell
Thornton had written a series of mischievous articles in the *Adventurer* in 1752–53,
one of which appears to burlesque the very argument being used against contem-
porary signs by the rationalists.[47] By the early 1760s when Hogarth and Thornton
staged the Signboards Exhibition nearly opposite the Society of Arts show in the
Strand, the battle lines were fairly clearly drawn between the adulation of old-mas-
ter paintings from the continent, and the depiction of contemporary-life subjects
by Englishmen in an irreverent and diversionary mode.

It is important too that by 1762 the very existence of signs in London was in
doubt. The offcial line was that trade in the capital was being held up by 'conges-
tion' and 'obstruction' in the street, even though contemporary views show little
obstruction taking place (Figure 7). A series of Acts pressed through Parliament
by George III's unpopular minister the Earl of Bute to pave, clean and light the
streets required the removal of hanging signs and, at best, their refixing to the

fronts of shops and premises. The 'Butification' of central London was regarded within Hogarth's group as destructive of variety and bright display, as well as essentially foreign.[48]

These several contexts for the Signboards Exhibition made it all the more poignantly both an anti-establishment and a patriotic event. It is not that signboards were to be paraded as art – rather that their ubiquity as trading emblems and their visual-verbal incongruity presented rich opportunities for humour and burlesque. One advertisement in the *St James's Chronicle* preceding the show solicits the sending in of 'any curious Sign … to be met with in Town or Country, or any Hint or Design for a Sign'; another, to 'any artist [who will] please to favour [the organisers] with a newly conceived Sign, either painted or devised by himself'.[49] The *St James's Chronicle* had been set up by Bonnell Thornton with George Colman, David Garrick and others in 1761, principally to advance the critical and satirical interests of the Nonsense Club, a group of men who dined together and irreverently discussed the art, literature, theatre and politics of the day. The *Chronicle* had already attacked the Society of Arts exhibition of 1761, and in its commentary on the Society of Artists' show had clearly sided with Hogarth against the connoisseurs. In 1762 the relationship between Hogarth and the Nonsense Club was particularly close. The

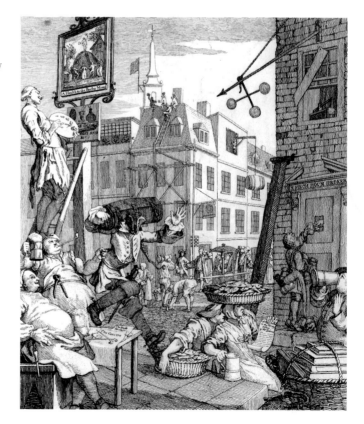

6 William Hogarth,
Beer Street
(proof state, February
1750/51),
35.9 x 30.4 cm.

7 T. Bowles, *Cheapside, with Bow Church and the Old Signs to the Shops*, c. 1751, 16.5 x 25.4 cm [Crace, XXI, 3.18].

Signboards Exhibition was intended to share the qualities of the Club itself, namely 'contradiction, moral and aesthetic relativism, rebellion against established forms, a love of spontaneity, and an extreme consciousness of self'.[50]

In the first place, its very catalogue was designed to burlesque those of the more serious affairs in the Strand and Spring Gardens. As one wag observed, the organisers had fixed the ticket arrangements to ensure that anyone entering the exhibition twice paid twice: 'The Society … of Sign Painters … have the Assurance to fix a Ticket to each Catalogue which they sell, for their own Profit, at a Shilling, and by obliging the Ticket to be torn off at the second Door, make the Purchase of a new Catalogue absolutely necessary for a second Admission.' He facetiously continues: 'Pity it will be, if all who are employed in the carrying on of this Cheat, are not seized and sent to serve the King [i.e. in prison]; And those who are Sharers in the Booty deserve likewise to be severely chastised. I am, SIR, yours &c. A Despiser of all Tricking'.[51]

Since no images from the Signboards Exhibition have survived, its ambience must be reconstructed from contemporary reports. The *St James's Chronicle* the previous year (23–6 May) had burlesqued the ambitions of the show, and in so doing had promoted them:

> The projected Exhibition … is only postponed, till a Room spacious enough can be provided … In the mean Time, the several ARTISTS (Natives of Great Britain) are invited to send to the printer of the Paper, a List of those Capital Pieces, which they intend to submit to the public Judgement. N.B. No Foreigners, and Dutchmen in particular, will be allowed a place in the Exhibition.

It is possible that in 1761 the idea of an exhibition of signs was a mere *jeu d'esprit*, conjured into existence for the amusement of the Nonsense Club.[52] Yet by 1762 plans were well advanced – though behind a crossfire of conflicting announcement, misinformation, and personal and political innuendo. Since the spoofed objections in the *St James's Chronicle* could no longer be distinguished from real ones, the ultimate effect was to generate publicity for the show and to sell copies of the *Chronicle*.[53] And yet the show did take place, and was in some sense a propaganda success. The *London Register* contained what purports to be a documentary account:

> On entering the Grand room ... you find yourself in a large and commodious Apartment, hung round with green Bays, on which this curious Collection of Wooden Originals is fixt flat, (like the Signs at present in Paris) and from whence hang Keys, Bells, Swords, Poles, Sugar-Loaves, Tobacco-rolls, Candles and other ornamental Furniture, carved in Wood, that commonly dangles from the Penthouses of the different Shops in our Streets ... (when we consider the singular Nature of the Paintings themselves, and the Peculiarity of the other Decorations) it may be easily imagined that no Connoisseur, who has made the Tour of Europe, ever entered a Picture-Gallery that struck his Eye more forcibly at first Sight, or provoked his Attention with more extraordinary Appearance.[54]

The *Register* also carried a copy of the catalogue entries, most of which are improbable satires on the connoisseurial conventions in use in the other two shows. Some examples are:

> 5. A Ship and Castle. *Thomas Knife*, written under. But it is not known whether this is the Name of the Artist or the Publican.

> 12. An Heroe's Head, unknown. By *Moses White*. With the least Alteration, may serve for an Heroe past, present, or to come.

And then, for the Grand Room:

> 1. Portrait of a justly celebrated Painter, though an Englishman, and a Modern'. [i.e. Hogarth]

Some signs hung together in significant pairs, such as:

> 19. Nobody, alias Somebody. A Character.

> 20. Somebody, alias Nobody A Caricature. Its Companion. Both these by *Hagarty* [i.e. Hogarth].[55]

– two pieces to which the *London Register* and the *Chronicle* added 'explanatory remarks' in case they 'may possibly seem obscure to those who have not been spectators, as well as readers, on this humorous occasion'. Thus Nobody is 'The Figure

of an Officer, all Head, Arms, Legs and Thighs. This Piece has a very odd Effect, being so drolly executed, that you don't miss the Body', whereas Somebody is 'A rosy Figure, whose Belly swags over, almost down to his Shoe-Buckles. By the Staff in his Hand, it appears to be intended to represent a Constable – It might else have been mistaken for an eminent Justice of the Peace', though Bertelsen connects both figures to a 1761 poem by Charles Churchill, perhaps London's foremost satirist in the early 1760s and perhaps in league with the Nonsense Club. Churchill in the poem celebrates a dissolute and pleasure-seeking life style based on drink, sex and licentious conversation, in which, to quote Bertelsen,

> Somebody is the man of 'Prudence', who reaps the benefit of society by unquestionably following its rules; Nobody is the independent underdog, who because he unashamedly acts out his physical desires – eating, drinking, fornicating – can see through the pretentious sham of the hypocritical Somebody. Somebody follows the establishment code, Nobody the unwritten popular code; Somebody supports the institutions of Tyburn, the Fleet, and Bridewell. Nobody understands the reason for crime, riot, and mob action.[56]

Another pair of signs was hung either side of the chimney and covered by blue curtains, with a notice that forbade touching (clearly a provocation to do so). The *Chronicle* explained:

> Behind the blue Curtains on one of these Boards is written Ha! Ha! Ha! and on the other, He! He! He! – At the first Opening of the Exhibition, the Ladies had infinite Curiosity to know what was behind the Curtain, but were afraid to gratify it. – This covered Laugh is no bad Satire on the indecent Pictures in some Collections, hung up in the same Manner with Curtains over them[57]

– indicating the extent to which some signs required the viewer's connivance not merely in 'completing' the work but in being able to laugh at the predicament thus created. In a similar vein no. 28, *The Loggerheads*, by Hagarty/Hogarth, showed two idiots' heads and the rubric 'We Are Three' – a sign that invited questions about the third idiot at the questioner's expense. Staged as a mock-art exhibition with catalogue and hanging arrangements to suit, the Signboards Exhibition played endless textual and pictorial games at the expense of the 'polite' and 'instructive' exhibitions on display nearby. In the centre of show hung a sign reading 'SPECTATUM ADMISSI RISUM TENEATIS', or 'having been admitted to observe this, restrain your laughter' (from Horace's *Ars Poetica*, Book 5), intended in self-mockery, since the aim of the exhibition was to make its visitors laugh. Like the popular eighteenth-century masquerade which was in some ways its equivalent, the show seems to have been genuinely 'labile and convulsive', an attempt at liberty 'from every social, erotic and psychological constraint … an organised infatuation with otherness' that had anti-decorum as its principal aim.[58]

The Royal Academy of Arts

The appearance in the spring of 1762 of three mutually contrastive exhibitions within a stone's throw of Westminster and St James's, together with the eruption of several shades of serious and lampooning criticism, demonstrates an emergent 'public' for the visual arts that was diverse and occasionally experimental. And yet not every part of the exhibiting spectrum would emerge from the melting pot on an equal footing.

With Hogarth's death in 1764 and the already clear desire of Reynolds and his group to manoeuvre themselves into positions of authority within the profession, the chances of a popular or a satirical high art in England, and with it prospects for the formation of a non-hierarchical profession of artists, went into sharp and possibly irreversible decline. In 1765 the 211 members of the Society of Artists obtained a Royal Charter as 'The Incorporated Society of Artists of Great Britain' and for a short time embraced most of the well-known artists practising in Britain – though it remained free of direct control by the King. Following the defection of the Reynolds group, the Strand exhibitions of the Society of Arts remained 'always third-rate and [their] influence small'.[59] By 1768, however, disputes over the right to the best places in the Society of Arts annual exhibitions reached a height.[60] Sir William Chambers, who had been George III's tutor in architecture, discussed with him the formation of a more compact and authoritative body, and on 10 December 1768 the Instrument of Foundation of the Royal Academy of Arts was formally signed by the King.

The Instrument of Foundation dramatically codified the principle of a monarchically connected academy along the lines established in France. Professionally an elite and clearly identified with the public image of the King, the new Academy would comprise 'forty Members only … they shall all of them be artists by profession at the time of their admission … Painters, Sculptors or Architects, men of fair moral characters, of high reputation'. They would be 'at least twenty five years of age, resident in Great Britain, and not members of any other society of artists established in London'. Forty members were named, it being specified that vacancies would be filled by election from within, as would the President (elected annually) and a Council. The elected Secretary and Keeper would be paid posts, 'approved of by the King'; whereas the Treasurer would be appointed by the King (he was named in the Instrument as Sir William Chambers), who would pay all 'deficiences' or debts. There would be students, and Professors of Anatomy, Architecture, Painting, Perspective and Geometry, and other officers; and there would be an 'Annual Exhibition of Paintings, Sculpture and Designs, which shall be open to all Artists of distinguished merit' to which all Academicians under the age of 60 would contribute one work (or pay a penalty of five pounds). All new regulations and variations to old ones would be subject to 'the approbation of the King'.[61]

Here then was Britain's first artistic organisation under the direct aegis of the monarch, devoted to the maintenance of artistic standards and values of a general

kind, and justified by nothing other than the idea of the cultural progress and pres-
tige of the nation in its most abstract embodiment. The link with manufacture or
industry had been lost.[62] Reynolds himself, consistently scornful of amateur pro-
duction and especially the habit of judging paintings by resemblance to nature,
held out for a high-minded critical framework based on knowledge of a canon of
European history painting of the past; an art that to many professional painters
working in England was still largely unknown. 'The principal advantage of an
Academy', said Reynolds in the first of his *Discourses*, delivered to students in
January 1769, was that 'besides furnishing able men to direct the Student, it will
be a repository for the great examples of the Art ... By studying these authentick
models, that idea of excellence which is the result of the accumulated experience
of past ages, may be at once acquired'.[63] In earlier writings and later *Discourses*
Reynolds urged that precedence be accorded to the authority of the past, in pref-
erence to what he took to be a 'lower' contemporary and popular taste for verisimil-
itude of gesture, and plausibility of action and pose.[64]

The significance of Reynolds' influential position is the contrast it also estab-
lished with the dubious claims of 'connoisseurs' who had principles to apply.
Although the new Academy could be internally varied and tolerant, from the out-
side it underlined and perpetuated such a series of divides. Reynolds' plea for tra-
dition, and specifically for history painting, became one element of an institution
for generating a 'national' visual culture within a structure staffed by experts and
validated ultimately by the King. And not only had the Academicians gained the
patronage of the King – they surely enjoyed the Royal imprimatur as guarantee of
their own prestige and authority – but the very existence of the Academy was
designed to enhance the King's own prestige and to suggest that their (and his)
artistic and moral values were those of the nation as a whole. Added to the secrecy
with which the Academy conducted some of its business, and the exclusivity of its
membership, this aura of officialdom served to open up a gulf between a minority
of favoured professionals and their specialised supporters and a far larger body of
practioners and viewers in the public body at large, including those who had only
a few years earlier been happy to enjoy such entertainments as the sign-painters'
burlesques. For democrats already suspicious of the King's arbitrary power, his
association with the Academy was another sign of patronage wrongly and harm-
fully deployed. For those whose interests lay in the art market, too, that patronage
distorted the pattern of distribution and consumption of art in a way that ran
counter to both 'liberty' and freedom of commercial action.

Contrasts and oppositions

Such opposition to the Academy and the King had been expressed before, notably
by the charismatic Member of Parliament (MP) for Aylesbury and member too of
Sir Francis Dashwood's Hellfire Club, John Wilkes. Wilkes had been close to the
satirist Charles Churchill (though both had been attacked by Hogarth in his print

The Times of 1762 for the tenor of their opposition to Bute and the King). Wilkite patriotism favoured trade and a continuation of the Seven Years' War (1756–63), and generated a popular following among middle-ranking merchants both in and outside London. Convicted of libel in 1764, he had gone into exile but returned in March 1768 to beg the pardon of the King, and made preparations for his election as Member for the City of London. His appeal to the electorate was that he was a 'private man, unconnected with the Great, and unsupported by any Party'.[65] He lost, but on standing for a Middlesex seat he won, instantly becoming an emblem of free speech, the right to oppose the King and Parliament without arrest, and the freedom to publish. Nonetheless, Wilkes's libel convictions were enforced and he was gaoled in June of the same year, serving a total of 22 months.

Wilkes was at the height of his ability to embarrass the government late in 1768, when the Instrument of Foundation of the Royal Academy was signed by the King. The first premises of the Academy were on the south side of Pall Mall in a modest building previously used by the auctioneer Aaron Lambe, with a shop front at street level surmounted by a library, meeting-rooms and studios (Figure 8). Equipment was obtained from the old St Martin's Lane Academy by George Moser, one of the principals at St Martin's Lane and now the first Keeper of the new Academy. As Reynolds in his first *Discourse* praised his patron the King, 'who promotes the Arts, as the head of a great, a learned, a polite, and a commercial nation',[66] Wilkes was in open prison for his misdemeanours, a popular hero. With Wilkite riots in the streets of London throughout the winter of 1768 and the spring of 1769, and with the middle classes apparently split between popular patriotism and the cultural splendour of the monarch, the Academy's founding moment was an unsettled one. A demonstration to deliver an anti-Wilkite petition to the King by a rump of City figures in March 1769 was opposed by a counter-demonstration of far greater proportions by Wilkes's supporters. 'An immense mob [who] came down Pall Mall, ... many of whom cried "Wilkes and no King", some singing "God Save great Wilkes our King"', were later indicted with having 'disturbed the peace of the said Lord the King before the Palace [i.e. St James's]'.[67]

No wonder, then, that the exhibition given in 1769 by the remaining members of the Society of Artists of Great Britain, now optimistically calling themselves the '*Royal* Incorporated Society of Artists of Great Britain', and the first exhibition of the Royal Academy of Arts of that year, were not untouched by the contemporary liberty debate.[68] The former, opening on 1 May 1769 at Spring Gardens and the tenth exhibition of the Society, was in aesthetic terms distinguished by a diversity of accessible styles: moonlights and candlelights, several by Joseph Wright of Derby; portraits of identifiable living persons; conversations; animal paintings; views of the Thames and nearby locations; landscapes, still-lifes and miniatures; a number of historical pictures (the unfinished *Darius obtaining the Persian Empire*, by Gilpin) and a scattering of foreign views (Rome, Naples, Tivoli and Florence, by Marlow); in addition to 'an Old Man's Head, drawn with a hot iron upon a piece of plained board; and ... the Likeness of a Gentleman, done with his own hair'.[69]

The contrast is with the first Royal Academy show of 136 works, in the top room at Pall Mall, which lasted from 26 April to 27 May 1769. On the opening day Reynolds was repaid for his flattery by a knighthood from the King. Inside the title-page of the catalogue was an 'advertisement' stating that

> although the public may expect free entrance to an institution supported by Royal munificence, the academicians regret that [though] this was very much their desire … they have not been able to suggest any other Means, than that of receiving Money for Admittance, to prevent the Room from being filled by improper Persons, to the Exclusion of those for whom the Exhibition is apparently intended.[70]

The show opened 'to a very crowded and brilliant route of persons of the first fashion', and in the four weeks of the exhibition it was estimated that for a shilling entrance fee between ten and twenty thousand visitors saw the show, or an average of about 500 per day.[71] The King and other members of the Royal family and entourage 'expressed themselves highly satisfied' with the show:[72] the King himself bought West's very popular *Departure of Regulus from Rome* (with the traitor Corvus perhaps modelled on John Wilkes) for a thousand guineas. There were three classical paintings by Reynolds, four classical subjects by Angelica Kauffmann,

8 View of the Old Royal Academy in Pall Mall from the extra illustrated edition of W. Sandby's *The History of the Royal Academy of Arts from 1768 to the Present Time*, 1862, p. 125, and from a drawing in the British Museum.

full-length double portraits of the King and Queen by Dance and an annunciation by Cipriani.[73] Reynolds himself set the tone (if not every instance) of Academic practice by preaching to the students the virtues of an elevated style; 'The whole beauty and grandeur of the art consists, in my opinion, in being able to get above all singular forms, local customs, particularities, and details of every kind', he would say in *Discourse* III at the end of the following year. The painters who

> applied themselves more particularly to low and vulgar characters, and who express with precision the various shades of passion, as they are exhibited by vulgar minds (such as we see in the works of Hogarth), deserve great praise; but as their genius has been employed on low and confined subjects, the praise which we give must be as limited as its object [whereas] it must not be forgotten that there is a nobleness of conception, which goes beyond anything in the mere exhibition even of perfect form; there is an art of animating and dignifying the figures with intellectual grandeur, of impressing the appearance of philosophick wisdom, or heroick virtue. This can only be acquired by him that enlarges the sphere of his understanding by a variety of knowledge, and warms his imagination with the best production of antient and modern poetry ... such a student will disdain the humbler walks of painting, which ... can never assure him a permanent reputation.[74]

The contest was one of detail versus generality, presentness versus history, genre versus portrait, anecdote and recognition versus embodied morality of an elevated kind: West's Academy picture of Regulus eschewing his family and friends in favour of disinterested high moral virtue – perhaps implicitly that of the King – versus the repeated emphasis on popular recognition of subjects and scenes at the Society of Arts show, most of which, such as the paintings done with an iron or made out of human hair, 'offered a demonstration of sheer technical skill as a principal source of delight'.[75]

But how are we to judge the composition of a metropolitan audience for art at a time when social and political affiliations were still in flux? From a Wilkite point of view, the King's power was in doubt. It is easy to imagine the misgivings some people felt not only at the attribution of artistic leadership to the Academy, but at the celebrations to mark the King's birthday on 5 June 1769, in which the Academicians were centrally involved:

> the whole front of the Royal Academy was illuminated in a very elegant manner, with transparent paintings and lamps of various colours. In the centre compartment appeared a graceful female figure seated, representing painting, surrounded with Genii, some of which guided her pencil, whilst others dictated subjects to her; at her feet were various youths employed in the study of the art, and over her head hovered a celestial form, representing Royal Munificence, attended by several other figures.[76]

Such pretentious magnificence, in this case designed and executed by Giovanni Battista Cipriani (Figure 9), was one example of how this particular monarch would embellish his aura at a time when the nation at home, basking in the victories of the

9 Giovanni Cipriani, *'The Arts': Illumination for the King's Birthday*, 1771, watercolour and pen, 45.8 x 59.6 cm.

Seven Years' War, was becoming accustomed to perceiving itself as the centre of the largest empire ever known. Replete with new lands in Canada, India, West Africa and the West Indies, Britain was now no longer purely a nation of commerce, the birthday celebrations seemed to be saying, but of empire; no longer a land of liberty but of warlike submission of alien peoples.[77] It was as if the monarch and his culture needed to be constructed within the terms of an increasingly ostentatious language of display.

Nearly two years later, in the spring of 1771, the King helped alleviate the overcrowding in the Academy's Pall Mall building by providing rooms in the underused Royal Apartments at Old Somerset House in the Strand – there is a Zoffany painting of Dr William Hunter, first Professor of Anatomy, lecturing to students and academicians in these rooms (Plate 3). In the same year the King's birthday celebrations were also transferred to Old Somerset House. The Academicians dined inside. Outside, Cipriani's illuminated screen was again erected as a means of attracting and giving form to public allegiance. Yet acclaim was mixed with dissent. One report tells us that 'the people, at least the *canaille* [scoundrel], filled every avenue, and rendered passing the streets very disagreeable';[78] which is consistent with Cipriani's own report that the screen was set on fire 'by the mob' just before midnight. The fire was quickly extinguished and from 1772 the royal birthday was

more modestly celebrated by a dinner, a band and a 21-gun salute fired from a yacht anchored on the Thames nearby.[79]

It is from the 1771 Royal Academy exhibition, held as usual in April, that we have one of the earliest images of the public who attended the show. Engraved by Richard Earlom after Michel-Vincent Brandouin (known in England as Charles Brandoin), the scene shows a crowd in the top room at Pall Mall, where exhibitions continued to be held until 1779 (Figure 10).

Owing something to the style of Hogarth, the engraving renders the crowd partially in caricature form. It is, on the one hand, a skit on the ideals of elevated and informed spectatorship erected for itself by the Academy. Beneath Barry's *Temptation of Adam*, flanked by two portraits, a fashionable woman flirts with a gentleman (who ignores her), while two others whisper behind her back. Two juveniles kiss, in front of a short fat lady and her tall thin husband, who have their attention elsewhere. A boy sits exhausted. Connoisseurs wearing spectacles or carrying catalogues purport to scrutinise the art. As a reflection on the motley social world and on the image's own status, the print also suggests that the 'public' for the Academy's shows in the early 1770s was in practice not unified but

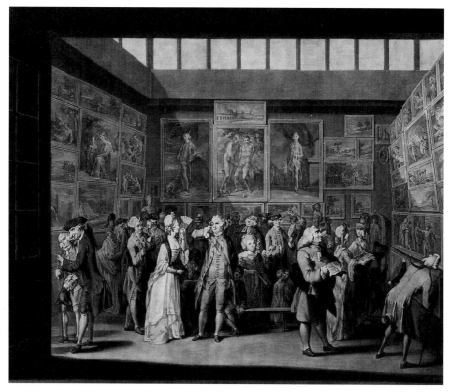

10 Richard Earlom, after Charles Brandoin, *The Exhibition of the Royal Academy of Painting in the Year 1771*, 1771, mezzotint, 47 x 55.9 cm.

highly diverse. Some were educated, some not; some attentive, some not; some 'serious', some not; also that the codes of social recognition were simultaneously complex and difficult to assemble.

And yet the drive for democratic and popular participation in the arts, raised by the conflicts out of which the Academy emerged, was not about to disappear. Wilkes, elected Mayor of London in 1774, continued to press Parliament and the King to provide public art institutions of a very different kind. He was, we should note, becoming something of an enthusiast for British art. By 1777, still protesting his entitlement to sit at Westminster, Wilkes made a plea to Parliament for properly financed collections of books and paintings to be housed at the recently opened British Museum: the argument was the simple one that London had no public library to compare with the Vatican in Rome or the King's Library in Paris. British printers should be obliged to deposit a single copy of every published book in such a library, and donations might be expected 'from private persons, who in England, more than in any country of the world, have enlarged views for the general good and glory of the state'.[80] Yet for paintings, Wilke urged the recognition of an 'English School', but supposed there would need to be a national gallery of good examples of continental art.

> Such an opportunity, if I am rightly informed, will soon present itself. I understand that an application is intended to parliament, that one of the first collections in Europe, that at Houghton, made by Sir Robert Walpole, of acknowledged superiority to most in Italy, and scarcely inferior even to the Duke of Orleans' in the Palais Royal at Paris, may be sold by the family. I hope it will not be dispersed, but purchased by parliament, and added to the British Museum.[81]

He added that it would offset the 'concern, which every man of taste now feels', that the Raphael cartoons, bought with public money and originally available to the public at Hampton Court, were now mouldering in the private apartments of Sir Charles Sheffield in St James's Park. The Raphael cartoons were 'an invaluable national treasure ... a common blessing, not private property.[82]

> The Kings of France and Spain permit their subjects the view of all the pictures in their collections, and ... an equal compliment is due to a generous and free nation who give their prince an income of above a million a year, even under the greatest public burthens. The treasures of a state are well employed in works of national magnificence. The power and wealth of ancient Greece were most seen and admired in the splendour of the temples, and other sublime structures of Pericles ... The sums expended on the public buildings of lettered Athens, in the most high and palmy state of Greece, after the brilliant victories over the Persians, diffused riches and plenty among the people at that time, and will be an eternal monument of the glory of that powerful republic.[83]

Parliament and the King would no doubt have been embarrassed to hear Wilkes's comparison with the Greek republic in which the national arts were available to

all. It would take at least another 40 years, and the onset of very different circumstances, before Wilkes's plea for a 'noble gallery' for the whole public, by that time a very different urban body, came up for discussion once more.

Publics for Trafalgar Square:
the National Gallery

WE SHALL BE CONCERNED IN THIS CHAPTER with the processes by which a much expanded population was constructed as an audience for art in London during the first half of the nineteenth century. These processes require us to look at overlapping discourses that extend beyond gallery management to embrace contemporary reforms of health, city planning and the very politics of the public space. The institution in question is the National Gallery in Trafagar Square.

Preconditions

In the mainland European states public art museums had already evolved out of princely collections during the last third of the eighteenth century: Dresden in the 1760s, Munich by 1779, Mannheim by 1785; the Medici collections in Florence opened to the public in about 1789; the Imperial collections in Vienna opened in 1792 to anyone 'with clean shoes'. The Museum Français (later the Louvre) opened to the public in Paris in 1793.[1] The relative lateness of the British Parliament in sponsoring national picture galleries other than the Royal Academy therefore calls for some comment. John Wilkes proposed in 1777 that Parliament purchase the Houghton collection owned by Horace Walpole; the chance was turned down.[2] 'We are anxious to have an English school of painters ... our artists must have before their eyes the finished works of the greatest masters', Wilkes urged:

> Can there be ... a greater mortification to any English gentleman of taste, than to be thus deprived of feasting his delighted view with what he most desired, and had always considered as the pride of our island, as an invaluable national treasure, as a common blessing, not as private property?[2]

In the event the Walpole pictures went to Catherine the Great of Russia; and the British royal family clung on to its treasures. The collector Noel Desenfans in 1799 offered the Government an old-master collection ready-made for the King of Poland shortly before his abdication. Desenfans' condition was that the government provide a proper building for it; but the offer was rejected and the pictures

went eventually to Dulwich College (then regarded as lying outside London) to become a private gallery with free public access from 1814.[3] The Royal Academy itself turned down a chance to acquire Sir Joshua Reynolds' collection, and declined to purchase that of Robert Udney in 1802. The government refused the chance to acquire the collection of the dealer William Buchanan, and also that of Joseph Count Truchsess in 1803; both had been intended by their owners to form the basis of a national collection.[4]

It is almost as if Britain was reluctant to evolve a public culture of the visual arts. Although lack of imagination must have played a part, other factors contributed. In contrast to large nations such as Russia and Austria, and unlike new nations such as France and America, Britain at the beginning of the nineteenth century possessed a state structure that was already highly compact and hence resistant to change. Fears of a 'revolutionary' public on the French model led to caution. More specifically, the concept of meritocratic or – even worse – popular 'service to the nation', whether in military, civic or cultural terms, was probably anathema to social conservatives who feared the arrival of anything resembling widespread participation in the construction and consumption of a public culture guided by the state.[5]

The formation of a genuinely public national collection was also delayed by the fact that connoisseurs and the well-bred had been able to indulge their patriotic instincts with visits to the annual exhibitions of the Royal Academy at Somerset House (it had moved there in 1780), or view the early attempts at defining a national artistic manner in the shows put on by the short-lived British School (from 1802) in its gallery in Berners Street, near Oxford Circus. Or they could visit the British Institution for Promoting the Fine Arts in the United Kingdom, which, established from private subscription in 1805, staged regular exhibitions from 1806 at 52 Pall Mall, the site of Boydell's recently bankrupted Shakespeare Gallery. The Peace of Amiens in 1802 had stimulated fresh comparisons with French art. Similarly, the British Institution (or British Gallery, as it was sometimes called) had framed as its mission 'to raise the standard of morality and patriotism; to attract the homage and respect of foreign nations, and to produce those intellectual and virtuous feelings, which are perpetually alive to the welfare and glory of the country'.[6] It had received royal patronage, but was both privately organised and socially elitist, acting as a showcase for old-master paintings from country-house collections and, according to its critics, allowing wealthy patrician collectors to exert influence over the identity of British art without conceding the need for a genuinely public national gallery; as *The Times* noted, it was the 'favourite lounge of the nobility and gentry'[7] – a view confirmed by the pen-and-watercolour painting *The British Institution in 1816* (Figure 11).

The existence of other essentially private galleries contributed to this pattern. A mixed audience could initially see the collection of the Marquess of Stafford at Cleveland House, near Buckingham Palace, from 1806, the first nobleman's collection to be open to the public on a regular basis, followed by that of Earl Grosvenor,

Plate 1
Richard Wilson,
*View of the Foundling
Hospital*, c. 1746,
oil on canvas,
diam. 53.2 cm.

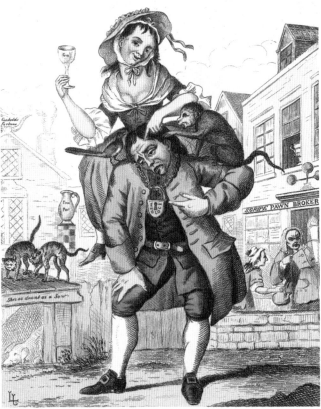

Plate 2
William Hogarth
(attrib.),
*A Man loaded with
Mischief, or
Matrimony*,
c. 1762, signboard.

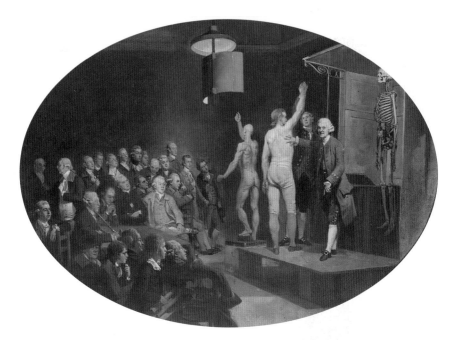

Plate 3 J. Zoffany, *Dr William Hunter delivering a Lecture on Anatomy at the Royal Academy*, c. 1772, oil on canvas, 77.5 x 103.5 cm, oval.

Plate 4 F. Mackenzie, *The National Gallery when at Mr J. J. Angerstein's House, Pall Mall, prior to 1834*, c. 1834, watercolour, 47 x 62.5 cm.

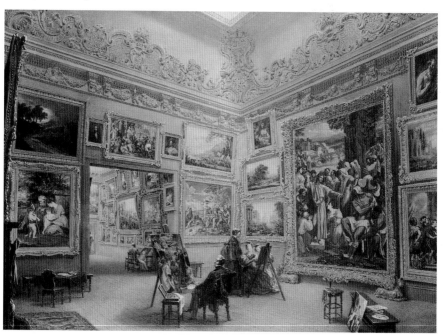

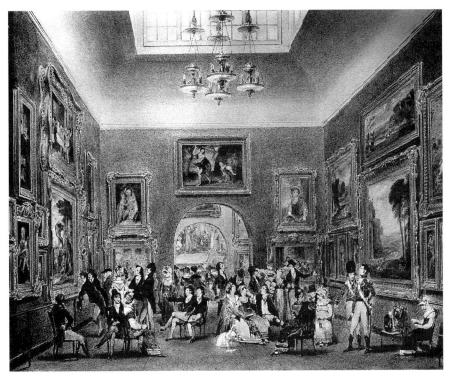

11 James Stephanoff and F. P. Stephanoff, *The British Institution in 1816*, 1817, pen and watercolour, with white highlighting, 21 x 29 cm.

who opened his Park Lane house a day a week during the 'season' (May to July) from 1808. Stafford's collection was available on Wednesday during the 'season' from 12 to 5 p.m. His gesture was greeted with such enthusiasm that he felt obliged to restrict access to those known to himself, his family or their friends. In a printed catalogue John Britton comments on the Marquess's dilemma, brought about by 'the ignorance, vulgarity or something worse' of the lower order, and by the 'frivolity, affectation and insolence ... in a class of lounging persons, who haunt most public places'.[8]

The fine British collection of Sir John Leicester in Hill Street, Mayfair, was made available in 1818, by admission card obtainable only by those known to the owner or his friends, on certain Thursdays during the same 'season'. Here the display itself was innovatory (Figure 12). Paintings were shown in spacious, symmetrical patterns, suspended from fashionably visible chains from a brass picture rail.[9] The first opening was described by Leicester's cataloguer John Carey as marking a 'memorable epoch in the British school', as 'the crowd of beauty and fashion, the chief nobility and gentry, the distinguished members of the legislature and of the learned profession, the taste and educted mind of England, assembled to share in the triumph of their countryman'.[10] Another good British collection, that of Sir Walter

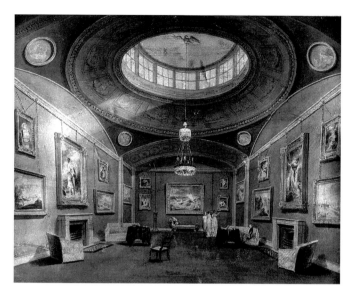

12 John Chessell Buckler (attrib.), *The Picture Gallery of Sir John Fleming Leicester at 24 Hill Street, London in 1806*, 1806-7, watercolour, 43.2 x 71 cm.

Fawkes, was opened to selected visitors for evening visits, in 1819. On the whole, however, these brief openings remained the exception rather than the rule, which was for aristocratic collections to remain closed save to acquaintances and friends. Most could never achieve a compromise between admitting a general public and preserving the dignity of the private house. But there were other motives at work. Both Leicester and Fawkes were patriots who wished to encourage recognition of a national British school. Sir John Leicester was keen to make his collection of British pictures the core of a national gallery of British art, and offered them for sale to the nation in 1823, only to be turned down.

And yet, at least from the outbreak of peace in 1815, particular considerations made the existence of a public national gallery of all the major schools, if not inevitable, then highly desirable to some. The Royal Academy was perceived as only partially a public institution. More importantly, the British Empire now covered one-fifth of the globe, and symbols of nationhood at the heart of the capital were on the minds of politicians of all persuasions. For the visual arts particularly it was well known that Paris possessed perhaps the most opulent collections of fine art in the world; for Britain to possess no national collection was in the circumstances something akin to a disgrace. Secondly, the end of the long and turbulent war against France had generated a widespread perception that victory should be accompanied by increased access to civil rights at home. Not only were constitutional and suffrage reforms now active parliamentary issues, but a whole raft of educational and welfare reforms were being vigorously advocated both inside and outside Parliament by Whigs, liberals and radicals (several of them followers of Jeremy Bentham) following the end of hostilities in 1815. Thirdly, George III's ill-health and his replacement by the far less charismatic George IV in 1820 presaged a change in the presence and authority of the monarch. Above all, the great drive

for parliamentary reform, eventually carried by the Reform Act (1832) and the ascendancy of Whig liberalism, irreversibly changed the nature of the relationship between people and nation, nation and monarch, monarch and state.[11] After 1820 the 'nation' was to be rhetorically formed, at least by liberal parliamentarians and reformers, around the image of a many layered but increasingly urbanised collective, governed by Parliament rather than the king or queen, devoted to manufacture as its principal talent, and consensually ordered around routines of work, education and self-improving recreation.

Older patterns of leisure-time activity had been under attack from before the turn of the century by reformers bent on eradicating drinking, gambling, sabbath-breaking and traditional forms of sociability. They were to be progressively replaced by 'rational entertainments' legitimated to the extent that they were conducive to, rather than interrupted, the manufacturing process: 'play-discipline' is the term sometimes given to the tendency.[12] The sphere of the visual arts provides a partially parallel transition. By around 1820 to the overwhelming majority of private art collections was still restricted of access and doubtless forbidding to members of the lower classes who were either not properly dressed or did not have the right credentials. Geography provided a different sort of barrier: a visit to Dulwich College Picture Gallery required a ticket from a print-seller in central London and, given the distance, was not likely to be frequented by the 'labouring classes', most of whom would be working when the gallery was open and exhausted when it was shut.

There was another type of painting altogether, displayed in a different setting and location, which proved immensely popular in such central London entertainments as Bullock's Egyptian Hall in Piccadilly or the nearby dioramas, cycloramas, waxworks and *tableaux vivants*.[13] It was precisely the gap between the two available forms of public pleasure – the traditional aristocratic pleasure of beholding valuable paintings, and the delights of marvelling at the painted commercial illusions and street exotica – that must have been striking in late Hanoverian and early Victorian London. The popular shows underscored the appetite for exhibitions; yet they remained commercial rather than 'fine' art. For all these reasons it seemed to reforming politicians that a national gallery in the centre of London could bring popular appetite and elevated pleasure into conjunction. Lord Liverpool's backsliding Tory Parliament, which lasted until 1827, would have to be converted. For Whigs, liberals and radicals in particular, either in government or outside it, for whom 'participation' could provide a lever against the old aristocracy and its now declining control over the British state, the project became at once a symbol and testing-ground of their most cherished endeavours.[14]

A gallery for 'the nation'

Given the British aristocracy's hesitancy in asserting patriotic values in post-Napoleonic times (on the grounds that doing so might encourage a desire for

participation in the affairs of the nation) it will come as little surprise to find that the origin of the nation's first fully public picture gallery was a *nouveau riche* entrepreneur whose collection had been formed seemingly out of mimickry of that same landed gentry that he wanted to expose as ungenerous and philistine. John Julius Angerstein was a Russian-born Jew whose commercial success in the shipping insurance business at Lloyd's had contributed significantly to financial (and military) security for the nation in the war against France, as well as making considerable private profits for himself.[15] Angerstein was uneducated and was generally perceived as vulgar by the patrician class; yet his commendable loyalty to the nation had been demonstrated in 1802 when he set up the Patriotic Fund at Lloyd's to raise donations

> for the Encouragement and Relief of those who may be engaged in the Defense of the Country and who may suffer in the Common Cause … so that the Mite of the Labourer, combining with the Munificent Donations of the Noble and Wealthy shall be the best pledge of our Unanimity … and shall impress on the minds of our Enemies the appalling conviction – THAT THE ENERGIES OF THIS GREAT EMPIRE ARE IRRESISTABLE, AS ITS RESOURCES ARE INCALCULABLE.[16]

The result was a sizeable fund, out of which £361,000 was given in 1806 to a school for naval orphans, with more to follow. The peerage contributed little, while business people in the City were magnanimous: Angerstein and his kind were soon being referred to in *The Times* as 'an injurious separate class … a commercial aristocracy'.[17] By the time of his death in 1823 Angerstein's collection of pictures was impressive. Through socialising with the best painters in London and with the particular help of Sir Thomas Lawrence, who painted his portrait (Figure 13), Angerstein had acquired paintings bearing the names of Rubens, Claude, Titian, Van Dyck, the Carracci, Poussin, Domenichino, Velázquez, Rembrandt, Reynolds and others, totalling 38 works of the very highest attribution.

Following parliamentary debate the Angerstein pictures were purchased cheaply for the nation and a lease acquired on his residence at 100 Pall Mall. The concept of a national gallery to display the Angerstein collection was predicated on improving national symbolism and a supposed raising of what the young Whig member George Agar-Ellis (later Lord Dover) called in Parliament 'the general taste of the public'. Speaking shortly before the opening of the rooms on 10 May 1824, Agar-Ellis reminded Parliament of the habit among artists of studying in Italy, but said that 'the great body of the people in the middling classes, as well as very many of the higher orders, could not, from their various avocations, have done this; and therefore, their only chance of becoming acquainted with what is really fine in art, was in the establishment of a National Gallery'.[18] Now, however, 'frequent viewing' and 'attentive studying' by a substantial and undifferentiated public could become a reality. The 'grandeur of design of the Piombo', the 'beautiful delineations of nature' in the Claudes, the 'brilliant colouring' of the Titians, the 'astounding chiaroscuro' of the Rembrandts, the 'noble simplicity' of the Carracci,

the 'correctness and purity of design' of the Van Dycks – these would have, said Agar-Ellis, an 'immediate effect upon the mind'. Moreover the effort needed would be minimal: the seeing of pictures by visitors could be effected 'without trouble or difficulty to themselves'. Yet it should not interfere with trade, since 'as we are a nation of much business and with whom, therefore, time is most precious, it is our opinion that we shall not go much out of our way to see a picture, even it were painted by Saint Luke'.[19] By means of this institution, 'the minds of all, who are not entirely dead to the feelings of pictorial beauty, will naturally be turned to the study of art, at the same time that their taste will be regulated by a just and proper standard of excellence'.[20]

Curatorial arrangements at the first Pall Mall gallery were simple and informal and involved much less overt surveillance of the public than was the habit at continental museums, particularly in France. The duties of the first Keeper, William Seguier (Figure 14) and his Assistant Keeper were minimally defined: hanging and occasionally cleaning the pictures, but little more. There were three attendants ('to

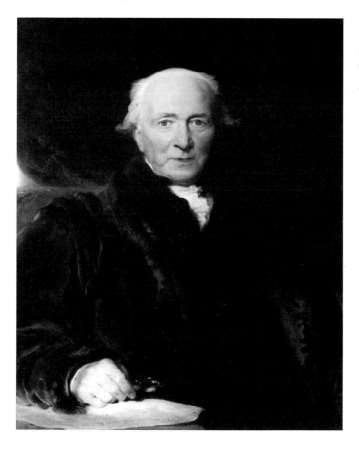

13 Sir T. Lawrence, *Portrait of John Julius Angerstein*, about 1823, oil on canvas, 91.4 x 71.1 cm.

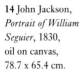

14 John Jackson,
*Portrait of William
Seguier*, 1830,
oil on canvas,
78.7 x 65.4 cm.

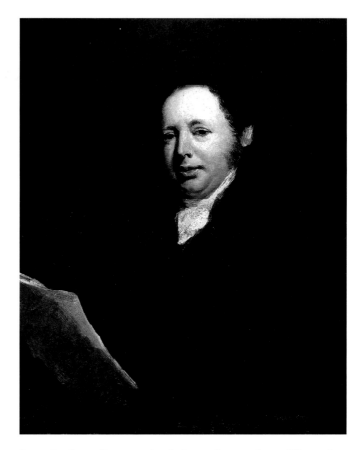

be in constant attendance in the gallery, to give information to the public, and to
see that no injury occurs to the pictures'), a housemaid ('to sweep and clean the
Galleries, the stairs and furniture'), a porter ('to take charge of umbrellas and
sticks') and a policeman at the door ('to see that no improper persons find their
way into the galleries'). Opening was from 10 to 5 on Mondays to Thursdays, and
the same hours for artists and students on Fridays and Saturdays. At first an
appointment ticket was required, but the practice was soon abandoned. Entry was
free. As Agar-Ellis had insisted,

> There must be no sending for tickets – no asking permission – no shutting it up half
> the days in the week; its doors must be always open, without fee or reward, to every
> decently dressed person; it must not be situated in an unfrequented street, nor in a
> distant quarter of the town. To be of any use, it must be situated in the very gang-
> way of London, where it is alike accessible, and conveniently accessible, to all ranks
> and degrees of men – to the merchant, as he goes to his counting house – to the peers
> and commons, on their way to their respective houses of parliament – to the men of
> literature and science, on their way to their respective societies – to the King and the
> court, for it should always at least be supposed that the sovereign is fond of art – to

the stranger and the foreigner who lodges in some of the numerous hotels with which St James's Street, and the neighbouring streets (the *quartier* which may fairly called the centre of London) abound – to the frequenters of clubs of all denominations – to the hunters of exhibitions (a numerous class in the metropolis) – to the indolent as well as the busy – to the idle as well as the industrious. In short, we consider the present abode of the National Gallery to be the very perfect situation.[21]

Art, to the young Whig politician, was to be an experience available to every class, education or profession, from the sovereign down to the decently dressed among the public: the terms 'indolent' and 'idle' could describe the highest as well as the lowest orders of society. The hope was that such a comprehensive mass, still internally differentiated but increasingly weighted towards its middle orders, could in a national gallery of art be momentarily united on more or less equal terms.

As a public space in which different classes could observe not only paintings but each other, however, 100 Pall Mall elicited conflicting impressions. To judge from the 1834 watercolour by Francis Mackenzie, Angerstein's rooms, which were 'built for Frederick Prince of Wales (Father of George III), with an entrance from the Gardens of Carlton House'[22] and hence already with a pedigree as a picture gallery, must have been quite spacious (Plate 4). Hazlitt was enthusiastic: 'We know of no greater treat [he wrote] than to be admitted freely to a collection of this sort … It is a cure (for the time at least) for low-thoughted cares and uneasy passions. We are abstracted to another sphere'.[23]

And yet in practice the room must have been crowded; visitor statistics for the period tell us that average numbers per hour in some of the early years were as high as 50, with a maximum of 200 persons present at any one time.[24] Then two other collections were added to Angerstein's in rapid succession: that of Holwell Carr in 1825 and that of Sir George Beaumont in 1826. By 1828 the Trustees were complaining of lack of space, and negative comparisons with the magnificence and vast spaces of the Louvre, strikingly captured in Charles Hullmandel's lithograph with its caption from *Hamlet*, '"look here upon this picture, and on this/ The counterfiet presentment of two brothers"' (Figure 15) added to the impetus for expansion. On 3 March 1834 the entire collection was moved to larger premises at 105 Pall Mall. Those alive to comparisons between collections in Britain and the continental galleries were still aware that the Pall Mall premises were by those standards pokey and underlit. For Trollope 105 Pall Mall was 'a dingy, dull, narrow house, ill-adapted for the exhibition of the treasures it held'.[25] The energetic Dr Waagen of the Royal Picture Gallery in Berlin (of whom we shall hear more) complained that it had a 'dirty appearance … [with] so little light that most of the pictures are but imperfectly seen'.[26]

By that date the parliamentary consensus had changed dramatically. The Whigs had won the election of 1830, and a decision had been taken to move the National Gallery to a purpose-built building in the centre of what would shortly become Trafalgar Square. The very prospect of a move from Pall Mall had inevitably

15 Charles Hullmandel, *The Louvre or the National Gallery Paris, and No. 100 Pall Mall or the National Gallery of England*, c. 1830, lithograph, 30.5 x 21.6 cm.

attracted speculation on the social and moral dimensions of the project. Aristocratic sentiments on the Gallery had been in favour of spreading enlightenment downwards, from the top to the bottom of society: as the connoisseur Lord Farnborough, a stalwart of the British Institution, had urged in a a pamphlet of 1826, 'among the accomplishments which peculiarly belong to the higher orders of society, and which those in inferior stations would find great difficulty in attaining, is a taste for the liberal arts'.[27]

But with the Whigs in power and the new Reform Bill before Parliament in 1832, the tone of advocacy noticeably changes. The Conservative peer Lord Ashley, in a Commons debate on the financing and design of a building to replace Pall Mall, suggested that the Gallery would be 'extremely beneficial for artists and mechanics ... he had reasons for believing that it would be frequented by the industrious classes, instead of resorting to ale-houses, as at present'.[28] Whig and liberal Members of the new Parliament took a similar line. The public pleasures of a new National Gallery would chime well with the reformist duty now placed upon Parliament to homogenise and educate, to refine and elevate, the working mass. What must be remembered though is that the reforms of 1832 were never more than a partial set of panaceas; in practice the Reform Act still excluded 80 per cent of men and all women from the franchise. Social amelioration was painfully hesitant and slow. It is only necesary to contrast the speeches of reforming Whigs and Conservatives in Parliament with the description Dickens gives a decade later of the inhabitants of the area near Drury Lane and Oxford Street, at the lower end of Tottenham Court Road:

> Wretched houses with broken windows patched with rags and paper: every room let out to a different family, and in many instances to two and even three – fruit and 'sweet stuff' manufacturers in the cellars, barbers and red-herring vendors in the front parlours, cobblers in the back; a bird-fancier in the first floor, three families on the second, starvation in the attics, Irishmen in the passage, a "musician" in the front kitchen, and a char-woman and five hungry children in the back one – filth everywhere – gutters before the houses and a drain behind – clothes drying and slops emptying from the windows; girls of fourteen or fifteen, with matted hair, walking about barefoot, and in white great-coats, almost their only covering; boys of all ages, in coats of all sizes and no coats at all; men and women, in every variety of scanty and dirty apparel, lounging, scolding, drinking, smoking, squabbling, fighting and swearing'.[29]

Dickens' tone is not only sympathetic and amused; but he particularises, in contrast to the cacophony of reforming voices that now generalised about ale and health. For the latter, the question was increasingly how an image of 'the nation' could be consolidated around rhetorics of abstinence, productivity and social order. Peel, among others, now leading the opposition against the reforming Grey administration, believed that the arts could help in this endeavour. The Reform Bill once passed, Peel echoed the prevailing mood of concern:

In the present times of political excitement, the exacerbation of angry and unsocial
feelings might be much softened by the effects which the fine arts had ever produced
on the minds of men ... [a national gallery] was the most adequate to confer advan-
tage on those classes which had but little leisure to enjoy the most refined species of
pleasure. The rich might have their own pictures, but those who had to obtain their
bread by their labour, could not hope for such enjoyment.

His register of the post Reform Act spirit of compromise was also concise. A new
National Gallery would 'not only contribute to the cultivation of the arts, but to
the cementing of the bonds of union between the richest and poorer orders of state
... joined in mutual intercourse and understanding'.[30]

By now, it could even be said that a linguistic strategem for recasting the iden-
tity of 'the public' was emerging across the political spectrum. For many reform-
ers but particularly those in the fields of health, urban planning, education and
leisure, terms such as 'England', 'Great Britain', 'the people', even 'the labouring
classes', were being used increasingly to stand interchangeably for the nation as
such; a collectivity of persons at the heart of empire whose avocation was manu-
facture and whose talent was trade. Such a vast and largely urbanised body was
still easily differentiated in point of housing and education, but in official rhetorics,
at least, decreasingly segmented in the language of the old alignments of class. It
can be said that in the period up to and beyond the 1832 Reform Act such terms
were beginning substantially to invert the older descriptions of British society; to
use Linda Colley's words, 'reducing the ultra-privileged few to sinister marginal-
ity and promoting the voiceless millions to centre stage as the best of patriots'.[31]
In the field of culture and the arts, the process was a potent one indeed.

The geography of art

The decision to locate the new National Gallery in Trafalgar Square was itself full
of significance. It was part of a process of reform of London itself; and since
London expressed the nation and gave it visible form through its exterior symbols
and functions, it was a decision which partook in the very redefinition of Britain,
and with it the identity of its public. A guidebook of a generation before had
divided the metropolis into three sections. The City, 'the most central and ancient
division ... is the great centre of trade and commerce occupied by the superb estab-
lishments of the East-India, Bank and other trading companies, and the ware-
houses, shops and dwellings of merchants and tradesmen'. Then there was the
'West, or Court, end of the Town ... the most splendid and fashionable district',
comprising Parliament, the Law Courts, the royal palaces and government build-
ings, and the 'town-residencies of the principal Nobility and Gentry' which com-
prised the area to the north-west of Charing Cross, extending to Hyde Park
Corner, Paddington and Regent's Park, and which included 'the most fashionable
shops' in Piccadilly, Old and New Bond Streets and Oxford Street. In contrast lay

'the East end of the Town', which together with its inhabitants was devoted 'to commerce, to ship-building, and to every collateral branch connected with merchandise'.[32] What was still missing from such a description was a sense that the city had a single hub, or focus; that it was an ordered and functioning whole; that it could express in its own identity that of the largest and most powerful nation on earth. The most overtly patriotic of the contemporary schemes for the rebuilding of central London are those of John Nash. His plan for a majestic street extending from the northern parts (what is now Regent's Park and Portland Place) to Charing Cross had already promised to produce 'a grand and striking effect' with shopping colonnades and a 'facade of beautiful architecture at the termination of every street'. It promised to fix the relationship between classes and solidify the psychic and social pattern of the city, by effecting, in Nash's words, 'a boundary and complete separation' between the squares of the nobility and gentry to the west, and the 'meaner streets occupied by mechanics and the trading part of the community' to the east.[33]

At the same time, Nash's scheme had a clearly patriotic significance. Until about 1820 Charing Cross had been the northernmost entrance to Whitehall and the Royal Park of St James. At that date the northern side of the junction – the area bounded by Whitcomb Street to the west and St Martin's Lane to the east – was still occupied by the complex of buildings known as the Royal Mews, divided by William Kent's 1732 building for the Crown Stables into a northern or Green Mews and a southern or Great Mews.[34] In 1825 a barracks for 800 men was built at the northern or Green Mews giving 'free access … [for troops] to all the North parts of the town'.[35] Most of the southern or Great Mews was demolished after an Act of Parliament of 31 May 1826 cleared the area in front of St Martin's so that Nash's schemes for Regent Street and Pall Mall could terminate there. Nash's design shows the beginnings of what would become Trafalgar Square, with the colonnaded National Gallery on the north side and a Parthenon to house the Royal Academy in the centre (Figure 16). The King's Stable, which faced down Whitehall, was first stripped of its contents and pressed into service as a National Repository, a short-lived collection of instructional objects inspired by the new Mechanics' Institute movement which was then moved on demolition in 1831 and finally closed as a commercial failure in 1835 (Figure 17).[36] By this time the government was ready to compress both the National Gallery and the Royal Academy into a single building on the north side, designed by William Wilkins, and do away with the Parthenon in the centre of the square, hence transforming an open meeting-place and crossroads into something approaching a celebration of the nation and indirectly of the empire.[37] It was supposed that such a square – at the centre of which would soon stand the hero of Trafalgar – would also accommodate government offices, the Royal Society and the Antiquarian Society. Now it was proposed that the College of Physicians and the Union Club House be added on the west, thus completing Nash's other scheme for a continuation of Pall Mall through to St Martin's Lane, ending with the portico of St Martin's Church in the manner of a processional route

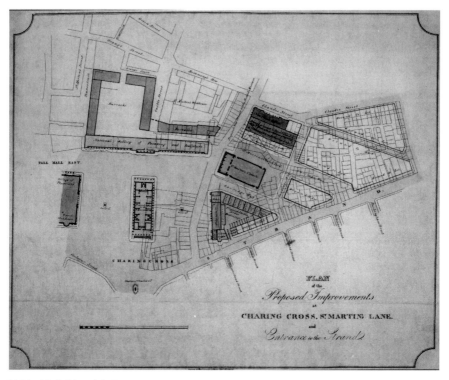

16 John Nash, Plan of the Proposed Improvements at Charing Cross, St Martin's Lane, and Entrance to the Strand.

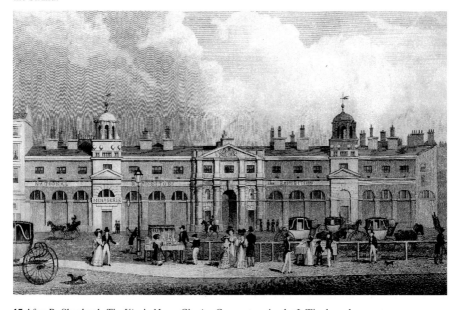

17 After R. Shepherd, *The King's Mews, Charing Cross*, engraving by J. Tingle, n.d.

from the west. At the same time, the gravity of the National Gallery's appearance would supersede the motley of signs and symbols, of advertising, trade and entertainment, that up to that time still littered the symbolic heart of the capital (Plate 5). The National Gallery would also terminate the triumphal passageway from Whitehall, comprising a series of imposing views and facades at the very centre of a great manufacturing empire.

By the same token, the siting of the Gallery at the centre of this hub represented a legitimation and a perpetuation of the larger social and psychic divisions of the city. The area to the immediate north and east still housed some of the poorest and most destitute families in London. To cleanse the routes opened up from Charing Cross to the north and east, plans were laid to remove the poor in the vicinity of St Martin's Church and open up a more pleasant passageway towards the British Museum. Provisions were therefore made

> to take down, take away, remove, alter or regulate ... all Signs or other Emblems, used to denote Trade, occupation or Calling of any Person or Persons, and all Sign irons, Sign Posts and other Posts, Sheds, Penthouses, Spouts, Buffers, Steps, Stairs, Bows and other projecting Windows, Window shutters, Palisades and other Encroachments, Projections and Annoyances ... which do and shall ... obstruct the commodious Passage along the Carriage or Footways.[38]

In this way new road axes which fixed the place of Trafalgar Square within a system of radiating travel routes facilitated communication to and from the centre, but in doing so divided neighbouring districts from each other. While catering to all parts of the city, the new layout would in effect perpetuate a social geography of difference within the metropolitan fabric, at the same time as symbolically unifying its disparate parts.

The nation defined

The new National Gallery would have its audience constructed for it in two main ways: one, by appeal to the elevated pleasures of art and a sense that those pleasures were the common birthright of Englishmen; the other, by concentrated efforts (both of language and administration) to redesign the nation's 'public' as clean and uncontaminated – just like the pictures they beheld.

The first way was through the official and unofficial printed catalogues, in which accessible information about the new Gallery and its pictures was generally conveyed in lists, with minimal historical or explanatory information, often prefaced by eulogising, sometimes moralising rhetoric connecting the experience of art to that of citizenship and hence to membership of the nation as such. An example of the latter, compiled sometime between 1832 and 1836 and published perhaps in 1836 or 1837, proposed not only a method for seeing and understanding the pictures (each of the 58 works is illustrated with an engraving and a description), but a statement of how the public ownership of pictures could help define the very

character of the nation. Great Britain was among the last of the 'civilized nations' on earth to foster the fine arts, yet from the example of the purchase of the Elgin Marbles it could be seen that

> free governments afford a soil most suitable to the production of native talents, to the maturity of the powers of the human mind, and to the growth of every species of excellence; by opening to merit the prospect of reward and distinction, no country can be better adapted than our own to afford an honourable asylum to monuments of the school of Phidias, and of the administration of Pericles – where, secure from further injury and degredation, they may receive that admiration and homage to which they are entitled, and serve in return as models and examples to those who, by knowing how to revere and appreciate them, may learn, first to imitate, and ultimately to rival them.[39]

To that ringing endorsement of successive governments in the reign of William IV was added the sentiment that the cultivation of the fine arts would in return contribute to the 'representation, dignity and character' of those governments that supported them. Yet *national* character – not merely the morality of government – was to be promoted by the very experience of art. The argument is a striking one. First, the Gallery would provide the 'means of cultivating such an intimacy with the grand and beautiful features of *Nature herself*, as shall add considerably to the sum of [the viewer's] sublunary happiness'. The pleasures of paintings were 'perennial ... capable of increase, of being cultivated till they bring forth fruits of ambrosial flavour'. We need merely bring to them 'an eye, an understanding, and a heart', and if we do, changes that occur 'will be in us, not in them'. A florid appeal is then made to a certain type of outlook in a unitary, male, yet ostensibly classless spectator:

> Oh! thou, then, whoever thou art, that dost seek happiness in thyself, independent of others, not subject to caprice, not marked by insult, nor liable to be snatched away by ruthless hands – who dost desire enjoyment over which Time has no power, and which death alone can cancell – seek it, if thou art wise, in books and pictures ... Indulge then, O fortunate mortal of the nineteenth century! in this innocent, schoolboy abandonment to calm delight, which while it inspires thought and engenders reflection, quickens the pulse of joy and life, without fear of the fever of mired friendship, or the grave of love.

The free availability of such pleasures, however, need no longer be linked with purely personal acquisition. On the contrary, the Gallery's property was the nation's. The collection '*is* our own ... and every Englishman has intellectual property in it: we feel honour and pride in *thus* identifying ourselves with our country, and in combining our own happiness with its prosperity'.[40]

That last sentiment, at least, can be compared to those expressed in the first of the many House of Commons Select Committee Reports touching on the functions and viewing public of the National Gallery, and published in its early years.

Dated 1836 and based on evidence collected in that and the previous year, the *Report of the Select Committee on Arts and Their Connexion with Manufactures*, chaired by the merchant and MP for Liverpool, the radical reformer William Ewart, urged the view – Ewart's own – that the central justification for the existence of a National Gallery was the improvement of design and manufacture, particularly in the face of foreign competition. The 'great object of a national gallery is the enlightenment and instruction in art of the public', Ewart said in cross-examining a witness before the Select Committee.[41] Echoing his own social and occupational background, Ewart called on factory inspectors, gallery curators, architects and others to provide evidence that the working population were eager for instruction in art (as in everything else); that consumers all over the country wanted good design; and that instruction in the fine arts through a rationally organised system of galleries was the surest means to those ends. Rather than displaying outright hostility to foreign nations – France and Germany – Ewart's report held them up as examples with which to promote reforming opinion at home: 'In nothing have foreign countries possessesd a greater advantage over Great Britain than in the numerous public galleries devoted to the Arts, and gratuitously open to the people'.[42]

The views of Ewart and his Report – unlike the catalogue's extravagant appeal to find nationhood in the experience of art – were radical in 1836 in the sense that they conceived of 'the public' as a body both conscious of its need for instruction in art and increasingly capable (this at any rate was Ewart's hope) of linking that instruction with the nature and obligations of citizenship. Aided by the polymathic Dr Bowring – who had translated the *Marseillaise* into English and had represented the English radicals in Paris at the time of the July 1830 Revolution – and supported by such other radicals as the Irish reformer Thomas Wyse and cotton manufacturers Thomas Brotherton and Edward Strutt (MPs for Salford and Derby respectively), Ewart himself dominated the committee and set the tone of the *Report*. As a radical reformer bent on slave emancipation, church reform and corn-law abolition, he was in no doubt that the old aristocratic domination of the arts was at an end. He believed that manufacturing productivity, 'gratuitous and general' access to the fine arts, and expansive nationhood would come to sit firmly together:

> In many despotic countries far more development has been given to genius, and greater encouragement to industry, by a more liberal diffusion of the enlightening influence of the Arts. Yet to us, a peculiarly manufacturing nation, the connexion between art and manufactures is most important ... The opening of public galleries for the people should, as much as possible, be encouraged ... casts and paintings, copies of the Arabesques of Raphael, the designs at Pompeii ... everything, in short, which exhibits in combination the efforts of the artist and the workman, should be sought for such institutions. They should contain the most approved modern specimens, foreign as well as domestic, which our extensive commerce would readily convey to us from the most distant quarters of the globe.[43]

Naturally, his *Report* is full of leading questions and prepared answers, and the evidence as actually given was no doubt carefully edited. Moreover the actual links between the experience of art and improved manufacture remain ultimately obscure beyond the vague assumption that art's civilising influence through colour, drawing and skilled execution was of benefit to the workman. Yet Ewart and his *Report* represented the voice of the Parliament reformed in 1832. 'The nation' in this scheme of things was an entity composed of free and competing manufacturing enterprises, working in competition with other nations and deriving its identity from its differences from them, in which 'traditional' British social hierarchies and values had no visible place. For example the *Report* was adamant that 'The Gallery be opened, in summer, after the usual hours of labour. It is far better for the nation to pay a few additional attendants in the rooms, than to close the doors on the laborious classes, to whose recreation and refinement a national collection ought principally to be devoted.'[44]

Such ideas – or the sentiments behind them – were those of the 1832 Reform Act, the measure that so helped disrupt the older class alignments in favour of the traditional Whig aspiration of 'improved but stable liberty and … the public good'.[45] In practice, the franchise was still minimal, whereas the Gallery was open to all. Yet a measure of participatory democracy had been achieved; that was the central value for which radicals like Ewart and Bowring were fighting.[46]

Health and sobriety in Trafalgar Square

There is a close connection too between the curatorial imperatives which formed the viewing conditions of the new National Gallery, and contemporary programmes of health reform. In the Pall Mall years, the late 1820s and early 1830s, the correspondences had been latent and perhaps inexact. The duties of the Keeper at Pall Mall, William Seguier, had been

> To have charge of the collections, and to attend particularly to the preservation of the pictures; to superintend the arrangements for admission; to be present occasionally in the Gallery; and to value and negotiate, if called upon, the purchase of any pictures that may be added to the collections, and to perform such other services as he may from time to time be called upon to do by instruction to the Lord Commissioners of the Treasury.

Those of the Keeper and Secretary, G. S. Thwaites, were

> to attend in the Gallery on the public days during the hours of admission; to carry into effect and superintend, under the direction of the Keeper, any arrangement it may be necessary to make for the admission of the public, and in regard to the artists who may be permitted to study in the Gallery, and to act as Secretary in the making of any communications, and the promulgation of any rules and regulations for the exhibition in the Gallery, by order of the board, the whole of his duties being executed generally under the direction of the Keeper of the gallery.[47]

Yet growing concerns for correct lighting (the absence of dark and gloom) and the definition of a well-dressed, properly instructed public were now central. And both concerns seemed to spill naturally over into a third, for the historical distinctness and visibility of the pictures. It is striking for example how witnesses questioned by Ewart's Committee, including the Keeper William Seguier, were cajoled into accepting not only that a newly organised National Gallery should show divisions into 'schools' (including an English school hitherto hardly visible) but that access to pictures should be by means of a Gallery free of literal darkness, full of information, and conspicuously historical, geographical and biographical in its physical arrangement. The success of each requirement would be dependent upon the others:

> It appears to the committee [the 1836 *Report* wrote in conclusion] that the most ready and compendious information should be given to the public by fixing its name over every separate school, and, under every picture, the name, with the time of the birth and death, of the painter; the name also of the master, or the most celebrated pupil, of the artist, might in certain cases be added. This ready (though limited) information is important to those whose time is much absorbed by mental or bodily labour.[48]

And if historical clarity was to be achieved by layout of information, the physical lighting of the collection was to be similar to that already adopted at the Royal Picture Gallery in Berlin or at the Munich Pinakothek and now heavily commended to the Committee under the weight of Ewart's cross-examination. Architect of the Munich Pinakothek Baron von Klenze was persuaded to explain how he had separated the sculptures from the paintings 'because the one and the other are so different in the light'.[49] The paintings

> are placed according to the schools. I wished to allow the possibility of arriving at any particular school without going through another, and for this purpose I have a corridor running the whole length of the building, which communicates with each separate room … The principle upon which the several dimensions were regulated [is that] all the pictures are fixed upright against the wall, not sloping. The highest point at which the top of the largest pictures should be placed was assumed to be 29 feet, the lowest 4 feet. The shortest distance from which it should be seen, 25 feet. The large pictures are in very large rooms lighted from above … The rooms are so arranged that the spectator is not annoyed by reflected light; but wherever he stands he sees the pictures without any reflection.[50]

This intersection of ordered and available historical information conveyed in a scenario of adequate light and uninterrupted attention from a distance (Figure 18) stands at the foundation of modern curatorial practice. The examples of Munich and Berlin were pressed upon the hapless Mr Seguier. Had he ever seen the arrangement or the architectural scheme at Munich? He had not. Would he approve of a rational arrangement into schools so that the eye of the visitor 'may at once take in on first impression' the differences between national schools? Perhaps, if the

18 Lighting scheme at the Munich Pinakothek, demonstrating optimum gallery proportions given the angle of incidence of the roof light (BC) reflected to the eye of the spectator (BA) standing at a distance of 7.5 m from the picture wall.

collection was large enough.[51] An older tradition of connoisseurship was criticised too: 'Is it not very desirable indeed to form a national collection, not through the mere instrumentality of connoisseurship, but by an historical investigation whether the pictures are the works of the men to whom they are attributed?' Answer: 'That would be very difficult.' 'But do you not suppose that in pictures, as in law, the best evidence is most desirable?' 'Certainly.' 'Should not the national collection therefore be founded upon history as well as criticism?' 'I think it should'.[52] 'Has it ever suggested itself to you that it would be very desirable, under each picture, to give the name of the master, and the time at which he lived and died, and the school he belonged to?' 'That might be done'.[53] 'And if he was the pupil of any celebrated master, the name of that master? Might it not be the most compendious way of scattering information among the public?' Mr Seguier replied: 'I should think that very desirable.'[54]

An analogical relationship between 'rational' curatorial recommendations in 1836 and the prevailing concerns about public health is to be readily found. The year of Peel's speech to Parliament mentioning 'political excitement' and 'angry and unsocial feelings', 1832, had also been that of the first major cholera outbreak in Britain and of the first tide of scientific and moral confusion over the causes and remedies of the disease. The major theories adopted by medical men and other commentators were 'contagionist' and 'anti-contagionist' – contagionism postulating infection by direct bodily contact, and anti-contagionism the action of 'miasma', which *The Lancet* defined as 'unseasonable weather combined with a column of pestilential matter arising in, or borne to certain districts, where it is attracted or detained by local causes hitherto unknown and undefined'.[55] The pattern of incidence of the disease favoured both, but neither fully enough for a vindication. In the early days of the outbreak, contagionism was generally favoured by the government authorities and the medical establishment. It was, as Morris puts it, a doctrine of 'strong government' that enabled it to quarantine infected persons, interfere with trade and create an atmosphere of stigma among the sick or dying. It could also cast citizens of any class in the unenviable light of an undesirable social group. Miasmatic theory on the other hand required more general standards of cleanliness, and could be applied to virtually any situation in which the deleterious action of dirt was suspected.

Particularly, the sources of the illness became linked in the middle-class imagination with the incidence of decaying vegetation and general filth in the poorer quarters of the cities – a conviction that remained curent for twenty years (Figure 19). At the same time a network of social ills was being uncovered by the reforming Whig barrister and MP for Shrewsbury Robert Slaney, who spent much time studying the health of towns and the condition of the manufacturing classes. Slaney alleged in a Commons debate in 1833 that for three decades the replacement of agriculture by manufacture had left large numbers of people underexercised and lacking in fresh air. London had few enough public parks for its already massive population, and some of the northern cities had none. As he argued, 'the rich, who had their own enjoyments, and who had so many means of recreation, ought to consider the situation of working men … and to afford every accommodation and the means of rational enjoyment to the working classes, upon whom, in so great a degree, the prosperity of the country depended'.

The progress of society should be conceived as a series of stages of 'increasing civilisation', Slaney believed; 'from the want of nature to the enjoyment of luxuries', including dressing 'decently' in public places. 'The poor workmen in the large manufacturing towns were actually forced into the public house, there being no other place for him to amuse himself in.'[56] Yet such changes as Slaney was recommending would also stimulate consumption, hence these public recreations

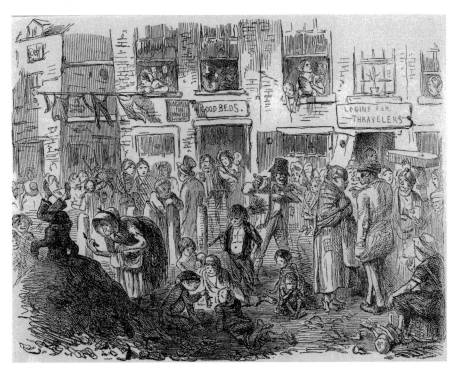

19 'A Court for King Cholera', *Punch*, vol. XXIII, July to December 1852, p. 139.

were essential to the national economy in two ways. Was it not also the case, Slaney would argue in his 1840 *Report* on health, that overcrowding and poverty lead to a high incidence of disease and crime and high rates of mortality, with the crowded eastern parts of London being especially neglected and filthy, comprising 'houses and courts without privvies ... large open ditches containing stagnant liquid filth, and houses dirty beyond description, as if never washed or swept, [with] heaps of refuse and rubbish, vegetable and animal remains, at the bottoms of those courts, and in corners?'[57] Such conditions in their turn had generated anti-social behaviour. Slaney gave figures which suggested a 500 per cent increase in crime between 1800 and 1840 for a population rise of merely one-third. And he could prove that alcohol consumption was rising fast.[58] The network of relationships was a familiar one: 'it is well known that healthy, happy men were not disposed to enter into conspiracies. Want of recreation generated incipient disease, and disease, discontent; which, in its turn, led to attacks upon the government.'[59]

That last statement embodied a familiar mixture of reforming intentions and anxiety lest the proposed reforms fall short and generate political dissension – the essential Whig dilemma of 1832. In such circumstances the proposed new National Gallery became a perfect focus for contemporary concerns about the redefinition of 'the public'. On the one hand its image was now increasingly forced into conjunction with that of the temperance movement, and hence made to stand for refinement and order on a civic scale (Figure 20). On the other, unhealthy housing and lack of recreation led to grudging productivity and low profits, suppressing the nation's prosperity. The result of such thinking was a gamut of parliamentary measures which constituted the remaking of a whole society, beginning with the 1834

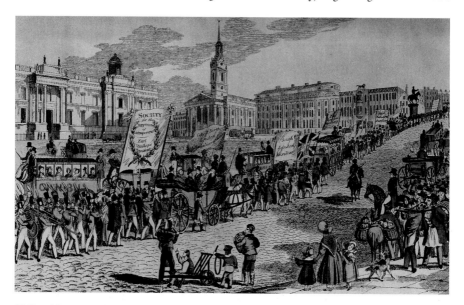

20 *Grand Procession of the Metropolitan Temperance Society passing Charing Cross, 8 June 1840.*

Select Committee on Drunkenness which recommended parks and open spaces for athletics, combined with a network of 'district and parish libraries, museums and reading rooms, accessible at the lowest rate of charge, so as to admit of one or the other being visited in any weather and at any time'.[60]

The opening of the National Gallery to the public on 9 April 1838 – an event which oddly passed almost unnoticed in the London press – can also be seen as a contribution to the debate on public health. Following Slaney's advocacy of general recreational facilities, an Act for Encouraging the Establishment of Museums in Large Towns was passed in 1845, licensing any town with a population of more than 10,000 to establish an art or science museum on the rates.[61] In each development, and extending to the pamphlets and reports of the 1840s and 1850s which presaged the reforms of the water, drainage and sewage systems of the cities, we find not merely empirical descriptions specifying change, but a range of images and metaphors recasting a whole range of attitudes to leisure, pleasure and the use of public urban space. Such images and metaphors frequently took on an ideological cast. For example the political and medical establishments still felt that poor clothing, overcrowding and diet predisposed to cholera; in reality they did not.[62] Yet by seeking to install its panaceas and remedies in the regime of the nation's first truly public gallery, the state now took the role of sanctifying a set of procedures that sought to regulate the urban profusion and guide its medical, moral and political order; in effect to make that order, and the sphere of culture, one.

The select committee reports, and other views

Cleanliness and the forms of social rectitude form a dominating theme in the several government select committees that either touched upon or looked extensively into questions arising from the interaction between the public and works of art between 1835 and 1853. The first, which sat in 1835–36 to inquire into 'the best means of extending a knowledge of the Arts and of the principles of Design among the People (especially the Manufacturing Population) of the Country', has already been referred to. A second, the Select Committee on National Monuments and Works of Art, was appointed in 1841 to report on 'the present state of the National Monuments and Works of Art … and to consider the best means for their protection, and for affording facilities for their inspection, as a means of moral and intellectual improvement for the People'. A third, a Select Committee on Works of Art, collected evidence in 1847–48 on 'the best mode of providing Additional Room for the works of Art' in an already overcrowded National Gallery. A fourth was the brief report by President of the Royal Academy Charles Lock Eastlake, the eminent scientist Michael Faraday and William Russell, who comprised a Commission, on 'the State of the Pictures in the National Gallery', published in May 1850. The fifth, the Select Committee on the National Gallery, reported in

July 1850 with the May 1850 *Report* as an appendix. The sixth was the Select
Committee on the National Gallery, which gathered lengthy evidence and
reported in 1853.

In terms of behaviour the image of the crowds contained in these reports is
one of orderly and peaceable attention – as if to prove that the National Gallery
like the British Museum was already a viable alternative to the public house. In
the 1841 *Report* this was held up as a remarkable result in view of the huge crowds;
the British Museum at that time boasted between 16,000 and 32,000 persons
daily.[63] The Keeper of Antiquities and Coins at the Museum, Edward Hawkins,
complained only of the 'constant habit that young people have of touching every-
thing, which dirties some of the objects'[64] – an early example of the cleanliness
criterion shifting to works of art. J. Gray, Keeper of Zoological Collections,
affirmed that visitors' behaviour was 'very good', and agreed with the Committee
that the Museum on a Sunday afternoon 'would afford rational amusement to
parties who have not time in the week to visit it, and who otherwise would be dur-
ing that period probably driven to the public-house'. As he pointed out, 'a man
with a family' would not be able to afford Hampton Court, but could probably
get to Bloomsbury. 'Such facilities not being given, many a man ... leaves his fam-
ily and gets intoxicated instead of taking rational pleasures with them'.[65] The
main witnesses to the 1841 Committee sounded impressively unanimous. John
Britton, who had worked for the Marquess of Stafford's gallery many decades ear-
lier, attested that the 'conduct of the public generally in public places [was] ...
considerably improved' in comparison with 50 years before. Questioned specifi-
cally about 'the mob', he agreed that they behaved in the British Museum with
'perfect decorum ... I have seen them conduct themselves with strict propriety
and with laudable curiosity'.[66] Asked about the class of persons usually seen in
the new National Gallery, Francis Chantrey's friend Allan Cunningham said that
they were 'men who are usually called "mob"; but they cease to become mob when
they get a taste'. They were now 'more attentive ... I saw a great deal of wonder
and pleasure ... [among] what appeared to me to be shoemakers, masons and join-
ers'.[67] The Assistant Keeper of the National Gallery, George Thwaites, affirmed
that conduct generally in the gallery had been 'quite unexceptionable ... quite as
satisfactory as we could have wished and expected';[68] and so on. John Wildsmith,
an attendant at Trafalgar Square, agreed that 'nothing could be more orderly'.[69]
Finally, William Seguier, the Keeper, told the Committee that so far as the visi-
tors' conduct was concerned, 'nothing can be better. There has not been a single
incident since opening the gallery.'[70] The Report concluded that the evidence
'proved the general disposition of the people to appreciate exhibitions of this
nature, and to avail themselves of the means of instruction and innocent recre-
ation ... and of the safety with which works of art and other objects of curiosity
may be thrown open to public inspection'.[71]

So far as the attitude of 'the people' was concerned, somewhat different lessons
were to be learned. Visitor numbers increased nearly fivefold between the last year

at Pall Mall and 1840 (See the graph below). Thwaites testified that although visitors conducted themselves 'peaceably and orderly', and although 'considerable interest is shown [in pictures] by a few individuals', nevertheless he did not think that 'the mass of the people who attend, particularly on holidays, take any particular interest in them; they come and go without paying very much attention'. Crowds of up to 10,000 visited the National Gallery on any one day, he said, and on Whit Monday 'nearly 14,000 people' visited. On such days, 'order was maintained, certainly, but with considerable difficulty'.[72] John Wildsmith was more positive. The working classes not only behave extremely well, but 'some of them take very great interest in the pictures … I have heard remarks [he went on] … that three fourths of our pictures are not good enough … I think some of our worst pictures are the most liked'. Overall he believed that 'interest in the pictures was increasing every day; I notice mechanics come, and they appear to come in order to see the pictures, and not to see the company'. Even at holiday time the crowds were self-regulating, since 'when the people were tired they went away'.[73] The descriptions used in the 1841 *Report* are on the whole those of self-improving virtue: 'decent', 'respectful', 'orderly', 'attentive', 'innocent', 'rational', 'not repairing to the ale-house', 'not there for the company' – the latter epithets particularly were being systematically applied to the lower classes by their social superiors in the management class.

Table 1: Visitors to the National Gallery, London, 1826–54

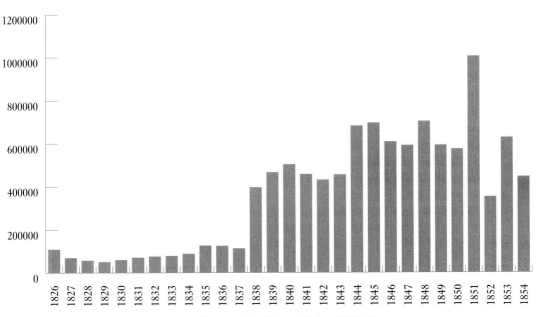

Source: *Reports* of the National Gallery, 1826–54

This was the language of government. The tone and the content are very different in independent eye-witness reports from within the already cultured portion of the middle class. Many of these express a smug satisfaction at the range of the National Gallery's social mix: 'Nobility came in their coroneted carriages; gentry in their several vehicles; and tradespeople, country folk, young persons, and well-dressed domestics in their holiday clothes, on foot', wrote one observer in 1843,[74] suggesting the sort of motley, enthusiastic crowd captured in the drawing by Richard Doyle (Figure 21). Or take Charles Kingsley's later, gushing account of the 'delight' he felt in watching 'in a picture gallery some street boy enjoying himself; how first wonder creeps over his rough face, and a sweeter, more earnest, awe-struck look, till his countenance seems to grow handsomer and nobler on the spot, and drink in and reflect unknowingly, the beauty of the picture he is studying'.[75] When 300 boys of the Marylebone workhouse visited the gallery in early 1844, on the other hand, the *Athenaeum* described an alien creature entering a space normally reserved for the respectable class:

> The arrangements to prevent confusion were complete, each boy following close upon the other's heels, having secured his line of march by encircling with his left arm the rail which prevents a too near approach to the pictures. The perspective of this living line … was singular, not unlike some huge snake, each boy forming a joint or vertebra of grey cloth and brass buttons.[76]

Visual images of the new Gallery are contradictory too. Early paintings portray it as a peaceable location with an easy traffic of persons and carriages at the very heart

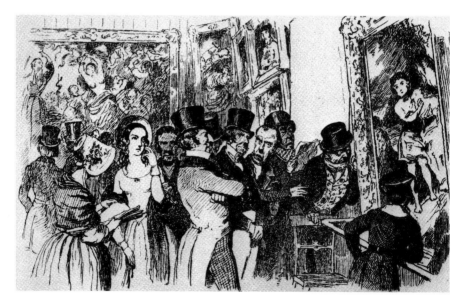

21 Richard Doyle, 'In the National Gallery', 1840, from *A Journal Kept by R. Doyle in 1840*, Smith Elder and Co., London, 1885.

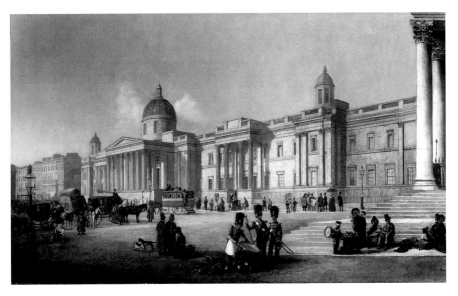

22 Henry Gritten, *View of the National Gallery and the Royal Academy*, 1838, oil on canvas, 52.1 x 87.6 cm.

of London (Figure 22); Gritten's is an optimistic, almost utopian image of an ordered urban space and an orderly public within and around it. Yet the peaceableness of Trafalgar Square was rudely interrupted by the Chartist demonstration against the new income tax of 1848 (Figure 23). Here, the gallery is no longer a backdrop to a well-ordered public space, but witness to a scene of riot and instability. The demonstrating mass is contained by a panoply of public institutions that surround the square, even as police constables attempt to enforce order upon the leaders of the unruly crowd. Another category of images lies at odds with the stern pronouncements issuing from the spaces of administration, supervision and legislation in those years. To look at Charles Compton's small painting *A Study in the National Gallery* of 1855 (Figure 24), or Aeron Hoven's *A Room Hanging with British School Pictures* of post–1856 (Plate 6), is to have it suggested that the Gallery could be and perhaps was, for some, a familial setting of safe and calm attention, a space in which women and children could gaze rapturously at a *Pietà* by Francesco Francia (the Compton), or commune inattentively in the Gallery's warm interior in the case of Hoven's family looking at the Turners.

And yet public scepticism about the efficacy of state exhibitions was by no means unknown. Reporting on a well-attended exhibition in mid–1843 of 141 cartoons of historical and literary subjects in the Palace of Westminster, part of the competition to decorate Barry's new building following the destruction of the old Palace by fire in 1834, the *Illustrated London News* carried an image of the well-dressed crowd which allegedly averaged between 20,000 and 30,000 people per day. The cartoons, hung on screens which obscured the light from the windows, met with an ardent response from what *The Times* called 'most respectably dressed people (Figure 25).[77]

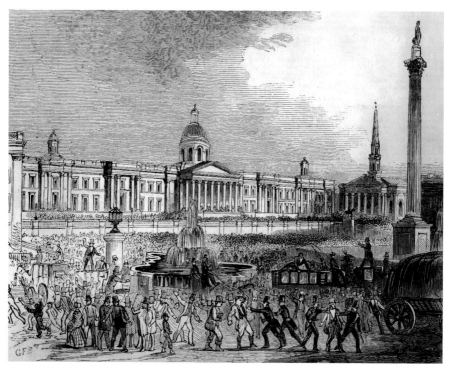

23 Chartist demonstration in Trafalgar Square, from *Lady's Newspaper*, 1848, pp. 214–15.

24 Charles Compton,
*A Study in the
National Gallery*,
1855, oil on canvas,
25.4 x 31 cm.

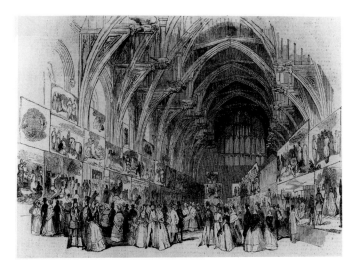

25 'The Triumph of History' (Westminster Hall Exhibition of Cartoons), *Illustrated London News*, 8 July 1843.

Sir Charles Lock Eastlake, secretary of the Fine Arts Commission, under whose auspices the exhibition was planned, wrote:

> the *éclat* given to the occasion by Her Majesty's visit [on 1 July 1843] ... rendered this exhibition, opened at first for a shilling, a very fashionable resort. At the expiration of a fortnight, the public were admitted gratis ... the daily throng is immense; the public takes great interest, and the strongest proof is thus given of the love of the lower orders for pictures, when they represent an event.[78]

Yet on the same day, the recently launched satirical magazine *Punch* drew a contrast between the sums lavished on the competition and the inability of the government to deal with urban poverty:

> There are many silly, dissatisfied people in this country, who are continually urging upon Ministers the propriety of considering the works of the pauper population ... We conceive that Ministers have adopted the very best means to silence this unwarrantable outcry. They have considerately determined that as they cannot afford to give hungry nakedness the *substance* which it covets, at least it shall have *the shadow*. The poor ask for bread, and the philanthopy of the State accords them – an exhibition'.[79]

Punch's cartoon (Figure 26) does not show the real entries by Edward Armitage, G. F. Watts, C. W. Cope and others, but shows instead paupers gazing unknowingly at pictures of fruit, a dead hare and sausages, a banquet, bishops and the smiling nobility. The portrait prominent on the left of the cartoon is the Duke of Cumberland, whose lavish income of £21,000 per year had just been debated in the Commons.[80]

For all *Punch*'s cynicism, however, the government was determined to regulate attendance at galleries and promote participation in art as a route to moral and spiritual health for the widest urban mass. This surely explains why the very experience of art was becoming hedged around with protocols of cleanliness and regularity

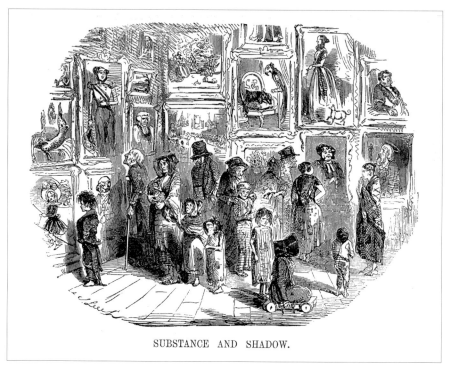

SUBSTANCE AND SHADOW.

26 John Leech, 'Substance and Shadow', *Punch*, vol. 5, 15 July 1843, p. 23.

of an altogether new urgency and scale. The symptoms of this concern were several. Attempts to clean and restore some of the National Gallery pictures, which would result in drastic overcleaning or overvarnishing (or both), was already under way. Charles Lock Eastlake, also Keeper of the National Gallery, would soon resign after a storm of negative press comment on the issue. A second cholera epidemic rocked the medical establishment in the revolutionary year of 1848, adding to already grave anxieties about external pollution in central London. Given that the causes of cholera were still unknown, alarm about noxious vapours and the spread of disease were still conventional. Yet the possibility of moving the National Gallery to escape the pollution of the city posed a particular dilemma: if the Gallery were moved to the suburbs, or to Kensington, as one proposal suggested, then perhaps fewer people would go. In the 1850 *Report of the Select Committee on the National Gallery*, set up to 'consider the present Accommodation afforded by the National Gallery, and the best mode of Preserving and Exhibiting to the Public, the Works of Art given to the Nation or Purchased by Parliamentary Grants', the problem was addressed in some detail:

> Our attention was drawn to the vicinity of several large chimneys, particularly that of Baths and Washhouses, and that connected with the steam-engine by which fountains in Trafalgar are worked, from which great volumes of smoke are emitted. In

the neighbourhood, also, the numerous chimneys of the various club-houses are constantly throwing out a greater body of smoke than those of ordinary private residences; the proximity likewise of Hungerford Stairs and of the part of the Thames to which there is a constant resort of steam-boats, may tend to aggravate this evil.[81]

The problem had already impacted upon that other favoured precondition for viewing: light. In an 1845 pamphlet Eastlake had urged that there 'should be a superabundance of light' in the gallery, since there was 'smoke to contend with' outside; 'what has been deemed necessary ... in the best lighted continental galleries should be ... exaggerated in London'.[82] But external dirt and darkness were not the only pollutants that threatened the correct appreciation of pictures. Given the levels of anxiety about 'cleanliness' and 'correct dress' among curatorial professionals, it comes as no surprise to find that the next major pollutant to be dealt with was the public itself. As the May 1850 *Report* stated despairingly, visitor numbers for 1848 and 1849 were as high as 703,410 and 592,470 respectively, in excess of 3,000 people daily,[83] a figure which would almost double in 1851. In the wake of the public outcry against harsh or ineffective cleaning methods, the physical conjunction of large crowds and fine pictures was emerging as a social, cultural and political problem of the the greatest proportions.

What is revealing about the debate on these issues is how innocent technical problems could become loaded with metaphors of cleanliness, class and ultimately moral value. The public-as-pollutant had already been an issue in the debate on lighting, since 'optimum' lighting of the pictures implied maximising the uninterrupted visual contact between the spectator and the work, hence minimising crowding in the gallery space. This was one reason why gallery professionals became sensitive about people entering the gallery who were not really looking at art. 'It appears that the gallery is frequently crowded by large masses of people', observed the 1850 *Report*,

> consisting not merely of those who come for the purpose of seeing the pictures, but of persons having obviously for their object the use of the rooms for wholly different purposes; either for shelter in case of bad weather, or as a place in which children of all ages may recreate and play, and not infrequently as one where food and refreshments may conveniently be taken.[84]

In the testimony of some, the argument *was* about class. 'According to my experience', said Dr Waagen from the Royal Picture Gallery in Berlin, 'the lower classes are not capable of appreciating them [works of art], but [only] of enjoying them'.[85] Mondays were a nadir, explained Thomas Uwins, Keeper of the National Gallery after Eastlake, for these were days

> when a large number of the lower class of people assemble there, and men and women bring their families of children, children in arms, and a train of children around them and following them, and they are subject to all the litle accidents that happen with children, and which are constantly visible upon the floors of the place.[86]

Uwins' misgivings were considerable:

> 'I have observed a great many things which show that many persons who came, do
> not come really to see the pictures. On one occasion, I saw a school of boys, imagine
> 20, taking their satchels from their backs with their bread and cheese, sitting down
> and making themselves very comfortable, and eating their luncheon ... On another
> occasion ... I saw some people, who seemed to be country people, who had a basket
> of provisions, and who drew their chairs round and sat down, and seemed to make
> themselves very comfortable; they had meat and drink; and when I suggested to them
> the impropriety of such a proceeding in such a place, they were very good-humoured,
> and a lady offerd me a glass of gin, and wished me to partake of what they had pro-
> vided; I represented to them that those things could not be tolerated. And on fre-
> quent occasions, I have perceived a quantity of orange-peel in different corners of
> the place, which proved that oranges, among other things, were eaten ... On another
> occasion, I witnessed what appeared to me to be evidence of anything but a desire to
> see the pictures: a man and a woman had got their child, teaching its first steps; they
> were making it run from one place to another, backwards and forwards; on receiving
> it on one side, they made it run to the other side; it seemed to be just the place that
> was sought for such an amusement.[87]

And again, the outside too often flooded in:

> On days on which the guard, after being changed, return to St George's Barracks
> [behind the gallery], the numerous crowds of persons without apparent calling or
> occupation who on such occasions follow the military band, are starting to come in
> large bodies immediately after it has finished playing, and fill the rooms.[88]

The syllogisms of dirt were by now almost complete. To maximise the ameliora-
tive effects of art, pictures should be properly seen. For this, they needed light.
But light presupposed the absence of a crowd, or at least the redundancy of those
who were not seriously attending. A second syllogism followed the first. The crowd
required ventilation. Ventilation admitted air; but the external atmosphere was too
dirty to be good for the pictures, hence the windows were best kept closed,[89]
whence the crowd would sweat and exhale foul air even more, creating the need
for more ventilation. If the external atmosphere could not practicably be regulated,
then the visitors could. As the May 1850 *Report* put it: large crowds 'add largely
to those results which may be supposed to affect the atmosphere of the rooms and
the surface of the pictures'.[90] Moreover visitor-produced dirt was subject to com-
pound increase: the greater the number of visitors, 'the greater also will be the
quantity of impurity produced within the building from the respiration and per-
spiration of great numbers of persons'. Miasmatic terminology did not need to be
chemically exact: 'This impure mass of animal and ammoniacal vapour, of which
it is difficult and perhaps unnecessary to distinguish and define the component
parts, is peculiarly liable to be condensed on the surface of pictures', leading to
dullness and a loss of 'brilliancy'.[91]

No less an authority than Michael Faraday was called in to confirm the noxious
effects of the crowd: 'Did you observe', asked one leading question in 1850, 'that

there were numerous persons without apparent calling or occupation who came in
there to lounge, merely on account of its being in the vicinity of the great thor-
oughfare?' 'I have seen persons there', Faraday replied, 'women, suckling their
infants, and others sitting about upon the forms, and others not looking at the pic-
tures'.[92] Another witness (William Connington) observed that:

> You constantly see women sitting there, with half-a-dozen children running about,
> and even with babies at the breast. There are numbers of people going on in that
> kind of way for no earthly purpose connected with the place, and they must act inju-
> riously in raising a great quantity of dust, as well as increasing the exhalations'.[93]

In trying to identify the nature of such exhalations, Faraday himself seemed to mix
guesswork with science:

> There is a substance which we call ammonia [he proposed] which gains access into
> the London atmosphere in many ways, arising considerably from some manufactur-
> ers, which would help very much either the sulphurous vapour or the miasma from
> the body, to injure the pictures ... The atmosphere is so charged with miasma and
> vapour from those crowds as to be liable to injure the pictures.[94]

The consequence for Faraday and the 1850 Committee was clear. The question
was put to him: 'Exactly in proportion as human beings congregate in any one
gallery, will be the evil arising from the presence of such human beings?' Faraday:
'No doubt of it'.[95] The presence of a substantial 'public' before pictures that were
ideally cleaned and lit was emerging as a contradiction in terms. The result was a
curious impasse in the professionalisation of art around mid-century. Either the
gallery was ideally clean, and empty; or else the public would itself contaminate
the very *mise en scène* of viewing. Both alternatives threatened a collapse of the
moral mission of the museum itself.

The curator and his public are redefined

But that very *impasse* can also be represented as a point of transition. Following
almost logically from the syllogisms of dirt, the impulse to observe and describe the
gallery public can be seen as a step in the direction of a complete modernisation of
the curatorial profession, and an extension, rather than a collapse, of the moral mis-
sion on which the idea of the public art museum was founded. Such dialectical
movements – of characterisation, segmentation, specialisation – were not of course
confined to the curatorial cast around 1850 but animated many of the new profes-
sions of the day. What concern us, however, are the norms which emerged in the
gallery management profession following the 1850 *Report*: those assumptions,
expectations and understandings developed between the management stratum and
the gallery's clientele as the period of intense governmental scrutiny of the gallery
came to an end. Increasingly it was now the art object in its state of preservation,
illumination, storage and mode of display that would become subject to protocols

of visibility, cleanliness and durability. These protocols in turn interlocked with a newly historicising attitude to the collection as a whole; supporting and supported by a new definition of the duties of the professional curator. The 'public' in its turn, unified by its modes of description from above, would become subject to the imperatives of cleanliness and decorum, but also those of education.

The last of the reports to be looked at here, the massive 1853 *Report on the National Gallery*, glossed in a Treasury Minute entitled 'Reconstituting the Establishment of the National Gallery' and published on 27 March 1855, examined in comprehensive detail the roles, functions and duties of the Trustees and officers in relation to the development, upkeep and display of the Gallery's pictures. The majority of the 1853 *Report* was concerned specifically with the cleaning and glazing of pictures, with management and with the Gallery's site. As to management, Ewart had already proposed in 1836 that *experts* should replace those of 'elevated rank' in giving advice on art purchases.[96] The sentiment had developed gradually into a generalised lack of confidence in 'gentlemen' Trustees who had no expertise in art but merely pretended to a cultivated manner. The 1853 *Report* recommended that the system of appointing Trustees be overhauled so as to encourage greater professionalisation and expertise. The Trustee system would henceforward have a particular purpose: 'to keep up a connexion between the cultural lovers of art and the institution, to give their weight and aid, as public men, on many questions of art of a public nature that may arise, and to form an indirect though useful channel of communication between the Government of the day and the institution'. Without this aid [the Minute continued] the new Director Sir Charles Lock Eastlake, aided by Ralph Wornum as Keeper and Secretary – would be in a high but insulated position,

> reporting periodically to the Treasury, but missing the counsel and experience of the Trustees and being without that stimulus to exertion which the knowledge of the bond of union existing between the lovers of art in this country and himself, through the medium of the Trustees, would be calculated to afford.[97]

The formal duties of the Director, which consisted in 'the selection and purchase, or recommendation for purchase, of pictures ... and in the arrangement, description and conservation of the collection',[98] are themselves indicative of the way in which responsibility rested for the first time squarely in the hands of an expert professional manager. With those duties emerged a new archival attitude to the collection and a set of new techniques for authenticating, organising and expanding it as an instrument of public instruction and improvement (at the very least, misattributed pictures needed detecting and screening out). The Director would be required to 'construct a correct history of every picture ... including its repairs, and describe accurately its present condition, which history will be continued from time to time by new entries as occasion may require'. He was further directed to seek out pictures from abroad rather than at home, and to focus above all else upon 'good specimins of the Italian schools', aided by a Travelling Agent (Otto

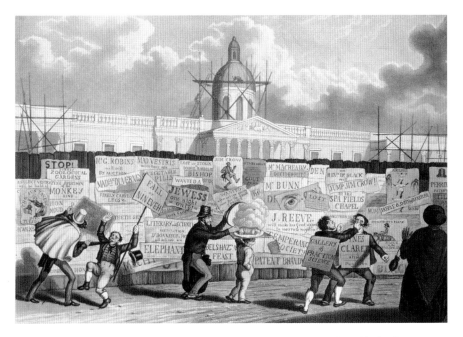

Plate 5 *Cross Readings at Charing Cross*, c. 1836, aquatint by Charles Hunt, coloured by hand, 22 x 31 cm, originally published by W. Soffe.

Plate 6 A. Hoven, *A Room hanging with British Pictures*, after 1856, dimensions unknown, oil on canvas (showing Turner's *Dido building Carthage* and *Ulysses deriding Polyphemus*, and Hogarth's *The Painter and His Pug*).

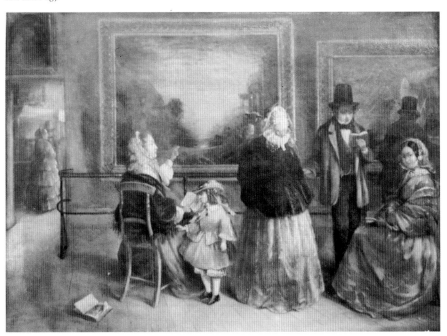

Plate 7
W. Mulready, *Interior with Portrait of John Sheepshanks*, 1832–34, panel, 50.8 x 40 cm.

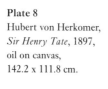

Plate 8
Hubert von Herkomer, *Sir Henry Tate*, 1897, oil on canvas, 142.2 x 111.8 cm.

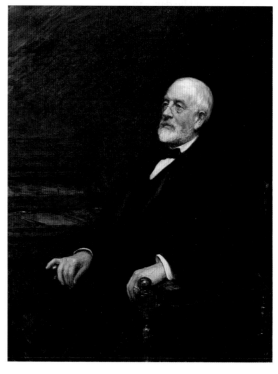

Mündler) appointed to help him by visiting 'the private collections of distinguished families abroad, ascertaining and describing the contents, and obtaining the earliest information of any intended sale.[99]

The identification of 'Masters who might, sooner or later, be represented in a National Gallery' was to be aided by the compilation of a catalogue of existing pictures in extensive and thorough detail – and soon published under the guidance of Ralph Wornum. Following the pattern set by Passavant's catalogue of Raphael, Orsini's enumeration of Perugino, Rigollot's of Leonardo, Waagen's and Michiels' of Van Eyck, and others, the National Gallery catalogue would take a tabular form giving the

> name of the master [followed by] a physical description (shape, number of parts, etc); subject; size (height by width, to the nearest quarter inch); the support material; the medium used; any inscriptions, dates and other marks; location; repetitions and copies; engravings; location of drawings and studies for the works; general history of the picture.[100]

Under Eastlake's administration the duties of cleaning and preservation of the pictures would also fall to the Keeper and Secretary, according to specifications that lay the foundations for much subsequent practice. They are worth quoting in full:

> The Keeper will see that the rooms are well and thoroughly swept in the mornings after every public day, and also on Monday evenings. It appears that, from the construction of the rooms and the mode of lighting, the evils of a close atmosphere in summer are more difficult to guard against than cold in winter. The Keeper will take all safe means in his power to ensure due freshness and the circulation of air; he will see that the openings in the windows, contrived for ventilation, work freely, and will, when necessary, cause the windows to be partially or entirely opened. An attention to the means of ensuring due ventilation is more especially requisite in the smaller rooms. The Keeper will attend to the state of the skylights, with a view to the proper lighting of pictures.
>
> In the colder months the Keeper will see that the apparatus for warming the apartments is kept in order, and will take care that all the rooms are, as far as possible, warmed in an equal degree ...
>
> With regard to the conservation and display of works of art, the following directions are to be observed:
>
> The Keeper will frequently inspect the national pictures, and should he detect in any of them any unusual appearance, any symptoms of decay, or any accidental injury, he will at once report the same to the Director. So, with regard to the satisfactory display of the works, he will notice when the surface appears too dull, whether from the effect of chilled varnish or from other causes, and will report the result of his observation accordingly.
>
> The Keeper will see that the blinds for excluding the sun's rays from the pictures are kept in repair, and will direct the attendants to be very careful to close them as occasion may require, so that no picture shall ever be exposed to the action of the sun's rays.

For the dusting of the surface of such of the pictures as are not protected with glass, and for the dusting of the frames, soft full feather-brushes should be used. The operation may require to be repeated daily in the most crowded season, and in warm, dry weather; but it should not be repeated unnecessarily, since, in damp weather, the surface of such pictures as are sound may require careful wiping rather than dusting, and this operation should be undertaken only by the person employed by the Director. In the instance of cracked pictures, which may have a tendency to chip, even the operation of dusting may sometimes require a no less careful hand. Pictures so cracked as to have a tendency should, if their size admits of it, be protected with glass, previously to more effectual means being taken to arrest the progress of decay.

The Keeper will see that the glasses by which some of the pictures are protected are cleansed as often as may be necessary.

No picture should on any account be varnished nor any repairs whatsoever undertaken by the Keeper, or by his order, without the special sanction of the Director ...

The arrangement of the pictures forming the national collection will at a future time require especial consideration. The chief duty of the Keeper, under existing circumstances, will be to assist the Director in devising means for providing sufficient space, consistently with the least possible sacrifice as regards position and light, of the principal works.

Among the details connected with the arrangement of the pictures, the perfect security of the fastenings and supports, the firmness of the boarded facing of the walls, and the safest contrivances for moving large pictures, will require attention on the part of the Keeper and Director.[101]

Though still familiar today, such measures to establish the exact description and physical condition of pictures and to ensure their cleanliness and visibility, evolved in the wake of the health scares of the 1830s and 1840s and coincident with concerns about the hygiene and degeneracy of a potentially 'fallen' labouring class, in fact went far beyond mere instrumentality alone. The new rituals of care – cataloguing forensically in order to authenticate and compare, cleansing, inspecting and repairing so as to arrest the process of decay – postulated new attitudes to the significance of valued objects and new values to be found in them. These rituals and attitudes on one level enshrined sound principles towards the preservation and exhibition of physically delicate objects; on another, they bespoke unconscious desires to enshrine, preserve and even extend the magical qualities associated with art objects by creating an *in vitro* region of absolute stasis and duration in which decay could be fended off and even death deferred. The implication of the gamut of government Select Committee reports from the 1830s was that the audience could and perhaps should see itself reflected in similar protocols and rituals; that they in turn might begin to regulate themselves adequately as to cleanliness, light, posture, and the warding off of physical decay incurred through reckless and undisciplined pleasure. Where art was concerned, they would be enjoined after 1853 to attend rationally, in an atmosphere devoid of dirt and darkness, to the framework of the historical sequences and orderings thus provided. They would henceforward become increasingly sensitive to the distinctions between master and

pupil, masterpiece and merely fine work, and between the 'schools' of different nations. Eventually it would be possible for the public to take pride in the distinction between the art collections amassed in foreign galleries and that in the possession of the British nation itself.

It is instructive to consider the health reforms of the 1830s and 1840s and the rise of the curatorial profession together, for a variety of reasons. By 1850, non-work time was becoming increasingly 'rationalised' in ways that progressively abolished those earlier working-class habits of violence, debauchery and riot in favour of timekeeping, effort, competition, skill, bodily fitness and self-improvement. Secondly, the quality most sought by the reformers both in and out of government is now 'taste' – an eighteenth-century concept dusted down and pressed into service as a standard that could operate across class. In the 1836 and the later *Reports* it parallels and mirrors the concern for hygiene: 'public taste' becomes a new source of anxiety, and its improvement the immediate goal. Entering a period of unparalleled prosperity and influence under the homely guidance of the young Queen Victoria, Britain could now occupy itself with a new exercise in public rhetoric, that of organising the familial nation around standards of health and education that had begun to apply to the quantitatively considerable middle class.

The process is as gradual as it is dialectical. On the one had, the 'respectable classes' of London become definitively separated from the *lumpenproletariat* in linguistic and rhetorical oppositions such as 'decent' versus 'indecent', 'civilised' versus 'animal', the 'stable family' versus the unstructured and 'nomadic', the productive versus the aimless and marginal, the healthy versus the diseased, the clean versus the repugnant and despoiled, and so on; these were the terms both of Chadwick's 1842 *Report* and of Henry Mayhew's *London Labour and the London Poor* of 1861–62. Chadwick's 1842 Report is about health; but it is also about the deployment of terms like 'degredation', 'dirt', 'noxious', 'refuse', which signal the fear, disgust and fascination both denied but also furtively reinscribed in the health reformers' texts. Mayhew in 1861–62 is explicit about the link between moral wickedness and 'physical filthiness' and effortlessly positions the fascinated bourgeois at the opposite pole to that of the nomadic, socially marginal and degenerate poor.[102] In Chadwick the argument, at times, involves a sinister causation: the 'reckless and intemperate' habits of the working classes were not brought about by, but actually caused, 'the abandonment of all the conveniences and decencies of life'.[103]

Yet by an opposite argument Chadwick is aware of the benefits of culture as an antidote to moral and physical disorder – witness the holiday given in Manchester in 1840 to celebrate the marriage of the Queen to Prince Albert, in the course of which 'arrangements were made for holding a Chartist meeting, and for getting up what was called a demonstration of the working classes, which greatly alarmed the municipal magistrates'. Chadwick reports that the Chief Commissioner of Police managed to persuade the Mayor to throw open the Botanical Gardens, the Zoo, and the Museum, recently opened, at just the time of the meeting. The result, that only

200 or 300 attended, and that the Chartist meeting 'entirely failed',[104] is symptomatic of the newly established link between public order and the experience of art.

The latter example particularly suggests how museum culture from the 1830s to the 1850s was perceived to have a profoundly ordering and quiescent effect upon a population traditionally given over to boisterous pleasures, drunkenness, explosive rioting or forms of political action. Or take another symptom of the new curatorial rationality, one which slightly pre-dated the National Gallery's own panoptic catalogue: Dr Waagen's systematic survey of the paintings, drawing, sculptures and illuminated manuscripts in the major collections of Britain, which established a way of looking at different segments of British society and their characteristic interests and which did much to solidify the emerging bourgeois consensus that the experience of art was 'good' for the whole nation.

The importance of Waagen's three-volume *Treasures of Art in Great Britain*, published in 1854, is that it inaugurated the genre of the panoptic survey-book that enumerated, classified and described works of art for a rapidly expanding public – not only a shifting and pleasure-seeking urban mass, but, with the advent of the railways, a burgeoning tourist class. It is a feat of accumulation; replete with lists, indexes, cross-references, comparisons, descriptions and evaluations, the books not only systematised the foundations of the various sciences and professions of visual culture, but established the conceptual tools for the recognition of a specifically 'British' school of art while positioning London at the artistic and cultural centre of the country and hence of the nation and empire as a whole. In his preface, Waagen is clear what audiences his panoptic account was intended to serve. The first was 'the larger class of the public who are interested in knowing the actual extent of the treasures of art in England, and also the more learned connoisseur of the history of art'. The second was 'those cultivated classes from all parts of England who visit the galleries of London during the season'.[105] 'Fine art', says Waagen on another occasion, 'as experience and reflection show, is the only means of affording to the lower classes a really intellectual improvement, of approximating their moral position to that of the higher grades'.[106] Chadwick too had been convinced of the benefits of what he called 'temperate pleasures on ordinary occasions, and their rivalry to habits of drunkness and gross excitement, whether mental or sensual'; he had called repeatedly for 'sound morality and refinement in manners and health'[107] by which the reformed part of the 'nation' would prosper in the world. In effect, the image of the art museum and that of its burgeoning public were to be brought into a kind of conjunction.

Instructing the whole nation:
South Kensington to St Martin's Place

THE 35-YEAR INTERVAL BETWEEN THE FIRST REFORM ACT (1832) and the introduction of household franchise in the second (1867) coincided with a drive for national prosperity guided for most of the period by an ostensibly free-thinking Liberalism in politics and the recognition of Britain both at home and abroad as a paradigm of successful free trade, social reform and material prosperity under the eye of a benevolent and much loved Queen.

Yet throughout this period a tension between pride in the nation and exasperation at the cultural level of its population was felt by many influential voices. In the decades following the establishment of the National Gallery, the idea of a national public ordered and defined through its participation in displays of art became widespread in England. The process had begun with the 1836 *Report of the Select Committee on Arts and Their Connexion with Manufactures* which had sought to place old-master paintings in front of all the classes in the metropolis and had postulated a causal chain between doing so and an improvement in both morality and design. The second step was the vast Exhibition of the Works of Industry of All Nations, held through the spring and summer of 1851 in Joseph Paxton's great glass structure in Hyde Park. Financed almost entirely by private capital encouraged by the patronage of Prince Albert, the Great Exhibition also identified manufacture with the 'national character' and posited the Queen and her family at its moral centre: Henry Selous's official painting of the opening on 1 May 1851 shows the great and the good of state, monarchy, church and empire against the background of what was significantly called the North Transept (Figure 27). Deploying 'sculpture and Fine Arts, Raw Materials, Machinery and Manufactures' from all over the world, in practice the exhibition did not encompass the fine arts in today's sense but displayed wood carving, ceramics, stained glass and a few paintings integrated into displays of manufacture, design and what would today be called decorative style. Sculptures were likewise integrated into rooms of design or, placed at the base of columns on the ground floor, lent to the interior a processional ambience in keeping with the building's ecclesiastical form.[1]

The Great Exhibition was marked too by the presence of the dynamic young administrator Henry Cole, a civil servant who had mixed with the group of

27 Henry C. Selous, *Opening of the Great Exhibition by Queen Victoria on 1 May 1851*, 169.5 x 241.9 cm, showing the British Commissioners, left, with the Archbishop of Canterbury and the Duke of Wellington, the Royal Family, centre, and foreign commissioners, right.

'philosophic radicals' including Thomas Love Peacock and John Stuart Mill and who had worked energetically in the Public Records Commission and the Treasury before joining the Society of Arts in 1846, from where his administrative career in the arts began. Though the Great Exhibition was in no sense a permanent museum of either design or art it was nevertheless an instrument of the state, and opened up new horizons for the centralised management of culture at a time when social revolution and the efficacy of the state were in a condition of crucial balance.

For example a remarkable management innovation at the 1851 Exhibition was the use of statistics to analyse, communicate and rationalise every aspect of the 6,039,195 visitors' behaviour. Statistics had grown as an analytical science since the 1830s and had been used in education and sanitary reform: the state was now quick to adopt these techniques as its own.[2] Indeed in the aftermath of 1851 a quasi-military operation was mounted to gauge the effectiveness of the exhibition as a scientific, cultural and social event. The construction of the building was examined and elaborately described. Scientific and technological displays were forensically analysed. The expenditure of visitors according to ticket price was analysed (a differential system of prices ranked tickets from £1 down to 1 shilling). The effect of crowding upon police tactics was closely scrutinised. Aided by the resources of the Royal Engineers, charts and statistical tables of visitor numbers

were assembled according to day of the week, ticket price, rain and temperature in the building. Refreshment sales were analysed in all the categories from sausage rolls to Victoria biscuits, jellies to ginger beer (see the table below).[3]

Table 2: Quantities of provisions sold in the refreshment courts during the Great Exhibition of 1851

Description of Provisions		Younghusband and Son Central Court	Thomas Masters Eastern and Western Courts	Total
bread, quarterns		25,536	27,558	52,694
cottage loaves		57,528	3,170	60,698
French rolls		7,617	–	7,617
pound cakes		28,828	39,600	68,428
"at 3d.		36,950	–	36,950
savoury cakes		20,415	–	20,415
savoury pies	(lbs)	–	33,456	33,456
savoury patties	(lbs)	–	23,040	23,040
Italian cakes		2,197	9,600	11,797
biscuits	(lbs)	33,722	3,600	–
Bath buns		311,731	622,960	934,691
plain buns		460,667	409,360	870,027
Banbury cakes		34,070	–	34,070
sausage rolls		–	28,046	28,046
Victoria biscuits		–	73,280	73,280
macaroons	(lbs)	–	1,500	1,500
rich cakes		–	2,280	2,280
pastry at 2d.		–	36,000	36,000
School cakes		–	4,800	4,800
preserved cherries	(lbs)	–	4,840	4,840
pineapples		–	2,000	2,000
pickles	(gallons)	1,046	–	1,046
meat	(tons)	113	–	113
potted meat, tongues, etc	(lbs)	–	36,130	36,130
hams	(tons)	19	14	33
potatoes		36	–	36
mustard	(lbs)	–	1,120	1,120
jellies	(quarts)	–	2,400	2,400
coffee	(lbs)	9,181	5,118	14,299
tea	(lbs)	–	1,015	1,015
chocolate	(lbs)	3,783	1,653	4,836
milk	(quarts)	17,257	16,175	33,432
cream	(quarts)	14,047	18,002	32,049
Schweppes' soda water, lemonade & ginger beer	(bottles)	536,617	555,720	1,609,337
Masters' pear syrup	(bottles)	–	5,350	5,350
rough ice	(tons)	180	183	363
salt	(tons)	16	21	37

Source: *First Report of the Commissioners for the Exhibition of 1851* (1852),
Appendix XXIX, p. 150.

Alongside its avowed aim of demonstrating Britain's prowess as the manufacturing centre of world trade, the Great Exhibition functioned to identify the different classes of the social order in the degree to which they participated in the work of the nation's design and manufacture and partook in its legitimate moral order. Given the political background of 1851, it was almost inevitable that the 'working' classes came in for special scrutiny. After 1848 the fear of general insurrection was real; the *Art Union* journal speculated before the opening that 'the loyalizing effect of [the Great Exhibition] is not the least of its moral recommendations. Every man who visited it would see in its treasures the result of social order and reverence for the majesty of the law.'[4] And yet as with 1836, such fears proved groundless. 'The experience of a few weeks after the Exhibition had been opened', reported Alexander Redgrave to Prince Albert,

> dissipated the aprehensions which, in the absence of all precedent, prevailed at the commencement of the year; the remarkable quietude and good order prevailed, the social condition of the Metropolis remained unaltered, and the conduct of the visitors … was entitled to the highest commendation.[5]

Train travel to and from the metropolis was gratifyingly efficient, police presence was effective, crime and drunkenness was minimal (even down), injuries and accidents were no more than average, accommodation for visitors was ample. Added Redgrave: 'The returns do not contain a single case of sedition, or seditious conspiracy, or of unlawful riot. Employment, regular wages and abundant food reduce to a shadow the duties of a police force in regard to political offenses'.[6] Equally, the influx of visitors into the capital increased by some three- or four-fold visits made to the British Museum, the National Gallery and other collections during the latter part of 1851, straining their resources still further. Yet as Thwaites of the National Gallery reported, 'no injury accrued to the pictures, and small as is our establishment, there was no occasion to call in additional aid, or any assistance of the Police Force in keeping order'.[7]

In the field of the fine arts the experience of 1851 was consequential on several fronts. It confirmed an earlier reforming belief that exhibitions managed by the state were 'good' for the population and that the experience of all the arts would lead to greater national superiority in design and manufacturing skill: other large-scale exhibitions in the metropolis would follow in 1862 and in the 1870s. Secondly, that same reforming belief served to pit a department of state against the ethos of London's major national art gallery. The Commissioners of 1851 already regarded the National Gallery – now a mere 15 years old – as too small and inflexible to reach more than a fraction of the population. The Royal Academy too was perceived as being too specialised effectively to reach the artisan and working class. Under Cole's determined leadership South Kensington became the centre of a movement massively to expand the reach of design but also the fine arts, not only throughout London but to the farthest reaches of the provinces, as a symbol and expression of how a great manufacturing nation should develop and instruct – and hence create – its subjects.

The South Kensington experiment

The Commissioners of 1851 were men mainly from the Society of Arts or from the government, and hence represented a coalition of persons not identified with a single political party but in possession of power at the very heart of the machinery of state. A parliamentary commission, 'to consider the question of a site for a new National Gallery', recommended to Parliament in August 1851 that a location near Hyde Park should be used to house the collections of design and fine art already housed in different parts of the capital, including works likely to accrue when the Great Exhibition was finally over.[8] By a further civil-service decree, a Department of Practical Art was established at the Board of Trade in February 1852 with Henry Cole as its General Superintendant, to administer a plan of art education and to set up a system of museums of design and art. 'With the establishment of Museums', said the Department's *First Report* of 1853, 'all classes might be induced to investigate those common principles of taste, which may be traced to the work of all ages.'[9] By that date the Department had formed a temporary Museum of Manufactures in Marlborough House (lent for the purpose by Prince Albert), in which various object collections were displayed, and in 1853 the School of Design was moved there from Somerset House, also to fall under the administration of Cole's Department. A year later the same Department became the Board of Trade's Department of Science and Art, and by 1856 the beginnings of a new museum had been erected in South Kensington on the strength of the argument that 'these large open spaces afford a present security against the inconveniences to which the National Gallery [in Trafalgar Square] is exposed, and are the only grounds which remain safe for future years amidst the growth of the metropolis'.[10] The earliest building was a much maligned temporary iron structure known as the 'Brompton Boilers', to which were soon added permanent buildings, many of them rich in didactic subject matter, and built in brick (Figure 28).[11]

But our subject is the exhibition of art. In the early 1850s, doubts about the suitability of Trafalgar Square for the National Gallery were rife. Cole's argument was that several art collections could be placed on view on the 'spacious and unencumbered piece of ground'[12] in South Kensington in a spirit of more or less open rivalry to Trafalgar Square. A substantial collection of British pictures from Hogarth and Reynolds onwards, the majority donated to the National Gallery by Robert Vernon and Jacob Bell in 1847, had been housed in a dark Trafalgar Square basement (Figure 29) and, following general protest at the inadequate conditions, at Marlborough House. Cole argued that they should be moved to the South Kensington Museum, where they were soon displayed with the Turner pictures in a set of 10 rooms known as the National Gallery of British Pictures. A neighbouring but separate suite of three large rooms displayed the collection of 336 paintings, drawings and sketches of John Sheepshanks, accumulated through a fortune from his father's textile mills and comprising works by contemporary artists (the majority Royal Academicians or Associates of the Royal Academy such as Richard

28 South Kensington Museum, general view, *Illustrated London News*, 27 June 1857, p. 635.

Redgrave, William Etty and Edwin Landseer) but including 5 Turners and 6
Constables. Both the Vernon and Sheepshanks gifts had stemmed from a desire to
establish publicly visible collections of British art. Vernon's, formed on the basis
of a successful business as a hackneyman and stable-keeper, had been open at his
house at 50 Pall Mall for those in possession of a ticket (obtainable only from
Academicians) for two afternoons a week during the season from 1843.[13]
Sheepshanks had been an avid collector of Dutch and Flemish prints – Mulready's
painting of 1832–34 shows him in his drawing room at 172 New Bond Street

29 Anon., The
Vernon Gallery in the
National Gallery,
Trafalgar Square,
wood engraving, 14.6
x 23.2 cm, from
*Illustrated London
News*, 4 November
1848, p. 284.

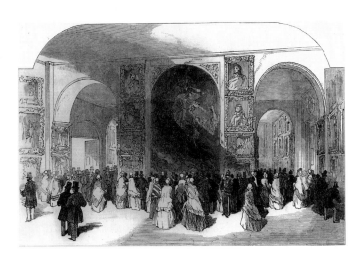

examining portfolios while his housemaid brings him mail and morning tea (Plate 7). By the mid-1850s Sheepshanks and his mostly British paintings and drawings had been installed in a grand house at 24 Rutland Gate, with the prospect that the house might be thrown open to the public with Richard Redgrave as resident curator. Sheepshanks was dissuaded, and in 1857 offered his collection to the nation as a gift, that a 'collection of pictures and other works of art, fully representing British art' be formed. It should be 'worthy of national support'; should 'have the advantage of undivided responsibility in its management, instead of being subject to the control of any body of trustees or managers' – a principal of entrepreneurial business which Sheepshanks wished to see transferred to art. Sheepshanks further specified that the building for a 'National Gallery of British Art' be erected by the government, and 'placed in an open and airy situation, possessing the quiet necessary to the study and enjoyment of works of Art, and free from the inconveniences and dirt of the main thoroughfare of the metropolis', a clear snub to Trafalgar Square in favour of Cole's South Kensington Museum and the Schools of Art. Sheepshanks had also threatened that if his pictures were not 'set properly', 'you shall not have them to thrust where your penuriousness or lack of appreciation may think good enough for them'. He added that 'as soon as arrangements can be properly made ... the public, and especially the working classes, should have the advantage of seeing the collection on Sunday afternoons'.[14]

But while the Sheepshanks gift had been pointedly withheld from Trafalgar Square, Vernon's 157 paintings and 8 sculptures had been given to the National Gallery while under Sir Charles Eastlake's directorship. Strident territorial arguments broke out over the design of the accommodation at South Kensington – with the result that the Sheepshanks, Vernon and Turner collections were given separate entrances with a communicating door between them kept locked: the most graphic illustration of the rivalry that now existed between the Department of Science and Art and the National Gallery, the former a department of state and the second a body under the direction of Trustees.[15]

Moreover the physical conjunction of art with design at the new South Kensington Museum was a mark of the extent to which aesthetic enjoyment, artistic skill, scientific knowledge and design competence were all considered to be indissolubly linked in the moral order of the mid-nineteenth-century British state: Trafalgar Square, by contrast, seemed to believe that 'art' by itself could elevate the common mass. Cole's social ideals in the South Kensington experiment were orchestrated according to a minor hierarchy of functions and inducements. Prizes and examinations were provided. Yet he wanted the state to wither away as the private desire for improvement became widespread: 'the greatest triumph [of the Department of Science and Art] would be the day when every workman will be able and willing to pay the necessary cost of teaching his child to add two to two, and to draw a straight line, without any State assistance'.[16] For Cole, distributing art and design from the metropolis to the provinces would be another utopian feat. The Museum's destiny was 'to become the central storehouse or

treasury of Science and Art for the use of the whole kingdom' by means of trav-
elling exhibitions: Sheepshanks had already said that though his pictures may not
be sold, they may be sent on 'temporary loan ... to any place in the United
Kingdom where any School of Art exists in connection with the Department of
Science and Art, or generally where there is a any safe and proper place for their
reception and public exhibition'. 'It will be a great step', said Cole optimistically,
'when one town can show that drawing is taught in all its public [i.e. state] schools;
the schoolmaster teaching the elements, and the Art master of the district teach-
ing an advanced class and inspecting the whole'.[17] What remains distinctive about
Cole's efforts at South Kensington at the time – aside from the rivalry cultivated
with Trafalgar Square – was the administrative methods by which the burgeon-
ing new system of art education would be delivered. There was something mani-
acal in its scale and style; even by 1857 there is evidence of Cole's belief in
individual reporting accountability and direct line management along military
lines, a belief he put into practice through his links with the Royal Engineers in
the wake of their successes in the Crimean War of 1854–56 and their new avail-
ablity for civilian duty.[18]

The second plank of Cole's programme of museums for the people, and his prin-
cipal boast, was public access. Although Sheepshanks' wish that his pictures be also

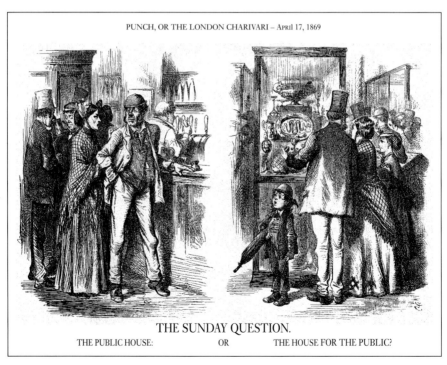

PUNCH, OR THE LONDON CHARIVARI – April 17, 1869

THE SUNDAY QUESTION.
THE PUBLIC HOUSE: OR THE HOUSE FOR THE PUBLIC?

30 Sir J. Tenniel, 'The Sunday Question: The Public-House, or, the House for the Public?',
Punch, 17 April 1869.

available to the working classes on Sunday afternoons had not yet been met, a debate on Sunday opening was well under way by 1857 and an extraordinary tug-of-war between the attractions of religion and fine art was well and truly joined (Figure 30). In the meantime, the South Kensington galleries were open six days of the week, on three of them for sixpence from 10 a.m. until dusk, but on Mondays, Tuesdays and Saturdays they were free, from 10 a.m. until 10 at night, lit in the later hours by gaslight. As *Lloyd's* newspaper commented, perhaps sarcastically:

> The anxious wife will no longer have to visit the different taprooms to drag her poor besotted husband home. She will seek for him at the nearest museum, where she will have to exercise all the persuasion of her affection to tear him away from the rapt contemplation of a Raphael.[19]

The experiment was on one level clearly a success. As Cole was eager to point out, attendances at the South Kensington Museum after only six months suggested likely annual totals of well over half a million a year, in excess of figures from the British Museum, the National Gallery and Marlborough House put together – hence vindicating Cole's conviction that the working classes (both male and female) could benefit from art as much as the wealthy:

> It is much less for the rich that the State should provide public galleries of paintings and objects of art and science than for those classes who would be absolutely desti- tute of the enjoyment of them, unless they were provided by the State … On Monday nights especially, great numbers are strictly of the working classes, to whom a day's visit would entail the loss of a day's wages.

Cole was prepared to wax lyrical too:

> In the evening, the working man comes to this Museum from his one and two dimly lighted, cheerless dwelling rooms, in his fustian jacket, with his shirt collars a little turned up, accompanied by his threes, and fours, and fives in little fustian jackets, a wife, in her best bonnet, and a baby, of course, under her shawl. The look of surprise and pleasure of the whole party when they first observe the brilliant lighting inside the Museum show what a new, acceptable, and wholesome excitement this evening entertainment affords to all of them.[20]

In truth, we do not know whether the working family came for the lighting, the warmth, the company, or the art. Nor do we know whether visitors were atracted once by the novelty of the spectacle, or came again and again – such evidence lies out of reach. But Cole was a man for figures; he could claim that in not one out of 110,000 evening visitors had a single case of 'misconduct' been reported. To endorse his claim about the unsuitability of Trafalgar Square, he advanced statis- tics gathered by the Commissioners for Defining the Site of the National Gallery which showed that out of 23 firms of all kinds – 'butchers, upholsterers, lock- smiths, builders, brewers and the like' – only 44 per cent visited the National

Gallery in a year. Cole produced further returns from a firm of upholsterers in Mount Street, a goldsmith's in the Haymarket, a decorator's in Wigmore Street, and a builder's in Grosvenor Street, which showed more damning figures of 10, 30, 9 and 8 per cent respectively; demonstrating beyond all reasonable doubt that despite his great South Kensington success, daytime use of the public galleries could be greater still. As he commented wryly, 'let it not be said ... that our National Galleries are [yet] for the use of the artisans who live by their daily labour'.[21]

The debate on access: Ruskin

The solution to Cole's problem lay not only, or even at all, in South Kensington: the east and the south of the city were to contribute to the process too – though it should be remembered that there was no system of effective local government in London until the 1888 Act which established the London County Council, and hence no means of planning demographically or socially on a London-wide scale.[22] It was left to individual voices to lobby on behalf of this or that solution to the uneven access to cultural facilities across the capital. Cole and his new Inspector-General for Art, Richard Redgrave, based their ambitions for wide access upon demographic and social changes across the city. As Redgrave had written in an 1857 pamphlet on the Sheepshanks gift,

> from the changes which have taken place, and are still in progress in the Metropolis, the working population now dwell almost wholly in the suburbs of London, and are to be found mostly in Lambeth, Camberwell, Vauxhall, Chelsea, Kensington, Paddington, Camden Town, Islington, Whitechapel and Rotherhithe, and it is only on the occasion of holiday-making, or at night, that they can visit the public galleries.

Of the holidays themselves he had added:

> [they] are earnestly to be encouraged; they tend to bring the whole family – the working man, his wife and children – to enjoy themselves *together*, and at the same time to get that fresh air and healthy out-of-doors exercise that could be got from a ramble afterwards in Hyde Park or Kensington Gardens.[23]

From the start, they believed that the Sheepshanks and Vernon gifts would provide the prototype of a 'local' art museum that could be duplicated at Tufnell park and Victoria Park, Greenwich and Dulwich – together with South Kensington all equidistant from the symbolic focus of St Paul's Cathedral. 'Why should not all of these places have its art gallery? Dulwich is already provided; it only needs to administer it in the way best suited to popular wants ... and a large constituency from all the surrounding districts would flock to it'.[24]

Theirs were not the only voices. John Ruskin was already teaching art at the Working Men's College in Great Ormond Street and had formed unorthodox yet

influential views on the links between education and art. Ruskin firmly believed that a national gallery was an expression of a nation's cultural level. Yet he had advocated the greatest care in the selection and hanging of work. He had given evidence to the 1857 National Gallery Site Commission, appointed to 'determine the site of the New National Gallery, and to report on the desirableness of combining it with the Fine Art and Archeological Collections of the British Museum': he had said that 'one of the main uses of Art at present is not so much as Art, but as teaching us the feelings of nations. History only tells us what they did; Art tells us their feelings, and why they did it ... the whole soul of a nation generally goes with its Art.'[25] Ruskin also felt that old masters were largely wasted on the underprivileged, who lacked the education to appreciate them, and that there should be two accessible national galleries, not one. The main or 'head' gallery would contain the best historical works and be some distance from the main thoroughfare of London, since those who really wanted to see the best would travel to do so; a second system of galleries would contain 'interesting but not unreplaceable' works for educational purposes only – and be as central as possible to the populations likely to use them.

As Ruskin famously said in his 1857 evidence, 'My efforts are not to making a carpenter an artist, but to making him happier as a carpenter'.[26] To this end he believed in putting before them a particular type of art:

> I teach [my working men] so much love of detail, that the moment they see a detail carefully drawn, they are caught by it. The main thing which has surprised me in dealing with these men is the exceeding refinement of their minds – so that in a moment I can get carpenters, and smiths, and ordinary workmen, and various classes to give me a refinement which I cannot get a young lady to give me ... Whether it is the habit of work which makes them go at it more intensely, or whether it is (as I rather think) that, as the feminine mind looks for strength, the masculine mind looks for delicacy ... I do not know.[27]

When Ruskin lectured to the British Institution 'On the Present State of Modern Art, with Reference to the Advisable Arrangement of a National Gallery' in June 1867, he addressed himself directly – as the author of *Modern Painters* might be expected – to the question of how modern, that is contemporary, art and national life were to be brought together. 'The whole body of the public is now interested and agitated by many questions respecting academies, galleries and exhibitions of art', he began by saying. He noted that 'Compassionateness' and 'Domesticity' had begun to appear in British art – not picturesque renditions of the poor, rather their actual poverty and circumstances – and concluded, *contra* the spirit of Reynolds a century before, that openly sentimentalizing art 'does not in the least appeal for appreciation to the proud civic multitude, rejoicing in Procession and Assembly. It appeals only to Papa and Mama and Nurse'.[28] Ruskin wanted what he referred to as 'disciplined citizenship, in which the household, beloved in solemn secrecy of faithfulness, is nevertheless subjected always in thought and act to the deeper

duty rendered to the larger home of the State'.[29] Yet he saw around him only shallowness and vulgarity; story-telling was defensible to Ruskin only on the rare occasion when the stories in question were 'pleasable and honourable' as a bulwark against the ugliness of a nation immersed in trade.

'The British lower public has no very clear notion of the way to amuse itself', Ruskin wrote tetchily; they migrated to the Crystal Palace and drank ginger beer.[30] 'Get your lower order washed and comfortable' was his first advice. Clean the cities and the streets, 'and you will need neither Parliamentary debates, nor Art lectures'.[31] This 'lower order' could then be given rest homes, amusements, libraries, educational museums – and a truly national gallery of art, provided the important distinction was preserved. 'A national museum is one thing, a national place of education another: and the more sternly and unequivocally they are separated the better will each perform its office – the one of treasuring, and the other of teaching'.[32] Ruskin's contrast between a 'Civic' and an educational museum was graphically drawn:

> You must not make your Museum a refuge against either rain or ennui, not let into perfectly well-furnished, and even, in the true sense, palatial, rooms, the utterly squalid and ill-bred portion of the people. There should, indeed, be refuges for the poor from rain and cold, and decent rooms accessible to indecent persons – but neither of these charities should be part of the function of the Civic Museum.[33]

A national gallery or museum of art (whether British or universal, and Ruskin is ambivalent here) should be 'A Treasury and Storehouse ... a stately place – a true Palace of Art, pure in the style of it indeed, and, as far as thought can reach, removed from grossness or excess of ornament, but not unsumptuous, especially precious in material and exquisite workmanship'.[34] As to the building itself,

> Build beautiful rooms for what you have got, let the things take up their abode therein, and when you get anything less like them, build another room for that, and don't disturb what you have already ... I should myself desire to see it built or inlaid with some beautifully coloured and fine stone – Cornish or Genova serpentine, or any kind of grey or green marble, with shining courses of white marble and bearing shafts of porphyry ... Subscribe only once for all as much money as you spend annually in gunpowder and canon ... Take the cost of a year's fireworks ... [and] build a National Gallery of Porphyry and white marble ... I only wish it may be pretty enough and rich enough for the French to want to come and steal it.[35]

Ruskin knew as he spoke that nothing of the kind would be done. But his aim was to set out principles that could animate the debate on the future relationship between a mass audience and a national gallery of British art, and to strike a set of contrasts with what was being done at South Kensington in the name of education through art. He had been right in saying that the question of public culture in London was intense. He called South Kensington 'a confused museum of objects ... out of which the student must learn what he can discover by chance',[36] a 'Cretan

labyrinth'.[37] Holiday crowds at the major museums and facilities were considerable (see the table below); The *Graphic*'s illustration of the Whit Monday crowds at South Kensington in 1871 projected museum-visiting as a social whirl for parents and children alike (Figure 31). The crowd here is seeing itself being seen. How far

Table 3: Visitors to the major museums and other facilities, Whitsun 1863

	British Museum	National Gallery	National Portrait Gallery	South Kensington Museum	Kew Gardens	Hampton Court Palace
Monday 25 May	11,907	10,200	–	6,552	11,631	23,256
Tuesday 26 May	4,451	6,887	–	4,467	4,031	2,570
Wednesday 27 May	4,991	3,980	115	1,248	1,839	1,127
Totals	21,349	21,067	115	12,267	17,501	26,953

Source: *Return of Number of Visitors, Whitsun 1863*, 1863.

this was conducive to study and improvement – and how far it worked against the interests of the working man – were questions that could well be asked.

Ruskin was right too to point out how frequently cultural conditions at the other end of town were a matter for concern. Rare but unco-ordinated visits to the National Gallery were planned in the late 1860s and 1870s by the Working Men's Club and Institute Union, an organisation devoted to the provision of 'comfortable, well-lighted rooms, abundance of magazines and papers, and refreshments, reasonable of price and of good quality', reckoned to be 'more likely than anything else to wean a man away from the public-house';[38] once more we see a graphic inscription of social relations generated and held in place by the mere fact of 'high' culture (Figure 32). Here as elsewhere the view taken by the middle-class press is problematic. The working man is depicted as a reluctant but inquisitive breed, impolitely dressed and as yet unacquainted with the proper physical postures to be adopted in front of pictures. The *Graphic*'s representation of another scene, a visit by a working-class family to the National Gallery while 'on holiday' in August 1872, echoes a similar chord (Figure 33). Awe-struck and deferential, the family is represented as a unified yet socially separate grouping in a space normally reserved for fashionable women, retired sea dogs and the more educated middle class.

A further context for Ruskin's British Institution lecture was the 1863 *Report* of the Commission appointed to inquire 'into the present position of the Royal

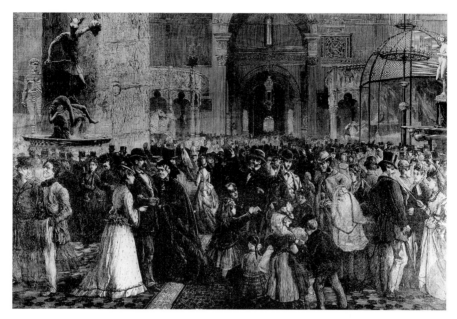

31 'The South Kensington Museum on a Whit Monday', *The Graphic*, 3 June 1871.

Academy in relation to the Fine Arts' in view of widespread concern at the rigidity of the selection procedure at the Summer Exhibitions, admission prices, lack of space, and declining public respect.[39] A yet further context was the debate leading to the 1867 Reform Act, in which the spirit of social improvement was rising and in which the question of cultural philanthopy was a vital minor theme. Passed into law in late 1867, the Act gave an extended franchise to the working class and endowed the trades unions with more rights than even they had expected to gain. The idea of extending the art museum physically to the farthest reaches of the city was certainly an active one in the wake of the 1867 Act (in practice the National Gallery was extended in Trafalgar Square by E.M. Barry in 1876). In his British Institution lecture Ruskin had not only proposed two types of museum, but had said 'I heartily wish that there were already, as one day there must be, large educational museums in every district of London freely open every day, and well-lighted and warmed at night, with all furniture of comfort, and full aids for the use of their contents by all classes'.[40] He may have known that the idea was already being explored by Cole, who at the very same time was considering how to extend the cultural franchise to another part of the city and to rid himself of the Brompton Boilers and various supernumerary collections into the bargain. In 1865 Cole had offered the moveable iron boilers to any local authority in the north, south or east of the city that would take them as a basis for a local museum. Only in the impoverished East End had the offer been taken up: a group of enthusiasts led by the founder of the Plaistow and Victoria Docks Mission, Sir Antonio Brady, and the leader of the parish vestry of nearby St John's Church, the Revd Septimus

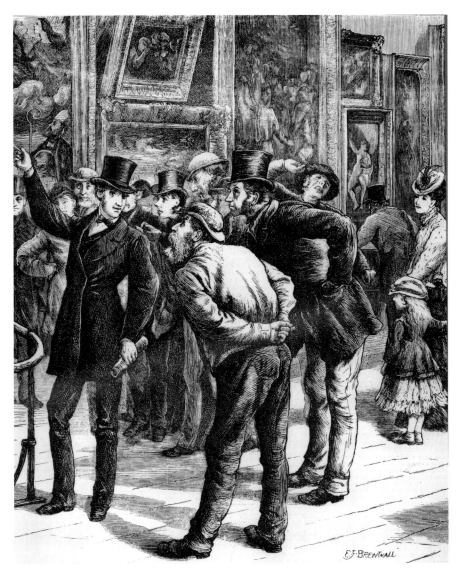

32 E. J. Brewtnall, 'A Party of Working Men at the National Gallery', *The Graphic Supplement*, 6 August 1870.

Hansard, and two local brewing firms (Messrs Truman, Hanbury, Buxton and Co., and Messrs Charrington) organised a subscription and bought a piece of land previously held in trust for the poor at the junction of Bethnal Green Road and Cambridge Road. It has been alleged that the first motive of the subscribers was to buy the land to ensure the open-space requirements of a nearby asylum (then in danger of losing its license).[41] The 'Brompton Boilers' were dismantled and re-erected there in 1868, leaving space at South Kensington for a new building.

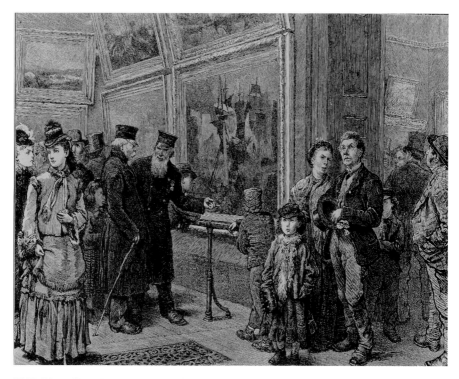

33 'Holiday Folks at the National Gallery', *The Graphic Supplement*, 3 August 1872.

From Whitechapel to the Peckham Road

The East London Museum was a rare attempt by a department of state to provide culture specifically for the working class largely independently of private philanthropy. Cole's first idea had been to provide a building and leave the running of it to local people – a parliamentary answer in early 1872 still referred to an exhibition 'able to minister to the social and intellectual needs of the East End population'. An architectural scheme for the front of the Museum, designed by J. W. Wild and comprising a cloister, clocktower and other buildings in addition to the transplanted boilers never came to fruition (Figure 34). Local grievances over a long-running series of 'broken promises' were widely and vociferously expressed. Shortly before the opening on 24 June 1872 the *Hackney Express and Shoreditch Observer*, complaining that 'East London is snubbed in everything', pointed out that the 'temple of Fine Arts in the East' had been delayed several years, and that the promise of an opening by the Queen herself would not be forthcoming. There was no evidence of the library and lecture room originally planned.[42] The laying out of the Green as a public gardens was not carried out – a letter by Septimus Hansard to *The Times* two years later still referred to an accumulation of 'old hats, old shoes, dirty pieces of paper, dead cats, old pipes, rags, brickbats, and other

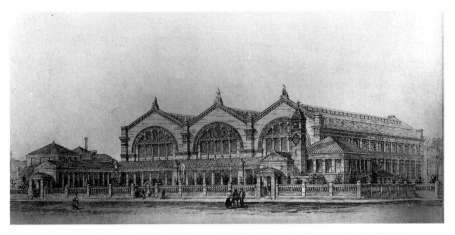

34 J. W. Wild, design for Bethnal Green Museum, showing cloister, clocktower and other buildings.

rubbish ... alongside a national museum containing one of the finest collections of pictures in the world'.[43]

Yet misgivings largely evaporated for the opening itself, characterised by an outburst of popular patriotic and monarchist sentiment for the the Prince and Princess of Wales – later to become King Edward VII and Queen Alexandria – on their first visit to the East End (Figure 35). A lavish programme of processions,

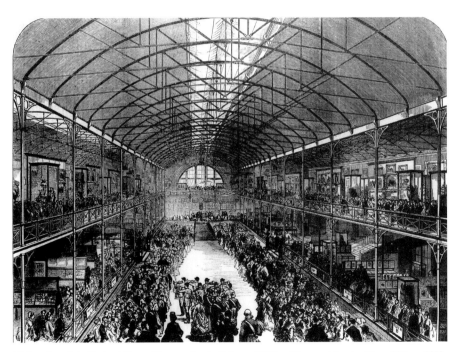

35 Opening of the Bethnal Green Museum by the Prince of Wales, *Illustrated London News*, 29 June 1872.

music and speeches was laid on.[44] Banners adorned the streets bearing the words
'Though At the East, Your Welcome's Not Least', 'Long Wished For Come At
Last' or 'Boots and Shoes Fit for the Prince and Princess at Democratic Prices' –
a reference to the democracy movement then under way in some parts of the East
End.[45] It is interesting to observe how relations between the East End working class
and the spectacle of Royalty revolved around a limited number of stereotypes in
the press of the day. The image of East London as a productive beehive proved
popular at local and national level. The opening verses of an 'Ode' composed for
the occasion –

> Welcome, welcome glorious Prince,
> Restored to health and glee,
> Happy are the worker bees,
> Thy beamy face to see.
> 'Tis seldom that a passing gleam
> Of sunshine gilds their toil,
> Then doubly glad they are to meet
> The Prince of Wales's smile.
>
> Thanks, gracious Prince for kindly gifts,
> Bee workers highly prize
> Altho' they have but little time
> For mental exercise.
> All love and venerate the Queen
> And hope she will 'some day'
> Visit the Park and Museum,
> E'er time it whiles away.[46]

– suggest a dewy-eyed subservience that was part ritual, part loyalty to a tradi-
tional hierarchy of class. A description given to the pavement crowds in the *Daily
Telegraph* gave a dystopic and immediately disputed picture of the area in which
the East London Museum was sited:

> That there were thousands on thousands among them whose chronic state of life is
> to be half-starved and half-naked, was only too painfully palpable from their mea-
> gre forms and attenuated lineaments, and from the rags which hung in unseemly
> *logues* about them. Mr Heather Biggs ... might have added a fresh chapter to his
> *Orthopraxis* had he studied the abundant examples of most melancholy deformity
> that were present in the crowd. Whence all those dwarfs and hunchbacks, those crea-
> tures bent double, those crooked and bandy and rickety babes, had come, was a ques-
> tion readily answered by every foul little street, full of shambling hovels, which
> opened away like a muddy rivulet from the broad stream of Shoreditch.[47]

Such writing seemed to glorify in the drama of deprivation. Whatever degree of
truth it contained, the crowds who flocked to the East London Museum were plen-
tiful enough: it attracted 25,557 visitors on the first day and an astonishing 901,464

within the first six months, settling down to about 400,000 per year, helped by evening opening to 10.00 p.m. daily.

The early displays at the Bethnal Green Museum – as it was soon known – form a pattern that was regarded as haphazard, at best. To some, it could be mistaken as a dump for surplus collections from South Kensington which the chaotically expanding Department of Science and Art wanted to dispose of: the Food Collection, the Museum of Economic Entomology, and the Animal Products Collection. In fine art the display was no less extraordinary. General uncertainty about the aesthetic mission of the museum appeared to be resolved when Sir Richard Wallace came forward with a timely offer to lend his superb collection of 709 English, Dutch, Italian, Flemish and French paintings and decorative art left to him by his father the Marquis of Hertford – later to form the Wallace Collection at new premises in Manchester Square. Placed on the spacious upper floor at Bethnal Green, it took up well over half the available display. Transported from Paris and Wallace's London home at the owner's expense for a whole year, extended in the event to three, the collection was described by all observers as a collection of incomparable quality and value. Yet we cannot tell with certainty how Wallace's old masters were seen in the East End – the 'official' art press had no way of investigating the matter that transcended its class interests. While it was noted that local furniture-makers took a keen interest in Wallace's chairs, tables and chaise-longues, the question of the suitability of his European pictures to an audience of artisans and the poor seemed to present a particular problem. The *Art Journal* felt that:

> 'it is not, perhaps, the precise kind of collection that should have been chosen for the locality … for any purpose of educational or moral influence; apart from the mere delight of a holiday, a very different principle of selection should regulate the choice of paintings to be displayed in such a hive of industry.[48]

For the first time the question was the difficult one of centre and periphery: of how the best fruits of high culture, and how much of it, could be taken to the city's fringes (and why). Sir Antonio Brady had envisaged material from the British Museum displayed along Ruskinian principles. A museum, he had said,

> for the improvement of the working classes … must be placed in a neighbourhood accessible to them, and must be open of an evening … it [must] be made *educational in the widest sense of the word*, and convenient and comfortable refreshment rooms [must] be added to the other attractions of the place.[49]

The Prince of Wales had even sounded Ruskinian in his opening speech:

> Whilst strength and solidity, neatness and finish, distinguish every production of the English workman, in the works of taste and art place must be given to his foreign competitor. It is to remedy this disadvantage that branch museums are designed.[50]

Yet the South Kensington plan had produced a jumble of contradictory interests, which the drawing published in *The Graphic* for 19 April 1873 captures with some precision (Figure 36). The image centralises two fellows of openly criminal demeanour lounging inattentively in a space newly created for culture and decency: to *Graphic* readers the contrast between them and those who could properly attend to Wallace's collection, especially the vulnerable female visitors, must have been clear. Patronisingly titled 'Art Connoisseurs at the East End', the illustration also captures a moment when the forces of upper-class philanthropy collide with the confused objectives of the state to ensnare an unfamiliar and still feared population of rogues, vagabonds and idlers within the enclaves of a purportedly 'national' museum. And those contradictions were not about to disappear. Notwithstanding frequent criticism of the museum's role in relation to the educational level and vocational interests of the Bethnal Green population, temporary fine-art displays were regularly held there over the next quarter-century.[51]

Meanwhile the efforts of the Sunday Society to promote Sunday opening had achieved some success – such is the message of 'A Sunday Afternoon in a Picture Gallery' (probably the fashionable Grosvenor Gallery, opened in 1877) (Figure 37), allegedly 'drawn from life' and published in *The Graphic* of 8 February 1879.[52] Here it is once more the lower-class subject under instruction from his betters that is the central motif. The contrast with 'A Sunday Afternoon in a Gin Palace' (also from life) could hardly be clearer (Figure 38): the pub is now a place of darkness, prostitution and poverty, while in the gallery the relationship between the upper-middle and working-class subject is one of sympathy but importantly power. The

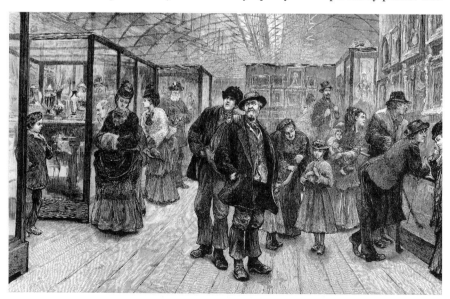

36 'Art Connoisseurs at the East End: A Study at Sir Richard Wallace's Loan Collection in the Bethnal Green Museum', *The Graphic Supplement*, 19 April 1873, pp. 368–9.

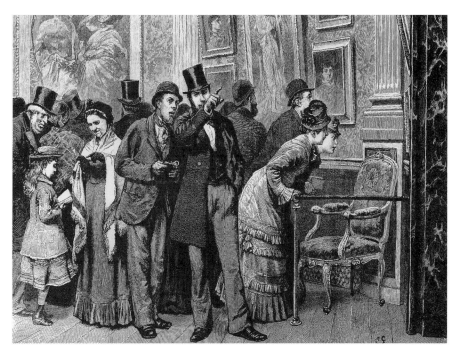

37 'A Sunday Afternoon in a Picture Gallery, Drawn from Life' *The Graphic*, 8 February 1879.

38 'A Sunday Afternoon in a Gin Palace, Drawn from Life', *The Graphic*, 8 February 1879.

image erases resistances and strife: it provides an orderly stereotype of the way in which a knowledgeable yet reforming class was succeeding in the business of leading a whole social stratum away from one set of pleasures towards another.

But if the Bethnal Green Museum in the 1870s was a combination of state (that is, South Kensington) objectives and private money, it was the 1880s which were to prove the real period of private cultural philanthropy in London. Here were numerous private initiatives, based mainly upon subscriptions from wealthy patrons and socially minded reformers, that deserve mention in a book devoted to national and metropolitan policy precisely because they tended to mimic initiatives already taken at the level of the state. For example in 1879 one William Rossiter, possibly a student of Ruskin's at the Great Ormond Street Working Men's College, opened a loan exhibition of contemporary paintings in two rooms of his own South London Working Men's College in Kennington Lane. There is little doubt that the exhibition was successful if measured by the size of the enthusiastic crowd, even though it was unkempt by the standards of the better off.[53] Rossiter's plan was also Ruskinian: his general conviction was that purely monetary gifts may actually feed the degenerate habits of the urban poor, rather than 'cure' them of their culturelessness. Those who underwrote Rossiter's gallery or lent paintings believed that contemporary paintings (more especially the viewing of them) could only induce habits of curiosity and enlightenment to those hitherto familiar with the spaces of the street and the pub.

Similarly, the series of temporary exhibitions put on in St Jude's Schools, Commercial Streeet, Whitechapel, by the colour-blind vicar of St Jude's, Samuel Barnett, and his devoted wife Henrietta, though an essentially local initiative, must be reckoned to stand in significant relation to the larger projects of the national museums and galleries. Certainly the squalid living and working conditions of the East End poor were regarded as fundamentally intractable by the establishment class: 'Few of us ever allow ourselves to dwell upon the life of the countless multitudes of our fellow-creatures who fill the East-End of London [wrote *The Times*]; if we did, we should almost yield to despair at the thought of the iron necessity which hems it in'.[54] For two weeks every spring between 1881 and 1898 the Barnetts contrived a show of paintings which were provided not with aesthetic or historical meanings, but moral and religious ones often running far beyond their visible content.[55] The Barnetts' conviction – also influenced significantly by the writings of John Ruskin – was that paintings and works of art were things of beauty that could be more eloquent than lessons from the pulpit – their watchword 'pictures as preachers' implied that to keep fine paintings in museum basements was something of a sin: 'the brush of the artist may be as inspired as the tongue of the speaker – which creates the tone of mind in which the Love of God and the love of man become possible'.[56] Canon Barnett's shows were primarily designed for East End folk who had neither the time nor money to 'clean themselves and travel to South Kensington, spend an hour in a gallery, return, and get enough sleep before next morning's early rising'.[57] The actual identity of the crowd is hard to

assess. The *Pall Mall Gazette* for 1886 reports 'all sorts and conditions of men, from the West-ender who goes down to see how the common people behave, to the factory girls who couldn't tell you why they go, but for whom the pictures have a strange fascination, and who wander in, evening after evening, when their day's work is done'.[58]

An extensive network of contacts among the great and the good enabled the Barnetts to acquire high-quality late-Victorian British paintings from Leighton, Holman Hunt, Herkomer, Fildes, Holl and other prominent Royal Academicians, to which were added the loan of the occasional Reynolds, Gainsborough, Turner, Canaletto, Rembrandt or Rubens. Aside from senior Academicians, lenders included MPs, the nobility, philanthropists such as Baroness Burdett Coutts or the sugar magnate Henry Tate, and in the Jubilee year of 1887 the Queen herself. Opening speakers of the order of Lord Roseberry, the Archbishop of Canterbury, Holman Hunt and William Morris – the latter delivering a scathing Marxist inter-pretation at the exhibition of 1884[59] – demonstrate that the idea of aleviating urban misery through displays of art had become a fashionable intellectual commitment for the upper-middle classes of the 1880s, no doubt part of what Henrietta Barnett herself meant by calling her exhibitions 'a daring social blending of East and West'.[60] Like Ruskin, the Barnetts believed that the 'guns' of philanthropy did not always hit their targets – dovetailing nicely with a growing consensus on the part of powerful establishment figures that paintings displayed before the East End poor were as likely to unify the social body of a deprived and distant part of the capital as the best-laid government plan. And for cultural professionals, it was the most they could practically do.

Moreover Barnett clearly revelled in the activity of interpreting to the assem-bled crowds the allegorical meanings alleged to be found in suitably selected paint-ings, notably those of Watts and Holman Hunt: 'they were often sermons, those picture talks', Henrietta tells us, 'suggestive sermons, not the dogmatic discourses to which one has often to listen in churches, which have the effect of stirring men-tal contradiction' (Figure 39).[61] Yet Barnett had first to run the gauntlet of the Lord's Day Observance Society who regarded visiting picture exhibitions on a Sunday as sacriligious. He wrote beseechingly to his Bishop:

> Never in my intercourse with my neighbours have I been so conscious of their souls and their souls' needs as when they stood around me listening to what I had to say of Watts' picture *Time, Death and Judgement* ... I cannot think that you would say it is better, for the value of old Sunday associations, to keep the people amid the paral-ysis and degrading sights of our streets, than to bring them within view of the good and perfect gifts of God.[62]

The Bishop consented, and for the best part of the 1880s and 1890s the St Jude's springtime exhibitions were open throughout the week, with free entry (from 1882) and evening opening until 10 p.m. In tandem with the Barnetts' other ini-tiative at nearby Toynbee Hall, a settlement for male graduates of Oxford and

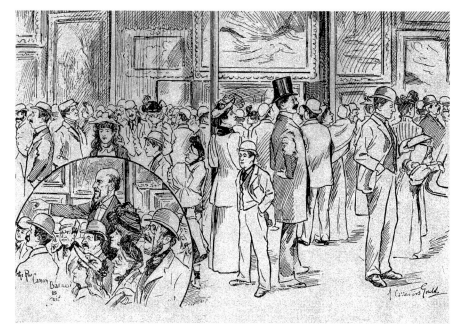

39 'Sunday Afternoon in the Whitechapel Picture Gallery', from Henrietta Barnett, *Canon Barnett, His Life, Work and Friends*, vol. II.

Cambridge which became a centre of social-welfare activity in East London, and their efforts in opening free libraries and subsidized housing in East London, the St Jude's exhibitions were designed to supplant the residual culture of pubs and music-hall entertainment for the working poor, and to forge a social coalition based on a shared agenda of education, literacy and Christian faith. Blending recreation with education, the fractured class relations of late Victorian London could in theory be restored. The selected paintings would also help define a body of British art that was exemplary in expressing 'the nation' at a time when discussion of a national gallery of British art was once again rife.[63]

This combination of Ruskinian visual education, Christian interpretation and national artistic tradition promised a very different socio-cultural programme from that of the 1836 *Report* or from Cole's South Kensington hierarchy. Yet the Whitechapel idea of an essentially religious education through the experience of art was widely copied in several parts of London and the provinces in the closing years of the century: at the Horsfall Museum (later Ancoats Hall), Manchester from 1884; at another gallery orchestrated by Rossiter that migrated through South London and ended up in the Peckham Road, Camberwell, from 1887; and at the People's Palace, again in the East End, from 1888. [64] Comparable exhibitions took place in the Public Hall at Canning Town, the 1896 exhibition being opened by Walter Crane who called for a redistribution of wealth and education in the name of Socialism:

> Art should not be regarded … as a luxury – as something outside our lives – but as something which should enter into the education of the people. Why should not the schools be painted with typical scenes of our own history, with portraits of our greatest men, with incidents in the lives of the people, with typical incidents of the struggle of the people for freedom, and so on?

The beauty of England should not be put aside for money-getting, Crane said; he would rather have 'art than armaments'.[65] Lord Herschell, opening the Whitechapel exhibition of that year, said 'there was never a time when all workers needed more the refreshment which art could bring'.[66]

The relationship between these local initiatives and the 'national' cultural institutions of the metropolis is at least partially clear. Cole had had at his command the full resources of the state, even if his art collections came from private gifts; Rossiter and the Barnetts were philanthropic private managers with strong social ties to a cultured social elite and even to monarchy – but they had no resources other than those they could assemble themselves. And if Rossiter wanted his gallery to be 'the National Gallery of South London … where the daily lives of the people most need such refreshment, and where the great artisan class, whose work beautifies the wealthier part of the metropolis, live with so little beauty either natural or derived from art',[67] and even if its new exhibition room was opened in 1893 by a national figurehead in the person of the Prince of Wales, its major inspiration remained Ruskin's idea of a local gallery for the education of the local mass.[68]

The order of government in London continued to support such a separation of powers. Like the new Whitechapel Art Gallery which in 1901 became the natural successor to the Barnetts' exhibitions in the East End, Rossiter's gallery eventually became the responsibility of a particular London borough and was never fully integrated into a reformed South Kensington system or made an outpost of the National Gallery in Trafalgar Square. And they were spaces for temporary exhibitions rather than repositories of permanent works. Rossiter's South London Art Gallery (now the South London Gallery) was taken over successively by the Metropolitan Borough of Camberwell and later the London Borough of Southwark. The Whitechapel Art Gallery, designed by C. Harrison Townsend on a site next to the public library in Whitechapel High Street under the aegis of a board of Trustees appointed by the Charity Commissioners, was in 1901 subsumed by the London Borough of Stepney, and under its first director Charles Aitken put on shows of Dutch, Spanish, Italian, Scottish, French, Chinese, Japanese, Indian, Turkish and Egyptian art, and of works by Cornish artists, Essex artists, Liverpool artists and others.[69] With the benefits of improved transport from other parts of the city the Whitechapel attracted some three million visitors over the period (sometimes as many as 16,000 per day), indicating an audience of local visitors mixed with a growing army of art enthusiasts from the middle class. The quickly changing place of art in Edwardian life also suggests that the Whitechapel became absorbed into a metropolitan pattern of museum-visiting as well as functioning

purely as an East End gallery. Yet the London local authorities (as they eventually became) could by definition not originate 'national' institions on their own, and in that sense the Whitechapel continued (as it began) as an essentially local but well-connected venue, a focus for philanthropic culture as well as a metropolitan gallery in its own right.

The Gallery of National Portraits

Mention must also be made of an institution which became 'national' in two senses between its founding in 1859 and its arrival in its permanent home in St Martin's Place in 1896. For a nation in command of the largest manufacturing base on earth and a growing colonial empire, it was almost inevitable that British traditions and personages should become a subject of investigation and popular mythology, and that attempts to historicize the nation would be underwritten by a succession of publications aimed at fixing the character of the nation's heroes and chronicling their exemplary deeds. Indeed, in the last three decades of the nineteenth century a sense of the nation's history passed from historians and antiquarians to a far wider public as the habit of reading and education grew. From writings by Carlyle in the 1840s to Macaulay's *The History of England from the Accession of James II*, published between 1848 and 1861, from Charles Dickens' *A Child's History of England* of 1851–53 or J. A. Froude's 12-volume *History of England from the Fall of Wolsey to the Death of Elizabeth* of 1856–70 to Seeley's *Expansion of England* of 1883, England as a nation with a particular past and a particular culture became at least a sharable if not always a shared ideal. A popularising work such as J. R. Green's *A Short History of the English People*, which, despite its title, ran to three volumes and almost 2,000 pages, defined the chain of English history and society from the origins of 'the fatherland of the race' in the fifth century to the second Disraeli government of 1874, complete with illustrations of English treasures, coinage, genre scenes, politicians and royalty, tables of genealogy, chronologies, and explanations of the composition of the Union Jack.

Later Victorian painters such as William Frederick Yeames or John Seymour Lucas would attempt to embody on canvas the events of that national culture, most of them imaginary in terms of detail or setting, while other artists narrativized events as they were known or were believed to have occurred.[70] But earlier in the century, where historical knowledge of the character or physiognomy of actual people was concerned, the discussion had entered the difficult territory of the true definition of 'art'; yet in the making was an institution devoted to paintings or sculptures which had a claim to being 'national' in the sense of being defined by the identity of the sitter in addition to that of the artist alone.[71]

A Commons debate on 27 June 1845 had seen Thomas Wyse, member of the 1836 Select Committee and a notable Irish reformer, press for a 'Museum of National Antiquities … for the presentation of those monuments and specimens, either of skill or feeling, which characterised the arts and history of this country'.[72]

Referring to it later in his speech as a 'Museum of National Art', Wyse said he 'knew of more than one gentleman who would willingly present their collections to the public, if the Government would make them accessible, by providing a place in which they might be deposited'[73] – a formula for combining the resources of private and state power that had been in use since the 1740s. A comparable sugestion was made in the same debate by the antiquarian Viscount Mahon, who proposed a collection of 'portraits of eminent men distinguished in the history of this country ... [which] might exercise a most beneficial influence upoun the rising generation'.[74] Mahon must have known of the British Institution exhibition of 1820, displaying 183 portraits of 'Distinguished Persons in the History and Literature of the United Kingdom', for which the importance of the sitter rather than the artist had been the criterion employed; and as an antiquarian he must have known Noel Desenfans' early plan 'to preserve among us, and transmit to posterity, the portraits of the most distinguished characters of England, Scotland and Ireland' since the beginning of the reign of George III in 1760.[75] Wyse's proposal was turned down. Mahon's intervention was also ignored. He had to wait until the tide of concern for national definition was running high in the wake of 1851; hence on 4 June 1852 he raised the possibility of 'the gradual formation of a gallery of national historical portraits ... No one who had visited Versailles [Mahon said in the Commons] could have failed to admire, amidst a large collection of gorgeous modern paintings, one gallery in which were deposited original portraits of many of the most illustrious men whom France had produced'.[76] Correspondence on the desirability of a national portrait gallery between Thomes Carlyle and the Scottish antiquarian David Laing was reported and discussed in the *Athenaeum* in 1855. But in the election of that year Mahon lost his seat in the Commons; and in the Lords on 4 March 1856, by now Earl Stanhope, he made a much lengthier and more effective speech urging the formation of a collection of historical portraits from the thirteenth century onwards in order to 'afford, not only great pleasure, but much instruction to the industrious classes' as well as a 'boon to men of letters'. The gallery would be historical and documentary, rather than art. Stanhope quoted one of Carlyle's letters:

> 'in all my poor historical investigation it has been, and always is, one of the most primary wants to procure a bodily likeness of the personage inquired after – a good portrait, if such exits ... Often I have found a portrait superior in real instruction to half-a-dozen biographies; or rather, let me say, I have found that the portrait was as a small lighted candle, by which the biographies could for the first time be read'.[77]

Carlyle's emphasis on 'instruction' betrays not merely the fact that he conceived of history as the biographies predominantly of great men, but that he personally valued authentic documentary images over all other genres and indeed took the position that 'historical portrait galleries far transcend in worth all other kinds of national collections of pictures whatever'.[78] But Stanhope's pleas went further in the direction of defining the best portraiture as art: his first argument was that a

gallery of 'men honourably distinguished in war, in statesmanship, in art or science' would be justified instrumentally as an 'incitement to honourable exertion'. He quoted the influential Sir Charles Eastlake, at that time both President of the Royal Academy and first Director of the National Gallery, to the effect that 'authentic likenesses' be collected 'not necessarily with reference to their merit as works of art' but that they 'would be useful ... as a not unimportant element of education';[79] at the same time adding that a gallery of national portraits would promote 'Art' by enabling portrait painters 'to soar above the mere attempt at producing a likeness, and to give that higher tone which was essential to maintaining the true dignity of portrait painting as an art', ending his speech with the argument that the fine arts 'were to be ranked not merely among the ornaments of human life, but among the appointed means for the elevation and improvement of the human mind'.[80] The Earl of Ellenborough, responding, insisted that bishops and judges be included too; and that the aesthetic merits of the pictures were irrelevant. The Fine Arts Commission could have no place in the scheme; 'it is not a question of fine arts at all; it is a question of great men, not of great pictures'.[81]

That antithesis set the terms for a debate on the status of a portrait gallery that not only inflected all subsequent definitions of its functions and its likely public, but the types of responses that such a public would be encouraged to make. Three months later, in the Commons, Palmerston was eloquently defining the concept:

> I am sure it will afford to the people of this country the greatest satisfaction to see the features, to become acquainted with the countenances, of men whose actions had excited their interest when reading the history of former times ... There cannot, I feel convinced, be a greater incentive to mental exertion, to noble action, to good conduct on the part of the living, than for them to see before them the features of those who have done things which are worthy of our admiration, and whose example we are more induced to imitate when they are brought before us in the visible and tangible shape of portraits'.[82]

The Gallery's first Secretary and Keeper, George Scharf, a self-educated immigrant who had aspirations as an antiquarian and had been Art Secretary and Director of the Gallery of Old Masters and Sculpture at the Manchester Art Treasures exhibition of 1857, was by December of the same year in residence at the Gallery's first and temporary home at 29 Great George Street, Westminster, close to the heart of the nation's power and in that sense lending itself to functioning as an emblem of approved British history. The Gallery's regulations were that its Trustees would 'look for the celebrity of the person represented rather than to the merit of the artist ... without any bias to any political or religious party'[83] and without consideration of 'great faults and errors' as grounds for rejecting a portrait deemed otherwise historically valuable. By 1859 the Gallery had been thrown open to the public on Wednesdays and Saturdays to those with tickets purchased in advance, and, as at South Kensington, reports on visitors' behaviour were reassuringly good.[84]

The accommodation was very cramped, the pictures being 'crowded closely together … consigned to some narrow passage, some unsightly corner, or some dark recess'[85] and threatened by damage from the exterior smoke. Scharf informed the Trustees that due to the 'narrowness and inconvenience … of the apartments' the Gallery was 'debarred from all attempts at arrangement or classification of the present pictures, and from all power to place them in favourable light … nothing now remains for the accommodation of future acquisitions but the dark and very limited wall-space of the hall … immediately connected with street-door'.[86]

Between 1866 and 1868 a series of chronological loan exhibitions from the collection were mounted at the South Kensington Museum through the agency of Richard Redgrave, and by 1870 the National Portrait Gallery was transferred from Westminster to the South Kensington Museum, where admissions almost doubled to the relatively small figure of some 60,000 per year.[87] Scharf's own watercolour of one of the rooms shows a helmeted warder sitting alone amongst the Elizabethan portraits (Plate 8). The collection's subsequent move in 1885 to the upper floor of the Bethnal Green Museum (Figure 40), partly occasioned by two incidents of fire in nearby buildings at South Kensington, was deemed by several commentators to be less than a total success. Carlyle's ideal viewers had after all been 'students and readers of history'. Stanhope himself had hoped for easy recognition of all the

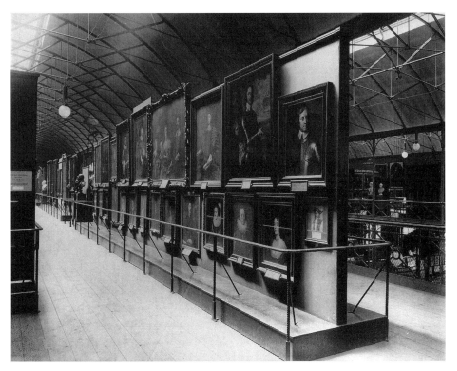

40 The National Portrait Gallery at Bethnal Green, after 1885, photograph by Emery Walker showing seventeenth century portraits.

sitters' names by 'a man of good education'[88] – and the Bethnal Green audience
comprised few enough of these. Furthermore Stanhope's opponents in the
Commons in 1856 had suggested that taxes levied upon the working classes ought
not be used to found a gallery 'for the gratification of the taste of the higher
classes'.[89] A report on the portraits in their new Bethnal Green home – probably
written by Scharf himself – complained that the collection was now

> as much out of reach of the general public, and especially of the student, as if it had
> been transferred to Kamtchatka, and where it affords no attraction whatever to the
> surrounding population. The Galleries which contain it are usually, of a day,
> absolutely empty, and the annual returns of the visitors to the Museum show they
> have not increased since its removal.[90]

By this time, however, the balance between aesthetic and documentary interest in
the acquisition of portraits was slowly shifting, though not with much consistency.
The antiquarian Stanhope was replaced as Chairman of the Gallery Trustees in
1876 by Viscount Hardinge, who was sensitive to aesthetic merit and often intro-
duced aesthetic criteria into discussion of new acquisitions. And yet the impor-
tance now attached to the authentication of works of art meant that antiquarian
attitudes were increasingly shared across the art–portraiture divide.[91] Thirdly,
more important paintings by more important artists came on to the market in the
1880s and 1890s (especially following the Settled Lands Act 1882) which exacer-
bated, without resolving, the dilemma of the aesthetic dimension of the portrait.
In practice, nevertheless, such works were priced well above the power of the
Gallery to purchase them, and the central criterion remained that of historical
rather than artistic validity. As late as 1888 Scharf was giving voice to the tradi-
tional view that

> artistic merit is no merit for the admission of the portrait into the National Portrait
> Gallery … what is required is, that it should be authentic, and that it gives a fair rep-
> resentation, as far as can be ascertained, of the features of the original … The visi-
> tor must recollect that it does not claim his attention as a collection of works of art,
> but that it is strictly what it purports to be – a collection of portraits, the best, and
> frequently the only ones that can be obtained, of Englishmen and Englishwomen,
> who are in any way distinguished in the annals of their country, or whose like-
> nesses … may be of interest to any class of the public'.[92]

– notice how the inclusion of eminent women was also on the agenda. Scharf him-
self retained his earlier belief that mixing up portraits with the fine pictures in the
National Gallery would be erroneous, which helps to explain the context in which,
when W. H. Alexander in 1889 offered £80,000 towards the cost of a new Gallery,
the question of its physical relation to the National Gallery became paramount.
Alexander himself remains a shadowy figure. A Hampshire man, he had inherited
from John Thurloe (Cromwell's secretary) considerable lands in Kensington and
specified that the government should provide land for the Gallery within one and

a half miles of St James's Street; further, that the little-known church architect
Ewan Christian should produce the design. Christian's impressive palazzo on the
north-east corner of the National Gallery site facing St Martin's Place is signifi-
cantly both connected to and distinct from the latter building. Notwithstanding
its Italianate style to the north, Christian took the utmost care to blend the new
Gallery to the Wilkins building on the eastern facade, seen here in a picturesque
guidebook photo of the later 1890s (Figure 41). Yet for the inside, the brief pre-
pared for Christian by George Scharf stated unequivocally: 'No communication
whatsoever to exist between the National Gallery and the National Portrait
Gallery. Very solid walls will be required to separate them'.[93] To this day they
remain neighbouring, but separate institutions.

For these reasons the projected audiences for the two galleries towards the end
of the nineteenth century were difficult to prise apart – even though 'fine art' was
intended to appeal to cultural appetites while the national portraits claimed an
audience mainly of historians, biographers and antiquarians. The significance of
the date of the opening, Saturday 4 April 1896, was that the following day, 5 April,
was the first Sunday opening officially sanctioned for all the museums of the
metropolis, and the National Portrait Gallery's newly appointed Director Lionel
Cust was keen to see the crowds, even to forego an opening ceremony to do so.[94]

In St Martin's Place in 1896, then, was an attempt to make good Stanhope's
original idea of English life and history instanced by eminent men of the 'civil,
ecclesiastical or literary history of the country',[95] augmented by some women, now

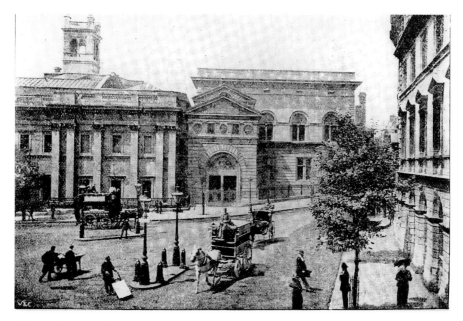

41 National Portrait Gallery from St Martin's Place, c. 1896, from *A Popular and Pictorial Guide to
London*, Ward Lock and Co, London, 1898, p. 88.

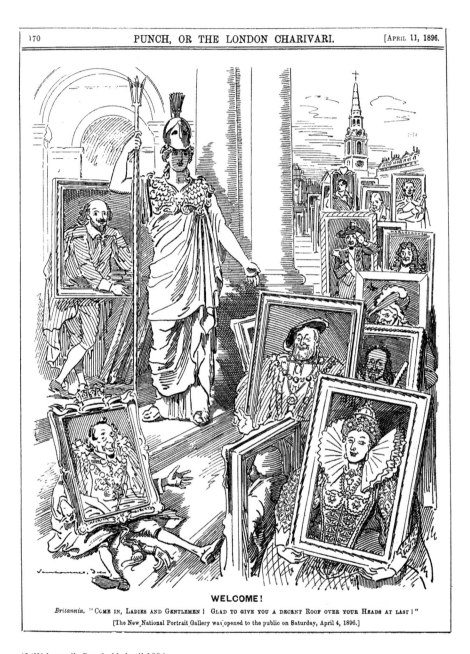

42 'Welcome!', *Punch*, 11 April 1896.

arranged in succession through the ages and conveying information about the physiognomy and character of the sitter – the very idea of verisimilitude is exploited in a *Punch* cartoon which merges sitters with their portraits as if the individuals were still alive (Figure 42). That such an institution might derive its audience and its habits of attention from the same audience that went to see 'art' nearby was better still. Moreover the idea of a gallery of images of persons deemed important in the history of England was part and parcel of the official formation in late Victorian Britain of a specifically English identity by which it could be distinguished from Scotland and Ireland – the Scottish National Portrait Gallery had opened in 1882, and the National Portrait Gallery Dublin in 1884. The London display gave a view of English history that was historicising and evolutionary, and that gave a sense of national character and progress whose implications for the present age were supposed to be clear: that English (and British) history consisted of the actions of eminent men; that their eminence derived from their actions; and that such a history was largely impermeable by 'foreign' traditions which might disrupt or destabilise it. Towards the end of Victoria's long reign, those sentiments were comforting to some and the idea of a metropolitan audience participating in that national destiny more comforting still. Of course, by 1896 such feelings were from another point of view already out of date. Yet they were celebrated in several other contexts before the century came finally to a close.

A national gallery of British art:
the Millbank Tate

THE IDEA OF A NATIONAL GALLERY OF BRITISH ART first found practical expression at the South Kensington Museum in 1857 – an institution which stemmed directly from the Great Exhibition of 1851. The efforts of Cole and Redgrave to establish a specifically national collection of pictures had distinguished the South Kensington Museum in both content and purpose from the National Gallery in Trafalgar Square: the former was to be popular and educational, the latter was to be elevated and selective. The Gallery of National Portraits, meanwhile, installed in a private house in Westminster and then shunted unceremoniously to South Kensington, to Bethnal Green and then back again to St Martin's Place, had likewise been an expression of a mounting concern to define a British cultural identity in the last half of the nineteenth century, and to prepare a public in an understanding of British history through an experience of visual images of its eminent (and mostly male) personnel.

The spread of museums and art galleries throughout the country from the 1850s was phenomenal. The Act for Encouraging the Establishment of Museums in Large Towns (1845) (8 & 9 Vict., c. 43) and the Public Libraries Act (1850) (13 & 14 Vict., c. 65) had stimulated the building of museums in towns of more than 10,000, with free access and financed by a halfpenny rate. At first these institutions contained objects of natural science and design. Galleries devoted to art (much of it British) soon followed, sometimes combined with art schools or museums: at Exeter in 1865, Brighton in 1873, Nottingham in 1876, Liverpool in 1877, Wolverhampton in 1884, Birmingham and Aberdeen in 1885, Sheffield in 1887, Leeds in 1888, Preston in 1893, Norwich in 1894 and several more.

The rapid historicising of 'Britain', combined with an almost unquestioned belief in the efficacy of picture galleries, must be part of the explanation for the offer made by the sugar magnate Henry Tate in 1889 to donate his 'contemporary' British pictures to the nation to found a permanent display separate from the now sprawling complex at the South Kensington Museum. And yet the opening of the National Gallery of British Art in London in 1897 belongs to a wider context of declining imperialism and the beginning of the end of the old European order that would eventuate in the war of 1914.

The 'nation' was after all subject to competing descriptions in the later years of Victoria's reign. In one image – that, roughly, presented to itself by the patrician, gentry and educated upper-middle classes – Britain had for a time been a nation at the height of its industrial and military powers, capable of virtually immeasurable 'progress' at home and abroad. Even today the picture is often presented of a nation basking in the sunshine of her conquests and effortlessly mastering whole regions of Africa and the wider world with a combination of military and diplomatic prowess resting on stable government and efficient manufacture at home.[1] But for those active in urban reform there were two further images: of a nation beset by declining trade and a crumbling urban fabric, and of a government trapped in interminable debate over home rule for Ireland – multiple signs of the fragility of the concepts of nation and empire alike. Although incomes for the larger middle class were rising, and although evidence from the aftermath of the 1880 dock strike was that unionisation could lead to the formation of a self-restraining and self-regulating working class, the trade slump of the mid-1880s and the ensuing riots in London had rung alarm bells of revolution for some. The poor were giving rise to continued concern in regard to housing, education and pay.[2]

Continuing imperialist adventures abroad helped distract attention from the social problems of the cities at home; yet the empire – by the late 1890s totalling some 370 million people across the globe – was showing signs of internal weakness and even of collapse. The outbreak of the Boer War in 1899 was a sign of that instability just as it also offered a momentary rise in popular imperialist sentiment; but it was a sign of ambition exceeded nonetheless, and can be set aside the mood of Joseph Conrad's *Heart of Darkness*, serialised in *Blackwood's Magazine* from February to April 1899, or Kipling's slightly earlier poem 'Recessional', which mixed pride in nation and empire with gloom at its excessive grandiosity and pomp:

> For heathen heart that puts her trust
> In reeking tube and iron shard
> All valiant dust that builds on dust
> And guarding, calls not Thee to guard
> For frantic boast and foolish word –
> Thy Mercy on Thy People, Lord!

More significant still, the poem was published in *The Times* at the end of the celebrations marking the Diamond Jubilee of the Queen in 1897. Jubilee Day itself, 22 June, had been the most lavish demonstration yet of national and imperial pride, replete with a panoply of Empire dignitaries in London and a host of celebrations of Britain's naval, military and industrial prowess round the country. 'We've been blowing up the Trumpets of the New Moon a little too much for White Men', Kipling wrote at the time.[3] As 'Recessional' had it, ' … all our pomp of yesterday / Is one with Nineveh and Tyre!' The occasion can be aptly described as one of triumph mixed with incipient decline. The British people were still 'Thy People' in the eyes of God; yet the flag-waving and trumpet-blowing were seeming hollow.

Kipling's poem was published on Saturday, 17 July 1897. It was the following Wednesday that another symbol of nationhood, the National Gallery of British Art at Millbank, was opened by the Prince of Wales.[4]

Henry Tate and his background

Little is known about Henry Tate as a person. He is described in one account as an undemonstrative, shy individual 'whose preference was to remain in the background'.[5] Posthumous biographies written under the aegis of the sugar firm of Tate and Lyle Ltd give a glowing account of his ability to bridge the gap between classes. One, published in 1960, tells us that

> He had lived in an age impressive in its greatness at one end of the scale, and remarkable in its squalor at the other. He had seen the rise of a great industrial middle class, of which he himself was a notable member – but never forgot the deficiencies of the social system of his youth. Secular and religious education, and the physical welfare of the mass of people less fortunate than himself, was his chief concern … There was nothing haphazard about his giving. It was carefully thought out, and designed to do the greatest good to the greatest number. It was an investment in people, and the dividend was measured in the number of doors opened into new worlds, and in the happiness of cultural pursuits'.[6]

Another, commenting upon the arduous obligations of wealth, proposes that

> these obligations were recognised by Tate, and he endeavoured to fulfill his part by repaying the nation in some measure for the success that he had been able to achieve … Tate's sympathies were broad and human. His interest in the institutions which his wealth created or assisted was not an academic one but based on a positive understanding of the needs of his fellow man … His mind was forward-looking and progressive in the best senses … his long life, but for 12 months, coincided with that of Queen Victoria. Rarely is it given to a man to see such changes in the social life of the nation over such a long period and yet to contribute so largely to its future welfare. His interests were maintained to the end, and he never seems to have lost his robust enthusiasm for the adventure of learning.[7]

Clearly he combined a talent for business with a keen sense of duty in the cultural sphere. It was in Liverpool that he started work as a grocer in 1832 at the age of 13. We find him owning his own business by the age of 20, that is, by 1839. Fifteen years later he was running six shops on modern chain-store methods and had initiated the use of the cash register, allegedly for the first time in England.[8] By 1861 he had disposed of his grocery shops, having already entered the sugar-refining business with the firm of Joseph Wright and Co. in 1859, reliant upon poorly paid labour forces in Liverpool and the West Indies.[9] In 1876 he patented a method for making cube sugar, in preference to crushing, and soon thereafter opened a large refinery in Silvertown in East London on a tide of commercial success, leaving his

sons in charge of the Liverpool part of the business. Installed with his first wife Jane Wignall in a mansion known as Park Hill in Streatham in 1881, Tate soon built extra rooms to house his pictures (Figure 43), which were then thrown open to the public on Sunday afternoons. With his second wife Amy (Tate remarried in 1885, two years after his first wife's death) he began to surround himself with the accoutrements of a cultured metropolitan life. Musical and theatrical events were frequent and fashionably regarded. Prominent Royal Academicians numbered themselves among the Tate's friends, particularly Sir John Millais, Sir Frederick Leighton and George Frederick Watts – and it was from the Academy that the overwhelming majority of Tate's pictures were purchased. Tate developed the custom of holding a dinner on the eve of the Royal Academy show each year, which was reckoned second only to the Academy banquet itself. There is a portrait of Tate by Hubert von Herkomer painted towards the end of Tate's life which gives a succinct materialisation of the way in which, within a nineteenth-century Academic optic, he wished to be seen: finely attired, benevolent, but by no means grand; handsome, avuncular, but essentially plain. As Herkomer wrote to Mrs Tate as he prepared to visit Park Hill to paint the portrait against the background of Tate's own furnishings and belongings, 'I shall thus ensure that the portrait of Mr Tate will reveal him *as he really is*' (Plate 9).[10]

Like many would-be reformers of the nineteenth century, Tate was a firm Unitarian. Members of this dissenting religious group were generally on the side

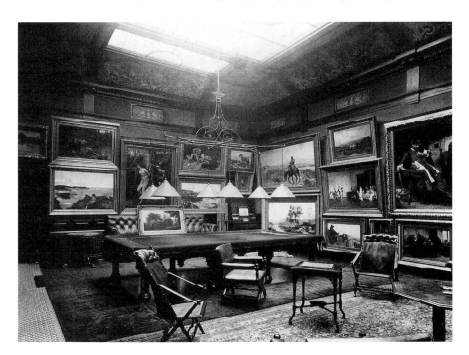

43 Henry Tate's Collection at Park Hill, Streatham (billiard room), c. 1892, photograph.

of social improvement, freedom of expression and non-dogmatic humanitarian improvement, and their names form a roll-call of the good and the great in nineteenth-century parliamentary reform, local government, education and welfare. Stemming from a dissenting religious tradition with origins in the sixteenth century, Unitarianism placed emphasis on active Christianity which elevated fellowship and tolerance into ideals at the expense of scriptural dispute and reliance upon church ritual. In the social sphere it is not difficult to see how Tate's predecessors in industry, particularly Whiggish northerners like William Roscoe or William Rathbone of Liverpool or the Ryland family of Birmingham, provided plentiful examples of benevolent behaviour. He may also have been fired by the social philosophies of John Locke and Jeremy Bentham, two earlier Unitarians whose conviction in the reforming power of education, particularly, could so easily be dovetailed with a claim for the ameliorative powers of art.

Liverpool had been regarded in the early years of the nineteenth century as gravely stricken by poverty, despite its reputation for dynamic commercial networks and mercantile traditions. Tate knew the gifts of the Rathbones and the Hills to that city. However it had been the figure of Roscoe that stood out. Roscoe had been fascinated by the Italian cities of the Renaissance, and by the figure of Lorenzo de Medici, about whom he wrote a book. Liverpool, for Roscoe, was the Florence of his day, a centre of intellectual and artistic activity as vigorous as its trade – hence his eager participation in the setting up of what may have been the first genuinely public art gallery in the country.[11] Tate was naturally also familiar with the foundation of the Walker Art Gallery by Andrew Barclay Walker in 1877.[12]

Tate's first bequests were educational projects, libraries or hospitals, and included the Tate Institute at Silvertown, in 1887, 'for the benefit of the industrious classes of Silvertown and its neighbourhood' on a 'non-political and non-sectarian' basis.[13] Many cultural gifts from industrial and manufacturing profits had been created within the span of Tate's own memory, such as Thomas Holloway's collection of Victorian paintings housed at Holloway College and opened by the Queen in 1886 – the college itself had cost £600,000 and the paintings £85,000.[14] Although himself an industrialist, in many respects Tate's various donations had more in common with those of religiously inspired philanthropists such as Samuel Morley, Joseph Rowntree and George Cadbury, who came to regard philanthopy as a continual obligation rather than an occasion for a single grand gesture. In comparison with Angela Burdett-Coutts' gifts totalling between £3 million and £4 million, Tate's donations were relatively modest.[15]

The collection as a cultural gift

We do not know when the idea of donating his pictures to the nation first arose. Tate must have known of the prestigious private collections of Angerstein, Beaumont and Carr that had formed the basis of the national collection in Trafalgar Square. He surely knew too of previous attempts to establish a 'British'

national collection that included contemporary art: by Vernon (1847) and Sheepshanks (1857). Sheepshanks had specified that his collection become available to the nation on condition that 'a well-lighted and otherwise suitable gallery, to be called "The National Gallery of British Art" shall be ... erected by the British Government'; that the whole should 'have the advantage of undivided responsibility in its management, instead of being subject to the control of any body of trustees or managers'.[16] There had been the examples of Turner's bequest of his own paintings, in 1856; and of Francis Chantrey's bequest of 1840 (it came into effect upon his wife's death in 1876) to form a 'Public National Collection of British Fine Art ... executed within the shores of Great Britain'.[17] The benefit of a gallery of national art had been urged periodically ever since, most recently by the landscape painter James Orrock at the Royal Society of Arts, who was supported by many correspondents to *The Times*.[18]

Tate's collection had been formed largely from successive Royal Academy exhibitions and, given the opportunites for purchase in the 1880s and Tate's lack of experience of France and the rest of Europe, it was a various and in many ways a fine one – certainly much admired by those who visited Park Hill on Sunday afternoons. Tate's Unitarianism had instilled in him a desire for both the social good and fine art; hence perhaps his purchase of Luke Fildes' *The Doctor* (exhibited at the Royal Academy in 1891) or Thomas Kennington's *Orphans* (1885), which evoke sympathy for the suffering of children as well as for wider conditions of deprivation and sorrow. There is a group of pictures dealing with mother–offspring relationships, which through their naturalistic technique and their simple narrative portrayal of longing, memory, comfort or loss, echo a range of emotions which the contemporary observer could find in him or herself with ease: James Hook's *Home with the Tide* (1880), Edwin Douglas's *Alderneys (Mother and Daughter)* (1875) (Figure 44), William Orchardson's *Her Mother's Voice* (exhibited 1888), Henry Davis's *Mother and Son* (1881) and Thomas Faed's *The Highland Mother*. The fact that these paintings evoke sentiments of familial relationships through metaphorical equivalents in the animal world is just one technique of a genre that by the 1880s and 1890s had become a familiar one, even if such works were soon to fall under the stern judgement of the *Burlington Magazine*'s first editorial in 1903 as 'cheap substitutes for thought and feeling [which emit] the odour of false sentiment'.[19]

That indictment itself raises the question of how to describe Tate's collection as it seemed, not to later dissenters, but to the taste which admired and supported it at the time. Tate was evidently not impressed – even if he knew of them – by 'modernist' developments such as Beardsley or Whistler in Britain, or by Impressionism or Post-Impressionism in France. The most general technical character of the works he admired was a high-polish illusionistic naturalism that sought to dissemble the qualities of the medium and its surface in preference for pictorial illusions of moral situations and scenes. The virtues of naturalism run strongly through later Victorian art criticism: it was consistently seen as supplying historical data and

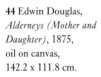

44 Edwin Douglas,
Alderneys (Mother and Daughter), 1875,
oil on canvas,
142.2 x 111.8 cm.

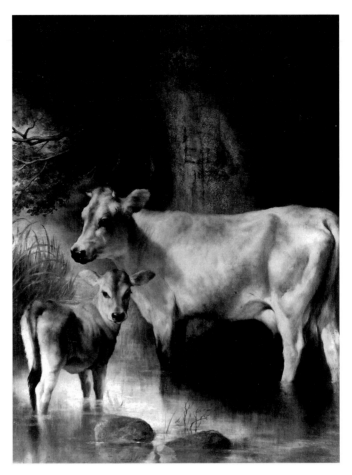

contemporary situations that could appeal directly to the experience and feelings of the observer. As Caroline Arscott has argued, materials could be evoked in all their richness and diversity in this late Victorian style, situations of domestic or historical significance could be recreated without difficulty and within a recognisable code of conventions, and a variety of moral, religious and social messages could be conveyed in a serious and sometimes entertaining way; 'through naturalism it was possible to reproduce the actual'.[20]

But it was Unitarian non-conformism and a belief in the toleration of difference, above all, that accounts for the content of Tate's collection as well as for the purposes he designed for it. For here was no narrow emphasis on a singular school or style: the collection embraced a wide spectrum of English paintings and sculptures of the day, from Millais to Dicksee, from Orchardson to Burne-Jones, from Frank Holl to Waterhouse, from Albert Moore to Stanhope Forbes, to Erskine Nicol, Briton Rivière, Dendy Sadler (Figure 45) and many more. It is significant too that the majority of Tate's works were 'contemporary', that is, resonant of the

concerns of his time and executed in styles that could evoke responses and sym-
pathies across a wide social group. Despite barbed criticism of some of his lesser
pictures in the periodical and newspaper press, the number of major (and expen-
sive) works by leading Academicians, either of Tate's generation or younger, could
be seen by both Whitehall and the artistic lobby that supported Tate's project as
legitimating his implied claim to have a substantial and valuable artistic legacy to
bequeath. But what Tate's collection served to express above all is the belief that
modern English men (and a few women) could provide the terms of an energetic
and purposeful humanitarian culture that need owe nothing to the examples of for-
eigners or the past – the real meaning of what is today perceived as a narrow nation-
alism in painting and sculpture but what in the 1870s and 1880s could be claimed
to underpin the tacit belief of English Unitarians everywhere, that they consituted
a kind of social and cultural 'vanguard of the age'.[21]

Yet the present case is complicated by the fact that the giver was not possessed
of explicit educational motives such as were the Barnetts in Whitechapel or the
Rossiters in Camberwell; nor, by the terms of his gift, was Tate capable of fully
determining the geography or the final arrangement of his collection: these mat-
ters required the involvement of ministers at the highest level of government,
prominent civil servants, royalty, and a small team of curatorial experts. Further,
the very destination of Tate's collection – Millbank was neither its first nor its best
location – was neither within the tried and tested central metropolitan circuits of
art such as Westminster, Charing Cross or South Kensington, nor within the
uncultivated outer areas of social deprivation to the east, south or north of the
administrative city. It was to occupy a space to the side of those more recognisable
areas, near to the Palace and to Westminster but without a clear local population
of its own. Symbol of English culture, imperial emblem, national treasure, phil-
anthropic gift – all four terms combined to make the establishment of Tate's gallery
an unusual case, sitting at the intersection of numerous discourses and causal
chains. Tate's gift had the character of a gesture precisely of its time. Coming late

45 Dendy Sadler,
Thursday, 1880,
oil on canvas,
86.4 x 141.0 cm.

in the imperial process and late in the re-formation of the London public as a body, it constitutes perhaps the final moment in which 'art' and 'nation' could so simplistically be thought together.[22]

Tate's offer

The actual transfer of property was far from simple. Tate's offer, first addressed to the National Gallery in a letter of 23 October 1889, was subject to three conditions:

> that a room or rooms be devoted exclusively to the reception of the pictures; that such room or rooms should be provided or erected within two, or at most, three years from the date of the acceptance of the gift; and that the pictures when hung ... should be called "The Tate Collection".

But the Treasury, which had responsibility for marking the funds for such a gallery, at first sounded unhopeful unless room could be found in the already overcrowded space at Trafalgar Square. The National Gallery's Charles Lock Eastlake (nephew of Sir Charles) told the Treasury it wished to accept Tate's offer provided that the 'absolutely necessary structural extension' was built. The Treasury responded by asking Tate whether the provision of separate rooms was an indispensable condition. He replied that it was. The Treasury felt it could not immediately oblige, and for a while the matter rested there.[23]

A reference to Tate's offering letter appeared in *The Times* on 13 March 1890. The paper was clear in its support, even if it had to admit that 'not all of Mr Tate's pictures are of equal merit'. Pointing to the recent rapid rise in the prices for English pictures, *The Times* feared that the oportunity would soon be lost of 'a really representative and choice collection of our art gathered together in some great central gallery ... that should do for English art what the Luxembourg does for French'.[24] Attempts were made to persuade Tate not to launch all his works upon the National Gallery unconditionally. *The Hawk* of 11 March 1890 proposed that

> the three pictures by Sir John Millais are the only ones the Trustees would be not only justified in, but congratulated on, selecting out of the modern section of Mr Tate's collection ... If these were accepted, Mr Tate will have made a worthy present to the nation; and we can meanwhile wait for better works than those which Lady Butler and Messrs Gow, Alma Tadema, Waller and Frank Bramley have hitherto been able to give us. Orchardson and Boughton, however, might be made exceptions.[25]

The Graphic of 17 March singled out Frank Bramley's *Sacred*, which though 'a very clever performance ... it is doubtful if the artist himself would not feel somewhat confused by the suggestion that it be enshrined in the temple of art in Trafalgar Square'.[26] Much of the criticism was fanned by resentment on the part of a supposedly 'cultured' London audience that a mere entrepreneur, a mere man of trade, should be encroaching upon the field of art. *The Hawk* complained icily:

That Mr Tate is actuated by the kindest and most philanthropic motives is not to be doubted for a moment, but what may be great works of art in the eye of a gentleman skilled in sugar refining are not necessarily so in the opinion of those who, knowing nothing of the sugar trade, do know something about pictures.[27]

Tate was not to be put off. He made another offer in the middle of June 1890. He would present to the nation 57 of his pictures (excluding the Bramley), with an option to choose more, providing that the Treasury agreed to finance the management of the collection, but only when

a suitable and separate gallery shall have been erected, or an existing one prepared for the reception, the situation and structure of which shall have previously met with my approval, providing that the Lords of the Treasury agree to their assistance by 30 June 1892.[28]

To this second letter were added further details, namely that the gallery be managed under a separate administration from that of any existing institution or government department; that it be established 'on lines similar to that of the Luxembourg Gallery in Paris, which is devoted exclusively to Modern Works of French artists'; that the works 'should have been publicly exhibited at the Royal Academy, the Royal Water-Colour Society, the Royal Institute of Water Colours, etc'; and that 'no dealer or trader in works of art be eligible as a trustee'. Tate further proposed that British pictures from Trafalgar Square and South Kensington be included, the collection being further defined as 'works by British artists since 1750 … such works being proved to the satisfaction of the Trustees as the work of British artists or of naturalised British subjects who have resided within this realm'. The Trustees would comprise four Royal Academicians, plus a member of each of the watercolour institutions, 'who shall be in the practice of art as painters of watercolours … and at least six gentlemen of repute as collectors of paintings and possessors of important works of British artists or acknowledged art connoisseurs, and the director of the gallery, *ex officio*'. The latter group would recommend new acquisitions to the Trustees, who would then require a majority two-thirds vote to permit a purchase. There would be no other bureaucracy. On the model of a private company, Tate specified that 'A director [would] have charge of the works, etc, and administer the details of the gallery, having sole control and management, with a seat and vote at the Board, to which he should report to all meetings in writing'. He further suggested that the National Gallery should stick to old masters, and that British works should be moved from the National Gallery and South Kensington (including those in the Chantrey Bequest) to complete 'the proposed new National Gallery of British Art'.[29]

The response to Tate's offer was hesitant. *The Times* two days later supported the concept of a national gallery of British art: 'We ought to have a collection to which we could take our French neighbours and our American cousins, to show them that the art of Great Britain is a flourishing reality.' The Paris Luxembourg

was again cited as an exemplar: 'Even Brussels has such a gallery, full of pictures of which many are of first-rate merit; and London can hardly be content to be out-distanced by Brussels'.[30] But *The Times* was unable to support the suggestion that the state should purchase the works of its professors. 'Art that needs state encour-agement is not healthy', it said, 'and had better die'.[31] The popular press often sounded a negative note: The *Daily News* believed that the generosity of Tate's offer had to be set against the fact that some of the artists in his collection were 'second and even third rate names', which 'no gallery properly constituted should be prepared to receive'.[32]

From the middle of 1890 to the spring of 1892 a number of sites for a separate building were considered. The 'east' and 'west' galleries of the South Kensington Museum in Exhibition Road, Kensington Palace and a site on the Embankment between Temple and Sion College were all explored; but progress was painfully slow.[33] Lingering doubts about the quality of Tate's collection combined with neg-ative press comment about his status as a 'sugar boiler' chimed well with a degree of uninterest on the part of Lord Salisbury's Conservative government (perma-nently preoccupied at this stage with the Irish tangle), exacerbated by indecision on the part of the Chancellor, Edward Goschen. By the beginning of 1892 public discussion had become cynical. Goschen was condemned on all sides for 'shilly-shallying'. The science lobby was seen to have at least as good a case as art's. Tate too was being set upon once more by anti-trade invective from the gossip press:

> Tate's sugar is getting a better advertisement now than ever any soap secured, and the proprieter must chuckle at the success of his boom. But the public should dis-criminate between sugar and art. Because a gentleman has purveyed 'crystal loaf' with success for many years it does not follow that he knows anything about pictures.

Had he 'recovered his temper' enough to accept the South Kensington galleries,

> we should have been doomed for generations to gaze upon the works of academi-cians whose sole claim upon posterity rested on the fact that they were good fellows and well in with the dealers. Then came the bribe of £80,000 – ostensibly to build a gallery for the homeless 60 – which was in danger of being accepted had not science and the City combined to thwart the sugar-boiler. And now the pictures go begging, and can find no roof to hide their shame under. For which the art world offers many and fervent thanks, for indeed the pictures are sad examples of the worst style of the worst RA's'.[34]

John Rothenstein later tells us that a letter to *The Speaker* by Edward Morris described Tate's pictures as 'rubbish'; that modernists like Sickert and George Moore also derided the attempt to confer immortality upon the likes of Henry Woods and Briton Rivière. As Rothenstein put it, 'they (Sickert and Moore) con-tended "that prospects for independent art were dark; a national Valhalla for shaggy cattle and rollicking monks would make them darker yet"'.[35]

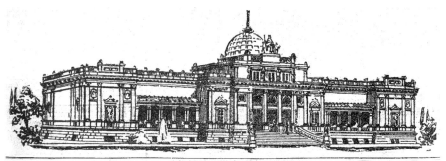

MR. TATE'S PROPOSED GALLERY.

46 Sidney R. J. Smith, proposed design of the Tate Gallery for Exhibition Road, London, published in *The Builder*, 19 March 1892, p. 226.

By this time Tate had instructed his architect Sidney R. J. Smith to draw up plans for an independent building in Exhibition Road (Figure 46).[36] In a letter to Tate as late as 29 February 1892, Goschen pointed out that 'the Trustees of the National Gallery are not disposed to fall in with [the intention to transfer works from Trafalgar Square], and that the Science and Art Department is precluded by the terms of its various trusts from parting with many of its most important works'; he further argued that the site was unsuitable and that 'it would be extremely difficult to design a picture gallery on the lines which your architect contemplated so that in that position it would not appear dwarfed by its surroundings'. The plans for the building 'have only one storey', and the building would occupy too much land.[37] Goschen referred again to the east and west galleries: he even seemed to offer the site occupied by the temporary buildings of the Art Needlework Society, further up Exhibition Road. Tate's reaction was immediate and indignant. He pointed out that he had never accepted the east and west galleries in the first place; that the Art Needlework Society's site was 'totally inadequate'; and that no other site now seemed to be possible, the Embankment site having been lost. He withdrew his offer (Figure 47).[38]

The Millbank site

The affair was galvanised once more by a proposal that had first been aired in connection with finding new buildings for the National Gallery back in 1890. In a letter to *The Times* of 17 March 1892, Sir Edward DuCane, a watercolour painter and chairman of the Commissioners of the Prison Act 1877, proposed that the land occupied by a disused penitentiary at Millbank might be put to use.[39] A further twist, the fall of the Conservative government at the election of 16 August 1892 – defeated over Irish home rule and in disarray – had an immediate effect. Goschen's successor as Chancellor, the elderly Liberal Sir William Harcourt, readily agreed for a portion of the land to be made over for a new gallery, and on 4 December 1892 demolition of the old penitentiary began.

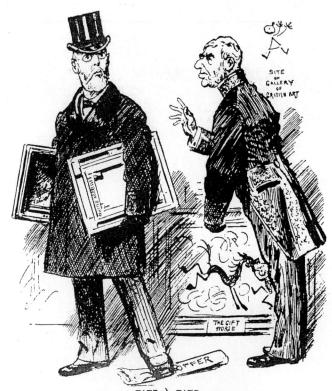

TATE À TATE.
[Mr. Tate has withdrawn his munificent offer.—*Daily Paper.*]
Goschen.—" MUCH OBLIGED, BUT WE ARE A NATION OF SHOPKEEPERS AND WE DON'T
WANT ANY ART TO-DAY, THANK YOU."

The sudden change of location from central London to the Thames embank-
ment made for a very different social and geographical understanding of the gallery
that Sidney R.J. Smith and Tate had originally proposed. Away from the
Kensington lands used for the 1851 Exhibition, which the London public had
grown to associate with exhibition-going, Millbank, though near to Whitehall, had
long remained a 'dangerous' location, excluded from the civilised city and heavily
associated with dirt, inaccessibility and crime.

The Millbank prison, built as a massive structure of six polygons radiating from
a central hexagon (Figure 48), had been the largest penitentiary in Europe at the
time of its construction between 1813 and 1816. In a history of the prison pub-
lished in 1884 it is described as 'the sole metropolitan prison for females', having
already earned a reputation for performing service as 'the sole reformatory for
promising criminals, the first receptacle for military prisoners, the great *dépôt* for
convicts *en route* to the Antipodes'.[40] Even by the time this account was written the
Millbank prison was on its last legs: a malfunctioning, disease-ridden wreck,
unsuitable for incorporation into the new centralised prison system and long since

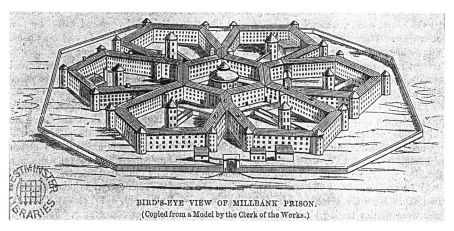

BIRD'S-EYE VIEW OF MILLBANK PRISON.
(Copied from a Model by the Clerk of the Works.)

48 Millbank Penitentiary (copied from a model by the Clerk of the Works).

overtaken in design by Pentonville and other places.[41] There are several reports, from fiction and elsewhere, of this almost forgotten corner of London. In *David Copperfield*, written in mid-century, Dickens had described the area as a site of decaying buildings and obsolete machinery:

> A sluggish ditch deposited its mud at the prison walls. Coarse grass and rank weeks straggled all over the marshy land in the vicinity. In one part, carcasses of houses, inauspiciously begun and never finished, rotted away. In another the ground was covered with rusty iron monsters of steam-boilers, wheels, crank-pipes, furnaces, paddles, diving-bells, windmill-sails and I know not what strange objects.[42]

Or there is Henry James' heroine Miss Pynsent, struggling through the gloom of the embankment with the young Hyacinth Robinson to visit the child's mother in gaol (James himself had visited the prison in 1884):

> They knew it, in fact, soon enough, when they saw it lift its dusky mass from the bank of the Thames, lying there and sprawling over the whole neighbourhood, with brown, bare, windowless walls, ugly, truncated pinnacles, and a character unspeakably sad and stern … This penitentiary struck her as about as bad and wrong as those who were in it; it threw a blight over the whole place and made the river look foul and poisonous, and the opposite bank, with its protusion of long-necked chimneys, unsightly gasometers and deposits of rubbish, wear the aspect of a region at whose expense the gaol had been populated.[43]

Arthur Griffiths, the author of the history cited above, tells us that the land on which the penitentiary was built was part of a larger plot, bordering both sides of what is now the Vauxhall Bridge Road, and was

> a low marshy locality, with a soil that was treacherous and insecure … people were alive only a few years ago who had shot snipe in the bogs and quagmires round this spot … no house of any account superior to a tradesman's or a public house stood

within a quarter of a mile [of the intended prison], and there were hereabout already one other prison, and any number of almshouses.

Griffiths cites Stowe's *Survey of London* of 1598 which refers to a bridewell for the 'correction of such coarse and idle livers as are taken up within the liberty of Westminster, and thither sent ... for ... whipping and beating of Hemp (a punishment very well suited for idlers)'.[44] There were also a number of 'pest-houses ... built near the Meads, and remote from people'. Griffiths, a former prison inspector, calls these buildings 'the chief occupants of those lonely fields, forming no unfitting society for the new neighbour that was soon to be established among them'.[45]

It will be clear that I am trying to evoke the mood of desolation and remoteness that still pervaded this corner of London at the end of the 1880s. Although the areas to the south of the river (Vauxhall, Clapham and lands to the south and west) had been built up as suburbia since the 1860s, the inaccessibility and dirtiness of Millbank was still being regularly remarked. The *Daily News* said it was 'altogether unsuitable [for a gallery], being full in the face of half-a-dozen manufactories ... a dirty spot ... blue mould and green damp are the prevalent conditions of the region'.[46] DuCane's letter to *The Times* warned that Millbank was far from the fashionable parts of London: the route from Westminster was 'narrow and is bordered by some shabby old houses ... I cannot think, however', he said optimistically, 'that this one bad approach would deter anyone from visiting the picture gallery who wanted to, or who would derive any benefit from it'.[47]

There is a fine irony therefore in the fact that Ruskin in his 1867 lecture had roundly called the area from Westminster to Vauxhall 'a disgrace to the metropolis'; 'Take the cost of a year's fireworks', he had said,

> take fifteen million boldly out of your pocket, knock down the penitentiary at Pimlico, and send your beloved criminals to be penitent out of sight somewhere, clear away the gasometers on that side, and the bone-boilers on the other, lay out a line of gardens from Lambeth Palace to Vauxhall Bridge on the south side of the river, and on this, build a National Gallery ... reaching that mile long from Westminster to Vauxhall Bridge.[48]

Ruskin could not have believed his plan would be carried out. Now, however, successive designs for a new gallery on the north bank proposed something comparable in spirit. A series of architectural designs attempted to reclaim territory for 'civilised' London from the ravages of darkness and sin: first, with a series of elevations that bore a structural resemblance to Wilkins' National Gallery and other more centrally placed prototypes where architecture already signified 'authority' and 'learning'; secondly, on the basis of a mass of regal and nationalistic detail that provided signifiers of 'nation', 'tradition' and 'empire'; and thirdly, with the aid of a temple outlook over the river Thames that was said to evoke ancient Rome.

Tate had already employed Sidney R. J. Smith to design a carriage entrance and a large garden folly at Park Hill in the classical style. The first of his designs for

Tate's gallery, intended for the site in South Kensington, had followed Wilkins's pattern of central pedimented entrance flanked by two symmetrical wings, though he had provided corner galleries on the ends (where Wilkins had to go back from the street) and a sculpture of Britannia over the pediment. Lacking the *gravitas* of the British Museum or the elegance of Trafalgar Square, this first design had been considered too slight for what might be regarded as proper for a state or civic build-ing. To Goschen's complaint about its lack of height, Smith had replied that it was not so insignificant: 100 feet to the cupola and 72 feet in the main part, compared with Wilkins' 62 feet and the National Portrait Gallery's projected 68. Smith claimed it would be as prominent as the Natural History Museum: 'I may say that Mr Tate instructed me to spare no trouble in producing a design which should have the best lighted galleries obtainable, and in order to attain this end I visited many of the picture galleries on the continent and in the provinces'.[49]

With the move to the Millbank site now in prospect, Smith worked up his designs to a more vividly imperial scale. In the spring of 1893 he proposed a mas-sive central dome over a central Corinthian portico, with smaller glass domes on the wings and an elongated flight of steps at the front, raising the building up over its river frontage with some strenuous rustication in the basement (Figure 49). Now too there was pediment sculpture over the doorway, as in Bloomsbury, and a determined grandeur throughout. This, the most imposing version of the design, the *Magazine of Art* called 'Italian in style ... faced with Portland stone';[50] but objections were immediately voiced about the height of the glass domes, not least by some of the Royal Academicians whose works were already in Tate's collection.

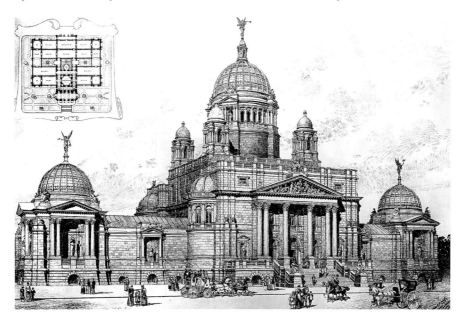

49 Sidney R. J. Smith, project for the facade of the Tate Gallery, Millbank, *Magazine of Art*, June 1893.

Several modifications were published before the final scheme emerged at the end of 1894, now lacking the corner domes and the central drum and by this time comparatively modest in ornament. The order was still Corinthian, but the niche statuary was gone – however, Britannia on the roof was now flanked by the lion and unicorn at the pediment ends (Figure 50). The *Art Journal* remarked on how it 'proclaimed its monumental purpose' externally.[51] *The Times* thought the building was 'actual and permanent expression given to noble thought'.[52] *The Sunday Times Short Guide to the Tate Gallery of Contemporary Art* – note the use of the gallery's 'popular' title – proposed that the building was 'in a modernized classic style ... the middle of the front is good, but the wings are weak, and the dome, while superior to that of the National Gallery, is still far from a success'.[53] *The Spectator* also demurred:

> It seems ungrateful to criticise Mr Tate's gift, but it is impossible not to wish that the outside of his building had been simpler and less grandiose in style. It is difficult to put an exact name to the architecture. Classic it is not, in spite of pediment and orders. There is something heathenish about its heavy pillars and frowning portico. This type of architecture has been happily called the Gorgonesque, and no other word defines the present building more closely.[54]

50 Tate Gallery, Millbank, front facade, *Daily Graphic*, 22 July 1897.

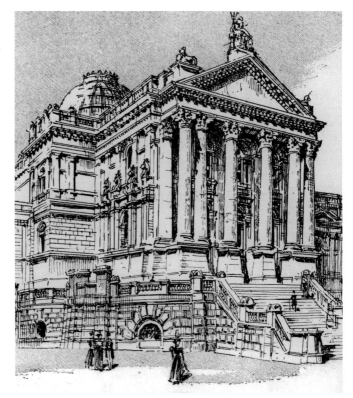

The reviewer in *The Year's Art* for 1898 called it 'a very poor and commonplace piece of construction',[55] but did not elaborate. In the spacious area provided by the demolished prison, the building was no doubt capable of looking isolated and squat. Alain-Fournier wrote some years later that it 'stands alone, small, circular, ugly'.[56]

But the most prominent assessment of the building had little to do with its classicism (which was mostly taken for granted) or its ornament or scale. It was the language of the 'temple' that came to the fore, frequently in conjunction with its river frontage. Here is one description from 1912:

> A shrine, no less sacred to Art than those classic monuments dedicated to Apollo and the Muses, or that lovely temple of Venus which is still standing on the flowing Tiber, is happily to be seen reflected in the waters of the Thames; flights of easy steps lead up to open portals, inviting and open to all.[57]

It is the language of an obituary, admittedly; but it serves to underline the wider point that 'temple' offered an enduring image among commentators who still liked to evoke the classical and religious roots of art. Politicians and some artists seemed enamoured of that image too, not least because it identified the interior of the gallery as a place of escape from the cares of the outside world (Figure 51). Here, art was akin to a religion that would sanctify the national 'public' at the same time as illuminate a dismal corner of the centre of London and the empire with more elevated images and ideals.

Metaphors of improvement: from penitentiary to 'temple of art'

The appearance of the new gallery combined well with the demise of the old prison as a harbinger of the 'progress of civilisation' in England. The triangle of associations was regularly and repeatedly endorsed. The opening of the building on Wednesday, 21 July 1897, an event attended by the Prince and Princess of Wales and numerous celebrities from government and the arts, provided the connection between art, the nation and the gradual eradication of crime. Having ascended the entrance steps to the accompaniment of the band of the Artists' Volunteer Corps, the royal party were shown round the Gallery, hung with 63 of Tate's pictures in the north-west corner, with those purchased under the terms of Francis Chantrey's will bequest in the south-west and south-east, and works from the Vernon gift from South Kensington and some works by British artists born after 1790 (from the National Gallery) in the north-east. A gift from G. F. Watts of his own works were in two small octagons at the front.[58] The principal speakers on this occasion – Henry Tate himself, Leader of the House of Commons and First Lord of the Treasury Arthur Balfour, the former Liberal Chancellor and now leader of the opposition Sir William Harcourt, and the Prince of Wales – liberally congratulated each other on the 'magificence' of the new institution (Figure 52). More specific values were celebrated as well: the state's effective and prudent management of the arts, its concern for 'culture' and the 'nation', the balm of royal patronage, and the

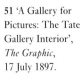

51 'A Gallery for
Pictures: The Tate
Gallery Interior',
The Graphic,
17 July 1897.

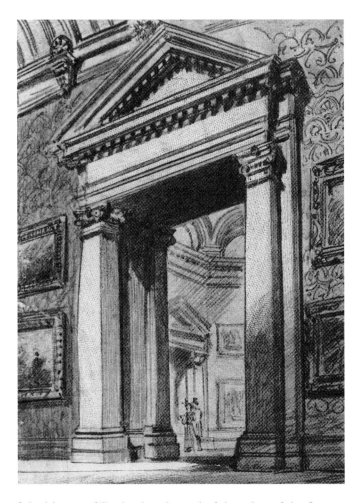

climactic progress of the history of England at the end of the reign of the Queen. Balfour referred to the 'radiance' which the Prince of Wales shed on the occasion, showering him with epithets connecting his very being with the health of art:

> The presence of no other individual could by any possibility have shed such a lustre on the occasion or could more fittingly give public expression to the national grati- tude for the generous gift which has today been opened to the public ... We should all feel that had his Royal Highness not been able to be present today, this opening ceremony, this initiation of a new era and epoch in connexion with British art [cheers] would have lost half its grace and significance.

The Prince replied that he 'gave way to none in the love and appreciation that he had for Art', and that of all the year's ceremonies, 'none had given him greater pleasure than the one in which he was now taking part'[59] – a remark made reso- nant in the light of the Queen's Jubilee celebrations in June.

But the theme of the prison was the prominent one. Balfour this time congratulated Sir William Harcourt:

> I believe it was his ingenious and happy thought to call into existence this cheerful temple of art upon a site hitherto associated only with suffering and crime, and none who can remember the old Millbank prison could, in their wildest imagination, have conjectured that in so short a period, by the generosity of one man, so vast a transformation could have been effected.

Harcourt, inserting a line from Byron – 'a prison and a palace on each hand' – and referring to the prospect of a soldiers' hospital and model dwellings on a different part of the site of the old gaol, suggested that

> the present appropriation of the site of Millbank is an illustration of what we have been contemplating in the last few weeks – the progress of society in England in the reign of the Queen [cheers]. When I first recollect Millbank it was a philosophical specimen of a reformatory prison; today it contains a Palace of Art.

The Prince of Wales, finally, had his say on the conversion:

> I am glad to think that in place [of the Millbank prison] we have this beautiful temple of art instead of a building where unfortunate criminals were undergoing punishment. I am inclined to think that in the gift which Mr Tate has made to the nation the nation will take now the place of the gaoler by taking care of all these valuable pictures, which I hope will ever remain within these walls, and to which many more, I hope, may be added.[60]

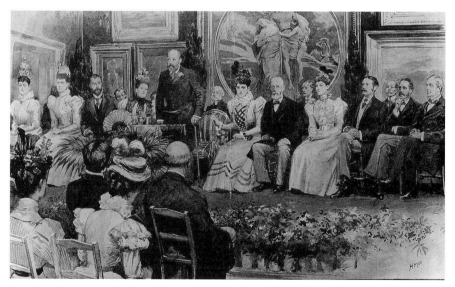

52 'Opening of the Tate Gallery, 1897', *The Graphic (Supplement)*, 31 July 1897, pp. 4–5, drawn by H. M. Paget (present are Mr and Mrs Tate, Prince and Princess of Wales, Duke and Duchess of York, Duke and Duchess of Fife, the Trustees Lord Lansdowne, Earl of Carlisle, Lord Brownlow, Mr Alfred Rothschild, Sir Charles Tennant, J. P. Heseltine and Mr Murray Scott).

Such examples of official largesse may seem routine for 1897 – but much is to be gained from attending to the metaphors they contain. The suggestion of an equivalence between the gaol and the gallery was in danger of becoming a running joke in the speeches of 21 July. Certainly the language of the art museum – one which treated the pictures as 'in care' and the gallery as the 'keeper' of art – lent itself readily to a linguistic association between the two institutions. The possibilities for humorous comment provided by the building of a gallery on the site of an ancient gaol had already been recognised, well before the building of the gallery. Back in December 1892, shortly after the demolition of the prison had begun, *Punch* had depicted the relations between Tate and the Academicians as one of gaoler and gaoled, the artists trudging round the exercise yard with their pictures, Mr Punch – representing as ever the view of the nation's middle class – looking quizzically on (Figure 53). The inversion was perhaps inevitable: the very idea of privileged members of the Royal Academy in the gaol yard, several in caricature form, was an improbability too good to miss. At the same time, the cartoon may be said to have expressed anxiety about the re-use of a prison for cultural purposes, in a location so close to the heart of civilised London and the elite culture of the Academy itself.

Perhaps the metaphor of 'improvement' had not been quite a possibility at Millbank in 1892. For one thing, the prison structure was still standing, and the plans for the gallery were still in dispute. No sooner had the prison structure

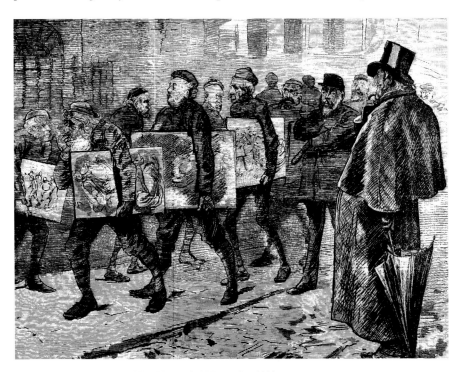

53 'Royal Academicians at Millbank', *Punch*, 17 December 1892.

disappeared – demolished by disenfranchised workers from the docks and building trades – than the metaphor of 'transformation' became readily available for use. The *Daily News* in December 1893 hailed Sidney Smith's plans as leading to a gallery which 'some day no doubt would adorn a neighbourhood over which the hideous old gaol for so many long years threw a gloom and a general air of degredation and depression'.[61] By the time of the opening three and a half years later, many of the daily and weekly papers had begun to elaborate on the change. The *Daily Graphic* spoke not merely of the replacement of the prison by the gallery, but of 'the splendid example set us by the *transformation* of Millbank Prison into Millbank Palace'.[62] The Prince's wry remark at the opening about 'the nation taking the place of the gaoler' met its response too. The *Daily News*, continuing the word-play, hoped that the Prince's analogy would not be taken too literally when it came to framing regulations for discipline in, and access to, the new establishment.[63]

It was a metaphor that was also flippantly elaborated in the upper-class press. The weekly magazine *Truth*, much given to puzzles and quizzes, expensive kitchen gadgetry and social events, invited readers' suggestions for the name of the new institution. This may seem puzzling, for despite its official name 'The National Gallery of British Art', other nomenclatures were already in circulation – such as that given in *The Sunday Times Short Guide* – which made explicit references to the donor.[64] The matter needed clarifying – or satirising. The suggestions poured in. A significant number played on themes of the Queen, Britishness or Tate himself: 'The Victorian Art Gallery', 'The British Gallery', 'The National Gallery', 'The Jubilee Gallery', 'Ars Britannica', 'The Art Temple', 'The Tatonian Institute', the 'Tate and Up-To-Date Gallery, the 'Tate, ah Tate (tête-à-tête) Gallery' – the last suggesting the gallery as a place of rendezvous. Several more played upon the prison theme: 'The Reformed Art Gallery', 'The Millbank Prison Art Exhibition', 'The Cubicle' (a reference to Tate's cubed sugar), 'Penitentiaries', 'Prisoners' Base Gallery', 'The Transformed Gallery', the 'Lock Tallery or the Lock Tate' (a play on Eastlake's middle name), and then finally 'The Millbank Gallery' – 'Why not?', wrote its proponent; 'There is nothing undignified in the name … [it] is associated with crime and a prison … Why not take it up, redeem it, glorify it with a new association?'.[65]

Other suggestions were accompanied by poetry. The name 'The People's Rest' was delivered with the following verse:

Where Millbank Prison frowned on noble Thame
A Palace now doth play a worthy part
And, gone for aye the dungeon's deepening shame
We hail the People's Rest – fair home of art.

A further suggestion – for the 'Phoenix Gallery' – had an explanation appended: 'I suggest this name as it is a thing of light and beauty arising on the crumbling dust of a place hitherto seethed in sorrow and shame.' Its author was skilful at alliteration too, witness this pair of epigrams:

1. Where prisoners ate 'skilly' in their cells
 Skill'd artists now exhibit to the 'swells'.

2. Here stood Millbank Prison, where convicts were confined
 Because each played in life dishonest part
 Not altogether chang'd, the Gall'ry to my mind
 For many here are captive held by art.

A poem by H. D. Rawnsley in the *Westminster Gazette* echoed the problematic of 'capture' in his poem:

> When the old monkish men of Westminster
> Wandered among their fields and watched the tide
> Surge up and brim and seaward turn, they cried:
> 'By ebb and flow Heaven's parable is clear!'
> And we who watched the generous builder rear
> His palace home for British painters' pride
> Where crime was purged and law was satisfied
> We feel God's river of good is refluent here
>
> Still by the ebb and flow of London's stream
> The Tides of Art will ebb and flow along
> No longer here pale prisoners shall be brought
> But multitudes in fetters pure and strong
> Shall stand enchained to dream the painter's dream
> And find these halls the prison-house of Thought.[66]

We are now quite suddenly on different ground: notice how each piece of verse (doggerel though the epigrams, at least, may be) shifts the principal image, changes the central metaphor. The second epigram ironically proposes that the gallery is '*not* altogether chang'd' from the prison function – that the art audience is 'captive held' by art. Rawnsley's poem plays on 'enchained' to suggest that art holds captive or captivates its beholders, the prison image now freed from its contrastive use and pressed into service to connote a romantic sense of subservience and duty: the language of 'capture' now characterising the very experience of art.[67]

Audience and class

Such metaphors may have characterised how one part of the Millbank audience thought it felt about the new gallery. But we know that art was not always encountered on those terms – even in 1897 – and that not all audiences would so describe the kinds of attraction exerted by the new gallery's display. This language helped show a particular audience to itself – helped characterise that audience both in its relation to art objects and to the 'missing' part of the public who would be excluded by the descriptions employed.

The way the dominant part of the Millbank public was constituted in 1897 provides further evidence for an obsession with cleanliness and healthy living, underpinned by a conviction in civic order and moral superiority that is characteristic of the later Victorian upper bourgeoisie. Cameo illustrations printed in the London daily and weekly magazines between 1892 and 1897 produced Millbank as an educational and leisure site – in one case complete with sailing boats on the Thames – precisely contrasting with the gloom and redundancy of the old prison.[68] Early suggestions for the remainder of the prison lands proposed schemes for a public garden, that ideal of sober recreation that had come in during the 1820s to alleviate the confinement of the 'labouring class' but which now almost epitomised the rectitude of the middle class.[69] By 1897 the plans included a military hospital and a sizeable new layout for LCC housing. As late as October 1897 this housing was reported as being for 'poor people who will be turned out of Clare Market in order to make room for other London improvements' (Figure 54). It would be 'a poor man's village; it may raise the tone of the Westminster slums, and it will be a boon to the Clare Market people, whom it will house at a distance not too distant from their means of livelihood in Covent Garden'.[70] In the event the new housing was scheduled for 'artisans', that new category of the respectable working class that had by now been effectively separated from the 'residuum' of the unredeemable poor.[71] The housing blocks that were (by 1902) eventually built at the back of the gallery site would be named after 15 notable British artists from

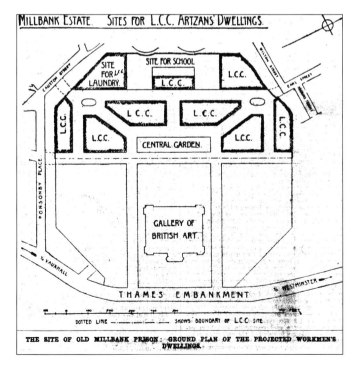

54 'The Site of Old Millbank Prison: Ground Plan of the Projected Workmen's Dwellings', *Daily Graphic*, 21 October 1897.

Reynolds to Leighton, a signifying practice which bonded the artisan consciousness to a tradition of national art in ways that were open to view.[72]

Such rhetorical practices served to assemble the population of the capital around art and a national tradition, culminating in a display of 'contemporary' or 'modern' work in a site of symbolic importance near to the old Westminster slums and the seats of monarchical and governmental power. The gallery must have constituted a splendid symbol of national unity towards the end of Queen Victoria's reign. Yet the place of the urban working class within the scenario of elevated culture – the issue that had so animated the reformers of the 1830s to the 1880s – remained chronically unresolved. In Whitechapel the crowds were expected to be destitute and the pictures could be interpreted accordingly – that is, moralistically. But Millbank was not the East End. In a region close to the very heart of London the constitution of a class audience, and with it the balance between moral and artistic concerns, was more uncertain still. Several reports can be consulted. The gallery was not opened to the public until 16 August 1897; after which the *Norwood Press* found that

> many working men and women were to be seen wandering through the rooms and gazing with much interest at the pictures, for Grosvenor Road borders on a very busy working-class neighbourhood, and it seems evident that the residents there are not going to neglect the beautiful art gallery which has been placed so close to their doors.[73]

The passage is typical of the attitude taken by the middle-class press towards the working class: the verbs 'wandering' and 'gazing' seem to imply that working men and women were unfamiliar with art (which no doubt they were), and with the codes of attention and deportment that came naturally to their superiors. At the South London Gallery, the correspondent of the *Pall Mall Gazette* described 'the crowd in the Walworth Road, from which the visitors to the humble "Gallery" were drawn', as

> boisterously gay, but pitifully sad to look upon. Under-sized factory girls with pale over-strung faces, under gaudy beflowered and feathered hats, set off with plush Directoire coats and tawdry satin paletots, with imitation jewellery in profusion, hustled each other in hoydenish fashion or marched to the time of a rollicking comic song. At one moment they would join in a coarse and loud guffaw; at another, would attract the attention of a group of men by a well-planned collision. Here were young girls of fifteen walking hand in hand with lads of the same age, who strutted with the dignity of bantam cocks, while they made love to the puffing of cheap cigars. Other girls there were who carried little babies in their arms, and had a hunted, hungry look in their eyes, that told an all-too-plain tale. Men, stunted, pale, hollow-eyed, 'mouched' along with trouser-pocketed hands, and lads, tired and old-looking, shouted under the railway arches or roared out fragments of Salvation Army Hymns.

Arriving at the gallery, this reporter asked the attendant, 'Do these people appreciate the pictures?' 'Not at first', came the reply, 'they have to come a few times,

and then they begin to understand them better.' Reassured by the numbers who flocked to the gallery on a Sunday, he reached the satisfying conclusion that 'whatever doubt might have been in my mind before as to the rightness of opening these "places of recreation" on Sunday, I came to the conclusion that so far as I had been able to judge, this was the only successful rival I had found to the public-house'.[74]

At Millbank, too, the suggestion was that this 'other' audience was simple and relatively brainless. The *Daily Graphic* depicts the working class as more or less stupefied by their first days in the gallery.

'Carriage folk were there in considerable numbers, but the majority of the visitors came from the immediate neighbourhood – people who had seen the vast octagonal prison-house disappear from among them and Mr Tate's handsome art temple rise in its place. Where once stood a building the inside of which no one wished to see, another has arisen, whose doors stand open ... whose cool fountain courts and cheerful galleries invite the reposeful contemplation of things of beauty. And so the crowd, nothing loth, entered yesterday into possession of their new palace of art, gazed in curious admiration at the fountain with its goldfish, wondered at the clean tesselated floor, and having thoroughly appreciated both, tried to understand the pictures, in which lay a new world of romance and mystery, mingled with the world they know better: on the one hand the allegories of Watts, on the other the realism of Frith.[75]

It is easy to tell – that is the point – who the real audience for the pictures at Millbank was supposed to be. The same journal carried a line drawing the following week (Figure 55), to which a description was appended. The description says that the crowd was

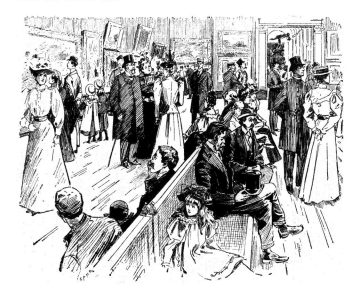

55 'Inspecting the Pictures at Millbank', *Daily Graphic*, 24 August 1897.

as interesting as the pictures. The well-to-do citizen who was there to see some of the pictures he "remembered years ago", and the citizen who having but doubtful domicile went in to have a rest; the dainty maiden, the costermonger, and the old maid; school board children, foreigners, the fashionable curate with his sister or somebody else's sister, the nondescript individual who may have passed a few days or longer in the original building – all were there.[76]

This then was one fantasy at Millbank – of a mixed audience at ease with itself, variegated and occupied. The drawing itself, however, shows a more consistent social milieu: the fashionable curate is on the right, perhaps, and the gentleman asleep, centre foreground. But where is the 'person of doubtful domicile'? *This* crowd is represented as an even more gratifying unity; self-possessed, upright, well-dressed, peaceable, and apparently absorbed by art, a class audience precisely undefiled by the 'costermonger' or 'the nondescript individual' of the written account. The sole intruder from the lower orders is the figure, lower left, with a working man's jacket and hat. Significantly, his face remains turned away from the viewer, all but invisible to the optic of a newspaper that preferred the 'problem' of the working class to go away. His body is thinly sketched. He is at best a *repoussoir* figure over whose shoulder we see the main audience constituted of the better middle class.

There is evidence too of the desire of the 'middling' part of the metropolitan art public to be free of the contamination of the lower classes altogether. The right-hand part of a drawing in the *Penny Illustrated Paper* shows a very sparsely

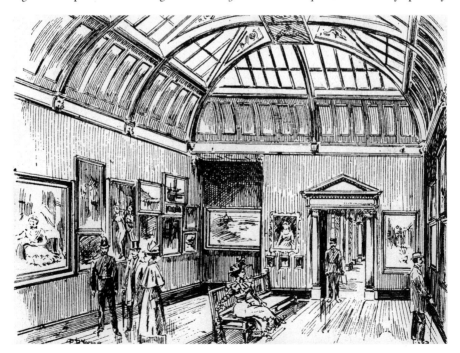

56 'Mr Henry Tate's Gift to the Nation', *Penny Illustrated Paper*, 24 July 1897.

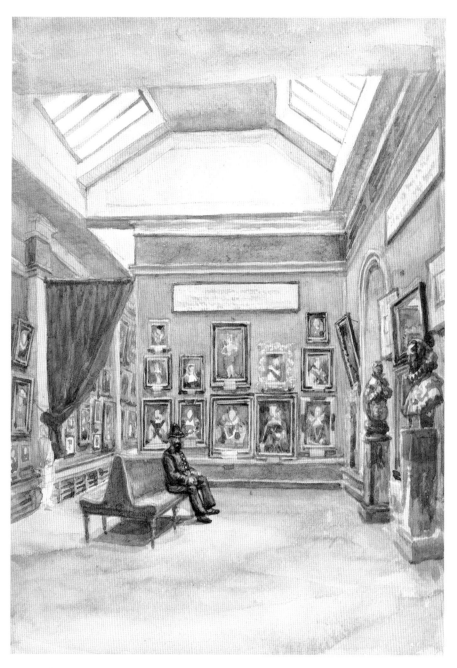

Plate 9 G. Scharf, *National Portrait Gallery at the South Kensington Museum*, c. 1885, watercolour, 35.1 x 25.1 cm.

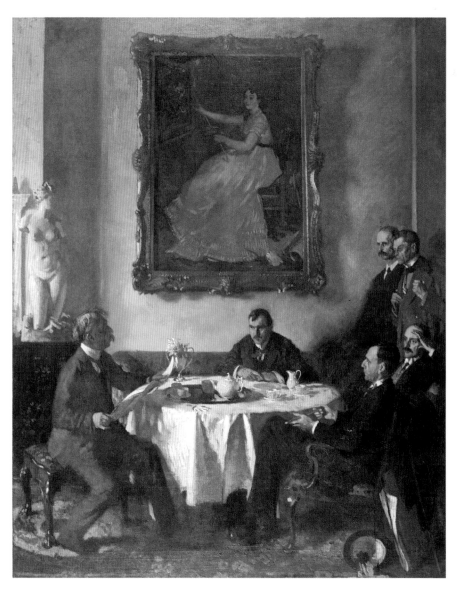

Plate 10 Sir William Orpen, *Homage to Manet*, 1909, oil on canvas, 162.9 x 130 cm (clockwise from far left: George Moore, Philip Wilson Steer, D. S. MacColl, Walter Sickert, Hugh Lane, Henry Tonks).

occupied interior peopled by a pair of expensively dressed couples accompanied by two symbols of the law: a uniformed attendant at the rear, and a policeman (Figure 56).[77] The left-hand image shows Millbank and some sailing boats on the river. In fact the image arranges a constellation of class signs: it appeared at the foot of the 'World of Pastimes' page, below an article about fashion at the Sandown Race enclosure and the Henley Regatta. The page as a whole presents an entire set of leisure pastimes, a well-dressed clientele, and above all that clientele's posture and social training. Inside the gallery, such individuals were secreted with the pictures they had come to see; undisturbed by alien class elements, social misfits, crime, poverty and the labouring mass. The highly polished floors, the classical door arches, the comforting presence of the law, the day off – these are among the major significations of this art public in its new ambience. Such scenes, then, represented regulated, prosperous, even luxurious spaces for the actual or aspiring well-to-do.

And these representations dovetail neatly with other ways of ordering the gallery's contents. In the first months and years the physical ordering of the pictures was not chronological (that did not come until the second enlargement of the gallery in 1910) but by collection or gift. One moved from the Chantrey pictures to the Watts and Tate gifts (galleries 1 to 3), then to rooms containing British school paintings from the National Gallery and Vernon collections (galleries 4 and 5) (Figure 57), through more Watts and Chantrey pictures (galleries 6 and 7), with the pictures and their authors identified numerically in *The Sunday Times Short Guide*. Sculptures were under the central dome, and watercolours and a single pen-and-ink sketch in the first-floor room overlooking the river. Undertaken by Sir Edward Poynter and Sir William Agnew, the hang was mostly on a 'plum coloured' fabric, with the Watts rooms being painted green at the artist's request.[78]

A second ordering was that of the gallery's own *Descriptive and Historical Catalogue* of 1897, arranged alphabetically by artist's surname. It provided biographical information on every artist and a description of each work in terms of the narrative and action portrayed, for example: 'a boy, balancing himself on his left foot, reaches forward with his right to touch a knuckle-bone standing on end in front of him; he must recover his position behind the line which he toes without putting his extended foot to the ground'.[79] Such descriptions – this one is of W. Goscombe John's sculpture *Boy At Play* (Figure 58), bought by the Chantrey Fund and positioned near the entrance – can be called 'literary'. Their more interesting characteristic is that they tell the reader what is to be seen in the way of narrative and action while omitting reference to methods of manufacture, or the devices and conventions of representation in terms of which the work had been conceived or made. Little beyond an ability to recognise what was written was needed for such a reductive mode of attention: which is only to say that modernism had not yet arrived. The language is that of empathetic identification: the values of the picture or sculpture are those of the persons and situations portrayed. Evoking sentiment or sentimentality, the descriptions appeal to emotional

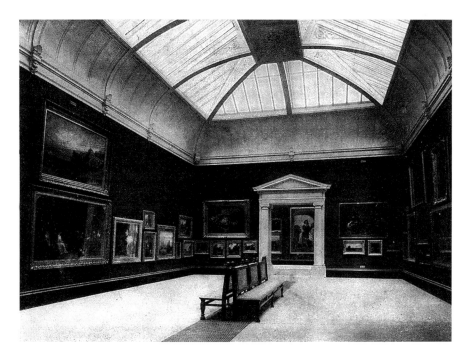

57 Tate Gallery
interior, showing
Galleries 4 and 5,
British School
pictures from the
National Gallery and
Vernon Collections,
St James's Budget,
16 July 1897.

58 W. Goscombe
John, *Boy At Play*,
c. 1895, bronze,
130.2 x 79.4 x 106.0
cm.

undertanding of relatively ordinary relationships and recognisable events. Nor was the collection itself a subject of reflexive comment. Even independent publications such as *The Sunday Times Short Guide* reiterated a conviction in the propriety of the collection and its status as a legitimate and representative display of modern British art. As particularly praiseworthy *The Sunday Times Short Guide* singled out the works of Millais, Stanhope-Forbes, Constable, Waterhouse and the Pre-Raphaelites; while a few artists were distinguished as 'national' or 'typically English' such as H. S. Tuke or Briton Rivière, whose Chantry Fund painting *Polar Bear* (1894), with its 'red sun-set [which] detects a white bear climbing a hill of blue ice', was described as being 'painted in the colours of the Union Jack'.[80]

A gallery for the nation

The new audience for this writing, indeed, was made aware that here was a British collection that would not suffer in the comparison with any other nation but more particularly with the French: as *The Sunday Times Short Guide* had it, 'the English public have in the National Gallery and the Tate Gallery an exact counterfeit [sic] to the Louvre and the Luxembourg at Paris'.[81] Here then was a final 'improvement' metaphor that animated the official rhetoric of the later 1890s. Hitherto only France had had a vigorous national school and a vigorous commitment to its modern painters. Now Britain, or sometimes England, could participate in the stakes for national self-definition. There was some confusion about the identity of the institution, on the one hand a collection of 'English modern pictures' housed in a gallery called the 'Tate Gallery of Contemporary Art'; on the other, a showcase for British artists born after 1790 and known by its official title of 'The National Gallery of British Art'.[82] Yet most accounts emphasised the fact that for the first time the British nation had a picture gallery in which works of national artistic talent could be viewed by a worthy and self-consciously national audience.

A graphic example of the latter tendency is the essay 'A National Gallery of British Art' which appeared as a preface to the catalogue of the Gallery following its first extension rearwards from the river, in 1898–99. Tate had endowed the institution with funds sufficient to relieve the evident congestion by a building programme to the north 'as occasion requires' – which was almost straightaway.[83] Lionel Cust raised a question that was evidently on everybody's mind:

> What is a National Gallery of Art? Is it a 'National Gallery' containing works of art, or is it a gallery containing 'National Art'? Most people would reply that it only means a gallery belonging to the nation, such as we are familiar with in Trafalgar Square ... And yet, if we turn to our neighbours on the Continent, we find that they do not take this view everywhere. At Berlin ... the National Gallery means the Gallery of National Art ... At Paris the gallery of the Palais Luxembourg is avowedly intended to contain the works of modern French artists ... In both Paris and Berlin, as well as in Munich, Dresden and elsewhere, a distinct effort is being made to maintain and

encourage a school of native artists by the collection and exhibition of their works in some building belonging to the nation.[84]

Cust was Director of the recently opened National Portrait Gallery, and it is fitting that he should have attempted to construct a 'British School' against a prejudice which he characterised as having it 'that there is no national art in Great Britain ... that our whole art is a mere worthless pastime, pursued ... by foolish people who have nothing better to do, and by more foolish people who either cannot keep their money in their pockets or merely want a bright and handy decoration for their homes', a prejudice which said that the 'British race' [sic] was no more artistic than it was musical; that 'if you probe deep into an English heart', you will find that it 'really prefers a Christmas oleograph, a touched-up photograph, a barrel organ, or a good swinging waltz tune'.[85]

Such were Cust's self-mocking descriptions of the English (or was it British?) artistic malaise. But he felt confident in claiming that in works from Reynolds, Gainsborough and Hogarth, through Crome and Constable to Landseer, Morland, Ward, Maclise and Frith, there were 'inherent ideas of life and art which are not to be found ... in the art of any country other than England'.[86] What Cust now defined as a 'British School' he claimed to be a century and a quarter old: it had begun with Sir Godfrey Kneller and William Hogarth at the Lincoln's Inn Fields Academy in the first quarter of the eighteenth century and had produced some 25 or 30 thousand artists since. What, asked Cust, had become of their works? What in their subject matter and technique defined them as British? In subject matter, he made the infamously reductive claim – one that had been made before and would be heard again – that

> art in England has been for the greater part of its history, and more than in any other country, devoted to the purpose of illustration of historical and literary anecdote ... It has formed part of the national desire for literary expression ... it is not difficult to draw an analogy between the enormous literary output of the English-speaking race, and its efforts to express itself in art.[87]

Concerning technique Cust had little to say. His only suggestion was that if you took Reynolds, Hogarth, Opie, Turner, Constable and Landseer and hung them alongside foreign masterpieces 'the eye will be at once arrested, the mind at once instigated, by the presence of something peculiar to themselves ... in the handling of the painting'.[88]

It was not much of an argument, perhaps; but it was the attempt at producing one that counted in 1899. There was something optimistic, too, in the suggestion that 'British art' had been born in the nineteenth century and would triumph in the twentieth: as Cust proudly related, 'in the closing years of the nineteenth century the nation is prepared to back its own countrymen to produce paintings or sculpture ... equal in merit, if not superior, to those of any other nation'.[89] It was

a period of almost transcendent self-confidence in which 'nation' and 'empire' resonated in the minds of ordinary citizens, who were justified in believing that Britain ruled the waves under the eye of God and who knew that more of the globe was coloured red than any other colour – a time when 'Britain' and 'England' still amounted to very much the same thing. The 1890s was a period of assertive nationalism in several walks of life: the elevation of 'English' as a substitute for classical languages within the national education system; the erection of national monuments to prominent Englishmen; the founding of the National Trust for Places of Historic Interest and Natural Beauty (1895); the launching of the *Oxford English Dictionary* (1884-1928) and *The Dictionary of National Biography* (from 1885); the publication from 1897 of *Country Life*, which promoted nostalgia for a pre-industrial past.[90] Such projects formed part of a wider network to which the National Gallery of British Art belonged, and which can be said to have created, as well as catered to, the prevailing mood of 'pride in the nation' – a nation, moreover, that was now increasingly free of poverty, artistic illiteracy, and above all crime.[91]

The metaphors of refashioning, reordering and redefining of the national culture were the dominant ones in 1897. But other changes were afoot. The founding of the gallery confirmed on an impressive scale that 'philanthropic' individualism in Britain was thoroughly compatible with a cultural authority deriving from the state and its civil service, and that something identifiable as 'the public good' could be defined by the conjuncture of the two. An earlier government had had few qualms about purchasing the pictures acquired by Angerstein's wealth. Sheepshanks had been enthusiastic about parting with the pictures his father's industrial fortunes had afforded. And it apparently caused no difficulties either to Tate or to his admirers that a plaque was erected in the sculpture hall of the new gallery at the moment of its opening which read 'This gallery and sixty-five pictures were presented to the nation by Henry Tate for the encouragement and development of British art and as a thank-offering for prosperous business of sixty years'.[92]

The Tate Gallery also represented a relatively new – for 1897 – compromise between the interests of entrepreneurial capitalism and the amateurish style of cultural management typical of the old nobility and aristocracy who still wielded power in government. At the same time, and by the same set of processes, the zenith of Britain's power in the world had passed, and some, such as Kipling, were finding the flag-waving and the self-congratulation too much. The year of the Queen's Jubilee was also the beginning of the end of the period in which self-confident nationalism could go completely unchallenged – as the outbreak of the Boer Wars in 1899 was conclusively to demonstrate.[93] The Queen was to die in 1901. What is more important here, the contest with foreign nations in the evolution of national artistic institutions was to become fiercer still. The gradual descent to 1914 was to see a set of realignments as far-reaching in the arts as would soon erupt on the field of battle.

Managing 'modern foreign' art: an extension at the Tate Gallery

THE COMBINATION OF PRIVATE WEALTH AND STATE AUTHORITY that gave legitimacy to London's national galleries in the nineteenth century also became the formula deployed throughout the twentieth. And yet in its inner quality that formula was changing fast. The last two decades of the nineteenth century had seen a consolidation of the legislative apparatus surrounding everyday life: housing, recreation, wages, insurance and much more.[1] 'Management' in all the professions was also becoming widespread, with the difference that it was now increasingly a meritocratic and upper-middle-class preserve, one which at the same time needed to normalise its relations with both a declining aristocracy and a relatively passivised working class. As we saw in the last chapter, the National Gallery of British Art very adequately fulfilled that role.

Artistically, the great explosion that was to disturb this consensus was 'modern' and specifically 'modern foreign' art. With the modernisation of at least a powerful fraction of the art profession in the later years of the nineteenth century and the early years of the twentieth, a struggle emerged between two alternative ways of seeing and knowing: one that inaugurated a powerful shift away from the narrow parameters of 'national' art that had dominated the proceedings at Millbank in 1897. The social significance of this stuggle is that it occurred not between or among classes, but in the ranks of the governing class itself: a consequence was that working-class participation in the national culture ceased to be an issue of importance in the years leading up to the opening of the new galleries at Millbank in 1926. On to centre stage now came the question of how to accommodate the 'modern' art of France.

It must be clear at once that this first encounter with 'modern foreign' art was at the same time a diplomatic and even military one. Before 1870-71 Britain's major artistic, architectural, religious and political affiliations had lain with Germany, but the Franco-Prussian war generated sympathy for the French, and the indirect result had been a wave of artistic francophilia, beginning with a show of Impressionist painting in 1870 at Paul Durand-Ruel's gallery at 168 New Bond Street, continuing at the New English Art Club, the Goupil Gallery and the International Society, and culminating in Durand-Ruel's massive exhibition of 315

paintings by Cézanne, Degas, Monet, Monet, Morrisot, Pissarro, Renoir and Sisley at the Grafton Galleries in the spring of 1905. A second wave of enthusiasm – for Post-Impressionism – would soon surface in London in the work of the Camden Town Group and the London Group, to climax before the public at Roger Fry's Post-Impressionist exhibitions at the Grafton Galleries in 1910-11 and 1912. Of course German art had its followers in this period too, particularly those associated with Alfred Orage and his journal *The New Age*, for whom spiritual and emotional 'expression', often with a revolutionary political dimension, provided the most important and innovatory art of the day.[2] But such formations were grossly unequal in social and cultural power. Ultimately, my thesis will be that a new set of relationships was consolidated in the public culture of the visual arts in London between the turn of the century and 1926, confirming the absorption into the British art establishment not only of a francophilic concept of 'artist' and of European art, but a dispostion to regard the arts as a culture of the professionalised middle classes alone.

What is perhaps unfamiliar about my account is that military and diplomatic relations with continental countries emerge as central determinants of the trend. The terms of resolution of the war of 1914–18, particularly, required that cultural relations were handled with both subtlety and urgency as the British 'nation' after 1918 was jolted out of its complacency and forced to adapt to a modernised, industrialised Europe in which the historical antagonism between France and Germany played a central part.

The New Critics and the Curzon Report

In the final years of the nineteenth century French Impressionism had met with two main – and opposed – reactions in London. In the first, transgressions of naturalistic form and colour, of a painting's narrative accuracy and naturalism, had been singled out for attack. Conservative critics such as F. G. Stephens, Ebenezer Wake Cook, J. A. Spender and Harry Quilter (he had endorsed Henry Tate) lent support to home-bred artists who produced for the Royal Academy paintings of legible stories, familiar scenes and historical events. Resistance to the new French art could quickly turn into explicit vituperation, as in Wake Cook's equation of progressive art with political revolution in his book *Anarchism in Art and Chaos in Criticism* (1904). Inspired by Max Nordau's *Degeneration*, published in English in 1895, Cook equated an interest in French art with 'anti-patriotism' and with sympathy for 'a French Revolution which shall begin by guillotining Academicians and other guardians of law and orderly development'.[3]

The second, or progressive reaction, however, held out for Impressionism's directness and efficiency of surface; for its ability to depict 'natural' effects in non-conventional ways, and for stimulating new types of pleasure in the adventurous viewer of art. English artists grouped around the New English Art Club (founded 1886) had travelled to France and had made the acquaintance of several French

artists. The 'New Critics' of the day – principally Frederick Wedmore, R. A. M. Stevenson, Frank Rutter and D. S. MacColl – supported the new painting with a kind of light-hearted eloquence that was in itself significant of new attitudes to pleasure, nature and painterly technique. Frederick Wedmore, in the first full-length article on Impressionism to appear in England, had complained that 'too much of what [England] gives us from her painters of modern life is familiar, tawdry, *banal*', whereas Monet (to take an exemplary case) 'sees with fresh eyes his autumn foliage, his shadows and cliffs on brilliant summer waters', even if at some cost to the 'moral force or moral beauty' of the subject. Degas and Renoir were highly admired; as Wedmore himself expressed it: 'the final basis of Degas' reputation is not the subject which is treated, but the capacity to treat it'.[4] R. A. M. Stevenson's influential book *Velázquez*, published in 1895, extolled 'impressionistic technique ... a running, slippery touch' in painting, and in so doing extended a vogue already under way for the art of Whistler and Corot.[5] Frank Rutter, an eloquent champion of both Impressionist and Expressionist modernism, art critic of the *Sunday Times* from 1903 and curator of Leeds City Art Gallery from 1912 to 1917, looking back upon the period from the 1930s, recalled what in some quarters still expresses a conventional way of looking at Impressionism today. Sisley, Renoir and Pissarro

> searched out the positive colour in shadows, rejoiced in the prismatic sparkle of reflected lights; but nobody rejoiced so light-heartedly, so gaily and spontaneously, as Monet. Sisley was perhaps even sweeter in his lyricism; Pissarro more learned and scientific ... But Monet gave them something to a higher degree than any of them – and that was a sense of exhilaration ... His joy in Nature was as innocent and disinterested as a lark singing in the sky. His landscapes are not pictures that calm us down: on the contrary, they lift us up ... 'What can be more beautiful', asked my friend [the art critic Paul] Konody 'than a glimpse of real sparkling sunlight, bodily taken from open Nature and magically transplanted on to canvas?' ... The human qualities in Renoir we could recognise at once. He *did* love girls! He loved sunlight also: but he loved it best when it was shining on young flesh.[6]

Rutter pointed out that with the exception of a single work – Degas' *The Ballet from Robert the Devil* (1876) in the South Kensington Museum (after 1901 the Victoria and Albert Museum) – none of the London art museums possessed a single modern French painting by 1905. 'I raged with indignation [he wrote] ... I agitated for all I was worth. I wrote article after article on the subject'.[7] In the wake of Durand-Ruel's Impressionist show at the Grafton Galleries of that year, Rutter organised a public subscription and for £160 bought Boudin's *The Entrance to Trouville Harbour* (1888) for the nation – a demonstration of the new taste, but a painting that a still reluctant National Gallery took much persuading to accept.

Much of even the best New Criticism – and I include Rutter's enthusiasms in this – was not always able to make its mind up on how the subject of modern art should be described: for example how so tragic a figure as the drinker in Degas'

L'Absinthe could be reconciled with the painting's almost exemplary technique.[8] And some of the advocacy for Impressionism was undoubtedly crude: I am thinking of Wynford Dewhurst's book *Impressionist Painting* (1904), which ascribed the invention of Impressionism to Constable, Turner, Bonnington and the Norwich School, concluding that 'as the genius of the dying Turner flickered out, English art reached its deepest degradation. The official art of the Great Exhibition of 1851 has become a byword and a reproach. In English minds it stands for everything that is insincere, tawdry and trivial'.[9] But there was some sensitive advocacy too, of which Dugald MacColl may be taken as the best representative. Trained as a painter under Frederick Brown at the Westminster School of Art – Brown was Legros' successor at the Slade and later taught Orpen and John – MacColl exhibited with the New English Art Club and wrote for *The Spectator* from 1890 to 1896, then for the *Saturday Review*, and for the *Architectural Review* from 1901 to 1905, before becoming Keeper of the Tate Gallery in 1906 – a post which he held until 1911 (though he returned as Trustee between 1917 and 1927). MacColl curated an early exhibition that defined nineteenth-century European art as a successful conjunction of British and French technique. Staged in 1900, the Glasgow International Exhibition scarcely deserved its middle name: only a handful of Dutch paintings intruded into an otherwise exclusively Franco-British affair. Yet in his 1902 book *Nineteenth Century Art*, based on that exhibition, MacColl eloquently argued that the best art of the nineteenth century was 'free, that is private, so little a thing of command, or even wide consent' – a latitude that coincided with the sudden decline of common artistic languages and a stable religious canon to 'leave individual inspiration to its own fires, langours and eccentricities … a picture of the relevant sort was the expression of an artist's uncommissioned mood'.[10]

The apotheosis of that tendency was Impressionism, MacColl said – what he calls art conducted 'in the open air'.[11] Monet and Pissarro, who together in London in 1870 had looked admiringly at Turner's snow and sunset paintings, had found not only a summary notation of form, an interest in reflected light and an 'anxiety to seize the character of a conjunction of tones in the short space of time in which it exists', but a positive 'journal of effects noted in shorthand' while in the open air.[12] But MacColl saw in Impressionism something deeper, something more articulate about the modern. Here was a demonstration of how to select and abstract, a capacity attractive to anyone not concerned with pure camera vision. Camera vision is the practical optic of the farmer or the hunter, says MacColl, for whom the smallest variation in the visual array may be important; whereas abstraction applies to 'the modern [who], using his sight for a particular end, abstracts it into a shorthand notation as ruthlessly as any primitive artist'.

> Take as an example the vision of a businessman hurrying to catch a train in the morning, and thinking of his engagements for the day. If one could note down what he sees of the familiar street it would be a vague of space [sic] out of which a few signs of distance, of turning places would emerge, a minimum of signals and recognitions

by which he finds himself guided to the platform of his station. He sees, out of what falls on his retina, what his mind requires of it. Practical, business vision, therefore, is a wild form of impressionism.[13]

Monet was the exemplar of how technique and subject could interact. He matched the *procedures* of painting to modern phenomena: the hurry and the effort of painting, the pressing of that effort up against the limits of the medium; an engagement with extremity and climax; selection, incompleteness and so on. MacColl's book (if not the exhibition it derived from) was within reach of the sophisticated part of the metropolitan readership. New Criticism was advancing philosophical and moral claims for the new French art that made narrative painting look tarnished and stale.

French art would soon come on to the London market in some quantity through the agency of the likes of Durand-Ruel. By the time of MacColl's book, however, the Tate Gallery, already once extended to the rear of the 1897 building, was becoming the focus of an attempt to rewrite the relationship between British art and that of the rest of Europe along largely francophile lines. In the eyes of the New Critics, British art of the kind celebrated by Henry Tate's collection – largely from the Royal Academy – was due for relative devaluation and decline. The Royal Academy, for its supporters, retained the prestige and authority of an ancient body. The stage was therefore set for a radically revised relationship between the Tate and the Royal Academy over what was the legitimate European art of the day. At the same time, the introduction of 'the modern' at Millbank would unsettle the Tate's relationship to the National Gallery – two institutions (still adminstratively linked) which had recently stabilised a division of the cultural continuum around British art at Millbank and European old masters at Trafalgar Square.

MacColl's decisive move was to orchestrate a growing dissatisfaction among the New Critics and their followers against the administration of the Chantrey Bequest, which until this time had been dominated overwhelmingly by an investment in paintings from successive Royal Academy summer exhibitions. Since 1897 Chantrey purchases had been given to the Tate in order to satisfy Chantrey's wish and intention

> that the works of art so purchased ... shall be collected for the purposes of forging and establishing a public national collection of British Fine Art ... in the confident expectation that whenever the collection shall become or be considered of sufficient importance the Government or the country will provide a suitable building or accommodation.[14]

Chantrey's will had indeed specified that purchases be made by the President and Council of the Royal Academy 'for the encouragement of British Fine Art in painting and sculpture', but had by no means insisted that purchases from dealers, private owners, artists outside London and foreigners working in Britain be excluded from consideration. MacColl engineered virtually singlehandedly the House of Lords Select Committee inquiry (headed by Lord Crewe) of 1904,

whose main conclusion – that the Chantrey Bequest should liberalise the selection of works and purchase works by foreign artists – he pressed independently in a series of articles for the *Saturday Review* which were published together as a book in the same year.

It was an effective intervention. Accusing the Chantrey Trustees of 'grave delinquency', MacColl cited Chantrey's original words to the effect that the Trust should purchase works 'of the highest merit in painting and sculpture that can be obtained either already executed or which may hereafter be executed by Artists of any nation Provided such Artists shall have actually resided in Great Britain during the executing and completing of such Works', claiming that foreign artists who had worked in Britain, such as Dalou, Legros, Fantin-Latour, Whistler, Degas, Matthew Maris and Manet – not to mention Pissarro, Monet and Van Gogh – be considered.[15] Here was a reading of Chantrey's wording which attempted to shift the whole balance of the fund's purchasing away from the British artistic establishment and towards the works of younger and less traditional artists 'of any nation', including those working in modern techniques and styles. By targeting the Chantrey Bequest MacColl also brought to light the fact that purchasing funds from government were scarce to the point of virtual non-existence: the Chantrey was a private bequest. MacColl's other line of argument was that Chantrey's will had specified that 'preference shall on all occasions be given to works of the highest merit that can be obtained', which he felt the Academy had not complied with in acquiring works by the likes of 'Joseph Clark, Val Prinsep, Walter Hunt, W. Small, P. H. Calderon, A. Hacker, G. Cockram, L. Rivers, H. S. Hopwood, Mildred Butler, Lucy Kemp-Welsh, A. Glendening, Chas Maundrell and others'.[16] MacColl was straightforward:

> If the Trustees are of opinion that their recent performance in the purchase of Mr Dicksee's Two Crowns (£2000) [Figure 59] fulfills the conditions [of the Bequest], the view is shared by no critic who has a reputation to lose. The Trust is being administered purely to foward exhibitors in current Academy exhibitions.[17]

The majority of the London press subscribed to MacColl's line. The critic Roger Fry used his column in *The Athenaeum* in 1903 and 1904 to press home MacColl's attack.[18] *The Times*, *Contemporary Review*, *Truth*, *The Spectator* and *Magazine of Art* all rallied to the cause, while sympathetic echoes could be heard from the *Westminster Gazette*, *Pall Mall Gazette* and *The Saturday Review*. Following the recommendations of the House of Lords *Report*, the Royal Academy Council the next year appointed two committees to recommend purchases of paintings and sculptures respectively. Yet to judge from the purchases actually made, the argument on behalf of foreign artists had been accepted in letter only; the first works by an artist of foreign birth to be purchased by the Academy were Lucien Pissarro's *All Saints' Church, Hastings* (1918) and *April, Epping* (1894) for £131.5.0 and £157.10.0 respectively in 1934 – and Pissarro had lived for most of his life in England. Otherwise

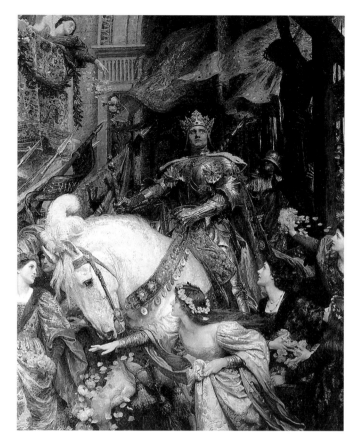

59 Frank Dicksee,
Two Crowns, 1900,
oil on canvas,
231.1 x 184.2 cm.

the style and type of painting purchased under the Chantrey fund was destined to remain more or less unchanged for at least fifty years.[19]

By 1905 or so Post-Impressionism had begun to make its appearance in England. In 1908 the International Society exhibition showed works by Signac, Cross, Denis, Cézanne, Van Gogh, Gauguin and Matisse. The Camden Town Group in London was vigorously championing the new work. But simultaneously, a concern was growing in the London art world over the number of old-master paintings from British collections being sold abroad, particularly to the wealthy American collectors such as Mrs Gardner, P. A. B. Widener, J. P. Morgan, H. C. Frick, W. B. Kickerman, J. G. Johnson, B. Altmann, J. H. McFadden, H. E. Huntingdon and C. P. Huntington, not to mention major foreign museums such as the Kaiser Friedrich Museum in Germany and the Metropolitan Museum in New York; the Harcourt budget of 1894 having introduced death duties on all forms of property, which led owners to divest themselves of works of art rather than submit to tax.[20] A committee set up in 1911 by the National Gallery Trustees under Earl Curzon of Kedleston and consisting of Sir Edgar Vincent (later Lord D'Abernon), Robert H. Benson (a Trustee) and the Director, Sir Charles Holroyd,

quickly found that the problem of retaining old masters ramified into questions of purchasing and display policy, gaps in the national collections, the workings of the Chantrey Bequest and the absence of modern works by 'foreign artists' for permanent exhibition in England, not to mention a suitable gallery in the capital in which to hang them.[21]

Unlike the mid-nineteenth-century government inquiries into audiences, class and conservation, the Curzon Committee had questions of management to settle; questions of the identity of the national collection at a time of military crisis and economic change. The terms of public access to the collections were scarcely discussed. The Curzon Committee when it reported in 1915 concluded that funds for the purchase of 'modern foreign' art by the National Gallery budget (the only source of revenue for the Tate until 1917) were sparse. Curzon's *Report* admitted that in contrast to the policy of other European countries vis-à-vis foreign works of art (including British) 'we in this country appear to possess neither policy nor method'.[22] The terms of Tate's own bequest did not appear to permit such works being hung at Millbank; yet now there was intense pressure for change. The Committee was told in evidence that 'there was no system of acquiring modern foreign paintings in comparison to Germany and other foreign countries' (Sir Sidney Colvin, formerly Keeper of Prints at the British Museum); that there should be 'a separate gallery for modern foreign sculpture and paintings' (Charles Aitken, Director and Keeper at the Tate); that England was 'dangerously isolated … [it was] bad for art that it has not a knowledge of what is really happening on the continent' (the critic Arthur Clutton-Brock); that Barbizon paintings should be purchased because 'they educate taste, but without dragging people away into new fashions and fads of execution' (Sir Walter Armstrong, Director of the National Gallery of Ireland); that the National Gallery should be subsidised 'for the important and pressing task of forming a representative collection of modern British and foreign art' (Roger Fry); and that a separate 'modern foreign' gallery ought to be set up immediately under the directorship of the wealthy young Irish art collector Hugh Lane, to make good the opportunities that had already slipped away (MacColl).[23] MacColl and Fry, particularly, continued to urge radical reform of the Chantrey purchase fund.

The Curzon Committee approached the formation of a 'modern foreign' collection with some caution: 'we have not in our mind any idea of experimentalising by rash purchase in the occasionally ill-disciplined productions of some contemporaneous continental schools, whose work might exercise a disturbing and even deleterious influence upon our younger painters' - a reference to Italian and Russian Futurism, French Cubism, and 'primitivism' of every shade. 'But the opposite theory that no foreign art of the present day is worthy of purchase is one which it is impossible to sustain', said Curzon's *Report*.[24] It was an attractive compromise, and one which seemed to open the door to foreign purchases without the burden of a commitment to contemporary art. It reflected Walter Armstrong's evidence: he was 'suspicious' of the sort of picture being produced in France and

Germany, but felt 'there ought to be a certain number, just to act as a stimulus, and let people see what foreigners are doing, but I do not think a great, separate gallery filled with specimens of Continental art would be a good thing for our art'.[25] In the light of such opinion, the *Report*'s conclusion that the formation of a 'modern foreign' collection was 'not merely a duty imposed upon us by the wise example of foreign countries, but … also essential to the artistic development of the nation',[26] might conceivably gratify the old guard as well as the new.

Yet clearly there was a problem about the purchase of German paintings in the midst of military hostilities. Thus the *Report*'s list of artists 'unrepresented in the National Gallery' were mostly early and mid nineteenth-century French names, of which Manet, Monet, Degas and Daumier were the youngest. MacColl, having given evidence to the Curzon inquiry, published his own conclusions independently in the same year; arguing against the acquisition of more old masters for Trafalgar Square and in favour of more selective and nationally segregated displays – Italian and Spanish at Trafalgar Square, Flemish, German and Dutch at the National Portrait Gallery, and British at the Tate. 'The French School would then fall to the Keeper of the Modern Foreign Gallery', argued MacColl, 'an independent establishment with a building and Keeper of its own'.[27] It was another step towards the canonisation of French art as the only serious art of the mid and later nineteenth century – MacColl mentions Millet, Daumier, Monticelli, Monet, Degas and Ingres, to add to the names of Delacroix and Ricard which he had given in his evidence to the Committee.[28]

What is significant about this debate is that the dynamic of progressive taste in art is already dovetailing neatly with events on the international stage: between the beginning and end of the Curzon Committee's work the war with Germany had erupted, bringing pro-French and anti-German sentiments to the fore. Diplomatically the process had been gathering steam for some time: the Anglo-French *entente* of 1904, followed by an *entente* with Russia against the Triple Alliance of Germany, Austria and Italy. Diplomatic crises in the Balkans and in Morocco, and the heightening of tension in a Europe divided by the growth of national stereotypes, had given impetus to the trend. The state in the form of its civil service clearly needed to manage such a development and give it cultural form.[29] By 1915 the momentum towards the assembling of a new collection seemed irresistible. Yet a problem addressed in the Curzon *Report* was that potential donors of 'modern foreign' works were being deterred by the lack of any gallery in London in which to put them – a government purchase grant was not, given the war situation, expected. The best that could be hoped for was a further extension of the Tate rearwards from the river, initially housing 'modern foreign' pictures from Trafalgar Square and the Victoria and Albert Museum, in the expectation that donors of other paintings and sculptures might come forward. The *Report* further speculated that ultimately a 'modern foreign' collection might assume such importance as to justify moving it to a separate and independent building, in which case the new extension at Millbank would revert to becoming

a gallery for British art (it would take nearly a century for that to occur). 'The only alternative to this suggestion', the *Report* concluded, 'is that some wealthy lover of the arts should be found who will relieve us of the responsibility of providing the funds for the erection of a modern foreign gallery'.[30]

Hugh Lane, Joseph Duveen and the plan for a new gallery

Two events now occurred that had a momentous impact upon the development of art in London and played directly into the hands of the National Gallery Trustees. The first of these was the torpedoeing by German U-boats of the *Lusitania* on its return from New York on 7 May 1915, bringing with it the death of the wealthy young Irish collector Hugh Lane, who in 1903 had helped initiate the exhibiting of modern art in Dublin and had in 1912 given a group of 39 paintings to the Corporation of Dublin on condition that 'a new and suitable' gallery be provided. Following disagreements about the funding of a building, Lane had sent his collection to be established in London in an effort to make the Dublin Corporation see sense, backing the loan by a new will dated 11 October 1913 bequeathing the pictures 'to found a Collection of Modern Continental Art in London'.[31] A date had been set – 20 January 1914 – for the pictures to open to the public in a room set aside in Trafalgar Square. The National Gallery, however, refused to exhibit all the pictures without a legally drafted bequest, and over half the pictures remained in store for several years – Lane had again felt mistreated.

Lane was already well known in both Dublin and London and formed part of the circle of George Moore, Orpen, Tonks, Wilson Steer, Sickert and MacColl; they can be seen together in Orpen's 1909 painting, now in Manchester (Plate 10), which pays homage to Manet through his portrait of Eva Gonzales, already in the Lane collection following its purchase from Durand-Ruel in 1906. Lane's collection of paintings by Renoir, Camille Pissarro and others was exemplary and unique. Yet his untimely death now precipitated a lengthy and bitter feud. Lane's sympathies for Dublin had returned following the Trafalgar Square debacle, and by a codicil of 3 February 1915 he had requested that his pictures go not to London but to Dublin: however the codicil had been signed but not witnessed, and on Lane's death its validity was immediately contested.[32] An Irish group including Lady Gregory and W. B. Yeats began to press the Dublin case; yet it was strenuously argued by Lord Curzon of the National Gallery Trustees, following legal advice, that the Irish argument was null and void. The *Report* of Curzon's own Committee clearly had Lane (at least) in mind in speaking of 'some wealthy lover of the arts' who might come forward as a patron. Against vigorous opposition from Dublin and the Irish supporters in London, English francophile modernists such as Aitken, MacColl, Witt (and Curzon himself) spared no efforts to keep the pictures in the English capital for subsequent permanent exhibition.[33]

A second development was equally in line with the spirit and wording of the Curzon *Report*. The young collector and dealer Joseph Duveen had already

mentioned his interest in funding a gallery for 'modern foreign' art at the time of the opening of the Turner Galleries at the Tate in 1910 – the Galleries had been provided by his father Joseph Joel Duveen. He had mentioned it to Lord Esher, Charles Holroyd, Lewis Harcourt and MacColl, so that the possibility of a new building was already semi-public knowledge, at least within the Curzon group.

A little biography will help resuscitate an almost forgotten figure (Figure 60). Born to a family of art dealers headed by his father Joel, who had died in 1910

60 Sir Joseph Duveen (1869-1939) and his wife Elsie, née Salamon (1881-1963), photographed by Kazamian, c. 1912.

shortly before the opening of the Turner rooms, Joseph had been sent to America in 1886 at the age of 17 to work for his brother Henry. He had assisted in the servicing of America's wealthy new patrons with valuable paintings and works of art from European collections: as Behrmann notes in his biography, it was Joseph Duveen who first noticed that Europe had many paintings and America much money[34] – the Harcourt budget already mentioned forced them increasingly on to the market. A mixture of hard-headed business drive and a charismatic personality had made Duveen successful with the Fricks, the Mellons and others. Frequently accused of over-restoring, attributing works to invented artists and even fraud, Duveen was by all accounts determined not merely to dominate the family dynasty but – like William Roscoe and other patrons before him – to become the Lorenzo de Medici of his day.[35]

With the impetus added by the Curzon *Report* and with the opportunity suggested by Hugh Lane's demise, Duveen was now ready to agree the terms under which he would endow a new extension to the Tate specifically for 'modern foreign' art. He wrote to the Chairman of the National Gallery Trustees, Lord D'Abernon, from New York in August 1916, stating his pleasure in D'Abernon's acceptance of his plan, 'especially in such times as those we are now passing through'. 'Contemporary foreign art is not well represented in England', Duveen emphasised, 'and I am very anxious to have this remedied'. But Duveen stipulated that his name 'should not be mentioned in connection with the new gallery scheme whilst there is enemy occupation in any part of France or Belgium' – a stipulation repeated in a further letter to the National Gallery Board written from his suite at Claridge's on 3 November 1916 at the time the agreement was finally signed.[36] Duveen himself was made an Associate of the Gallery – along with Lady Tate and Mrs Watts – with the formation of a separate Tate Gallery Board of Trustees in May 1917.

By this date a plan was being formulated by the Trustees indicating the period to be covered by a gallery of 'modern foreign' painting and the extent of pictures already available. The document in question (undated but perhaps of early 1917) effectively canonises modern art as predominantly and almost exclusively French. Artists who died after 1820 were to be included, divided into four periods: the David period, the Romantics, the Impressionists and the Post-Impressionists. On the basis of a nucleus of 119 oil paintings and 31 watercolours and drawings from the Salting and Lane bequests – overwhelmingly French, plus Goya – the Trustees now drew up a list of painters 'unrepresented, or at present inadequately represented ... whose work it would be desirable to secure for the new Gallery'. To 5 Belgians, 2 Danes, 10 Germans, 10 Dutchmen, 3 Italians, 2 Norwegians and Swedes, 5 Spaniards, 2 Swiss and no Russians (unsurprising given the alarm of the British establishment at 'Bolshevist insanity') were added no less than 85 French artists from the early nineteenth century down to the generation of Boudin, Degas, Monet, Renoir, Pissarro, Signac and Seurat – even Picasso appears in the French list.[37] Now, with the end of hostilities in 1918 and in the midst of the complex diplomatic situation opened up by the preparation of the Versailles Peace Treaty, the

New Critics' advocacy for French pictures dovetailed exactly with a national mood in favour of France and antagonistic to the Germans. A Tate Gallery statement of 1918 made the matter clear enough:

> Mr Duveen's gift at the present moment is particularly well-timed as it marks the increasing unity of the Allied Nations, for with the exception of neutral Holland, when we speak of modern foreign art, it is predominantly of the paintings and sculptures of our allies and above all of the French that we are thinking.[38]

Forming a canon of 'modern' art

That was only the first step in the creation of both a gallery and an audience for modern art. It has been asserted already that the 'modern foreign' pictures assembled at the Tate after 1918 gave an ordering of modern art predominantly if not consistently centred upon France (the exception was the Drucker Bequest of Dutch pictures which had been given in 1910). To the Salting Bequest of Barbizon paintings, also given in 1910, were added works by Ingres, Delacroix, Monet and Forain from the Degas sale in 1918. The Lane Bequest (as it was contentiously called) supplied pictures which with the exception of works by Jongkind, Madrazo, Mancini, Jacob Maris and Alfred Stevens were all from France: Barye, Bonvin, Boudin, John Lewis Brown, Corot, Courbet, Daubigny, Daumier, Degas, de la Pena, Fantin-Latour, Forain, Fromentin, Gérôme, Ingres, Manet, Monet, Monticelli, Pissarro, Puvis de Chavannes, Renoir, Rousseau and Vuillard. To these were added two Gauguins, one presented by the Contemporary Art Society in 1917 and the other by Duveen in 1919[39] – the list shows how canonical those names were becoming and yet how abruptly the canon stopped short of the more adventurous and problematic productions of Matisse, Picasso and Braque.

At the same time, the Samuel Courtauld gift of £50,000 to the Tate Gallery in 1923 represents a further instance of well-to-do entrepreneurial patronage that explictly asserted the stylistic superiority of French art and made a certain reading of its principal artists canonical in the early 1920s. Since at least the time of his appointment as joint managing director of the very successful international family textile firm in 1917 (he was appointed chairman in 1921), Courtauld had developed beliefs about the efficacy of art in the business world that were not dissimilar from those of nineteenth-century industrialists with a philanthropic approach to art. Like Henry Tate, Courtauld and his parents were Unitarians, in whom had been born a belief in progressive self-enlightenment combined with public duty. At the foundation of this thinking was the conviction that outright materialism (the profit motive) was harmful on its own: both monopolistic capitalism and socialism were to be abhored.

Equally, Courtauld was concerned at what he believed to be a low level of artistic awareness among the English middle and lower classes. In his later years as an industrial grandee (Figure 61) Courtauld reflected how the Parisian working class

on a Sunday afternoon at the Louvre could be 'shrewd' in discussion and knowl-
edgeable about pictures, while a comparable British crowd would talk only about
subject matter and anecdote.[40] Art of a certain kind, for Courtauld, was backed by
claims of universalising relevance and efficacy, and could in the best circumstances
function as a kind of balm: 'the most civilising influence which mankind has ever
known ... it is universal and eternal; it ties race to race, and epoch to epoch. It over-
leaps divisions, and unites men in one all-embracing and disinterested and living
pursuit',[41] resulting eventually (here he echoes Redgrave and Cole) in an improve-
ment in design and the industrial process.

From the earliest days, Courtauld's tastes in paintings centred upon French art
of the late nineteenth century to the virtual exclusion of other schools. He wrote
how, on return from his first visit to Italy (and after his second in 1901), it had
seemed to him that 'British art had died. I felt nothing but artificiality and con-
vention, and could detect no progress in technique'.[42] Even by that time his tastes
were for early and mid-period Impressionism (in Renoir's case nothing after 1880),
with selections from Post-Impressionist art up to and including Cézanne. By the

61 Samuel Courtauld
IV, July 1936.
Photograph by
Barry Finch.

time of his 1923 gift Courtauld had evolved a view of the grand procession of
European art history according to which it marched directly from the Italian old
masters to the French Impressionists and Post-Impressionists with precious little
between or afterwards. As Courtauld said in a covering letter to Charles Aitken,
by that time Director of the Tate, 'In my own mind the central men of the move-
ment are Manet, Renoir, Degas, Cézanne, Monet, Gauguin and Van Gogh'. An
appended list, representing 'the modern movement from its inception to the pre-
sent time', mentioned 35 artists from Chardin through Géricault and Delacroix to
the Post-Impressionists and finally Picasso and Matisse – though as Courtauld
recognised, 'the fund will not be large enough to secure examples of them all'.[43]
At the same time, Courtauld's tastes drew much from the formalist tendencies of
the Bloomsbury group and its critical champions, Clive Bell and Roger Fry; yet
while Fry confined his most powerful advocacy to the Post-Impressionists,
Courtauld's preferences stopped short of the wilder shores of Cézannism which
Fry so famously espoused.[44] 'They [the Impressionists] have taught me to see
nature in pictures and pictures in nature, and I have derived infinite pleasure from
this', Courtauld later wrote.[45] Manet's *La Servante de Bocks* of 1878 or 1879, pur-
chased from Knoedlers for £10,000, was one of the Fund's earliest and most
expensive aquisitions. Seurat's *Bathers at Asnières* of 1883–84 (Figure 62) was
another. In practice, the Fund did not extend to all 35 artists listed in the Trust
Deed but still managed to acquire major works by 'the men of the movement',
namely Manet, Monet, Renoir, Degas, Sisley, Pissarro, Seurat, Cézanne, Van
Gogh, Utrillo, Bonnard and Toulouse-Lautrec.[46]

Other personalities played their parts too, and their preferences form vital ele-
ments of the Tate's outlook upon foreign art in the period leading up to the open-
ing of the new Modern Foreign and Sargent galleries in June 1926. There is the
spinsterish, celibate Aitken, New English Art Club member and Keeper at the

62 Georges Seurat,
Bathers at Asnières,
1883–84,
oil on canvas,
201 x 300 cm
(Courtauld Fund).

Tate in succession to MacColl: 'prim in manner, he might well have been mistaken for a church warden ... he did not like anything that was contemporary or foreign; his taste was for the crucifixion and the annunciation of the early Italian painters, and the Pre-Raphaelites'.[47] This was the man whom James Bolivar Manson sought to convert to Impressionism (and some Post-Impressionism) after the latter's appointment as assistant at the Tate in 1912 – and who remained aesthetically loyal to his younger painter-colleague throughout the period leading up to the opening of the Modern Foreign wing. Kenneth Clark probably overstates the case in saying that in the 1920s and early 1930s Aitken and Manson 'set their faces against all Post-Impressionist painting, and did their best to prevent such pictures entering the Gallery, even as gifts'.[48] In a text of 1926 Aitken claimed that he wanted to steer 'a discreet *via media*' between the 'right' and 'left' wings of opinion, between the view that 'dangerous modern experiments are being encouraged', and the view that 'interesting developments are not being adequately handled'.[49]

A more important figure was Manson himself (Figure 63). He had gone as a painter to Heatherley's, the Lambeth School of Art and the Académie Julian in Paris, had met Lucien Pissarro in London in 1910 and joined Sickert's Fitzroy

63 James Bolivar Manson, *Self Portrait*, 1912, oil on canvas, 50.8 x 40.7 cm.

Street group, then the Camden Town Group and the London Group, became Assistant Keeper at the Tate in 1917 and finally founded the 'Monarro' group (from the names of Monet and Pissarro) in 1919.[50] He exhibited at the Leicester and Wildenstein galleries and the New English Art Club, and was a competent if unwavering Impressionist painter in the English manner: he never went as far as to admire Cubism. In a guide to the collection published in 1926, Manson would acknowledge the familiar narrative that British art stretched from Hogarth through Blake and Constable to the Pre-Raphaelites, followed by such later nineteenth-century painters as Orchardson, Clausen, Leighton, Poynter, Waterhouse and Legros. However, for Manson this development involved a fall from grace – and an increasing disregard of the effects of light and shade. 'There is a romantic quality and a certain carelessness in English painting ... a vigorous breadth ... the English, generally speaking, are too impatient to practice the more precise and careful detail of the Dutch.'[51]

By Constable or Crome's standards of bucolic informality artists such as Holman Hunt and Lord Leighton came off badly in Manson's account: Hunt was 'not a good artist ... stodgy, heavy and dull, never clear-cut and decisive', while in Leighton there was 'no artistic merit ... [only] relentless power of rendering what is called finish ... sickly prettiness not surpassed even by ... Bouguereau'.[52] About Orchardson Manson said that his art resulted

> from his patron's demand for sentiment ... no changes of mood, no variety of technique ... not enough essential realism to stir even the ghost of an emotion ... the chief purchasers of pictures at the time were rich merchants and manufacturers, who still enjoyed the fruits of the peace and prosperity of the Victorian era'.[53]

The key distinction for Manson was between 'painting picturesque scenes to illustrate interesting stories according to a definite formula' (English art) and the realisation – matchlessly exemplified by the Impressionists in France and a handful of their English precursors – that 'the aim of the artist is to express his own personal emotion', the signal discovery that led to the real 'awakening of modern art'. And yet the English accommodation to modernism needed to be one of cautious good judgement in the face of continental excess and exuberance. The wilder and more recent kind of artist – Cézanne and Van Gogh – take as their purpose 'the expression of emotion aroused ... by the contemplation of nature'; in them it is 'purely modern feeling ... the direct expression of life [in which] technique and intuition are ... inseparable'. But for Manson this would ultimately remain a continental task. 'No English painter could have discovered Impressionism or invented Cubism'.[54]

France as a 'supplement'

The opening of the Modern Foreign galleries at the Tate Gallery on 26 June 1926 expressed the insertion of French modern art into British cultural life at the

officially sanctioned level of the national institution, the state and the monarch: yet the nature of that *entente* needs making plain. Since Lane's pictures could not be put on show because the case was still allegedly *sub judice* – even though a House of Lords Committee had in fact already prepared a report – a loan collection was quickly assembled including works owned by Fry, Clive Bell, John Maynard Keynes, Sir Michael Sadler, W. Burrell and the Davies sisters. Some works from the Courtauld Fund were put on display. For this temporary show the Impressionist canon was extended to Post-Impressionism and beyond: from his own collection Courtauld contributed Marchand's *Saint-Paul* of 1921 (a small Cézannist landscape that stood out from the rest of his purchases). There were works by Derain, Gauguin, Seurat, Matisse, Van Gogh, even a single Picasso *Still Life* from the collection of Clive Bell. Sculpture by Rodin and Degas, and a substantial drawings display, were added.[55] A statement released to the press shortly before the opening had promised that when complete, 'London will possess one of the largest art galleries in Europe ... and the largest gallery in the world devoted to modern art'.[56] Notes written for the guests themselves elided the terms 'modern foreign' and 'recent ... continental art',[57] suggesting 'modern art' to be not only European but virtually equivalent to that of the French.

Having shown the King and Queen round the new galleries (Figure 64), the company assembled in the Turner galleries (Room VI) for the official speeches – the scene was painted twice at Duveen's request by John Lavery (Plate 11).[58] Chairman of the Tate Trustees Lord D'Abernon read an address, probably drafted for him by MacColl, in which he said that 'for many years the masters of the later continental schools and preeminently the French painters and sculptors of the nineteenth century had been calling for representation'. D'Abernon referred to the gift of Samuel Courtauld, 'who had not hesitated to pay the ransom for deficiencies in the past' and had now 'supplied students with examples of certain artists

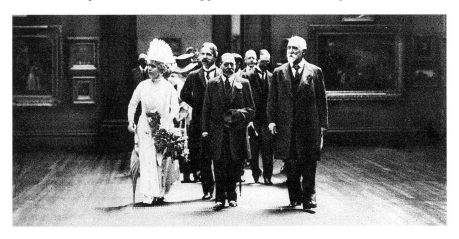

64 Opening of the Modern Foreign and Sargent galleries, Tate Gallery, 1926: the King and Queen, accompanied by Lord D'Abernon.

who, despised and rejected in their lifetime, have peculiarly interested the present generation'.[59] But it was the King himself who gave voice to a central axis of the new relationship, when he spoke of 'the satisfactory completion of the British collection, and the timely addition of the Continental masters'. The King described the new galleries as 'a very welcome and necessary undertaking ... the establishment in London of a permanent collection of fine pictures by the great Continental painters cannot fail in many ways to exercise a beneficial influence'. The Tate collection, not yet 30 years old, 'can now be regarded as so fully representative of modern British art that the Trustees feel justified in supplementing it with a collection of paintings of modern schools in foreign countries'.[60] The *imprimatur* bestowed by royalty is the important ingredient here. 'Supplement' lies close to the dictionary definition of 'a part added to complete a ... work', 'something added to supply a deficiency'; but also 'an auxiliary means, an aid' – a double term that captures effectively the role of continental art vis-à-vis the British. 'Foreign', too, interestingly inhabits a bipartite term: both 'proceeding from other persons or things', 'not of one's family', but also 'alien in character ... irrelevant, dissimilar, inappropriate ... not belonging to the place in which it is found'.[61]

It was a duplicity captured efficiently by the architecture too. In a further metaphor, *The Times* reported that the new galleries 'lie beyond' and 'communicate with' the galleries erected by Tate and Joel Duveen[62] – a supportive yet supernumerary function that is graphically echoed in successive plans for the galleries. An 'evolutionary' hang, either 'on-the-line' within single rooms or providing a sequence for the gallery as a whole, had by the early 1920s become standard in both the National Gallery and the Tate (transported from French and German practice of more than 60 years before). A kind of pre-script for an evolutionary chronology had been written into the enlarged Tate Gallery of 1899-1910, pulling apart the individual collections in favour of a chronology of British art from Fuseli and Blake to the later nineteenth century; but the first unabashedly chronological script had been deployed at Millbank once the pictures were back from wartime storage in the tunnels of the London Underground in 1921. It provided a layout later officially described as a 'fully chronological survey round the edge of the gallery' of English art from Gainsborough and Hogarth through later nineteenth-century art to 'contemporary' paintings, sculpture and drawings (Figure 65).[63] Here for the first time was a museal 'text' for British art history in the form of a processional route unfolding clockwise through the building, coeval with the physical compass of the Gallery and with the viewer's likely encounter with it.

To this basic historical chronology three smaller 'supplements' to this route are already visible on the 1921 plan: sculpture, (room XVI), a refreshment room at the basement level in the Gallery's centre, and the Turner Wing containing Turner's paintings and a now single 'Modern Foreign School' room (VIII) leading from (and returning to) a small display of Rossetti and Burne-Jones on the north-western corner of the building. Since its completion in 1910 the Turner Wing had leapt off from a group of mid-nineteenth-century drawings, paintings and watercolours.

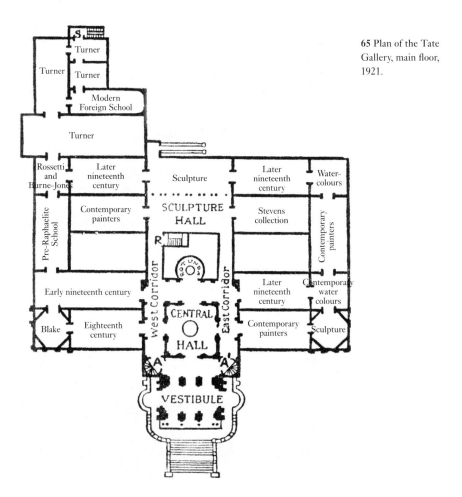

65 Plan of the Tate Gallery, main floor, 1921.

By 1921 Turner and his 'modern foreign' confrères appear as additional to, yet part of, the great pageant of British painting unfolding from Gainsborough and Hogarth to the modern day: Rossetti and Burne-Jones were two artists who by 1921 were widely seen as constituting a kind of cul-de-sac into which British painting had run technically in the 1860s, and from which Turner and the 'moderns' provided a temporary escape. Having seen how Turner and 'modern foreign' painting strayed into technical experiment conducted in the open air, the visitor could be reintroduced to the sturdier spectacle of later British nineteenth-century art, aware, perhaps, not only of its limitations but of the dangers of exceeding those limitations by going 'too far'.

What occurred with the opening of the 'Modern Foreign' galleries in Millbank's north-west corner in 1926 – the temporary loan collection was replaced in October of that year with the Gallery's own works – was a deepening of the museal unconscious established in 1921: not just Turner and a handful of foreign

painters, but an entire suite of Turner rooms opening out onto a 'Modern Foreign' suite of three galleries capped by a single Sargent room, also donated by Duveen and housing *inter alia* the 1922 gift by Alfred Wertheimer of paintings by Sargent, at the very furthest stage (Figure 66). Now, the 'supplemental' additions to the great pageant of British art were in place. Even though the basic linearity of British art was emphasised repeatedly – the visitor could 'follow the course of British art from Hogarth to the present day' in 'a continuous outer line'[64] – it was now supplemented at least twice: once by Turner, and for a second time by the French modern masters whom Turner by implication had inspired (Figure 67).[65]

Those relationships of identity and difference were celebrated in various ways. *The Times* took it upon itself to make a general point:

> Nobody can pass through the British rooms at the Tate Gallery to the new foreign section without seeing that, allowing for the increased cosmopolitanism of art throughout the world, British art has well marked characters. Broadly, in landscape and in figure painting, they amount to an emphasis upon subject interest. Whether or not these [British] characters are 'artistic' is an idle question. They are ours; and if the opportunity for comparison afforded by the foreign section drives home the truth that, in the long run … British art gains when its characters are accepted and loses when they are self-consciously avoided, a very useful purpose will be served. In any case the broader view cannot fail to stimulate interest in British art'.[66]

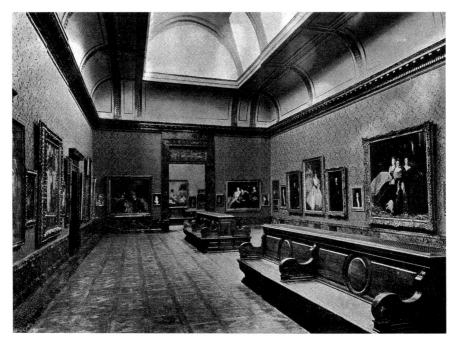

66 Tate Gallery: Modern Foreign and Sargent galleries (Sargent Gallery, Room XIV, looking towards the Modern Foreign Galleries), 1926.

Above all, the diplomatic view taken of the French needed to converge, at least, with the cultural. The military *entente* signed between Britain and France in April 1904 had been strikingly successful. Wartime alliance, despite regular diplomatic disagreements, had held sufficiently well to last until the unified command under Foch of March 1918. After Versailles and at least up to the settlement of the disputed Rhineland territories in 1925, relations between France and Britain had remained firm in the face of suspicions on both sides. Britain had been generally for loose interpretation of the Versailles conditions, especially those relating to reparations payments, while France was always insistent on a firm line. 'Collusion' between Britain and Germany was sometimes claimed; yet the prior need was always to remain vigilant about Germany's longerterm aims.[67] So while it cannot be stated that Anglo-French diplomatic relations were always unblemished, the wider culture already contained enough caricatures of the national eccentricities of the three nations to make certain kinds of comparison inevitable. The Armistice had encouraged a negative view taken of German modernism in general and Expressionism in particular (the art of Scandinavia, Switzerland, Spain, Belgium and Russia lay well outside the frame). But to look at

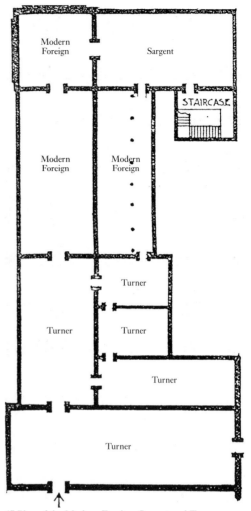

67 Plan of the Modern Foreign, Sargent and Turner galleries, Tate Gallery, 1926.

Lord Curzon's interventions or Lord D'Abernon's is to observe a gradual knitting together of *realpolitik* with the cultural sphere. Curzon had been Parliamentary Under-secretary for Foreign Affairs under Lord Salisbury, Viceroy of India, Chancellor of Oxford University, Leader of the Lords and Foreign Secretary, before being narrowly passed over when Baldwin became Prime Minister in 1923. In D'Abernon's words, he was

> born grandiloquent ... dignified, ostentatious, ... an aristocrat of the English eighteenth century ... [who] already spoke like a Prime Minister when still an undergraduate ... [and whose report on the National Gallery] constitutes an epitome of all that administrative wisdom and an instructed taste could suggest.[68]

D'Abernon himself was Ambassador to Germany from 1920 to 1926 after a career in politics and diplomacy, and handled the reparations negotiations and the Treaty of Locarno in 1925, which settled the question of French security after years of lingering post-Versailles animosity from the Germans. D'Abernon had been close to 'the Souls', an intellectual group of the 1890s comprising Arthur Balfour and George Curzon (its leaders), Margot Tennant, Haldane, George Wyndham and Henry Cust, possessed of 'a passion for education and reading – an appreciation of verbal felicity – enjoyment of literary style – affinity to French culture – a taste for introspection and self-analysis'.[69] It was a group which, in common with the Crabbet Club, had in its heyday glorified in after-dinner sophistry and brilliant conversation against the conventional grain. Yet imperialists and Tories its members mostly were; and in their later careers came to wield enormous power and influence in government, the civil service and the cultural world.[70] The domination by Lords Curzon and D'Abernon of the Government committees on art and of the Boards of Trustees at Trafalgar Square and Millbank had made them, in effect, the real power-brokers of post-war British art.

D'Abernon in particular came to hold a view of French culture *vis-à-vis* the British which chimed exactly with the imperatives of the 'modern foreign' project at Millbank. In applied arts as well as fine, they had a gift for the 'light and fanciful, the graces of life, the intimate scene'; the two nations together have a 'peculiar reciprocal trust'. The Germans, on the other hand, were unattractive but great. The French have suavity and grace. The Germans were sturdy, hardworking, thorough, earnest plodders; nature-loving and sporting, they took copious libations, possessed a predilection for discipline and precision, and were tolerant of pain (they needed less anaesthetic than the English); they were erudite, lacking in political instinct, naturally envious, mentally encylopaedic, exhaustively thorough, dry, objective: they were 'reliable and Doric', as D'Abernon finally puts it. As for the French, 'there is no nation in the world that better knows how to enjoy life; perhaps another way of saying that there is no nation more intelligent'. They are more civilised, more logical, more given to finesse and irony, have 'supreme manners'; they have refinement; are amused by immorality (when not actually immoral themselves); they are also instinctive and pleasure-seeking, and have a 'feminine bias in the French nature, a bias which pervades their whole attitude to life'.

> Self-satisfaction is so natural in them as to cease to be offensive; there is no bravado; no assumption; merely the recognition of their own conviction of superiority. In the cult of Narcissus they are past masters, and we have much to learn from them. [They are] ... blithely and justifiably free of interest in other countries. Why trouble about what less polite, less cultivated nations have done or are doing? Is not Paris the centre of light for the universe?

As for the British, D'Abernon needed merely to say that his countrymen 'have a vague consciousness that together [with France] we stand for the strongest

elements of European culture and civilisation', borne of the knowledge that we have been 'fighting on the same battlefields since the eleventh century'.[71]

An audience for modern art?

So far as the public for modern art is concerned, matters are considerably more complex. In the first place there is little documentary evidence of exactly who visited the Tate Gallery in 1926 or what they saw or felt once there. On the other hand a variety of texts can be assembled that reveal how far the constitution of a London art public had evolved since 1897. These texts are various and contradictory: from them one can deduce a conflicting play of expectations, demands and self-identifictions, from which several publics within the middle and upper classes begin tentatively to emerge.

It should be remembered that not all published opinions on modern art were enthusiastic or even temperate. To the *Morning Post* the Tate was a 'a dump for work of those addicted to isms of internation art anarchy', while patrons and collectors like Sir Michael Sadler or Lord Henry Bentinck were part of a 'precious bolshie art set'.[72] 'If the artist does not paint for the public, for whom does he paint?' asked the *Morning Post* in 1923:

> today the walls of picture galleries are defaced with graphic abberations which are not pictures, and which are not art. They have nothing to do with art. They are destitute alike of drawing, design, and true colour. They are extremely ugly, and sometimes worse than ugly. But the public are told by persons who assert their authority that these horrible objects are the fashion. Hence the public declines to buy any pictures at all. They will not waste their money on futurist, jazz, cubist, and other forms of insanity ... the degradation which has befallen British art is appalling to contemplate ... It is of no use to try to cast the blame on the foreign eccentrics, Gauguin and Matisse and the rest of the Bolsheviks in art. They have nothing to do with England; and English artists have never yet achieved any good by imitating foreign fashions, which are derided even in their country of origins ... It is impossible to paint a state of mind; though the enterprise is frequently attempted in lunatic asylums, as any mental specialist will testify. Our Bolshevist practioners would find it greatly to the benefit of their health to dig in the garden, or break stones, or do anything else in the open air which was both honest and fatiguing.[73]

Morning Post aesthetics were evidently familiar to E. Wake Cook, who followed his 1904 book *Anarchy in Art and Chaos in Criticism* with a new critique entitled *Retrogression in Art and the Suicide of the Royal Academy* (1924). Cook, who had been founder of the Victorian Artists' Society and Secretary of the Royal British-Colonial Society of Artists, fulminated splenetically against the 'Inversionists', 'Newists' and others (mostly members of the New English Art Club) whom he accused of encouraging fashionable and even degenerate work. The reader may be entertained by Cook's description of an 'Inversionist':

When once a person gets caught in the whirl of 'Modernity' he has partaken of 'the insane root that takes the reason prisoner', and 'fair is foul, and foul is fair' to these Inversionists. The pathological aspect of such abnormal tastes is like those cases shown by Dr. Soltau Fenwick quoted in the *Morning Post*, where people eat paper, hair, thread, varnish, polish, mud, clay, soot, sand, glass, and live fish. There have been dirt-eating epidemics, as described by Hunter; and the Inversionists who prefer mud to colour, and deformity (bad drawing) to beauty, are equally abnormal. Then there is Satanism and the Black Mass by the Inversionist in religion; and the burlesqueing of all things hitherto held sacred, by the Bolsheviks in Russia. All these are forms of the same disease.[74]

Of course, when the *Morning Post* lambasted 'anarchy' or when Wake Cook insisted that gallery directors exhibiting 'deformities' should be given 'half a century's leave of absence to recover their normality', each was using colourful rhetoric much closer to everyday speech (and much less vunerable to libel) than would be acceptable now. But the close correspondence between the views of a very conservative middle and lower-middle-class newspaper and a cantankerous *retardataire* watercolourist demonstrates an important cross-class alliance against the freedoms of modern art. Importantly, a less extreme version of that alliance could be easily detected within the Royal Academy of Arts. Following a degree of liberalisation between 1921 and 1924 at the hands of Sir Aston Webb, Frank Dicksee, already a beneficiary of the Chantrey Bequest and President of the Royal Academy from 1924 to 1928, pulled in the reins once more to counsel a frankly imperialist approach to the practice of art. 'You of the British race, do not consent to be dragged by the heels behind continental dealers', he urged the Academy's students in 1925; the best works of art of the past 'are surely better guides than those false prophets who cry aloud to Baal'. Identifying true art with 'inner spirit' and erecting standards of 'absolute beauty' based on classical and high Renaissance masters, Dicksee chastised artistic 'primitivism' that came from the era of the cave-dwellers to find its contemporary expression in modern 'foreign' art from Van Gogh to Cézanne:

> Our ideal of beauty must be the white man's; the Hottentot Venus has no charms for us, and the elaborate tattooing of the New Zealand Maoris does not, to our thinking, enhance the beauty of the human form; so in spite of some modern tendencies, if we have to bear 'the white man's burden', in Heaven's name let us at least keep his ideals![75]

Dicksee at least recognised that the recent world war had constituted a 'ruthless mutilation' on the face of civilisation, and that for some it had issued in calls for new standards of beauty to correct the perceived prettiness of some Victorian art. Yet by 1927, the year following the launching of the new galleries at the Tate, he was repeating his counsel that 'deviating from nature' was 'morbid', 'unwholesome' and 'contorted', proclaiming that the new order of beauty 'founded on a negroid or other barbaric type' was akin to an 'unclean presence' or 'miasma' that 'has been spread around [and] from which it is difficult to escape – it affects the temperature, and in the sum of things lowers the average'.[76]

Like Wake Cook, Dicksee was an establishment figure who knew that his voice was being heard. The Royal Academy particularly could be likened to a public platform from which important pronouncements could be made (Figure 68). As he put it in a toast preceding the 1927 Academy Dinner, 'we have always found … the greatest in the land at this table, representing the Sovereign, the State in all its many Departments, distinguished representatives of foreign Nations and the leaders in all the Arts and Sciences and mental activities that contribute to the age in which we live'.[77] Dicksee clearly knew that the sovereign had opened the Tate's modern galleries the previous year. The point is that two establishments in British culture were now in existence; two major institutions with their own methods of articulation and appeal, each intent on garnering an audience and instructing that audience in generally divergent ways; a higher and modernist audience predominantly from the educated upper middle class, and a residual and larger – but arguable less powerful – lower audience formed out of an alliance of plain men, patriots, imperialists and political traditionalists whose first duty was to 'the countryside', to 'England', and to 'the nation'.

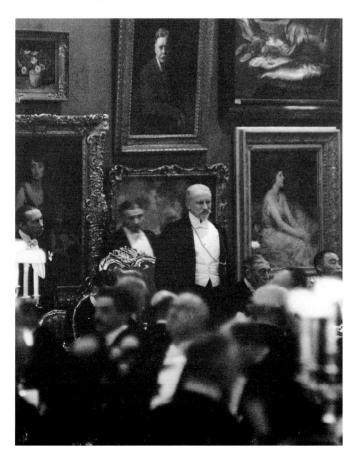

68 Sir Frank Dicksee, President, speaking at the Royal Academy Dinner, 2 May 1925, photograph.

Native Englishmen and visitors alike were seemingly obsessed in the early years of the 1920s by what England had become within a rapidly modernised and still modernising world. Anxiety about the particular survival of the 'English character' could take an overtly nostalgic, idealising form. From George Santayana's *Soliloquies in England* (1922) through Stanley Baldwin's prime-ministerial *On England* (1926) to J. B. Priestley's *Good Companions* (1930) or his *English Journey* (1934) the nation was reminded of characterisations of Englishness that for that lower and plainer constituency had an enduring appeal. They ranged from Santayana's defence of the Englishman's snobbery, caution, simplicity and cleanliness – his 'weather in the soul' – to Baldwin's passionate conservatism, his love of moderation and the Worcestershire countryside, to Priestley's middlebrow tales of ordinary folk and their suspicions of the city, of trade, of artistic sophistication in any form.[78] Above all, according to Baldwin,

> England is the country, and the country is England … The sounds of England, the tinkle of the hammer on the anvil in the country smithy, the corncrake on a dewy morning, the sound of the scythe against the whetstone, and the sight of a plough team coming over the brow of a hill, the sight that has been seen since England was a land, and may be seen in England long after the Empire has perished and every works in England has ceased to function, for centuries the one eternal sight of England. The wild anenomes in the woods in April, the last load at night of hay being drawn down a lane as the twilight comes on … these things strike down into the very depths of our nature, and touch chords that go back to the beginning of time and the human race'.[79]

Tension between industrial modernity and cleavage to a national past was arguably near its height in the spring and summer of 1926. The BBC had recently announced ten million listeners within range of a transmitter: what was still the British Broadcasting Company in 1926 was to become the Corporation by the following year. Baird's principle of transmitting motion pictures – television – was demonstrated at the Royal Institution in London in January. For nine days in May 1926 the Trades Union Congress announced a general strike. Stanley Baldwin's announcement on 12 May – on the radio – that the strike was over was followed by the sounds of a choir singing 'Jerusalem'. Baldwin himself had just given a speech to the dinner of the Royal Society of British Sculptors at which he had hoped that English town and countryside

> should be permanently beautified by whatever art in its proper place has to offer, [and that] that art should be our own native British art. I hope, in spite of some evidence to the contrary, that we may pass through that curious snobbish subjection to foreign names and tastes which has been rife in this country so long.[80]

As his speech 'England' had reminded the nation (it had been published to popular acclaim just before the General Strike and would become a staple of popular patriotism right up until the eve of the Second World War):

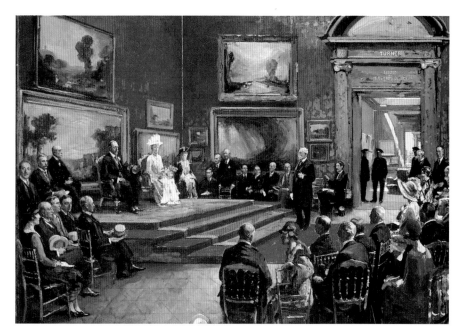

Plate 11 John Lavery, *King George accompanied by Queen Mary at the Opening of the Modern Foreign and Sargeant Galleries at the Tate*, 1926 (also shows Phillip Sassoon, D. S. McColl, J. B. Manson, Charles Aitken), oil on canvas, 85.7 x 116.8 cm.

Plate 12 Alfred Munnings, *Does the Subject Matter?*, 1956, oil on canvas, 78.8 x 106.7 cm.

Plate 13
Festival of Britain, 1951: left, the Sea and Ships Pavilion with Siegfried Charoux's *The Islanders* facing the river; right, the Dome of Discovery; background left, the Skylon by Powell and Moya.

Plate 14 John Hilliard, *Ten Runs past a Fixed Point (3), 1/500 to 1 second,* 1971, and *Sixty Seconds of Light*, 1970–71, photographs, 'The New Art', Hayward Gallery, 1972.

There are chronicles ... who said it was the apeing of the French manners by our
English ancestors that made us the prey of William the Norman, and led to our defeat
at Hastings. Let that be a warning to us not to ape any foreign country. Let us be
content to trust ourselves and to be ourselves.[81]

Writers on the city of London, meanwhile, did their patriotic best to transport pic-
turesque notions of 'nation' to the heart of the industrial metropolis. St John
Adcock's three-volume *Wonderful London*, published for a home audience in 1926,
contained short essays and photographs on the 'variety', 'charm', 'elusive beauty',
'strangeness' and 'fascination ... that so many realise, but so few feel able to put
into words' concerning 'the greatest city the world has ever seen'.[82] The poet
Alfred Noyes painted a verbal picture that attempted to dispel a lingering image
of cosiness, tradition and the 'olde worlde'. The fogs were 'only the outward and
visible sign of [London's] inscrutable character', Noyes said; 'it is the deepest city
in the world. No one has ever fathomed it's mind or heart ... [a city] of bigness
and substantiality', a world capital that did not mind being indifferent to the indi-
vidual – indeed it was the 'bigness and substaniality' of the place 'upon which most
of our individual freedom depends. And there is no freedom for the individual like
that which is bestowed upon him by the indifference of London'.[83] It was a place
of rapidly multiplying possibilities, a city that would not blush at the sight of 'an
Oriental potentate ... striding along a London pavement, or a visitor riding a camel
down Piccadilly'; a city of the Mother of Parliament, of Chaucer, the Crusades, the
Golden Hind, Shakespeare and his plays, an 'authentic fairyland, and all the more
indubitable for its solidity and even its grossness', replete not only with the dew-
drop pretences of the pantomime but with the 'more substantial nutriment [of]
steak and kidney puddings [and] a tankard of proper ale'.[84] In 1926 – the year of
Bye Bye Blackbird, the first traffic lights in Piccadilly Circus and the General Strike
– London was a city in which all classes and ethnic types, all degrees of wealth,
refinement, criminality, trade or occupation could be found together: London was
a city of boatmen, flowergirls, charladies, urchins, street musicians, hawkers,
harpists, Punch-and-Judy shows, cats and dogs – all were celebrated affectionately
in photographs and text (Figure 69).

Of course little could be done that would reconcile the London of urchins and
flowergirls with the audience projected by Duveen's new galleries. Indeed, a
remarkable result of the drive for 'modern foreign' art was that the lower-class
residuum that had been so important to the Barnetts and the Rossiters in the 1890s
fell out of consideration; the battle for audience definition was increasingly con-
fined to the internally differentiated spectrum of the middle class.

Few things exemplify the struggle between modernity and tradition so well as
the new building itself (Figures 70, 71). Perhaps it was obvious from the beginning
that a 'modern foreign' gallery at Millbank would require resolution of at least three
potentially conflicting demands: continuity with the existing edifice, a sense of up-
to-dateness in the decor, and what Duveen himself (as the donor) was inclined to

Concertinas can be played well by skilled hands, but an organ depends on maker rather than player. At one time the Italian organ grinder with his monkey in fez and jacket was a familiar sight ; he is gone to-day, but this patriarch carries on the tradition without simian aid.

Some street musicians make their appeal by the sweetness of the strains they produce : some, one would think, by blackmail. " Till enough has been subscribed, O public, endure us ! " Nor would Pharaoh have hardened his heart before an ill-played concertina.

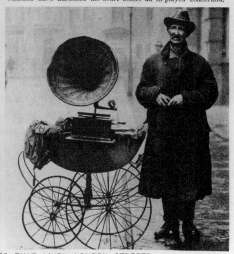

SOME OF THE SIGHTS AND SOUNDS THAT LIVEN LONDON STREETS

Curb-side hawkers are to be found wherever shoppers congregate, but Holborn at Christmas-time is a favourite pitch of theirs. With their nodding dolls and acrobatic toys—mechanisms that never appear to function so deftly after purchase—they are often a greater joy to children than all the expensively garnished shop-windows on the other side of the pavement. The gramophone charioted in a perambulator seems the last and most sordid victory of the age of science. Even a barrel-organ, they say, needs some skill in the grinding.

69 'Some of the Sights and Sounds that liven London Streets', from A. St John Adcock (ed.), *Wonderful London*, 3 vols, 1926–27, vol. I, p. 221.

decree in terms of architectural scale and size. The 'progressive' reaction against
late Victorian wall coverings in red, mauve and green that had been urged by Morris
and the Aesthetic Movement, tending towards lighter wall surfaces and sparser pic-
ture arrangements, had only selectively been adopted in England in the first decade
of the century. However, a 'modern' decor had been adopted for the redecoration
of most of the Tate Gallery after its reopening in 1921:

> for the most part, Sundour fabrics, with broken texture but without pattern, for all
> hangings; pale neutral tones, as a rule, being selected for the modern Impressionist
> pictures; darker dawn shades for the eighteenth and early nineteenth century pic-
> tures and a reddish-purple for the pre-Raphaelites.[85]

Yet Duveen, who knew the Turner Wing had met with opprobrium in this respect,
still favoured richness and grandiosity for the new building: it was not only his taste,
but his experience of how the modern American collections were being hung. There
had followed a lengthy and acrimonious disagreement between Duveen and the
Gallery. Duveen wanted Verde Antique marbling; the Tate wanted the quieter
Tinos marble. Duveen wanted lofty doorways and a high cornice; the Tate wanted
continuity with the existing building and a less grandiose appearance. The lighting
and roof structure were also disputed. Early in the project Aitken wrote to Lord
D'Abernon complaining that Duveen's architect W. H. Romaine Walker 'seems to
have almost an obsession with height ... he also favours a somewhat ornate scheme
of decoration ... his style seems to me neither good in itself nor even the *dernier cri*
of the taste of the moment.[86] The resulting compromise merged the grandiose
impulses of the transatlantic collector and the 'moderating' influence of the English
artistic establishment, with relatively liberal use of wall space for the pictures. The
press statement announcing the opening of the new galleries claimed that 'no
money has been spared in the decoration ... the green marble doorways, silk wall
hangings, painted and gilt ceilings, walnut seats and marble-bordered polished par-
quet floors creating an atmosphere reminiscent of old Italian palaces', while the
lighting system, based on principles devised by S. Hurst Seager, was claimed to
'eliminate the bright illumination of the floor which caused dark and low-toned
paintings to become merely mirrors for the spectators'. For the ventilation, 'the
whole of the air in these galleries is washed and purified ... In fact it would be pos-
sible to entirely eliminate the glazing of the pictures, as in these galleries ordinary
London atmosphere with its well known detrimental effects, will no longer exist'.[87]

The point is that such a space, structured architecturally around a compromise
between British aestheticism and Duveen's transatlantic Mogul style (or what he
could get of it) made for a particular ambience: on the one hand sufficiently 'mod-
ern' to sustain brightly coloured paintings in a visibly post-Victorian space; on the
other, an evident nod in the direction of the opulent vulgarity which Duveen
believed was *au courant* at the time. In 1926 it was surely an ambience suggestive
of a particular audience for paintings and the life-styles and acquisitive interests
implied by them. Authoritative if vulgar classicism, spacious country-house

dimensions and a set of 'classics' of modern French painting could connote travel, sophistication and Britain's membership in a new if still unstable European order within a wider world.

What positioned and distinguished the truly 'modern' observer in 1926, perhaps – what lent at least the illusion of participation in that wider world – was a degree of cognitive and perceptual risk. Indeed there are signs in the later part of the decade that a more 'primitive' account of 'modern foreign' art was being contemplated: signs that the projected audience for modern culture could define its identity by incorporation of a more dangerous, libidinous art. To isolate one important symptom: a split emerges in the later 1920s in the very language with which paintings are described: between the laconic, ratiocinative taxonomy of the catalogue descriptions, and what was permitted in that very different interface between the Gallery and the public, the guide–lecturer's speech. Thus Monet's *Beach at Trouville*, purchased through the Courtauld Fund in 1924, reads in the words of the Gallery's *Catalogue* for 1926 like a coastguard's or a meteorologist's report:

> Foreground, left, a woman in white, seated, three quarters length, facing right and holding a blue parasol; a hat with flowers; right, a woman in black, three quarters length ... black hat and black parasol; background ... the sea; cloudy sky with glimpses of blue. Signed 'Cl.M.70'.

Or the same artist's *Vétheuil: Sunshine and Snow*:

> Right, cottages and poplars on a river bank sloping left to water with a boat, sunlit hills beyond; all under snow, clear blue and primrose sky.[88]

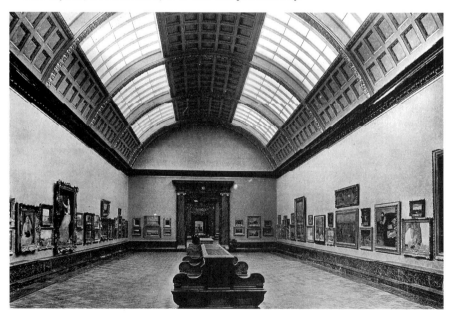

70 New Duveen Wing: Modern French gallery, *The Builder*, 9 July 1926.

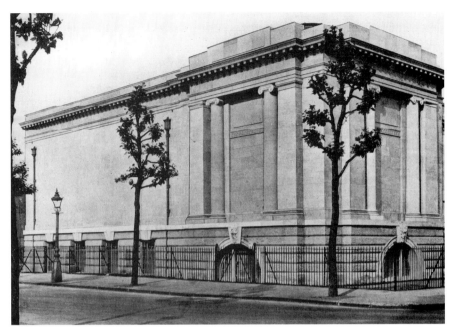

71 New Duveen Wing: South Pavilion, *The Builder*, 9 July 1926.

By contrast, Edwin Fagg's little book *Modern Foreign Masters* of four years later –
he had been appointed the first guide–lecturer to the Tate in 1927 – describes the
latter work in terms of

> mature purpose ... great sincerity and often great beauty... the charm of the paint-
> ing's light was feelingly analysed and lived again in [Monet's] discerning studies; the
> exquisite moments yielded their colour secrets to his sympathy, penetration and
> method. And it is obvious that his method was strictly appropriate to his end; the
> broken surface, the bold touches of colour in juxtaposition bring with them the glam-
> our of sunshine and snow with a power that could not be surpassed. Over the river
> bank, and the water and the sunlit hills beyond, against the pallor of the sky, the bril-
> liant light vibrates in tones of rose and gold; cool shadows echo a luminous cobalt,
> with here and there a touch of green and violet.[89]

Fagg's language is suddenly sensuous and climactic, suggestive of a rich obser-
vation of 'nature' which the visitor will appreciate and understand. The passage
brings us directly to Van Gogh and Gauguin, two artists who were accepted into
the fold of 'modern foreign' painting relatively late in the day. Van Gogh's *Yellow
Chair*, also purchased by the Courtauld Fund in 1924 (Figure 72), was described
efficiently in the 1926 *Catalogue* as 'a yellow rush-bottomed chair with an orna-
mental clay pipe and an open packet of tobacco on it', with the artist himself per-
functorily as 'Dutch school, painter of still life'.[90] Yet in guide–lecturer's prose
the two painters become

those strangely romantic men, the first with some of the qualities of a saint, the second with a stronger dose of the devil in his nature. [They are] both true Bohemians – that is to say, most unpleasant fellows, but each with the instinct for some fundamental in painting, and an enemy to its pedantries.

Van Gogh's moods were 'double-edged', now 'engaging and simple', now 'flaming and ecstatic'. The *Yellow Chair* – the painting that Wake Cook and other traditionalists had so roundly condemned – now became

neither merely illustrative nor tamely decorative; it has received a bold treatment, in tune with [Van Gogh's] heightened feeling, which makes it actual and not merely a discreet abstraction; in the painter's vision its rusticity had become heroic, evoking the luminous pigment, lifting the yellow chair, red tiles, blue-green door, and whitewashed wall to the level of his rare emotion.[91]

By extension Gauguin – at least his Tahitian world – is 'primitive, remote, and above all calm, with the static note which invites rich pigment to rise to barbaric splendour', and in which the artist is given to 'primitive work [whose] strong

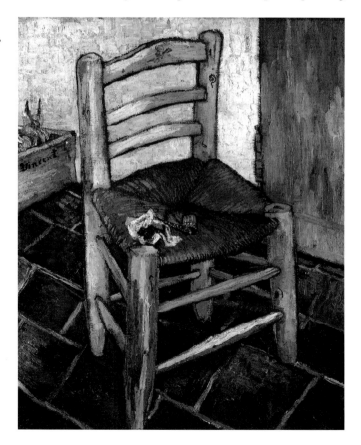

72 Vincent Van Gogh, *The Yellow Chair*, 1888–89, oil on canvas, 91.8 x 73 cm, purchased by the Courtauld Fund, 1924.

appeal which outlasts the moment lies in the fact that the artist is saying only what he really wants to say'.[92] Myths of the 'primitive' creativity of the modern artist were born in these years, while comforting narratives of hearth and home, such as had been provided by Tate and the Chantrey Bequest a mere thirty years before, were being expunged from the sophisticated metropolitan and national psyche.

In a literal sense this was effected in the early hours of Saturday, 7 January 1928, when a flood tide on the Thames – in some reports a surge from upstream – caused the river to burst its banks in central London, first near Lambeth Bridge and again directly opposite the entrance to the Tate at Millbank (Figure 73), flooding the basement to a depth of five and a half feet in the front of the Gallery, and to eight and a half feet in the Turner and Modern Foreign galleries at the rear. Director Charles Aitken, roused at five a.m. with Sir Robert Witt and Jim Ede, commandeered pumps and salvage equipment and with the help of workmen lifted most of the submerged pictures to safety on the upper floors (Figure 74). By the Gallery's own account of the flood, of the 234 oil paintings imperilled, 197 suffered no or only slight damage, 27 were seriously damaged and 18 were 'completely spoiled'. But these were mainly Victorian paintings of the kind that by 1928 did nothing for the dominant part of the national psyche: a verbal report in Parliament on 9 February said of the badly damaged paintings that they 'belong, almost without exception, to the mid-Victorian period, and none of them can be regarded as of primary importance ... All the most important pictures in the gallery, being hung on the ground floor, remained unaffected by the flood'.[93] The Gallery's own report confirmed that 'few [of the destroyed pictures], which included works by Archer, Davis, Delaroche,

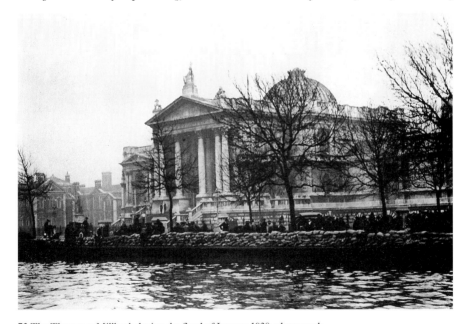

73 The Thames at Millbank during the flood of January 1928, photograph.

74 Pictures being taken to safety following the flood at the Tate Gallery, London, January 1928, photograph.

Harding, Hilton, Lance, Landseer, Leighton, Martin, Philip, Smirke, E. M. Ward, J. Ward and West would be regarded as of primary importance from an artistic point of view'.[94] At issue in the framing of such descriptions is the outcome of the struggle already joined: on the one hand, the values of Victorian art still championed by cultural traditionalists, pitched against the modernisers who wanted a special kind of accommodation to the late nineteenth- and early twentieth-century culture of the French – or the 'primitivising' part of it that could function as a supplement to a more traditional sense of national identity at home.

Yet it should be remembered that those myths of primitivism were themselves keyed to the dynamics of the competitive industrial world. 'Never before', Manson wrote unwittingly in his guide to the Tate Gallery of 1926, 'have men, who had been guilty of foisting new ideas on a reluctant world, been so conclusively vindicated': Degas, Monet, Renoir and Pissarro 'though willing to starve for their principles, lived to see their derided works competed for by collectors and galleries ... for sums of which they little dreamed in those early days',[95] that is, very close to the way in which the Victorian business world had evolved through individual invention, persistence and raw determination in the face of hostile opinion. Attempts to consolidate an idea of 'nation' around Baldwin's speeches or the remnants of empire were not, after all, likely to be successful in the longer run. The Wembley Empire Exhibition of 1924–25 and the activities of the Empire Day Movement, both bolstered by the nascent patriotism of the BBC and directed especially at the young, had gone off like damp squibs.[96] The cultural modernisers felt they had a solution: the arts could propose a new relationship with the continent, and with France in particular, such that 'Britain' as a concept would emerge as an entity all the more secure. A result of this dialectic would be that battle lines between the Royal Academy and the Tate Gallery would become even more certainly defined in the years to come: what remained of 'the public' as a body would participate, first in the spectacle of its own division and fragmentation, then in its eventual decay.

Post-war positions:
Arts Council, LCC and ICA

IN THE YEARS 1945–49, the state attempted to assume far greater responsibility for (if not direct control of) the conditions of public culture than in pre-war days. The Labour victory of 1945 presaged a kind of nationalisation of culture as well as of education, transport and the major industries. There are reasons why this should have been so: the nation that emerged victorious from the experience of war was arguably better disposed towards concepts of cultural democracy and shareable values than the class-fragmented society of the 1920s or 1930s.

There indeed occurred a vigorous and often shrill debate in the national press and media in those years which gave every appearance of first intensifying and then resolving the battle between a 'modern' and a 'traditionalist' public for art that had erupted in the ranks of the middle classes over a generation before. Yet now both the context and content of the discussion was different. First, the number of national or quasi-national bodies in the public space of art was greater than before: the Arts Council of Great Britain and then the Institute of Contemporary Arts joined the dialogue between the Academy and the Tate that, already frenzied enough, would reach a kind of *dénouement* in 1949. Secondly, the extension of reading, listening and viewing downwards and horizontally across the classes lent to the cultural debate a quality that was altogether new. The national press and media treated the already fragmented middle 'public' to a spectacle of identification and dis-identification which allowed citizens access to the debate on artistic values to an unprecedented degree. Cartoons and newspaper correspondence indicated habits of appearance, attitude and allegiance (frequently with both position and counter-position on display). An enlarged audience was brought into the debate by staged discussions on radio and TV. Yet the terms of that access are inevitably controversial: how it affected the quality and make-up of the London public is the question to be examined here.

War-time energies

After 1945, many 'insider' observers confidently claimed to have noticed a real growth of interest in the visual arts since 1939. John Rothenstein, appointed

Director and Keeper at the Tate Gallery in succession to James Manson, wrote
that there was 'an unprecedented demand [during the war years] for opportuni-
ties of seeing works of art'. He spoke of 'the emergence of a larger and more exact-
ing public' in the period to 1945.[1] 'The war and post-war attendance and interest
of the general public ... is now about three times as high as it was in 1939', wrote
Mary Sorrell of *Queen* in her excited review of art in the year 1946.[2] Even provin-
cial audiences were reported to be high.[3] 'There is a growing consciousness in
England that to appreciate art would be to double the joy of living', Cora Gordon
wrote in her 'London Commentary' in *Studio* for February 1946; 'and as this joy
has sadly diminished through world trouble, a craving to live more through mind
and spirit has grown'.[4] Admittedly *Studio* took a progressive line on the arts and
had already expressed guarded acceptance of 'the modern'.[5] Gordon now
expressed the distance between Academy naturalism and 'modern' art in terms of
the educational experience of the viewer:

> Reading has become a serious occupation of leisure but art still remains a puzzle to
> the many bewildered folk who have been encouraged to record and applaud the imi-
> tations of prettiness as 'Truth'. As they learned at school that 'Truth is Beauty' and
> they didn't also learn what Truth implied, they are now left to dispose of all their
> distaste for the old and the modern masters by the caustic remark 'I suppose I'm not
> educated *up* to all this'. Now, however, a growing public is dropping cheap sarcasm
> for a definite desire to educate itself 'up'.[6]

In other words a perception existed at the end of the war that education was both
necesary and sufficient; that 'a craving to live more through the mind and spirit'
was a mark of enlightenment (perhaps of survival) in the hostile post-war world.

The idea of art as a civilising instrument reaches back through the morality pic-
tures shown in the East End in the 1890s to the first public exhibitions in London
in the 1760s. Advocacy for the emancipatory virtues of 'modern' art could be
traced to the end of the nineteenth century and latterly to several positions taken
in the later 1930s. We can try to summarise them. For a well-rehearsed sympathy
for modern French art, take Manson's phrases from a lecture prepared and deliv-
ered in 1936. If art is first intuition, Manson says, then the 'technique of expres-
sion or realisation is a definite form of the inner feelings'. It is 'the outward
expression of an inward emotion aroused by the contemplation of almost anything
in nature'. Van Gogh is the exemplar, particularly his *Yellow Chair*: 'his life was in
his work in a way that is without parallel in the whole history of art'.[7]

Yet Manson's Post-Impressionist sympathies had their limits. By the later 1930s
another generation had come to speak and write on behalf of Picasso, Klee and the
Surrealists. These men, among them Herbert Read, Kenneth Clark, John
Maynard Keynes, Phillip Hendy, John Rothenstein, Philip James, Jasper Ridley
and Vincent Massey – I shall identify most of them in due course – had academic
rather than artistic backgrounds and had entered a milieu of cultural prestige and
influence while they were still young. Becoming powerful in metropolitan circles

and national institutions, these new mandarins (the term is at once apt and mis-
leading) were more intellectually adventurous than Manson the artist could be:
their terms for the appraisal and legitimation of new art went beyond 'feeling',
'intuition' and the 'felicitous expression of nature'. Inheriting or adopting a power
base in the educated middle and upper-middle class, they developed tastes and
preferences that were 'progressive' (if not politically 'left'), and became highly
articulate on behalf of international rather than merely British art. Prepared to
countenance technically new and cognitively unfamiliar appearances, 'modern art'
up to and including abstraction was their *métier*.

 Some limited dovetailing of interests had occurred in the 1930s between the
mandarins and those immersed in the politics of the working class. William Emrys
Williams of the British Institute of Adult Education began an experiment from
March 1935 called Art For The People, which circulated loan exhibitions of British
and French modern paintings to towns lacking galleries (Barnsley and Swindon
among them): Williams quite consciously moulded his efforts upon Samuel
Barnett's cultural philanthrophy of the 1880s and 1890s, and his relationship to
metropolitan high culture was comparable too. The Adult Education Institute
involved itself with the Ashington Group of miners in Northumberland, sent an
exhibition of modern art to Tyneside in 1937, and promoted an exhibition
'Unprofessional Painting', opening in Gateshead-On-Tyne in October 1938 and
moving to Peckham Health Centre and Fulham Town Hall in London, which
linked modern and working-class art as complementary kinds of 'primitivism'
(Figure 75).[8]

75
The 'Unprofessional
Painting' exhibition,
1938–39: Green-line
bus-driver Henry
Stockley with an
example of his work.

For all that, most mandarins were ambivalent about radical politics and had their sights fixed upon the reform of the national artistic consciousness and the attitudes to modernism of its institutions. In *Art Now* (1933) Herbert Read had forcefully promoted Picasso as a 'subjective idealist' whose creations 'come to him from beyond his own limits'. Abstraction for Read was a 'spiritual attitude' in man in escape from the realites of life. Surrealism, with Professor Freud as its real founder, had embarked on voyages in a world 'more real than the normal world'.[9]

Or take Rothenstein himself. Son of a painter and himself a historian by training, he had done university teaching in America and an art-history doctorate in London before launching a modernist curatorial revolution, first at Leeds City Art Gallery and then in Sheffield: 'Among the ugly and disorderly cities of Britain', Rothenstein would write later,

> Leeds was among the ugliest and most disorderly: surely the proper function of the Art Gallery was to be a place where the standards of beauty and order would be uncompromisingly upheld, a place from which beauty and order should radiate and permeate the minds of the citizens and thus effect, even unconsciously, the way they felt about visual things, the way they made them, caused them to be made, the things they bought, and the city they lived in. How could this high ambition be remotely realized so long as the Art Gallery remained, quite simply, a place disgusting to enter?[10]

Putting nineteenth-century paintings in store and modernising the interior was the policy Rothenstein subsequently pursued at the Tate, made all the more possible by the closure of the Gallery at the start of the war and its damage by enemy bombing in 1940 (Figure 76). Some 422 works in the categories of modern British or modern foreign art were acquired under Rothenstein's directorship between 1939 and 1945, including paintings by Renoir, Sisley, Cézanne, Toulouse-Lautrec, Modigliani, Rouault and Vuillard from the modern foreign school, and by Sickert, Steer, Augustus John, Spencer, Matthew Smith, Sutherland, Moore, Piper, Burra, Ravilious, Pasmore and David Jones from the British. Works by Klee, Chagall and Ernst, among the first beyond the Anglo-French canon, were also added to the national collection in those years.

During the war itself exhibitions of modern, amateur and old-master paintings were co-ordinated by a network that included the Tate Gallery, the newly formed Council for the Encourgement of Music and the Arts (CEMA), the War Artists' Advisory Committee, the Museums Association, the Victoria and Albert Museum, the National Gallery (Figure 77), the British Institute of Adult Education and those commercial galleries that remained open – not to mention talks on modern art on the BBC.[11] Exhibitions in London and in the provinces reported large and enthusiastic audiences, often inflected as a 'national' audience in defiance of the German threat.

The wartime relationship between the Tate and CEMA was of particular significance to what follows. CEMA was founded early in 1940 to keep the spirit of culture alive in wartime, sending world-class musicians and theatre groups round

76 The Tate Gallery following a bombing raid in September 1940, photograph.

the country as well as organising concerts by Myra Hess and others at the National Gallery (captured in two films made for the Ministry of Information by Humphrey Jennings, *Listen to Britain* (1942) and *A Diary For Timothy* (1944–45)). CEMA had grown out of the initiative of Thomas Jones, Secretary of the wealthy Pilgrims' Trust, who had fortuitously been involved with the Commission for the Special Areas in the 1930s which sent experts in all the arts and crafts to provide culture to the unemployed of South Wales and Co. Durham. Jones negotiated £25,000 of

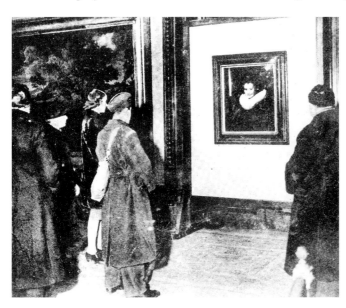

77 Rembrandt's *Portrait of Margaretha de Geer*, 1661, on show as the first Picture of the Month at the National Gallery, London, January 1942, *Illustrated London News*, 24 January 1942, p. 101.

the Trust's money to persuade government to set up the Committee (then the Council) for the Encouragement of Music and the Arts, including himself, Lord Macmillan, Kenneth Clark (then Director of the National Gallery and Chairman of the War Artists' Advisory Committee), William Emrys Williams and Sir Henry Walford Dance (Master of the King's Musick).[12] Initially CEMA was a populist organisation operating under the slogan 'The Best for The Most' – a phrase that implied both aid to professional artists and the patronage of rural and local communities. However, when John Maynard (Lord) Keynes joined CEMA half way through the war he first congratulated Jones for CEMA's social welfare beginnings – as Keynes wrote to Jones, 'without private enterprise to start the ball rolling, no balls get rolled'[13] – and then set about replacing CEMA's social-welfare emphasis with his own programme of a national culture based on what he saw as high artistic standards alone. 'There was, alas', Williams later said of Keynes, 'in this great scholar and art connoisseur a streak of donnish superiority and a singular ignorance of ordinary people'.[14]

Towards the Arts Council of Great Britain

The class constitution of the art public in London – and its relation to the emergent Arts Council – can be partially reconstructed though surveys and some press reports. Though we know relatively little about the actual individuals who visited art exhibitions in the years before, during and after the Second World War, the descriptions generated within the Mass-Observation movement can be revealing as well as bizarre. Thus from the Storran Gallery in November 1938:

> Middle aged M and W. Not art gallery sort. Lower middle class. Dull dark sort of clothes. He moves about and squats down on his heels sometimes to look at pictures close to. She stands with her feet well apart and stares expressively. She has a curious way of looking at pictures. She never stands facing them but always half sideways to them and looking over her shoulder. They look around for five minutes and then suddenly with one accord they go out.[15]

Or from the Tate, in December:

> Two women (about 30 years) entered 11.14. A: bareheaded, black overcoat, coloured silk scarf. B: black hat with veil, astrakhan coat, both upper class … At 11.18½ A goes into room 23, B looks at 3468, 3842, and 4923, then follows A … Both look at 4239 (20 seconds) and *Portrait of Lady Ottoline Morrell* (on loan) 15 seconds, *The Rock of Gibraltar* by Charles Conder 15 seconds. Enter room 21, 11.26, but before leaving look back at 4239 and A says ' … whopping great flower … '[16]

Of course, such descriptions raise doubts about the Mass-Observation method: little can be deduced from them about the formation of subjectivity in front of art, and there are few guarantees of the reporter's objectivity. Yet hints of a social typology are there. In a report on the 'War Artists' exhibition at the National

Gallery in September 1941 (organised with CEMA's help) a respondent lists visitors by age, social status, sex and sometimes overheard speech:

> F.36.B. Grey-blue costume, large black fox-fur round shoulders, with husband and son, very ultra-suburban ... R.45.B. Mauve woollen hat *à la Beret*. Navy coat, black shoes, stockings, spectacles, hair over-permed. Rather the more intellectual schoolteacher-cum-bridge playing type ... M.30.B. Dark grey bags, green corduroy jacket, navy shirt without tie, horn rims and long hair – definitely arty.[17]

In such descriptions social recognition has become almost effortless, I suggest; as if status and cultural capital alike could be read off from sartorial appearance and deportment (perhaps it could). The rest of that day's overheards and observations confirm a familiar picture: most National Gallery visitors were social B's, and 'wandered around vaguely in twos and threes, with boyfriend, husband or friend'. The Sickert exhibition, also at the National Gallery, attracted more focused interest: 'many appeared appreciative, but there was no high-sounding expert criticism of the paintings and a frank bourgeois bewilderment at anything verging on the extreme'. At the Leicester and Léger Galleries the clientele was different: 'more select, aristocratic and commercial, and people made loud-voiced and would-be expert criticisms ... awesome [with] a certain gloom everywhere'.[18]

Support for working-class participation in art was at the same time declining. Kenneth Clark's idea at the end of the war that 'if the middle and better-paid working classes in England thought it natural to buy an original painting at least once in their lives, art would become, in the most direct and positive sense, a national concern',[19] could as easily be read as a Keynsian distaste for prints, reproductions and amateur art. By the time the Tate reopened on 10 April 1946 with three small exhibitions amounting to a specifically modernist agenda ('Braque and Rouault', 'Contemporary British painting', and 'Watercolours by Cézanne') the rhetoric was certainly diverse. Foreign Secretary Ernest Bevin opened the galleries before a crowd of some 4,000 people gathered in front of the building at Millbank: 'the people of this country love things that have form and beauty', he said in his speech, 'they need them for the complete fulfilment of their lives, and after what they have been through in the last six or seven years, they deserve them'. Yet in the crowd was 81-year old Frank Emmanuel, Acting President of the Society of Graphic Art, who shouted a vociferous protest:

> I protest against this national institution being used for exhibitions like this. Most of the people here do not understand what they are looking at ... these works [by Braque and Rouault] violate nature. They violate art and craftsmanship.[20]

Emmanuel's protest is the only one that has entered the record; it reminds us that there were several art constituencies in London in the period, each contesting the space of public opinion so as to ensure that its tastes were incompatible with those of its adversaries. Each constituency emerged from the hostilities in 1945 with its

own agendas and agencies of proselytising and appeal – but with its own stereotypes and images too. One constituency (that to which Emmanuel belonged) was the Royal Academy of Arts, which had long attempted to represent 'sensible good judgement' and the values of craftsmanship and tradition. The Academy establishment were neither civil servants nor self-appointees, but elected by open vote in what had become a public ritual. Secondly, with its royal *imprimatur* and its ancient teaching establishment for young artists, the Academy still stood close to the tastes of the old landed gentry and the new industrial patrons, the armed services, the Church, and Whitehall, as well as to the sensibilities of a predominantly provincial intelligentsia who supported them politically and morally. Notwithstanding rare and untypical flashes of modernity, Academicians upheld – as the Chantrey Bequest *débâcle* had already amply demonstrated – a defiant British traditionalism as a counterweight to the forward speed of the modernists of all shades.

The second constituency had by 1945 developed a streamlined bureaucracy and had demonstrated a real talent for administration. Characteristic of this constituency was the Arts Inquiry, established in the autumn of 1941 at Dartington Hall to examine visual art, music, drama and what it called factual film. Ready by June 1945 and published as a PEP (Political and Economic Planning) pamphlet in 1946, its report *The Visual Arts* sought to intensify and magnify the campaign that was already under way among the mandarins for the re-education of British taste. Modern art and its appreciation, the formulation and education of democratic and universal values, not only contributed to a vision which purported to connect nations rather than divide them, but on an individual level were to be related to the development of personality and the inculcation of standards of 'beauty' in a world still marred by ugly and dismal homes, streets and schools. *The Visual Arts* was an eloquent, even utopian tract: it recommended a new gallery for the British collection at the Tate, and a museum of modern art along the lines of New York's for temporary exhibitions of contemporary interest, 'from that of primitive peoples to the works of modern artists'.[21] It lobbied for a museum of oriental art and a museum of ethnology, a pavilion of industrial design, a central gallery for temporary shows on the model of the Orangerie in Paris, a programme of improvement for the London Museum, and much more. It lambasted the royal art collection, at that time the largest private collection in the world and still for the most part closed to the public – as a 'picturesque survival'.[22] Its support for contemporary art was unstinting, advancing the argument that 'attendances steadily decrease when exhibitions are dull, but in spite of apparent hostility, increase when there is a less conventional exhibition, particularly of contemporary art'.[23] Urging the use of guide–lecturers and descriptive labels in the national museums, evening and weekend opening, gallery publications and catalogues, *The Visual Arts* claimed to speak for 'the majority of visitors [who] do not know how to look at works of art and [who] walk round an exhibition and out again without having stopped to consider any one of the individual works; they get no benefit from the exhibition and are not likely to return'.[24]

In short, the Arts Inquiry proposed a nationwide programme of 'educating up' the population from the nursery onwards with the help of Herbert Read's *Education Through Art* (1943) and the writings of progressive art educationalists such as Frank Cizek and Marion Richardson. Art education, Read had said in his book, would produce 'better people and better communities';[25] and the PEP Committee were pleased to repeat him. 'Too often the natural impulse towards self-expression is repressed'; an emphasis on 'free painting' under the tutelage of experts in child development and psychology would be just one part of a gradual reprofessionalisation of the national culture. *The Visual Arts* saw as its purpose not a populist agenda, but 'ultimately to assist in the formation of a public of discriminating adults'.[26]

The major result of the Arts Inquiry was the Arts Council of Great Britain, first announced by the Chancellor as CEMA's sucessor on 12 June 1945 and the subject of a BBC Home Service broadcast by Lord Keynes three weeks later. There were many emphases in Keynes' short talk. Reminding his listeners of the Council's origins in CEMA, he said that

> State patronage of the arts ... happened in a very English, informal unostentatious way – half baked if you like. A semi-independent body is provided with modern funds to stimulate, comfort and support any societies or bodies which are striving with serious purpose and a reasonable prospect of success to present for public enjoyment the arts of drama, music and painting ... We do not think of the Arts Council as a schoolteacher. Your enjoyment will be our first aim. We have but little money to spill, and it will be you yourselves who will by your patronage decide in the long run what you get ... Everyone, I fancy, recognises that the work of the artist is, of its nature, individual and free, undisciplined, unregimented, uncontrolled. The artist walks where the breath of the spirit leads him ... But he leads the rest of us into fresh pastures and teaches us to love and to enjoy what we often begin by rejecting, enlarging our sensibility and purifying our instincts ... There could be no better memorial of a war to save the freedom of the spirit of the individual ... How satisfactory it would be if different parts of this country would again walk their several ways as they once did and learn to develop something different from their neighbours and characteristic of themselves. Nothing can be more damaging than the excessive prestige of metropolitan standards and fashions. Let every part of Merry England be merry in its own way. Death to Hollywood.[27]

The Arts Council was formally founded by Royal Charter on 9 August 1946,

> for the purpose of developing a greater knowledge, understanding and practice of the fine arts exclusively, and in particular to increase the accessibility of the fine arts to the public throughout Our Realm, to improve the standard of execution of the fine arts and to advise and cooperate with Our Government Departments, local authorities and other bodies on any matters concerned directly or indirectly with those objects, and with a view to facilitating the holding of and dealing with any money provided by Parliament and any other property, real or personal, otherwise available for those objects.[28]

Granted by His Majesty the King, the new Council's charter, perhaps drafted by Keynes, inaugurated a new era in national patronage and a new call to national unity under the aegis of George VI, 'by the Grace of God of Great Britain, Ireland and the British Dominions beyond the Seas King, Defender of the Faith, Emperor of India'.

That lofty designation, of course, was to play little part in the new culture that the Arts Council was promoting: as an 'arms length' disburser of Treasury funds for the arts, it was simultaneously a national body and a professional one, a combination widely felt to represent the BBC, the art mandarins who favoured modern and foreign art, and the upper echelons of the civil service. Its more visible professional profile was of a self-electing system of committees that caused Raymond Williams later to characterise it as 'persons of experience and goodwill' who made up an 'an informal ruling class'.[29]

Scandal at the V & A

The acceptability of modern art was tested time and again in London in the period immediately following the end of the Second World War. The *cause célèbre* of the early post-war years was a show in late 1945 and early 1946 at the Victoria and Albert Museum: the 'Exhibition of Paintings by Picasso and Matisse' was a key index of public allegiances to and phobias about 'the modern', whose expression in the press and media became a kind of carnival in its own right.

The 'Picasso–Matisse exhibition' originated in a reciprocal arrangement between the British Council (acting with the Tate) and the French authorities, according to which a collection of contemporary British paintings would tour the continent after the end of hostilities in exchange for a French show offered by the Direction Générale des Relations Culturelles in Paris (through the Association Française d'Action Artistique).

Until the mid-1930s, British exhibitions abroad had mostly been trade shows handled by the Exhibition Branch of the Board of Trade or (since 1918) by the Exhibition Division of the Department of Overseas Trade. A fledgling Overseas Relations Committee of the Foreign Office, which became the British Council for Relations with Other Countries in December 1934 and was renamed the British Council in July 1935 – it was funded both by the Foreign Office and the car magnate W. E. Rootes – established a Fine Arts Committee in 1936 on the basis of a report written by A. A. Longden suggesting that

> one of the [British Council's] most important missions should be to indulge in propaganda abroad in the sphere of the arts, [since] such propaganda has repercussions not only in the political but also in the commercial fields. It would be difficult to deny that the impression made on the world by an exhibition of Fine Arts goes beyond the walls of the exhibition buildings themselves and enhances the respect and admiration felt for the country that produced such works ... thus promoting commercial and social intercourse and the study of the English language, which latter study is

the best medium for the enhancement of national prestige and the advertisement of national products.[30]

Now, after the war, it was the Council's Advisory Committee on Fine Art, which included Phillip Hendy (Director of the National Gallery), John Rothenstein (Director of the Tate), Campbell Dodgson (former Keeper of Prints and Drawings at the British Museum), Kenneth Clark, Clive Bell and Herbert Read, which was to organise the British show for France and welcome the 'Picasso–Matisse exhibition' on British soil. The exhibition of 25 works from wartime Paris by Picasso, and 30 selected paintings by Matisse from 1896 to 1944 (Figure 78) was opened by the French ambassador late in 1945 at the Victoria and Albert Museum 'as a token of the high place which such an event holds in Anglo-French relations', or, as the Ambassador's deputy Monsieur Varin said at the Manchester opening four weeks later, to re-establish cultural contact with England after the war: 'We of France owe so much to England, who has done so much during these difficult last years for the whole world'. The British Council felt that the choice of Picasso and Matisse was a 'most natural one, as these two artists are regarded in France and in many other countries as the two most eminent of living painters'. France was projected as the place where Picasso had found freedom and from which 'Matisse, the true Frenchman', hailed.[31]

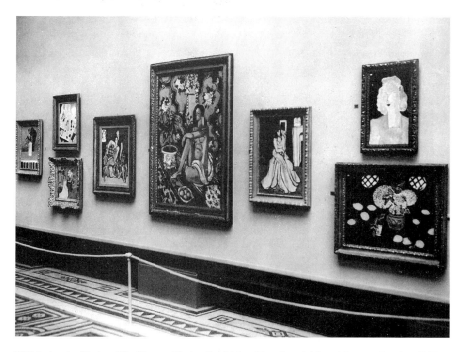

78 Paintings by Matisse, The Picasso–Matisse Exhibition, Victoria and Albert Museum, London, 1946, photograph.

The response was overwhelming. Attendance at the V & A totalled a record 220,000 people, nearly double its normal level. Talks were given by the BBC. Packed lectures were given by R. H. Wilenski in Manchester and T. J. Honeyman in Glasgow, where audiences for the show were 73,000 and 88,000 respectively. The British Council was delighted that 'never has such an exhibition received so large an attendance or so much comment and discussion in the press'.[32] 'There is no doubt', Longden wrote to Honeyman as the show arrived in Scotland, 'that we have ... got the whole country dancing about this show, one side being feebly conducted by the PRA'.[33]

The triumphalism of Longden's tone is instructive of how divided was the response to the fractures and incongruities of both artists' work. Colour prints and a new crop of publications during the war had brought Picasso's images before the interested public, and for those prepared to scan the French newspapers small black-and-white illustrations of his works could be frequently seen. But the Victoria and Albert Museum exhibition brought the phenomenon to life on a much larger scale and made it a talking point for the exhibition-going part of the London public – seen here looking at works by Picasso (Figure 79) – from the enthusiastic down to the scandalised and the hurt.

It is an index of the commitments of *Studio* in the mid-1940s that it presented Picasso as an important artist advancing into emotional and intellectual territory

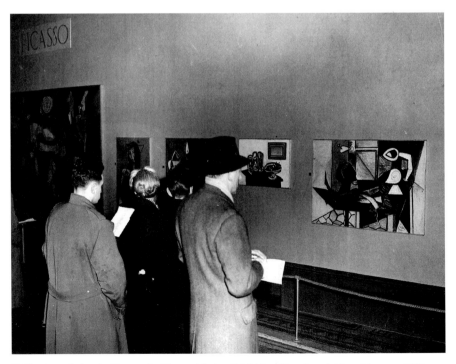

79 Viewing paintings by Picasso, the Picasso–Matisse Exhibition, Victoria and Albert Museum, 1946, photograph.

as yet unexplored – a reputation which survives to this day. Cora Gordon in her 'London Commentary' suggested that

> to see [Picasso's] large canvases at the Victoria and Albert Museum is to experience a stunning blow and a stimulant at the same time. This experience in a crowded hall full of muted worshippers and garrulous scoffers is about enough for one day. The only possible policy is to creep back the next day, trying to realise what has happened. I think that the first thing to realise is that Picasso has allowed himself to be gripped and overmastered by those emotions that he himself considers to be the foremost quality in an artist. The deep, rather melancholy feeling of his post-adolescent blue period seemed for a time in later years to be superseded by his restless intellectuality, and thus onwards emotion and feeling appeared to wrestle with each other. But now his emotional element seems entirely and violently reborn. Released from the gentleness of pity, it can only be sensed as something great'.[34]

There were other supporters: reasoned endorsement by Philip James on the BBC Home Service, by Roger Marvell in the *New Statesman and Nation* and by Eric Newton in *Picture Post*; an enthusiastic notice in the *Observer*; a statement to the press by Phillip Hendy; and some sober analysis in *The Times* which attempted to divine the source of the violence that visitors felt they saw in Picasso's recent work:

> On the surface, Picasso seems to have been less concerned with the events of the war than he once was with the small massacre of Guernica: none of the new pictures makes any such obvious protest or so directly records any event. On the other hand, the vitality of this abstraction is more terrifying than ever before, and they seem to have taken in, though without apparently getting closer to nature, a new range of sensation ... the artist's grasp and sense of design are as astonishing as ever.[35]

The higher-class magazines showed signs of being 'thrilled' by Picasso as well as by the Paul Klee show at Trafalgar Square. 'Last year was the most exciting since the war ended', warbled Mary Sorrell in *Queen* a year later. The 'Picasso–Matisse exhibition' had been a 'thunderbolt ... shocking, stimulating, and causing the biggest stir in artistic circles for a long time'.[36] The correspondent for *Tatler* described Picasso as 'a rare artist before whose genius I normally stand entirely in awe ... I hold [him] to be one of the greatest painters since the Renaissance'.[37]

The stylistic distance between the new work and the Tate's *Woman in a Chemise* (1905) was certainly a puzzle to some. 'The change, we are told, is in the artist', said the *Illustrated London News*: 'It is modern civilization, it is moral indignation. There can surely never have been, since Jeremiah, so formidable an indictment of modern times'.[38] *The Sketch* of 9 January 1946 referred to the 'blast of hot, searing criticism in daily papers, clubs, pubs and drawing-rooms' and, reproducing images by Picasso and Klee (the latter with a near-simultaneous exhibition at the National Gallery), suggested that 'our readers might like to compare samples of the two shows, to "start you talking" in the BBC manner'.[39]

For the rest, the reaction to the show was one of undiminished amazement and spleen. Correspondents to the *Daily Telegraph* threw phrases such as 'protest', 'artistic heresy', 'sordid', 'mischievous', 'defies the test of intelligibility', accusing Picasso of the 'corroding influence of that particular style of ultra-modernism which sets traditional values at nought'.[40] A minority defended Picasso's work on the basis that El Greco had also distorted form and colour; but the overall mood was one of outrage, resentment and pain. A vicar from Wimbledon Park put himself on the record as believing that 'distortion is the only word we can apply'.[41] The headmaster of Bembridge School, speaking at the Conference of Educational Associations, dismissed Picasso's work as 'jungle of deformity': 'We are shown deformed bodies, parts of limbs and parts of faces, with some of the limbs protruding from the tops of their heads … Some of the drawings are openly indecent … the youth of the day has no use for this morbid rubbish.'[42] A no less offended response appeared in the letter pages of *The Times*, where echoes of the controversy could be found on most days between 4 December 1945 and 12 January 1946. The ageing critic Dugald MacColl and Barber Institute Director Thomes Bodkin complained of the 'crazy guying of humankind', the 'wild extravagance' of Picasso and the 'pointless distortion of the natural forms' in Matisse, recommending finally that 'school children … should be barred'.[43] Outrage was expressed by a correspondent from Rochester 'in a state of bewilderment';[44] by Lord Brabazon of Tara (writing from the Athenaeum), 'amazed' at the distance between Matisse's recumbent women and humanity: 'we shall soon be told a multiple drill has sex appeal',[45] he exploded. Norman Wilkinson of the Royal Institute of Painters in Watercolour claimed that the show was 'an insidious growth … which, if unchallenged, will sap the roots of all that is fine in painting'.[46] Evelyn Waugh compared Picasso and Matisse to 'crooners' whose devotees found themselves 'sent'.[47] The work of both painters (but Picasso in particular) was 'squalid and brutish', 'unfertile', 'crude', 'Belsen horrors', 'the phantasmagoria of a demented mind'.[48]

Patterns of caricature

The responses thrown up the 'Picasso–Matisse exhibition' took place in a public arena of sorts: namely the national press. Yet what is significant is the frequency with which the same phrases recur. Moral and political alignments were still regularly atached to art; yet one feels that their attachment has become routine. Positions on both sides were becoming repetitious and caricatured.

One difficulty which traditionalists felt they were having with modern art can be conveyed by a comment made by Sir Ernest Benn in the *Telegraph* about the 'Contemporary British Art' exhibition, Britain's reciprocal gift to the continent. Back in London in the spring of 1947, the show struck Benn as thoroughly Bolshevist:

> faithful witness to the way in which some British artists have joined their revolutionary brethren abroad in their fight against Nature and all her ways. Only if peace and goodwill can be found in the godless Left can its sponsors be justified.

Un-British and objectionable ... [Burra's *Mexican Church*] might have been bor-
rowed from the anti-God pictures on which Lenin founded his regime, and its exhi-
bition all over Europe by the British Council must have strengthened the suspicion
that we are following the Moscow road.[49]

The identification of 'modern art' with the political left embodied for many (and
does so still) a suspicion that its purpose lay in the overthrow of existing values
and their replacement by new orderings of matter and form as representations of
the world. For the 72-year-old Benn in 1947 it represented a more specific threat.
As a self-proclaimed 'capitalist' and 'individualist' – Benn had recently founded
the Society of Individuals and published a strident manifesto against the state – he
upheld a potent mixture of 'enterprise' and 'independence' as a 'characteristically
British property', having its fundamental antithesis in all forms of statist, collec-
tivist or totalitarian thought.[50] Benn's 'fight against Nature and all her ways'
became a kind of reproach to all involved in modern art. The Bembridge School
headmaster who had accused Picasso of bringing 'only messages from the mortu-
ary' believed he was placing his trust in decency and a return to common sense:
'Youth would respond to true leadership and would build again a beautiful world',
he said; it would make a stand for 'truth or beauty or common humanity'.[51] The
traditionalists were disturbed too by the new role played by the artist: they wanted
constructive feeling, optimism and a desire to rebuild, while the modernists were
arguing that the artist had a duty to reflect the horrors and deficits of the age. For
both, modern art provided a pessimistic diagnosis of the condition of the modern
world, for which the artists themselves would at best offer consolation and a heal-
ing touch. 'Picasso and Matisse are X-rays of an internal cancer in modern civi-
lization', a sceptical correspondent wrote to *The Times*, 'but the function of an
X-ray is not the function of the artist'.[52] What was referred to as a 'new dark age'
(in a letter from Felix Topolski) was something to be transcended, not enjoyed.[53]

In a series of further formulae, the most splenetic observers complained that
modern art was both deceptive and cognitively misconceived. Many expressed the
conviction that Picasso and his colleagues had defective vision (an assumption
recently made programmatic in Hitler's diatribes against modern art). 'What did
he have over his eyes to enable him to see such things as these?' a lady was over-
head inquiring of her companion at the Victoria and Albert Museum show. The
wider allegation that supporters of modern art were a 'clique', a 'cult', a 'few peo-
ple "in the swim"', a 'pseudo-artistic sect'[54] was rife: the accusation was one of pre-
tentiousness, elitism, fadishness, self-reference, insincerity, even femininity.[55]
There were protests about the use of *public* museum space for what was reckoned
to be a disreputable and even dangerous art.

Let us look more closely at the accusations of cognitive incompetence that were
being aired by the protesting voices. It is striking how often words like 'monstros-
ity' and 'deformity' appear in these attacks; how often it was supposed that the
modern artist was taking leave of Nature, Humanity, Goodness and the Moral Life,
let alone Art. It is clear too that many believed that Picasso (the prime offender)

was manufacturing a new reality that did various sorts of injustice to the actual one. In fact many protesters made no distinction between locating the cognitive problem in the painting, and locating it in the artist.

Cyril Asquith's description of Picasso's early Cubism as 'half a guitar with a tram ticket under the strings and a human ham in the offing'; or of his *Woman with a Fish Hat* of 19 April 1942 (Figure 80) as 'a bone, an eye, and a piece of wet black mackintosh'[56] seem to contain implications of both. They are excellent descriptions in their way. Asquith *was* outraged; his technique was to inflict damage on the work by mixing up literal description with what might have passed for an account of something absurd. Like other attacks, such rhetoric traded on the later nineteenth-century assumption that a picture existed to narrate and describe; then insinuated that Picasso and his fraternity had got that descriptive job somehow terribly wrong. The argument took either of two forms: one alleged that the artist was an incompetent descriptive agent (blind or incapacitated or a fool), while the second accused him of positing a reality that was not and could not be 'there'. In the first, the artist could not represent; in the second, the world was not as his picture claimed it to be. Either way, modern art's treatment of its content was thrown under the severest and most implacable doubt.

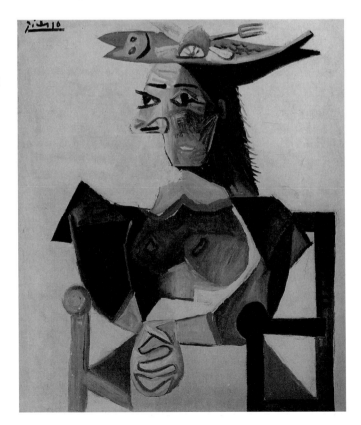

80 Pablo Picasso, *Woman with a Fish Hat*, 19 April 1942, oil on canvas, 100 x 81 cm.

But there was a further register rich in verbal and visual caricature that became prominent in the London press and magazines from the mid-1930s through to the end of the 1940s. What is distinctive about this register is its ubiquity and accessibility: consumed rapidly and without high seriousness, cartoons reached beyond an audience of gallery visitors to a mass public whose impression of modern art had been formed either through previous cartoons, or through hearsay, or worse. Secondly, such cartoons (unlike the polemical broadsides of the eighteenth century) were anonymous as well as multivalent: they deployed visual techniques to summarise topical issues without risking identification with a single viewpoint or position. Frequently, and this was their genius in the later 1940s and beyond, they encapsulated contrary points of view within a single mass-circulation image. For example, while Lee's *Evening News* cartoon of 1936 (Figure 81) accused the modern artist of childish incompetence in representation, the drawing in *Punch* for 9 November 1938 (Figure 82) implied that the representation *was* the thing and vice versa. The latter cartoon, in its turn, brought out the fact that Cubistic fragmentation lent itself to visual satire even more effectively than El Greco-like elongations

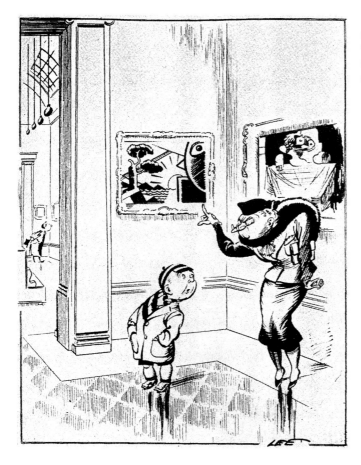

81 Lee cartoon, 'Willy! Did you do that?', *Evening News*, c. 1936.

and changes of proportion and scale. *Drawing* here is perceived to be modern art's
primary problem – rather than colour or perspective, which the cartoon medium
cannot reproduce so well. That it is the upper classes in their pinstripes and top
hats who are the subjects of modern art's Cubist and Expressionist armoury is
another twist again. The caricatural mix-up between modern artistic syntax and the
reality it wrongly pictures is then turned upon other subjects: the artist, notably,
who is already reckoned to be socially rebellious, or mad, or both. What would the
modernist artist look like if his appearance could be deduced from his self-portrait?
Lilliput's Hayland cartoon for October 1943 (Figure 83) provided one hilarious
answer.

Who then were the audiences for these early caricatures? Whose views did they
reflect? In 1936 the *Evening News* was on its way to becoming the 'largest sale of
any evening newspaper in the world', within a decade to reach 1.64 million read-
ers throughout London and the home counties.[57] *Punch* described itself as 'the
leading British humorous and satirical journal'.[58] *Lilliput* was second only to
Picture Post in the Hulton Press pantheon, advertised after the war as a magazine
that '500,000 people of both sexes and all ages from the upper income groups
buy'.[59] An earlier advertisement claimed *Lilliput* to be 'for goods that sell on qual-
ity rather than price … its appeal is to sophisticated, intelligent, well-circum-
stanced folk'.[60]

Lilliput's self-characterisation is particularly important because it points to
the existence of a public that in matters of consumption and enjoyment was
already self-aware: a public that could enjoy a series of parodic positions vis-à-vis

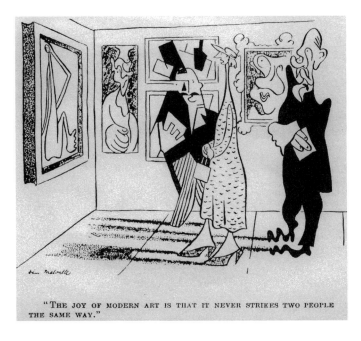

82 'The Joy of
Modern Art', *Punch*,
9 November 1938.

"THE JOY OF MODERN ART IS THAT IT NEVER STRIKES TWO PEOPLE
THE SAME WAY."

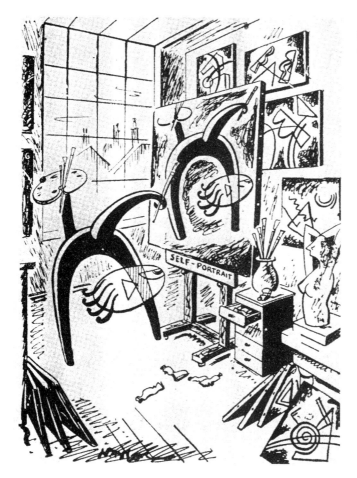

83 Hayland cartoon,
Lilliput, October 1943.

modern visual art that had no obvious counterpart in modern music, writing or drama. Furthermore the cartoon provided a language of stereotype and easy humour: lacking in real anger, it was a carnivalesque idiom that criticised affectionately, yet refused to take its adversary too seriously. It made fun, but without real scorn.

The logic of the argument is that the language of the cartoon helped reproduce but also effectively contain and perhaps ultimately defuse the public debate about modern art after the war, especially in the wake of the 'Picasso–Matisse exhibition' of 1945–46. There were, after all, plenty of occasions for the carnival: the Paul Klee exhibition at the National Gallery in 1946, the large Van Gogh extravaganza of December 1947 at the Tate, followed by Chagall at the Tate in February 1948. The later case is interesting: for there is some evidence that Chagall was regarded as a daring artist across a wide constituency of viewers. When the Ashington Group came to London on a trip in 1948, they went to the Chagall show at the Tate and visited the National Gallery (Figure 84). Having been already introduced to

modern art courtesy of the Adult Education Institute and CEMA, they took the Tate show entirely seriously. 'These pictures may be difficult', the colliery clerk Arthur Whinnom warned; 'Eric Newton says "Chagall's world is not easy to share"'. 'I shall have to meditate on Chagall', he said after seeing the show. 'After I had been round his work I went to see the French Impressionists' room and was struck by how insipid they seemed to be'.[61]

The Chagall exhibition stimulated further visual caricatures in the mass-circulation press. The artist's habit of fragmenting a torso 'illogically' across the canvas evoked predictble accusations of 'incorrect' drawing. Amid news stories of a five-hour blaze in the Ipswich Public Hall, policemen delivering a baby in Acton, and the exploits of a gin gang in Northampton, readers of the *Evening News* for 26 February 1948 were offered a drawing by Lee showing a response that was seldom (if at all) offered to Picasso two years before, namely the hysterical laughter of one who thinks he is being entertained (Figure 85). The 1.64 million readers who saw this cartoon were learning *both* that pinstripe dissent from the standards of modern art was justified; *as well as* the contrary view that pinstripe traditionalists were as risible as the art itself. Such careful ambiguity was becoming the cartoon genre's most potent and defining weapon.

The 'fragmentation' problem was revisited by the *Evening News* on 24 March, when Lee drew a further cartoon that trained attention on the by now well-known

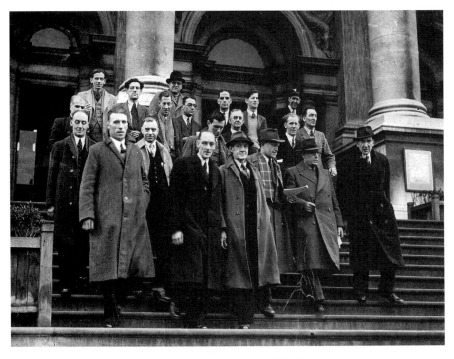

84 Members of the Ashington Group outside the Tate Gallery, 1948, photograph.

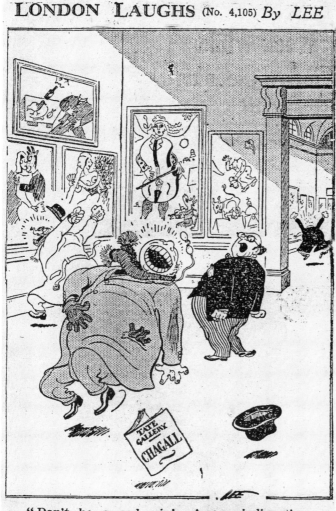

85 Lee cartoon,
'Don't be a cad, sir!',
Evening News,
26 February 1948.

rift between the Academy and the Tate (Figure 86). Amidst the human-interest stories of boys drinking sherry, milk thieves and cows grazing on the Glasgow–Euston line, the cartoon contains the regular mixture of *both* modernist and traditionalist establishments. A dandified figure is telling the Academy warder to 'show this – er – person back to the Tate'. Simultaneously, it is a Chagallian human whose head floats away from his body in the form of a self-playing double bass (the narcissistic accusation). Here were the rival camps, receiving short shrift in equal measure before an audience of London commuters. The rhetoric of pro- and anti-modernism was becoming a spectacle in itself.

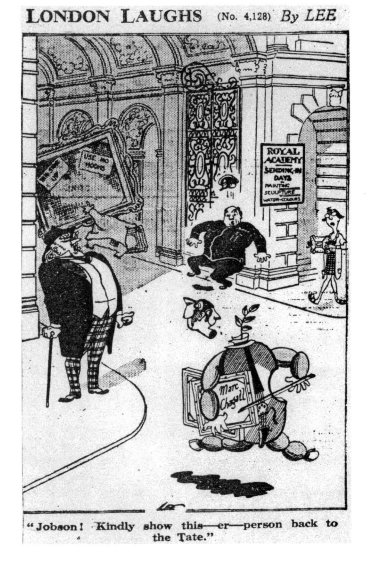

New patrons: the ICA and the LCC

The London public was at the same time assailed by patronage organisations on a hitherto unknown scale. We have mentioned the British Council (from 1935); CEMA (from 1940); the Arts Council (from 1946). To this list we can now add the Institute of Contemporary Arts (ICA) and the London County Council (LCC) – two bodies which entered the arena of the visual arts in the early part of 1948.

As the Tate Gallery prepared for its Chagall exhibition in early February, the ICA launched its first show, '40 Years of Modern Art: 1907–1947: A Selection

from British Collections'. The origins of the ICA lay in a letter written two years earlier over the signatures of Roland Penrose, Herbert Read and E. L. T. Mesens calling interested parties to a meeting to found a Museum of Modern Art in London.[62] Representing the visual arts, music, ballet, theatre, broadcasting, architecture and film, the organising group consisted of private individuals who had reservations about the welfare-state economy and were generally opposed to state management of the arts; having little money of their own, they were determined to build an avant-garde centre in London where individualistic experiment could flourish and the best examples of recent international modernism could be displayed.

Since that initial meeting over a year had elapsed before the organising committee agreed on a public statement of the aims of the 'Museum of Modern Art Scheme' – as it was initially known – and began in earnest to find funds and a temporary exhibition space for its activities. After acrimonious discussion among the organisers, agreement was reached on a public statement in the late spring of 1947, when a letter to *The Times* by Herbert Read advertised the existence of the organising committee and offered a copy of its new Policy on request:

> The need for such an institution will be obvious to all who are aware of the aimless and sporadic character of artistic activities in our capital city. While institutions such as the national galleries, the Arts Council, the British Council, the Courtauld Institute, exist for the purpose of exhibiting contemporary art, nothing of a more direct nature is done to encourage its creation. The BBC and various educational bodies endeavour to teach the appreciation of art, but this again is a policy for consumers, not for producers. What is needed is some centre where artists of all kinds can meet with a cooperative intention, and where their activities can be presented to a public ready to encourage art in those preliminary stages which are so vital for its development.
>
> The institute will differ from existing institutions in that it will initiate definite projects, and not merely collect and exhibit the chance productions of isolated artists. It will attempt to establish a common ground for a progressive movement in the arts, and will enable artists of all kinds to join together in the search for new forms of social expression.[63]

According to the Statement of Policy, the Institute would

> not compete with national institutions like the Tate Gallery, the Arts Council, or the British Council. Its function would not be retrospective, nor propagandist. Rather it would be co-operative, experimental, creative, and educational in the real sense of the words, and for the benefit of the community.
>
> The Institute would be co-operative in that it would gather together into one coherent effort those manifestations in the various arts which at present are isolated and sporadic. It would attempt to establish a common ground for a progressive movement in art.

The Institute's communitarian spirit was expressed in words which gave it a national as well as an international appeal:

A living art, that is to say, a progressive art made for and understood by its contemporaries, is an essential in any vital community, and we believe that it can be fostered in England. The spirit of the time speaks (not always consciously) through the work of all artists – painters, poets, sculptors, architects, musicians and philosophers – and art should be a part of the life of the community as a whole.[64]

Proposing nothing short of a 'springboard for the future' and an attitude of support for non-commercial artistic experiment across all media, the statement appealed for founder members and subscribers who would raise a preliminary fund of £50,000. It is important that even by this date, Arts Council money had begun to flow into the ICA, not for specific exhibitions but for general expenditure – hence inaugurating a mechanism whereby the Arts Council could support avant-garde and modernist art without drawing direct public opprobrium for doing so.[65] In this way Treasury funds could flow to modernist art indirectly, and in so doing alter the balance of cultural power in London virtually at a stroke.

In Herbert Read's spoken address at '40 Years of Modern Art' on 9 February 1948 his plea for a marriage of modern art and national consciousness was elaborated in a way that made the ICA's financial dependency upon the Arts Council far more overt. Read sought to blend the internationalism for which he was already known with the centripetency of the Arts Council's work:

> In London there should be a national art centre, the nucleus of all the local art centres, projecting to a scale of national consciousness the best products of the smaller localities, and acting as an exchange for the creative art of all contemporary nations. This is the function we envisage for an Institute of Contemporary Art.

The creation of such art centres, said Read diplomatically, lay at the heart of the Arts Council's mission:

> Its aim is to stimulate the appreciation and the production of art on the widest national basis ... these centres, which will be specially designed for their function, will be social centres where art is created and shared 'in widest commonality' – where the playwright and the actor, the painter and the sculptor, the poet and the musician, emerge from the general body of the community to express its ideals and give form to its joyful life. Every town of any size – every borough and rural district – should have its art centre, not merely receiving art but also creating art and exchanging it in friendly rivalry with other centres ... None [but the ICA] is in any practical sense concerned with art in its social origins or orientated towards the future. None exercises effective patronage. None provides a *foyer*, a hearth round which the artist and his audience can gather in unanimity, in fellowship, in mutual understanding and aspiration.[66]

What cannot be doubted is that '40 Years of Modern Art' provided a focus for modernist art across all the media: first performances in England of works by Stravinsky, Berg, Dallapiccola, Bartok, Phyliss Tate and Serge Nigg; poetry readings by

Kenneth Rexroth, Robert Penn Warren, Robinson Jeffers and Kenneth Patchen (from the USA) as well as by T. S. Eliot and Dylan Thomas. Contemporary chamber music was composed for the occasion by William Alwyn, Benjamin Frankel, Elizabeth Lutyens and Humphrey Serle. Displaying works by Moore, Klee, Modigliani, Braque, de Chirico, Dali, Ernst, Marc, Matisse, Picasso, Rouault, Tchelitchev, Utrillo, Epstein, John, Wyndham Lewis, Piper and Sutherland inside, public attention outside the exhibition was drawn by the disturbing presence of F. E. McWilliam's surrealist *Kneeling Woman* of 1947 on a bomb site next to the Academy Cinema (Figure 87), a work which could be seen to subtly change from naturalistic to fragmented depending upon the viewer's position. Half formal demonstration and half surrealist joke, McWilliam's work acted as both advertisement and provocation for a truly modernist event.

We again have too few reports from individuals or groups to be able to characterise public reactions to the show in much detail. According to one account, the crowds on Oxford Street greeted McWilliam's work – a 'sculptural concoction' – with 'interest, wonder, amusement, derision or horror'[67]. Yet the idea of outdoor modern sculpture in the capital was already being considered on a much larger scale. The impetus came from Patricia Strauss, then Vice-Chairman of the LCC Parks Committee, who in May 1946 had floated the idea of an open-air exhibition of modernist sculpture.

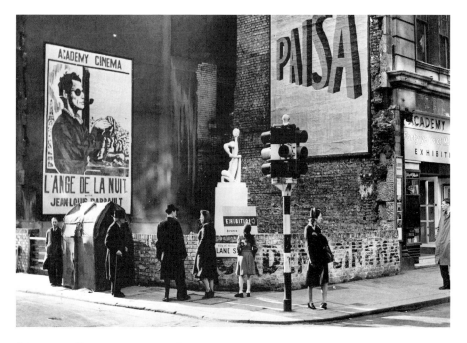

87 F. E. McWilliam, *Kneeling Woman*, 1947, cast and carved stone, height 145 cm, on the corner of Poland Street and Oxford Street, as part of the exhibition '40 Years of Modern Art', Institute of Contemporary Arts, 1948.

> Public interest in the arts is increasing but sculpture is rather the Cinderella ... [an
> outdoor exhibition] would serve the triple purpose of serving the public, encourag-
> ing art, and giving publicity to the [London County] Council ... [My idea] is to show
> our public and the world the trends of modern sculpture. Indeed, I would like it to
> be frankly an exhibition of modern sculpture, and if the discussion aroused is con-
> troversial, so much the better.[68]

The LCC admitted immediately that the help of the Arts Council or British
Council (or both) would be needed. The first response of the Deputy Director of
the Tate, Humphrey Brooke, was that there were 'very few good sculptors in this
country ... only four or five whose work would attract favourable notice' and that
the show would have to be international: the idea was dismissed as 'charming' but
impractical.[69] But the Arts Council was interested from the start. The choice of
site, selection of sculptors and arrangements for security were swiftly resolved.
Battersea Park was preferred to Kenwood – the first suggestion – because it was
'right opposite Chelsea, one of the alleged centres of modern art',[70] and could be
closed to potential vandals at night.

Quite early on the Arts Council gained control of the exhibition's Working Party,
whose smaller Selection Committee came to be dominated by a group of influential
figures with known sympathies to modern art both nationally and internationally:
Sir Kenneth Clark, Frank Dobson, Henry Moore, John Rothenstein and Philip
James. Only Royal Academician Charles Wheeler (given an O.B.E. in the 1948 New
Year honours list) could be associated with a conservative tendency. The LCC was
unrepresented. The Working Party, led by Mrs Strauss, for the most part (if reluc-
tantly) accepted the Arts Council's expert advice subject to the provision – a vital
one, given the LCC's wider mission – that the exhibition be communicated effec-
tively to the 'plain man', the ratepayers and the taxpayers of the metropolis.

It is at this point that tension between the Arts Council mandarins and the more
local accountability of the LCC began to become apparent.[71] Sensitivities about the
appearance on the poster of Henry Moore's *Reclining Figure* of 1938 stemmed from
its unfamiliarity to the 'general public'.[72] A small sixpenny catalogue was 'prefaced
by an introduction [by R. R. Tomlinson] to enable a person on the threshold of the
study of sculpture to take an intelligent interest in the exhibits'.[73] For the main illus-
trated catalogue, to be sold for 5 shillings, Eric Newton was engaged to write a pref-
ace, though the LCC made it clear in its commissioning letter to Newton that

> The Council desires that, although the exhibits shall be of high order, the exhibition
> shall appeal to the ordinary citizen and ratepayer. The article which we should like
> you to do is intended to help the plain man to understand what to look for in a piece
> of sculpture, not necessarily the particular pieces to be exhibited ... It would ... be
> invidious of you to make any special reference to any particular piece or artist, except
> as the representative of a school or trend.[74]

Newton's first draft contained references to public 'timidity' and 'blindness' and
accused the planners (the LCC) of lack of interest, so was sent back to its author

for 'toning down'.[75] Newton replied testily that he would make some changes but felt that 'after many years of trying to educate the public in the visual arts … it is impossible to encourage the public without criticising them'.[76] The result was a short but generalised text appealing for the artist's right to depart from appearances in favour of form for form's sake: according to Newton, the arts were to 'make life more seemly and also to add to its meaning'; large-scale sculpture was 'the furniture of our cities … and London is worthy of good furniture'.[77]

Open from May until September 1948, the 'Open Air Exhibition of Sculpture' ranged from avant-garde to conservatively figurative: McWilliam, Dobson, Epstein, Gill, Gertude Hermes, Leon Underwood, Hepworth, Michael Bedford, Heinz Henges and Henry Moore at the abstract end, to William Reid Dick, Charles Wheeler and Havard Thomas at the figurative, supported by works by Maillol, Lipchitz and Zadkine and a bas-relief by Matisse. Guide-lecturers were appointed by the Arts Council to 'explain' the sculptures to visitors (Figure 88), and their reports are further testimony to the wide range of opinion on relations between abstraction and the figure which became the key aesthetic question of the show. One guide-lecturer reported that

> almost everyone was charmed and delighted by the novelty of the occasion, and almost everyone wants to know … what is the *meaning* of the Moore group … Apathy on every hand is shown towards the Matisse, and Dobson comes off badly, the usual cross-section being worried by this obvious attempt to impose abstraction on plump wenches

The same guide noted that 'Reid Dick has not many supporters, even among the least enlightened'.[78] Another reported on the 'open-mindedness of the very cosmopolitan crowd of visitors and their genuine curiosity and desire to understand the less familiar forms of sculpture … the informal atmosphere made people far less self-conscious than they are as a rule in a gallery'. This report spoke of 'little real antagonism' for the two pieces by Moore:

> Those who did not like them were usually the people who said they were 'lovers of beauty' and who were obviously looking for a sentimental idea or a little moral uplift in their sculpture; but as [Wheeler's] *Spring* and [Reid Dick's] *Man Child* provided them with these they went away quite happily convinced that there were a few sculptors left.[79]

A third lecturer divided the visitors into three: 'the reverent listeners, the disputative ignorants (who go angry or poke fun), and the Quoters or Misquoters from "Horizon" and other sources of aesthetic information'.[80]

The significance of the exhibitions of early 1948 is on this evidence that the nature of the debate over modern art had changed even from the swapping of stereotypes that had been characterstic of 1945–46. The organisers of the 'Picasso–Matisse exhibition' may in some sense have 'got the whole country dancing'; but the Battersea Park attendance figures of 148,901 were not huge: no

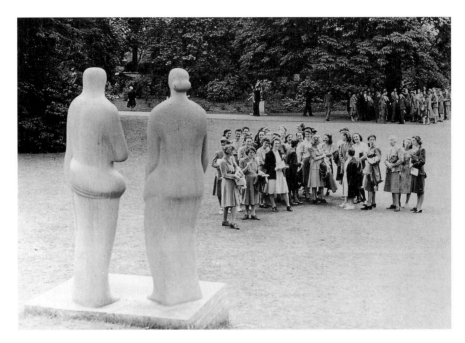

88 Guide-lecturers showing visitors Henry Moore's *Three Standing Figures* at the 'Open Air Exhibition of Sculpture', Battersea Park, May 1948.

more than the numbers who visited the National Gallery for the same period in 1838; or the South Kensington Museum for the same period in the 1850s. Admittedly the guide-lecturers' reports were addressed to the Director of the Arts Council by sympathetic experts in the field: yet there appears to have been little public hostility to the exhibition, which could probably be taken to demonstrate that modern art was becoming an event of consumption as opposed to one of debate. Admittedly too the cognitive challenges of the show were not on every occasion met. The fate of the Henry Moore *Three Standing Figures* is symptomatic: in August 1948 a hapless Parks Department official – not a guide-lecturer – was overheard telling a group visiting the gardens that the figures were 'sort of members of the Civil Defense in atomic armour expecting an air raid'.[81]

But it signified a change in the consitution of the public interface with art that no less than six radio broadcasts and a television report were devoted to the 'Open Air Exhibition of Sculpture'. Four times the number who visited the exhibition could read about it in *Picture Post*. The suspicion generated by such tendencies is that the public encounter with modern (as indeed with other) art was tending for the first time to become administered rather than participatory, spectacular and even remote, not to mention the competition for attention in the form of advertisements for services and goods. Many signs were now present of the domination of cultural discussion by the blandishments of a new consumer world. The impact of 'personalities' upon public discussion was only just beginning.

Wild and dull nonsense: 1949

A characteristic of the later 1940s in the field of art in London was the more or less open hostility between the national institutions themselves. Though simmering for decades, the major clash between the modernisers and the Royal Academy erupted the year after the Batersea Park exhibition, in the spring of 1949. The ICA had already fanned the flames: in introducing '40 Years of Modern Art' Herbert Read had written that 'The great museums and art galleries are retrospective in their policy. The Royal Academy if not retrospective is at any rate stagnant ... The Royal Society of Arts, which was created with wider aims, has become a scholastic institution, divorced from the creative reality of art'.[82] But the immediate background to the great public *dénouement* was a House of Commons committee, which in May 1946 concluded almost two years of discussions with far-reaching proposals for the reorganisation and re-resourcing of the London national collections. Headed by the Canadian diplomat and art patron Vincent Massey, the *Report on the Functions of the National Gallery and Tate Gallery* came out forcefully in favour of consolidating the power and influence of the Tate. It recommended that the Tate ought henceforward to be divided into two separate collections, a National Gallery of British Art of all periods, and a National Gallery of Modern Art

> under the same roof as the National Gallery of British Art ... [and] accommodated as a separate entity ... the two collections being locally distinct ... [with] notices displayed making it clear to the visitor on entering the building that the Tate comprised two separate collections and indicating the rooms in which each was displayed.[83]

The Tate would receive an exchequer grant of £5,000 annually, lose a group of Alfred Stevens pictures to the V & A and acquire the British Museum watercolour collection to become the main collection of British watercolour painters. The Tate Trustees would be made independent of the National Gallery, and would receive the Chantrey Bequest money directly, if necessary by modifying Chantrey's will by legislation – a proposal calculated to be a red rag to the Academy bull.[84]

Since his election as President of the Royal Academy in 1944, the horse-painter and traditionalist Alfred Munnings had done everything in his now considerable power to rally suporters to his cause. Incensed by the Massey *Report* and a tide of opinion running in the mandarins' favour, Munnings tried in the middle of 1946 to assemble a group of allies to his cause. He wrote to his ally at the *Sunday Times* Sir Desmond MacCarthy, referring to the 'Picasso-Matisse exhibition': 'The crowds at the V and A Museum were terrific, seeing the Picassos!! I don't suppose you went. All commercialism and camp and these silly small amateur experts are swallowing it!'[85] Noting the names of those who had written to the *Times* against the Picasso–Matisse show, Munnings had invited them all to a dinner at the Academy along with other eminences – Sir Cyril Asquith, Sir Malcolm Hilbery (later Lord Mayor of London), Sir Alan Lascelles (Private Secretary to the King), Sir Giles Gilbert Scott, the Academicians who supported him, and the

Prime Minister Clement Attlee. Newspaper editors were called in on a separate occasion, wined and lunched and exposed to Munnings' views on the shortcomings of modern art, delivered in his usual ribald, rollicking style. Yet relations between Munnings and the modernists were not without friendliness: it had been Rothenstein who in 1945 had supported the acquisition under the Chantrey fund of Munnings' *The Racehorse Hyperion* – which he and Vincent Massey held to be 'a not unworthy inheritor of the tradition of Stubbs and Ben Marshall'[86] (strangely, the Academy members had voted against it). For his part Munnings regarded Rothenstein as a friendly foe: as a man to be sparred with and eventually caricatured. 'I hate you John, you villain', Munnings said, 'but there's no one on earth whom I'd rather look at pictures with'.[87] The remark's occasion was a dinner, on 5 January 1949, given by Munnings at the Academy, to preview the controversial exhibition of Chantrey Bequest pictures, shortly to open there – many from the vaults of the Tate Gallery – to which Jasper Ridley, Humphrey Brooke, Norman Reid (all from the Tate, or its Trustees) had been invited along with several Academicians to hear Munnings' own proposals for a reform of the the Chantrey Bequest.[88]

At the dinner itself Munnings got drunk and made no proposals; in any event the simmering battle for art, and for the tradition represented by the Chantrey fund, was approaching its climax. Rothenstein published an article in the *Daily Telegraph* explaining why the Tate would never exhibit its Chantrey pictures as a group and why the £150,000 spent by the Chantrey fund had been mostly an error. Two days later a fierce polemic was published by Geoffrey Grigson in *Picture Post*, summarising the chequered history of the Bequest and pointing out that of the money spent on the Chantrey pictures, 'thus far the greater part of this money has been wasted'.[89] Grigson called Frank Dicksee's *Two Crowns* 'theatrical sentimentality … on the level of schoolbook illustration'. Frederic Cayley Robinson's *Pastoral* (purchased in 1924) was 'weak in design and feebly painted … [it] would make an inoffensive decoration for a café'. Lord Leighton's *Bath of Psyche* was 'a sugary nude on boarding house walls'.[90]

Grigson's broadside in *Picture Post* came in the last week of another ICA show, Herbert Read's '40,000 Years of Modern Art: A Comparison of Primitive and Modern', like its predecessor held in the spacious basement of the Academy Cinema, from 20 December 1948 to 29 January 1949 (Figure 89). Including Picasso's *Les Demoiselles d'Avignon* on loan from the Museum of Modern Art in New York and Lipchitz's *Figure* (1926–30) (Figure 90; seen by Penrose at Battersea Park), '40,000 Years of Modern Art' stood in a line of exhibitions attempting to trace correlations between 'the primitive' and 'the modern'.

From Munnings' point of view the London situation in early 1949 must have seemed grim. Following Picasso and Matisse, Van Gogh, Chagall, the Battersea Park sculptures and two avant-garde exhibitions at the ICA; with a substantial body of London press opinion exercised by the problems of modern art and with signs that some Academicians were becoming interested in the modern movement,

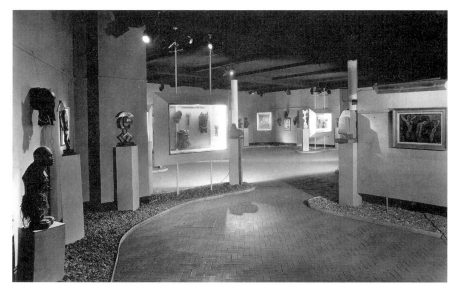

89 '40,000 Years of Modern Art', Institute of Contemporary Arts, 1948–49, Academy Cinema basement, London.

the time seemed right for a final defensive gesture from the rearguard of the Academy ranks. Following overtures to newspaper proprietors and influential civil servants, Munnings' next move was to court the friendship of Winston Churchill, now a national icon following his wartime leadership but also a painter of apparently anti-modernist bent who had shown at the Academy's Summer Exhibition in 1947 under the pseudonym 'David Winter' and whose booklet *Painting as a Pastime* had been published in that *annus mirabilis* of 1948. Churchill was now appointed to the invented position of honorary 'Academician Extraordinary' on the occasion of the Chantrey show. Relations between the two men were cemented in public on the evening of 28 April 1949, when both Munnings and Churchill made broadcast speeches at the banquet preceding the 1949 Academy Summer Show – the first since before the war and, given his intention to retire, the last at which Munnings would make the presidential speech (Figure 91). For Munnings this was to be the final *débâcle*.[91] Churchill referred jokingly to the ambiguous connotations of being called 'extraordinary' and 'honorary', and to the excusable quality of his own paintings which were on display. Munnings rose to speak next, 71 years of age and not a little drunk. 'I am getting somewhat distressed', Munnings began, referring to the number of toasts he had already imbibed. 'As they say in hunting, I've been up in the air all the time.' But he wondered whether the 'men' of the Royal Academy were really worthy of praise:

> Are we all doing the great work which we should do? … I find myself a President of a body of men who are what I call … shilly-shallying. They feel there is something in this so-called modern art … Well, I myself would rather have a damned bad

failure, a bad, muddy old picture where somebody has tried to do something, to set down what they have seen, than all this affected juggling, this following of ... the School of Paris.

The speech, broadcast live to a radio audience of millions (Munnings claimed he forgot he was on the air), was remarkable largely for its hectoring, dismissive tone: 'There has been a foolish interruption to all efforts in art, helped by foolish men writing on the press, encouraging all this damned nonsense, putting all these younger men out of their stride'. Munnings hectored everyone that night – Anthony Blunt, who had supported Picasso against Reynolds; the Battersea Park sculptures; Henry Moore's *Madonna and Child* at Northampton, and Matisse's *Trivaux Pond* (*La Forêt*) (1916), accepted under the Stoop bequest in 1933 (Figure 92).[92] He invoked establishment figures like the Lord Mayor and the Aldermen of London; the Master of the Mercer's Company Lord Selborne, and Academician Extraordinary Winston Churchill: 'he, too, is with me, because he once said to me

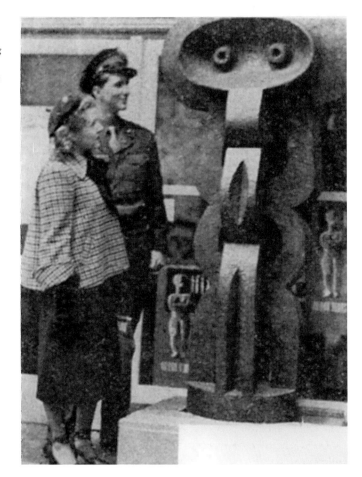

90 Shoppers in Oxford Street looking at J. Lipchitz, *Figure*, 1926–30, exhibited as part of '40,000 Years of Modern Art', London 1948–49, from *The Star*, n.d.

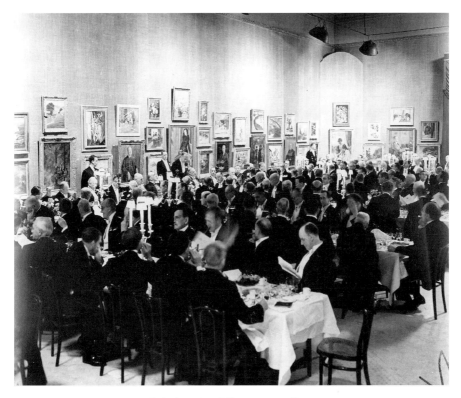

91 The Royal Academy Dinner, 1949 (the Duke of Gloucester speaking).

"Alfred, if you met Picasso coming down the street, would you join me in kicking his ... something, something, something?" I said, "Yes, sir, I would!"[93]

The result of the broadcast speech was a sort of opinion poll on modern art. The BBC switchboard was immediately jammed with calls from those taking offence at Munnings' 'damned'. On the other hand, Munnings claimed he was roundly congratulated by acquaintances and strangers eager to endorse his views. Letters poured in, the majority allegedly supportive of his line.[94] Cartoons in the newspapers and magazines abounded: David Low's drawing in the *Evening Standard* depicted the Royal Academy position as a cavalry charge on the Tate (Figure 93). Even within the Royal Academy the moderns and the traditionalists were viewed with a kindly mixture of affection and derision (Figure 94): in such drawings, personalities and their incompatibilities could be easily identified and the reader could absorb the essence of an issue without needing to take sides. The 'public' could watch from a distance, and enjoy.

In the aftermath of the speech, Geoffrey Grigson was answering a press question about the battle between modern and traditional art in which he said: 'There are excesses either way; excesses to the left, of wild nonsense, and to the right of dull nonsense ... At least painting in modern times has rediscovered that it has

more to do with man than with the things which man merely sees with his two eyes.'[95] The remark, which was unrehearsed, aptly summarised the dilemma of public culture in post-war London. On the one hand there was an apparently vigorous debate in which modern art was represented as seeming to the common man to be a fugitive, alien language – Grigson's 'wild nonsense' – compared with which Munnings' 'dull nonsense' was familiar and reassuring: 'Go round to the Tate Gallery, look at that damn *La Forêt* thing by Henri Matisse, then use your Lancashire commonsense and write what you really think about that adjectival collection of sticks.' His views on the mandarins was no less picturesque: 'Ninety nine per cent of the people in a country like this are normal. One per cent are not, and they get into the positions and get the jobs. That's the queer thing.' To an ageing Academician, Englishness excluded 'those men in Paris, with their drunken orgies, their incapacity, their sordid and distorted outlook; men like the drunkard and drug-fiend Modigliani [who] got together and set out to knock the whole thing to pieces'. Who then was to be the judge of what was good art, the reporter asked?

92 Henri Matisse, *Trivaux Pond* (*La Forêt*), 1916, oil on canvas, 92.7 x 74.3 cm (Stoop Bequest, 1933).

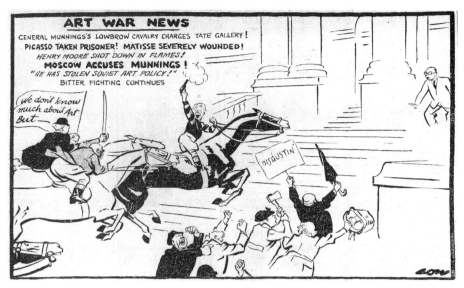

93 David Low cartoon, 'Art War News', *Evening Standard*, London, 4 May 1949.

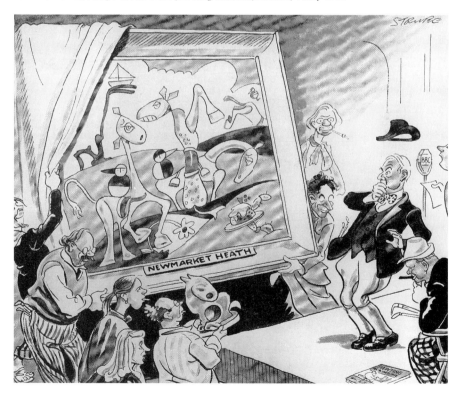

94 Strube cartoon, 'The Moderns present a Farewell Gift to the President of the Royal Academy',
The Tatler, 11 May 1949.

'The man in the street', replied Munnings unhesitatingly. 'He's a good judge when it comes to a really fine picture.'[96]

On the other hand participation in the debate would have to be described as consumption-like rather than engaged. The social theorist Jürgen Habermas summarised a post-war tendency: 'What can be posed as a problem is [now] defined as a question of etiquette: conflicts, once fought out in public polemics, are demoted to the level of personal incompatibilities.'[97] In any event, the decline of Victorianism as an art was by 1949 a prelude to its reappearance as history, a field not for artists but for historians, biographers and dealers. Munnings' last broadside took the form of a painting prepared for the Academy Summer Exhibition of 1956 entitled *Does the Subject Matter?* (Plate 12), depicting three men, a semitic-looking John Rothenstein, Humphrey Brooke (now Secretary of the Royal Academy) and John Mavrogordato (Professor of Greek at Oxford) and a well-dressed young woman, gazing appreciatively at a lump intended to caricature a work of Barbara Hepworth. In the rear stand Profesor Bodkin and an unidentified figure. On the wall are some accurate transcriptions of paintings by Picasso – the first and the last Munnings would paint. That painting was exhibited a matter of weeks after, and in response to, the Tate Gallery's epochal 'Modern Art in the United States' of January 1956: both phenomena in their respective ways demonstrated that the carnival of art had entered another phase.

For an international public: the Hayward Gallery

THE OPENING IN CENTRAL LONDON IN 1968 OF A NEW GALLERY for major temporary exhibitions was an event of significance in the unfolding relations between the public and modern art. As the last chapter sought to show, the battle between 'moderns' and 'traditionalists' was already won and lost by 1949. The Royal Academy no less than the Arts Council and the Tate had become subject to jokes and stereotypes that made the differences between those institutions themselves an exhibition of sorts (Figure 95). Simultaneously the spread of consumer culture in Britain in the late 1940s and 1950s made 'the public' a culture-consuming as well as a culture-debating body – that is what the growth of the mass media seems to suggest.[1] By the same token, educational capital now came to matter as much as, if not more than, income or social rank alone. Aesthetically, the battle was on for consumers from whatever fraction of the broad and divergent middling class.

The birth of the Hayward Gallery was important in giving permanent form to these tendencies. It was significant in other ways too. No completely new gallery with a national remit had been built in London since 1897, and none with public money: the Modern Foreign galleries at the Tate in 1926, a new suite at the National Gallery in 1930, the National Portrait Gallery extension of 1933, and the gallery for British and Modern Foreign Sculpture (again at the Tate) in 1937, had all been extensions to existing institutions, and privately endowed.[2] The Hayward, positioned on the South Bank of the Thames opposite Charing Cross, would thus complete a geographical clustering of institutions in the heart of London in an area close to the first public exhibitions in the Strand of the 1760s. And yet the Hayward would be in various ways different. First, it would represent a novel management collaboration between the modernist-inclined Arts Council that had so spectacularly collected new audiences for modern art in the 1940s and 1950s, and the Greater London Council, a local government body with metropolitan responsibilities alone. Secondly, the period of detailed planning and building of the Hayward Gallery, 1961 to 1968, was a time of ferment in London's self-identity and in the public understanding of art, architecture, music, fashion and politics, most often identified with emancipated social energies, cultural experiment and a new mood of popular participation in the arts following the election of Harold

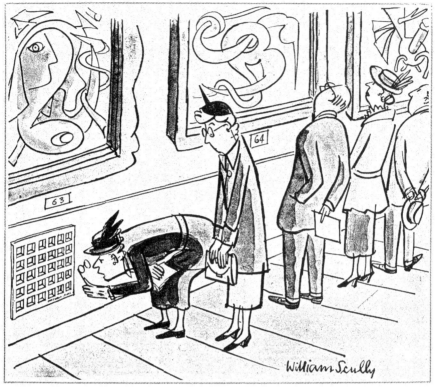

"It says, 'Air Conditioning by Ajax.'"

95 Scully cartoon 'It Says "Air-Conditioning by Ajax"', *The Sketch*, 7 May 1952.

Wilson's Labour government in 1964. For a brief moment, Hayward Gallery exhibitions would suggest ideals of citizenship of a kind seldom seen in London since the 1760s. For a younger 'revolutionary' public, new standards of participation momentarily prevailed.

A further development was that after 1968 those allegiances would have an international as distinct from a national or local scope. Certain kinds of contemporary art, like the public to whom it was addressed, would be perceived as being *in* Britain but not necesssary *of* Britain; *in* London but not *of* it. In terms of its traffic with art, London was ceasing to be merely a national capital, to become one site among others in an international network of cultural circulation and exchange.

South Bank policy

The South Bank of the Thames was already geographically significant by the time thoughts of a new exhibition gallery first arose. The area of central London bounded by today's Waterloo Station and the river, between Westminster Bridge and London Bridge, had long been considered a site of neglect and decay. Until

Blackfriars Bridge in 1760 and then Waterloo Bridge in 1815 London Bridge had been the only exit from the city to the south and the continent, and the area bordering the river on the south side, drained as late as 1790 and filled with warehouses, timber yards, railways, small plots of land and some residences, remained haphazardly used until well into the twentieth century. It was marked as an 'unhealthy area' by a committee of the Ministry of Health in 1920–21.[3] A report by the London newspaper *The Star* in the late 1930s remarks on the anomaly of the land near Waterloo Bridge:

> lying only a few hundred yards across the river from some of the most valuable land and buildings in the world ... the area is a promontory thrust like a fist into the very heart of central London. It should be the richest ground in the world. It has been neglected as if it were a kind of backyard.[4]

Given that the only twentieth-century building on the site was the LCC building, designed by Ralph Knott and built between 1909 and 1933, and standing immediately to the north of Westminster Bridge, *The Star* had a point (Figure 96). The scheme that paper offered for the whole of the river frontage, a classicising modernist scheme with a 70-foot-wide embankment motorway and 'gardens and pleasure grounds for the people, a new colony of Government and civic buildings, new

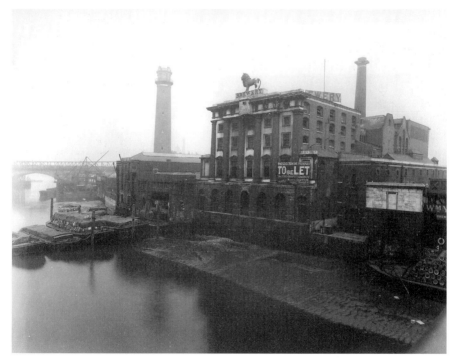

96 The South Bank before the Hayward: the Lion Brewery and Waterloo Bridge, March 1930, photograph.

theatres, hotels and cafés [that will] add enormously to the wealth, beauty and amenities of the capital of the Empire[5],' was never built due to the onset of war (Figure 97). And yet the thinking it embodied, seemingly inspired by the 1935 Moscow plan with its wide axial routes, domineering public buildings and massive open spaces at floor level, set a scale and a style for what was eventually to come.

Following the *Star* scheme, the LCC in 1939 obtained powers to redevelop the area north of County Hall, proposing a halving of residential and commercial densities, a doubling of areas for 'civic, cultural and public buildings' and public space, and an eightfold increase in offices.[6] Urgency was added to the replanning of central London by the heavy bombing of 1940 and 1941, while the Abercrombie plans of 1943 and 1944 underpinned the schemes already in place for the area.[7] The South Bank became a 'comprehensive development area' under the 1947 Town and Country Planning Act, and in the *Administrative County of London Development Plan, 1951*, a confident proposal was put forward that the area

> should be redeveloped as a whole for the purpose of dealing satisfactorily with conditions of bad layout and obsolete development, and war-damage and extensive areas of vacant land, [including provision for] improved traffic conditions, the provision of public buildings for central and local government purposes and buildings for cultural, office, commercial and industrial uses, and the provision of public open space together with the extension of the river wall.[8]

By this time, the Festival of Britain had been staged as a demonstration of the cultural, scientific and industrial prowess of a reconfigured Labour Britain, and a decision taken to preserve its single architectural masterpiece, the Royal Festival Hall, designed by London County Council architects Robert Matthew and Leslie Martin. Opened on 3 May 1951 and visited the next day by King George VI and Queen Elizabeth – seen here passing Basil Spence's Sea and Ships Pavilion before reaching the Skylon of Powell and Moya (Figure 98) – the Festival was marvelled at by huge crowds flocking into the metropolis in the summer months of 1951. The optimism, vigour and triviality of the Festival has often been remarked. Yet its impressive concentration of public sculptures and art exhibitions alongside works of technology and design (Plate 13) resonated in the public mind both as reminders of the propaganda success of 1851 and of a new commitment to a modern and democratic culture stretching seamlessly from the industrial to the aesthetic. The Festival had been intended as a potent symbol capable of redefining national identity after the victory of the Second World War, and to demonstrate 'British contributions to world civilization in the arts of peace' (though an international trade fair within the Festival was dropped in part because Britain's enthusiasm for European co-operation was low).[9] Re-establishing the 'self-respect and morale of the British people' – to use Herbert Morrison's words about a Festival he himself was co-ordinating in government – was the first and perhaps insular priority of 1951. As the Archbishop of Canterbury said at the opening ceremony at St Paul's on 3 May,

GREAT SOUTH LONDON SCHEME

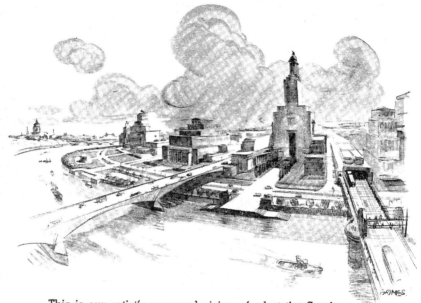

This is our artist's personal vision of what the South Side might become. Other lovers of London may have other dreams, but they are united in their aspiration for a South Side that will be worthy of the heart of the Empire. In order to awaken civic pride and to stir the imagination of Londoners to a sense of the immense possibilities of their heritage

IS PRESENTING A SCHEME TO TRANSFORM THE SOUTH SIDE OF THE RIVER THAMES

"THE STAR" LOOKS FORWARD TO A NOBLER LONDON

97 'Great South London Scheme', *Star*, late 1930s.

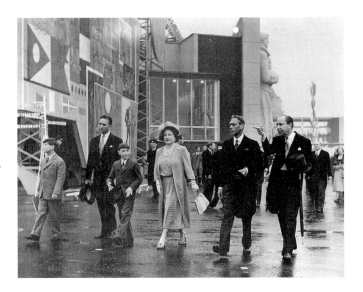

98 Festival of Britain:
Queen Elizabeth and
King George VI
passing the Sea and
Ships Pavilion,
4 May 1951. On the
left is Prince Michael
of Kent, James
Holland, and Prince
William of Gloucester.
Gerald Barry,
Director General of
the Festival, is on the
right.

the chief and governing purpose of the Festival is to declare our belief in the British
way of life, not with any boastful self-confidence nor with any aggressive self-adver-
tisement, but with sober and humble trust that by holding fast to that which is good
and rejecting from our midst that which is evil we may continue to be a nation at
unity in itself and of service to the world. It is good at a time like the present so to
strengthen, and in part to recover our hold on all that is best in our national life.[10]

The slight hesitation in Archbishop Fisher's last phrase suggests that the sense of
wartime national unity was already in disrepair (it would not, of course, ever fully
recover, not even by dint of that other festival, the Coronation of 1953). On the
contrary, a 'national' public, conceived as a body that recognised itself as subjects
of British culture and as living embodiments of its traditions – such a public was
already primed to fragment and disappear. Secondly, the assertion that the Festival
captured a uniquely 'British' style in art, architecture, design and decoration had
always been implausible to some. As Reyner Banham put it in a caustic later com-
mentary, most of the Festival's architecture and design was taken directly out of
previous French, Italian and Dutch models and was in any case less advanced than
the display techniques used for an exhibition at the Institute of Contemporary Arts
(ICA) in the same summer entitled 'Growth and Form': 'the officer-and-gentle-
man establishment had, in historical fact, just about caught up with a particular
stylistic package that was about exhausted'.[11] Banham's wider argument was that
the 'Britishness' of Festival style lay in its content rather than in its form: a rever-
sion to far older prototypes in furniture and landscaping dressed up in a spindly,
splay-legged style imported from design modernism elsewhere.

 And if the concept of British 'style' – the end point of a perceived national tra-
dition – was problematic in 1951, then so was the concept of a specifically British
approach to modernism in the visual arts. At issue here was the difficulty of

grafting a set of international formal ideas on to a shared British artistic legacy whose very identity had only recently coalesced around themes of countryside imagery (the 'New Romanticism' of Sutherland, Piper and Nash) in combination with an expressive constraint seldom tempted by extremes of inwardness, abstraction or experiment – witness the Festival exhibition 'Sixty Paintings for '51' organised by the Arts Council, comprising a mixture of Euston Road, Bloomsbury and St Ives painting (49 men and 5 women) and representing a series of cautiously 'advanced' aesthetic positions in British art of the day.[12] Partly owing to the hiatus of the Second World War, the implications of that grafting process were perhaps insufficiently understood within the culture as a whole. In practice, artists and designers could be said to have oscillated between attraction to available international models and home-grown traditions in a way that itself bore some of the hallmarks of an overriding British pragmatism and self-control. It is not surprising in such a context to find that the two major agencies responsible for the planning of public exhibitions in the capital after 1951 – the Arts Council of Great Britain and the London County Council (LCC) – made for somewhat uneasy bedfellows in the legitimation and management of the contemporary public visual arts.

By 1951, there was already agreement amongst the good and the great that a major new gallery in the capital was desirable. A *Times* leader of August 1949 had drawn attention to a lack of exhibiting space for temporary shows:

> The claims of the other arts are on their way to being met. London will have at least a new concert hall in 1951, and a national theatre is to follow … The spacious hospitality of the Trustees of the National and Tate Galleries has been gratefully appreciated, but London should clearly have some roomy gallery set aside for the purpose of housing worthy exhibitions from abroad – or from the provinces – justifying the establishment of a special gallery as near to the centre of London as possible, so that the chance passer-by, as well as the more deliberate gallery-goer, may profit.[13]

– a sentiment which the chairmen of the National and Tate Galleries and the Arts Council were happy to endorse. 'London is at a serious disadvantage compared with other European capitals', *The Times* pleaded. Organisations such as the Royal Fine Art Commission, the Standing Conference on Museums and Galleries, the National Art Collections Fund and the Contemporary Art Society needed headquarters too.

In one sense the major agencies for cultural planning shared a common objective. By 1951 the Arts Council had established a reputation for cautious but determined advocacy of modern art, and for exercising a moderating influence upon the enthusiasms of the ICA.[14] The LCC had also established a reputation for progressive encouragement of the visual arts and design, but within the metropolis alone. It had circulated contemporary paintings for use in schools from 1948, and in so doing had 'probably helped to whet the appetite of the next generation of electors for various activities of a more adventurous kind'.[15] Its open-air sculpture exhibitions in Battersea Park in 1948 and 1951, with further shows to follow

in 1954 and 1957, had further stimulated the public debate on the values of modernist visual culture (Figure 99). Throughout the period leading to its *Policy on the Arts* of 1955 the LCC was giving muted emphasis to a concept of modernist London abreast of international developments, providing pioneer examples of how welfare-state thinking could be transferred into the sphere of the public visual arts.

By the time of the LCC's 1953 *South Bank Comprehensive Development Area Plan*, a proposal to build a new gallery on the South Bank was firmly on the record – even if its terms were still extremely vague. The Development Area would contain a site for a national theatre, an air terminal and office buildings, with an international conference centre and an exhibition gallery linked physically to the Festival's surviving structure, the Royal Festival Hall. In the words of the 1953 *Plan*, their use would 'not be confined to office hours and ... activities would occur in the evenings'. Its buildings would be designed on the principle that

> hotel reception foyers, shops and other accommodation that would be lighted and frequented in the evenings should occupy most of the ground floors. The aim is to try and avoid the deadness so often associated with commercial buildings after office hours and to secure that the site will have a lively attractiveness by night as well as by day.

Pedestrian links with Waterloo Station would be by 'a series of promenades and open spaces at the level of the RFH terrace'.[16] There would be an office population of 'about 12000', a conference centre, and a helicopter landing pad on the station roof. Yet significantly, in 1953 details of the exhibition gallery remained 'still under consideration'.[17]

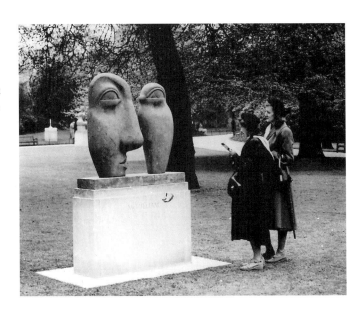

99 Visitors looking at F. E. McWilliam's *Head in Green and Brown*, Battersea Park Sculpture Exhibition, 31 July 1951.

But the seeds of inevitable conflict between the Arts Council and the LCC were already sown. The Arts Council now let it be known that it needed a larger exhibition space for its own shows: neither the cramped ground and first-floor rooms adapted for exhibition purposes at the Arts Council headquarters in St James's Square, nor the premises leased from the Ministry of Works at the New Burlington Galleries (until 1955 when the Galleries were closed) were suitable for larger temporary exhibitions as they became available. The ICA also needed to move from its confined quarters in Dover Street. Discussions with the Treasury and the Ministry of Works on a new South Bank gallery seemed to be getting nowhere: the Treasury argued that government expenditure was in decline and that the LCC should be approached to push the proposal forward. By the mid-1950s, the Arts Council's internationalist tendencies combined with its non-profit status as a Treasury client showed every sign of clashing with the geographically more local and financially accountable agenda of the LCC. In a series of meetings set up by the Arts Council's newly formed Housing the Arts Committee of Inquiry from 1956, an agreement was tentatively reached whereby the interests of the Arts Council and the LCC could be brought into conjunction. Leslie Martin, Chief Architect of the LCC, outlined to the sixth meeting of this committee a plan whereby the new South Bank complex would house a small auditorium for music, a gallery of 15,000 square feet with a courtyard for sculpture, and a smaller gallery of 6,000 square feet. Yet Isaac Hayward, since 1947 energetic leader of the LCC and now Chairman of the South Bank project sub-committee, argued that since the LCC already subsidised the Royal Festival Hall it might not be prepared to fund the small hall and gallery in addition:

> The art gallery ought to be made economic, and ... the LCC would have to look to the Arts Council for cooperation in ensuring that it paid its way. The general idea was that it should be an empty gallery in the sense that it would be available for letting for exhibitions, receptions, etc.[18]

This statement would soon impact heavily on the Arts Council's policy of continuous, professionally curated shows.[19]

The conflict with the aesthetically more cautious and financially more accountable LCC was to become openly visible by the end of the decade. The Arts Council's *Housing the Arts in Great Britain* report of 1959 could state with some confidence that for temporary art exhibitions London was 'singularly ill-equipped' in comparison with a centre like Paris (an older but still valid measure):

> One has to consider not only the necessity of housing such temporary exhibitions as turn up from time to time, but also the fact that if an optimum-sized gallery existed which was devoted to such a purpose, a considered, rather than an opportunistic, exhibition policy could be worked out ... The Commmittee felt that the South Bank would be an excellent site for the new Exhibition Gallery.

The Council's conception of its likely public was, however, both optimistic and circumscribed:

It is clear that on this site the new gallery will find no difficulty in attracting visitors both during the day and in the evenings. This is of particular importance since there is a large potential exhibition audience in London which is free to attend only after normal office closing hours. Furthermore, the existence of such a gallery would prove an attraction, if its exhibition policy was sufficiently compelling, to visitors from home and abroad.[20]

That is, a white-collar clientele from the metropolis, supplemented by visitors from the provinces and tourists from overseas, which had been the Arts Council's target group since its inception, now came into its own. To judge from the Arts Council exhibitions brought to London in the 1957–58 season – the last complete season before the publication of the 1959 *Report* – the assumption also being made was of an audience interested in European modernism that saw itself as significantly distinct from that which frequented the historical exhibitions staged at the Royal Academy of Arts: the Arts Council had displayed Ingres drawings, Picasso ceramics, 'New Trends in Painting', Lynn Chadwick, Persian miniatures, George Chinnery (1774–1852), 'Arts of the Ming Dynasty', Robert Delaunay and 'Modern Israeli Painting'.[21] The LCC itself was promoting some modernist work in the capital, including such semi-abstract work as Willi Soukop's Camberwell mural of 1959 (Figure 100) or Franta Belsky's fountain for the new Shell Building complex being erected between Waterloo Station and the South Bank between 1957 and 1961.

But the function and management of the gallery – now scheduled to occupy some 20,000 square feet – was to become subject to tension between the two bodies. At a late stage in the Housing the Arts Committee reference had been made within the LCC to a

> free-standing building … let to the Arts Council on terms which would give the latter a definite locus and an obligation to organise exhibitions there for an agreed

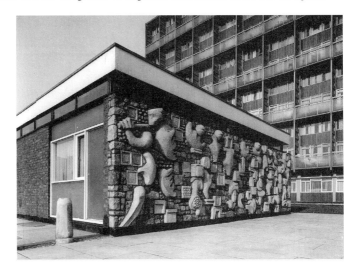

100 Willi Soukop, *The Pied Piper*, 1959, relief, concrete, granite and pebbles, 244.0 x 1005 cm, Elmington Estate, Camberwell.

period, possibly a fixed period every year ... at other times the gallery would be run
by the LCC, which would be free to use it or let it for any purpose, including com-
mercial exhibitions.

Housing the Arts had endorsed that division of labour.[22] Yet the following year Sir
William Emrys Williams for the Arts Council was expressing the view that

> it was important that [the gallery] should not be used for commercial exhibitions ...
> [that] on a rough average there would be one major [art] exhibition a year, a number
> of minor exhibitions, various exhibiting societies who would be sponsored by the
> Arts Council, and the regular small exhibitions currently held at St James' Square.[23]

Here was a real as well as a symbolic clash of views: one which might undermine
the autonomy of the gallery as a space for art and threaten its public identity as a
cultural as opposed to a commercial space. It also implied a calculation with far-
reaching financial implications that would take over two decades to fully resolve.
The terms being offered by the LCC were that the Arts Council would be charged
the 'economic rent' of £25,000 per year, with around £10,000 for extra services,
and an extra £13,500 for rates, maintenance and lighting, totalling nearly £50,000.
The LCC would be able (under the 1954 Landlord and Tenant Act) to reclaim the
gallery for short or long periods subject to a term of notice. But the Treasury
refused to pay the Arts Council more than £25,000, suggesting that the LCC pay
the balance; to which the LCC responded by proposing to reduce the size of the
gallery to lower the rent – or to reduce the proportion of the year the Arts Council
could use it. The Arts Council protested that it never had to rent the Tate or the
Victoria and Albert Museum, and offered the LCC a peppercorn rent and inter-
nal maintenance and upkeep, provided the LCC would look after the exterior and
abstain from pressing the case for commercial exhibitions.[24] The Treasury finally
agreed a new salaries scale and a maintenance budget of £40,000, but insisted that
it would have to be met from the Arts Council's annual grant. Even more signifi-
cantly, the social utopianism of the South Bank vision had by 1960 been curtailed
by pressures on the public purse and by a fading of the once optimistic spirit of
the post-war welfare state. By 1960 the design of the whole site had been shorn of
its residential buildings, its hotel, the air terminus, the projected opera-house site
and a tentative suggestion to rehouse St Martin's School of Art.[25]

On the site of the gallery itself other difficulties were soon to arise. 'Economic
restrictions' entailed a deferment of the completion date from early 1964 to the
autumn of 1966.[26] Further delays, attributed by the contractor Higgs and Hill to
'the overloading of the building industry in the south east, which has made it
impossible ... to recruit and maintain a labour force that is sufficiently skilled',[27]
put the opening back to the spring of 1967, with the result that a Picasso sculpture
exhibition organised by Roland Penrose, scheduled to mark the artist's 85th birth-
day on 25 October 1966, was lost. More delays in obtaining skilled labour for the
lighting and detailing put back the opening date once more, to 1968.

Architecture as symbolic form

Notwithstanding, the detailed conception and planning of the gallery during the period 1961 to 1968 was suffused with unquestionable technological and moral optimism. It should be remembered that the period was already rich in change in the visual arts. During the later 1950s the Arts Council, the Tate Gallery and the Whitechapel Gallery had become the standard-bearers of progressive appetites in art, the Tate having received two shows of the new American abstraction ('Modern Art in the United States' in 1956, and 'The New American Painting' in 1959), and the Whitechapel Gallery having mounted a succession of pioneering shows of Hepworth, Mondrian, de Staël and Jackson Pollock under its energetic young director Bryan Robertson. By the late 1950s and early 1960s Pop, Op and Kinetic art were about to burst on to the scene: Pop Art in particular in the later 1950s supported (and supported by) new attitudes of irony and humour based upon the embrace of popular culture originating in the United States. Established hierarchies everywhere were suddenly placed in doubt. Photographs of the royal family semi-affectionately included in paintings by Peter Blake, or the mixture of artless style and homo-erotic content in David Hockney's early work, all embodied attitudes challenging to traditional expectations and helped to launch a process of widespread artistic dissent.[28] Such artists and their works postulated new standards of pleasure in the younger viewer and new postures of rebellion and frivolity that would accumulate and multiply as the 1960s wore on.[29] In practice, the sudden release of social and creative energy around new forms of popular music, fashion and life-styles that characterised the image of the early 1960s was creating its own estrangements and de-definitions of any remaining social identifications based on politics and class – a process in its turn inseparable from global developments such as the emancipation movements among blacks and women in the United States, the thawing of East-West relations, and the wider success of global marketing emanating from the United States but echoed in those European countries which had been united as a Common Market by the Treaty of Rome in 1957. At the same time, a new urban public, subject for the first time to television and a rapidly expanded marketplace for services and goods, was becoming a fragmented and consumption-conscious atomised urban mass.

A marked effect of such processes was to put into historical perspective the older nationalisms that had characterised the era of the bourgeois public sphere and that had held in place stereotypical animosities between nation states as trading and military rivals. That period was now ending; and with it came a desire to establish distance from the most recent manifestation of British historical self-consciousness, particularly the Festival of 1951. Already by 1960 it was clear that the new concert hall and gallery would be stylistically 'sculptural' precisely as a 'foil' to the Royal Festival Hall, the National Film Theatre (opened under the southern approach to Waterloo Bridge in October 1957) and the Shell Building, due for completion in 1961. Models of the new complex made available in March 1961

announced a swing from *both* the spiky futurism of the Festival *and* the plate-and-glass rationalism of the international school. An architectural idiom of awkward and bulky concrete forms would now convey the impression that taste was both dynamic and rapidly oscillating, and that London's new-found self-confidence as a fashion and cultural centre was transferable to, and synonymous with, the field of the visual arts.[30]

Designed by Hubert Bennett and Jack Whittle of the LCC on three levels, with five large internal galleries and three sculpture courts around a central vertical circulation core of two stairways and a lift, the building would combine a modish external apearance with high-tech specifications internally to demonstrate to the world that LCC architecture and arts management were thoroughly abreast of their time. Internally a circulation core would enable each gallery to be accessed independently and hence used for different exhibitions as the need arose. Once complete, a system of adjustable screens fitting into a grid of floor-and-ceiling connectors offered further internal flexibility expressive of a spirit of toy-box playfulness that was intended to pervade the whole. Staff and storage facilities would be tucked away beneath ground level while the galleries were fitted out with a 'sealed utility' system in the form of

> a complete range of air-conditioning equipment which is filtered with automatic controls which operate to compensate for variations of heat and moisture sensed by the various thermometers … Heating in other areas is generally provided from fan-assisted and natural warm-air convectors. In the entrance lobby warm-air units are concealed within the false ceiling positioned to give an even distribution and also to provide a curtain of warm air at each entrance door.[31]

The *in situ* reinforced concrete exterior – a 'broad pattern' design combined with pre-cast concrete panels with Cornish aggregate implying few external windows, for which 'bunker' would become the dominant description – provided a tough yet modernist appearance in line with an avant-garde idiom already practised stylishly by Le Corbusier in France and the Smithsons in Britain (Figure 101).

The opening itself – in line with a tradition stretching back to George III in the 1760s – was dominated by expressions of national redefinition in rapidly changing times. The complex of buildings as a whole was designed to outmanoeuvre Paris in terms of artistic experiment and vitality: the name 'South Bank' was preferred over other contenders such as 'Greater London Arts Centre' or 'Barbican' on grounds of its correspondence to Paris's 'left bank'.[32] Individual buildings were given a nationalistic nomenclature: the concert halls were to be called the Queen Elizabeth Hall and the Purcell Room, while the gallery itself was named after (since 1959, Sir) Isaac Hayward, a man from working-class origins in Wales who had lead the LCC from 1947 to 1965, had steered the sub-committee dealing with the new buildings from its inception and whose name therefore marked the South Bank with indices both of class and metropolitan loyalty.[33] It is only surprising at such a moment that the Queen herself, who appeared at the opening in a short floral dress (Figure 102)

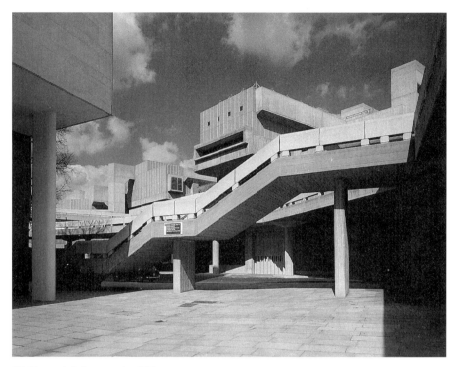

101 Hayward Gallery exterior, 1968.

should say little about the capital or its public and attempted instead to reconcile the LCC with the Arts Council as agencies of a general culture: 'This Gallery marks another forward step by the Greater London Council as Patron of the Arts and *we all* look forward to seeing here many distinguished Exhibitions arranged by the Arts Council' [my emphasis].[34] Of course, such appeal to an unspecified national collectivity was routine for a royal speech. It masked the particular contradictions enveloping the Hayward Gallery and its opening exhibition – contradictions which centred upon the relationship between architecture and Matisse's art (Figure 103). Here is one statement about the former:

> The lower rooms are artificially lit from tungsten spots, with directional lighting whose position can be varied to suit any display arrangement. Upstairs, conditions are more closely controlled to permit the display of fragile or light-sensitive works of art. Natural light from the roof lanterns is regulated by sun baffles and motorised blinds, diffused by an airtight double layer of polythene panels (the upper skin filtering off ultra-violet rays), and augmented by florescent tubes. Blinds and tubes are coordinated automatically by photo-electric cells. An electrified track allows tungsten spots to be used to highlight individual works.[35]

To Guy Brett in *Saturday Review* the lighting resembled street-lighting, while the high-tech architecture and controls were alienating and unkind. For another writer

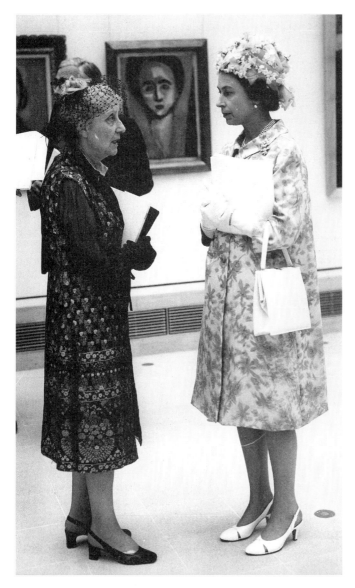

102 Queen Elizabeth II speaking to Mme Duthuit at the opening of the Matisse exhibition, Hayward Gallery, 1968, *Daily Telegraph*, 10 July 1968.

the comparison was with the conditions of hygiene appropriate to the care of the physically ill: 'The lower galleries will be mechanically ventilated and the upper galleries will be fully air-conditioned including refrigeration, a ventilation standard higher in some respects than that employed in hospital operating theatres under current Ministry of Health standards'.[36]

Above all it was the external and internal concrete that generated the tetchiest response. As Lawrence Gowing wrote in the preface to the Matisse exhibition catalogue, 'the gallery has a sort of half-finished look … the texture of rough wooden

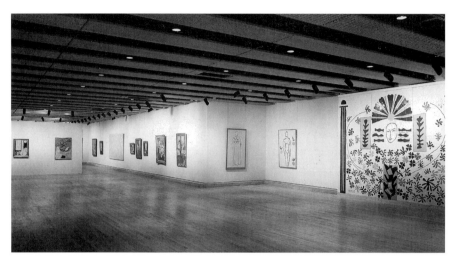

103 Matisse exhibition, Hayward Gallery, London, 1968, installation view.

battens, and its ceiling has the appearance of an almost, but not quite, completed construction'.[37] 'Concrete is everywhere', wrote *The Guardian*; 'externally it gives the appearance of a mothballed dreadnought complete with forecastle, bridge and smokestack'.[38] To the *Daily Mail* the Gallery was 'the biggest architectural bloomer of our times ... a squashed hat-box of concrete ... a half-open chest of drawers made of concrete with things hanging out of the drawers ... a floating warship carved with pill-boxes, a terrace for the denizens of the art zoo, or an adventure playground for Daleks'; while on the outside:

> you are baffled by a labyrinth of steps, overhead balconies, corners, passageways and massive spiral staircases that look like the bolt-holes to a nuclear bomber ... The building's crying, basic fault was obvious. It is *inhuman*, like its sister concert hall. Painting and music are done by people for people – yet these crush people out of existence.[39]

In fact the *Daily Mail* was pointing unwittingly to a wider contradiction lurking near the centre of 1960s metropolitan life: between the freedoms and licences associated with 'art' and the numerous pretexts for control and rationalisation in the heavily administered capitalist city of the first information age. The professional curators naturally took a jauntier line. Said the Arts Council, 'we wanted a flexible art gallery ... It's been expressly designed for contemporary life and art'.[40] Yet to others it was stifling and oppressive. 'Why is it difficult to feel the effect of paintings in this environment?' asked Guy Brett in his review:

> Chiefly, I think, because the visitor is at the mercy of two kinds of professionalism ... the architects have employed a functionalism which has forgotten the functions it is dealing with and become manneristic, and the Arts Council has expressed a concern for protection of the art-works which has become almost obsessive.

The seating and the lighting were subject to rigid controls which 'perpetuate the restrictions we know from the city outside'.[41]

It is certainly true that against the perceived rigidity of the curatorial frame, the opening exhibition seemed to assert a set of contrary values: 'Matisse' as a signifier was perhaps more capable of combining the illusions of hedonism and freedom – combining those illusions with his assured modern master status – than any other artist within the modernist canon. The contradictions shone through graphically in reports from the broadsheet press, which now abandoned the role of examining rival aesthetic opinions and instead articulated the reactions and assumptions of a middle-class 'public' already attuned to the more decorative parts of French modern art. It may be added that by the mid-1960s 'endorsement' journalism was beginning to play a largely conformist role in relation to a public body defined by the need to consume: most readers would be oblivious to the distinction between one art journalist and another.

Certainly the intelligent press of the day seemed little inclined to contradict the received Matissean indicators of personal aspiration and life-style. For former Whitechapel Director Bryan Robertson – and for the public he now addressed through the columns of *The Spectator* – the appeal of Matisse lay both in the artist and the places he inhabited:

> In the middle of his hotel-studio at Nice, dressed in baggy flannels and cardigan … wholly intent, benign and at ease, demonstrating startling virtuosity with the calm of a Chinese calligrapher, the maestro is also smoking a cigar and looks rather like a friendly magician, which is what he was. I believe that Matisse as a practitioner represents an absolutely ideal state of sophisticated grace in the mind of practically every living artist.

Citing 'absence of nostalgia … which is felt to be a constricting, inhibiting dross, a false currency and an irrelevance to the exchange of urgently new ideas', Robertson effectively summarised the source of Matisse's easy charm:

> It is understandable: the suite of rooms and studio in a comfortable, spacious Edwardian hotel [in Nice], the pretty girls, the gaily patterned textiles, the huge plants and palms, the view of gardens and bay …, the books and cigars and wine, the goldfish, flowers and caged parakeets in cool-white spaces with vivid colour accents, a relaxed worldliness, sun, brilliant light – and success. Who could ask for more?[42]

Broadsheet journalists were virtually unanimous in saying that the appeal of Matisse revolved around his decorative abilities, colour, the sun-lit world of southern France and North African interiors, luxury, vegetation, relaxation; all anti-urban, anti-Protestant, anti-traditionalist values assumed to be rich in sophistication and good taste: 'celestial good spirits that make us all feel just that much more lucid, observant, discriminating',[43] whose ease and spontaneity were nevertheless hard-won, the 'reward for ceaseless effort and self-criticism'.[44] Such too were the dreams of otherness sustained by the tourist literature – dreams of

pretty girls and parakeets, of escape from (yet by means of) the consumption routines of the industrialised northern European cities where the weather was permanently grey. 'Before, we equated tonal colour with moral rectitude and conscience [Robertson wrote] – colour dimmed by nostalgia, trapped by specific time, moods and association – as well as with the portrayal of reality'. Whereas Matisse could re-evoke 'the happy time of Cassis, St Tropez and Villefranche, Schiaparelli, Lanvin and Chanel, a basket of fruit and bottles of wine on a Riviera terrace, and the innocent, direct enjoyment of life that went with a measure of sophistication blessed with good taste'.[45] For such writers, Matisse was the perfect embodiment of the evolutionary gradualist who expressed no discontent; he was the respectable bohemian who revivified a French 'tradition' stretching from Chardin to Impressionism; who suggested an end to angst and uncertainty; and who proposed a refurnishing of the northern European social space through a version of gracious bourgeois living insulated from the cares of the world[46].

Alternative publics for art

Yet it is very doubtful whether, in the booming metropolitan atmosphere of 1968, the terms of Matisse's *luxuria* could have captured more than a fraction of the larger middle class. Not every group would have been able to identify with the establishment modernism either of Matisse or of the Gallery: the dissenting tone of the architectural criticism is evidence of that. In particular, a younger generation of artists and their supporters was already changing the very terms on which art was consumed and produced; and they would demand to be heard as a 'public' too.

A prescient index of the new sensibility could be found in the pages of *Silâns* (phonetic spelling of the French *silence*), a small magazine edited by Barry Flanagan, Alastair Jackson and Rudy Leenders – all students of the sculptor Anthony Caro at St Martin's School of Art – between September 1964 and June 1965. *Silâns* consisted mainly of drawings and free verse by Flanagan, Stanley Brobyn and John Sharkey, and prose writings by Jackson and Leenders on art in the age of consumer freedom, of which the following (by Leenders) is typical:

> After having been used and misused by kings and churches, by revolutionaries and councils, now, the artist is free to say what he wants to say and how he wants to say it ... However, unable to cope with his freedom, afraid of responsibilities, like all revolutionaries, the artist quickly turns into a reactionary, his freedom becomes a vested interest in abstraction or Pop or another -ism of his choice. There he remains, secure, protected by contracts, catered to by reviewers, flattered by his friends, turning daily more academic than the academicians, entrenching himself in his style ... Is it because we have come to rely for our fame and income on our customer's visual identification, just like New Blue Duzz? Maybe we are not so free.[47]

Such a challenge to establishment modernism, beginning in the fertile context of the art-school studio, quickly developed into concerns about the viability of

institutions, about creativity and the effects of commodification, which spread throughout an entire generation. The differences were made graphically public in the distance between the 'New Generation' exhibition of constructed sculpture of 1965 featuring St Martin's sculptors close to Caro such as Philip King, William Tucker, Tim Scott, David Annesley, Michael Bolus and Isaac Witkin (Figure 104), and Flanagan's own first exhibition at the Rowan Gallery the following year, in which he exhibited a hundredweight of sand poured on to the floor with four scooped handfuls removed (Figure 105), together with works made by pouring plaster into hessian bags which were allowed to assume their own shape. While 'New Generation' perpetuated the assumption of a public competent to discriminate between formally interesting and uninteresting configurations and capable of admiring nuances of construction, profile and material, Flanagan spoke relentlessly against the constitution of that audience and appealed to a negative or subtractive aesthetics of denial, simplicity and honesty. As Flanagan wrote in the catalogue to his Rowan Gallery show: 'Sculpture is without /audience message /communication / … good or bad looks / … sculpture is without notions /of itself /even / … '[48]

By this time the search for alternative forms based on a conflation of material simplicity, systems thinking and undogmatic theory, all designed to stimulate

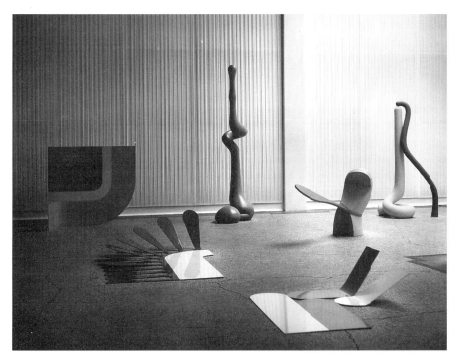

104 'New Generation' sculpture exhibition, Whitechapel Gallery, 1965, installation view showing (clockwise from rear left), Michael Bolus, *Bowbend* (1964), Isaac Witkin, *Volution* (1964), Isaac Witkin, *Dawn* (1963), Isaac Witkin, *Nagas* (1964), Michael Bolus, *January* (1965), Michael Bolus *September* (1964).

105 Barry Flanagan,
ring n, sand, 45.5 cm
radius, 1966,
Rowan Gallery,
London, 1966.

105 Barry Flanagan, *ring n*, sand, 45.5 cm radius, 1966, Rowan Gallery, London, 1966.

'awareness' of elemental objects and situations – in the best cases a wholesale re-enchantment of the banal and the everyday – was under way in London as it was in other capitals such as Amsterdam, Paris and New York. The move against com-modification and the market became widespread. Richard Long, another student at St Martin's from 1966, showed a work at the Galerie Loehr in Frankfurt in 1967 consisting of sticks collected in Ireland and sent through the post with instruc-tions. In *A Line Made by Walking*, also of 1967, the artist walked backwards and forwards across a field in south London and photographed the resulting line to record, not an object, but the effects of a formulaic event.

It would not be long before the dissenting mood among younger artists would coalesce with a revolutionary critique of the British higher-education system to impact profoundly upon national and metropolitan institutions of art. As the Queen was preparing to open the Hayward Gallery in the summer of 1968 the student movement reached its disorganised yet energetic height. Here, at least briefly, was a younger emancipated public in the throes of working out alterna-tive social programmes in a range of practical, theoretical and cultural forms (Figure 106).

Institutions like the Arts Lab in Drury Lane (near to the site of Hogarth's 'Signboards' exhibition of two centuries before) or the ICA (now reopened in the Mall, close to Spring Gardens) played their part. Five days before the Queen opened the Hayward Gallery and the Matisse exhibition, and on the day after the north London police armed with dogs invaded Hornsey College of Art to quell the month-long sit-in (4 July), a didactic exhibition opened at the new premises of the ICA illustrating the opposing ideals which had emerged from the student debates. In the words of the ICA's newly appointed Director Michael Kustow, it

'propounded a different syllabus and new forms of assessment, open forums involving artists and members of the public, and served good, cheap food from a mobile canteen'.[49] Entitled 'Art Transplant' and coinciding dramatically with the first showing in London of Jean-Luc Godard's apocalyptic *Weekend*, it too appealed to a constituency of youthful well-wishers rather than to the urban mass.[50] Kustow himself had atended the Hornsey sit-in, and was determined that his new audience would be hedonistic, experimental and free.[51]

The events at the Mall stood in open but inevitable contrast to the modernist extravaganza on the South Bank. The major part of the dissenting student lobby held that contemporary institutions of art, including the institutionally determined conditions of spectatorship in a 'bourgeois society' and particularly the art market, were elitist and corrupt. One 'Marxist' art student wrote of the reversal that occurred in late capitalist society whereby 'the good art is the art of the intelligent, enlightened, sensitive minority of the population, and the bad art is the art of the unfortunate, unenlightened working class'. He continued:

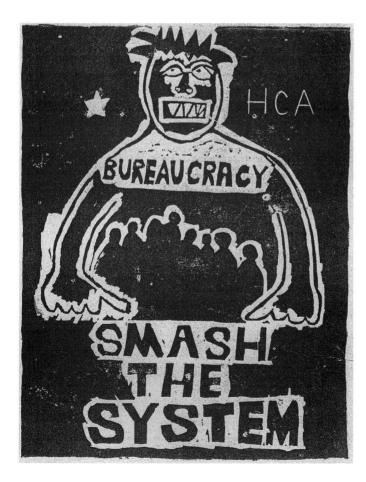

106 Poster designed by students of Hornsey College of Art, London, 1968.

The only people able to patronize the exclusive art galleries are the very rich, so that to exist in society the artist must rely on rich Americans or the British boss class to purchase his work. He is therefore dependent on the position of galleries in society. They must be situated in the most affluent, exclusive areas.

Establishment intellectuals

frown patronizingly at the workers, but refuse to examine their own rotten, corrupt system of producing art objects which are supposed to be aesthetically beautiful, yet which find their homes in the palaces of the exploiters of the working classes and in galleries financed by the big monopolies.[52]

Such proletarian rhetoric (soon to produce in London a short-lived curatorial tendency known as 'Art For the People'), was never to find favour with the modernist establishment – and in any case had to meet head-on the citizens of north London who remained happy as they were. In the immortal words of the *Wood Green, Southgate and Palmer's Green Weekly Herald*,

A bunch of crackpots, here in Haringey, or in Grosvenor Square, or Paris, or Berlin, or Mexico, can never overthrow an established system ... The system is ours. We, the ordinary people, the nine-to-five, Monday-to-Friday, semi-detached suburban wage-earners, we *are* the system ... We *are* it and we like it.[53]

But that conflict between proletarian students and their immediate bourgeois neighbours was only one variant on the deeper underlying cultural crisis now under way. The same conflict was cut very differently by establishment figures distanced from the new art movements as a matter of principle: 'The[se] representatives of the younger generation', wrote the Warden of All Souls' College John Sparrow,

are less interested in political than in ethical and aesthetic questions ... as for art, they care more about it than for it: indeed the avant-garde among them favour 'anti-art', rejecting the hitherto accepted idea of art as a special form of conscious creative activity, in favour of Op Art, Pop Art, the 'happening' and the 'live-in'. Many find their spokesmen on ethical and aesthetic questions in the leaders of the pop groups and pot groups.[54]

Yet for a younger generation, formerly revered cultural symbols were being everywhere debased. Idols such as Mick Jagger and John Lennon were for a moment more popular (certainly more charismatic) than the royal family, Parliament or the established church. Nation and monarchy had become subjects of casual irony: as Paul McCartney sang at the end of side B of *Abbey Road* (1969), 'Her Majesty's a pretty nice girl /But she doesn't have a lot to say'.[55] As Warden Sparrow reminded his readers in the article just cited, John Lennon himself (a former art student) had decreed that 'The Mona Lisa is a load of crap'.[56] Marcel Duchamp, who had

defaced that very painting in a mocking Dada gesture of 1919, was greeted at the
ICA like a guru when he attended a packed lecture on his work by Arturo Schwarz
late in 1968. John Cage gave performances. The 'swinging' city was alive with the
promise that culture would never be the same.

The institutionalisation of new art

In such a fluid and discontinuous social moment all attempts to rhetorically organ-
ise a unified metropolitan or national public would seem vain. But attempts to form
publics for art there certainly were, most of them strenuous and committed. Their
antitheses are well illustrated by two exhibitions of 1969. The early part of that year
saw the full-scale apotheosis given to the modernist art and ethics of the teacher of
the younger generation, Anthony Caro (Figure 107). There can be few instances in
which 'difficult' new abstract sculpture was presented to a London audience in
terms so elevated and demanding: here, in the catalogue by the American formal-
ist critic Michael Fried, was a very different kind of 'emancipation discourse', one
which took the form of an appeal to critical competencies that uncovered in the art
object magically redemptive qualities for the capable few. The central proposition
was that Caro's abstractness was not 'theatrical' – that is, not work 'that in one way
or another makes the beholder aware of the situation in which it is encountered, a
situation that includes not just the space (or room) in which it is sited but the phys-
ical presence of the beholder himself'.[57] For Fried, sculpture's task was to engineer
the denial of the world-and-the-body in abstraction: 'it is the only way in which
[our bodies and the world] can be saved for high art today, in which they can be
made present to us other than as theatre'. Naturally, such high-minded conceptions

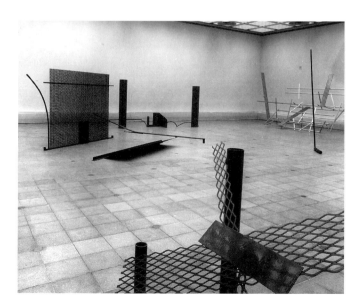

107 Anthony Caro
exhibition, Hayward
Gallery, 1969,
installation view. Rear
left are *Source* (1967)
and *Horizon* (1966);
rear right *Hopscotch*
(1962) and *Eyelit*
(1965); foreground:
Red Splash (1966).

of the viewer's gender and role would sever any last vestiges of a 'literal, situational connection between the beholder and the piece':[58] only through the silent absorption of the male beholder in modernist abstraction could what Fried called 'presentness' or 'grace' be achieved. Minimalist and conceptual art, together with its typical audiences, were Fried's central antagonists: it (and they) were to be redeemed through modernist attention to modernist work.

In practice, however, the broadsheet critics received Caro's work precisely against the grain of Fried's formalist view. The *Observer* critic made out that Caro's sculpture made the Hayward look 'rather handsome'.[59] The *New Statesman* critic observed that the floor-hugging metal structures made the building seem 'strangely empty';[60] *Queen* felt the sculpture 'did not fill the gallery at all'.[61] For the *Sunday Telegraph* the show was 'the baptism of the Hayward Gallery as an exhibition space for sculpture'.[62] The *Times* critic, again contrary to Fried's prospectus, wrote that Caro 'needs a gallery of the acreage of the Hayward to give an idea of the variety of his work'.[63] Such understandings in turn generated kinaesthetic and anthropomorphic values out of the experience of the work. One critic wrote that 'what it does above all, in a way no other modern sculpture does, is to stretch, reach and extend ... this does more for one's awareness of space than anything since Moore's exploration of the hole and hollowness'.[64] Another wrote that 'we experience Caro's work physically, with our whole bodies: we respond to its reach, its firmness and its instabilities, its slow repetitions and its apparent bursts of speed'.[65] The work has to do

> with the experience of *being* a figure, from the inside: the experience of being a walking, sitting, leaning, running, dancing, sometimes floating, buoyant, exultant, sometimes shuffling, bowed, tired, enclosed human figure ... Caro is primarily a sculptor concerned with the day-to-day experience of being alive: that is, alive to oneself.[66]

A less enthusiastic account found his sculpture lacking in just such liberating qualities:

> You can't go inside it or relate yourself to it in any very direct way except walking round it and staring at it. Ultimately this becomes unsatisfactory because the process remains intellectual and totally uninvolving ... [Caro's] work has become increasingly elegant and refined ... chilling little exercises in technical expertise.[67]

The suggestion carried here is that real uncertainty about the appropriate bodily response to Caro's sculpture characterised at least some audience responses at the time. That the lofty ideals set by the Caro show could not be met in practice stemmed partly from their disconnectedness from wider social and institutional ideals in public life; partly from the sheer abstractness of the formalist appeal to artistic understanding and virtue.

Another show of 1969 attempted to situate and define an audience on the basis of utterly different postures and beliefs. The ICA, by now in financial crisis and unable to generate costly exhibitions of its own, welcomed the opportunity of

displaying an exhibition first curated by Harald Szeemann at the Bern Kunsthalle and now remodelled for its London showing by the deputy editor of *Studio International* Charles Harrison for its London showing. Reaching London in late August 1969, 'When Attitudes Become Form: Works–Processes–Situations– Information' (further sub-titled 'Live In Your Head') veered sharply away from both proletarian populism and formalist modernism, collecting some 69 artists from Europe and America who, in Harrison's words, 'share a dissatisfaction with the status of the art work as an object in a finite state, and a rejection of the notion of form as a quality to be imposed upon material'. Those artists included Carl Andre, Eva Hesse and Hans Haacke from New York, Joseph Beuys and Michael Buthe from Germany, Jan Dibbets from Holland, and Victor Burgin, Barry Flanagan, Roelof Loew and Bruce McLean from London (Figure 108). Here was a very different and relatively cerebral demonstration of the new attitudes to art. The exhibition comprised felt pieces, process pieces, concept pieces, installations and projects which exemplified what one catalogue writer called 'a new natural- ism or realism born of extended collaborations between the artists, nature, chance, material, even the viewer'.[68] Explanations of the new 'anti-form' approaches ranged from Harrison's own, which prioritised process, activity, indirect reference, concept and information, with a special emphasis upon freedom from 'normal consciousness' and upon opening the imaginative faculties to 'what has not already been pronounced serious and socially acceptable'[69] – to Szeemann's ambitious sociological generalisation which attempted to summarise the emancipatory spirit of the times:

> Certainly, the majority of artists exhibiting here might be seen as part of an artistic development to which the pre-experienced work-process of Duchamp, the intensity of Pollock's gesture, and the unity of material, physical exertion and time in the

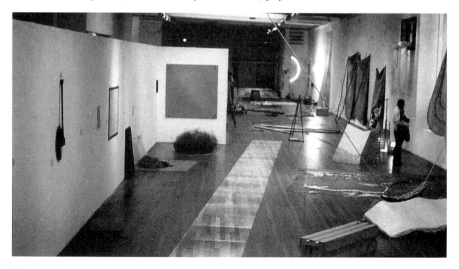

108 'When Attitudes Become Form', Institute of Contemporary Arts, London, 1969, installation view.

Happenings of the early 60s also belong. And yet for some of these artists the desire to create does not spring from purely visual experiences. It was inevitable that Hippy philosophy, the Rockers, and the use of drugs should eventually affect the position of a younger generation of artists. It is significant that some of the major exhibitions come from the West coast of America, an area particularly open to eastern influences. Many anti-social ideas, on the one hand the tendency to contemplation, and on the other the celebration of the physical and creative self through action, can be seen at work in this new art. Additional parts of the pattern can be found in Europe: the lack of a real centre has persuaded increasing numbers of artists to remain in their home towns and to work against all the ideas and principles of the society in which they found themselves. Evident at the same time is the desire to break down the 'triangle in which art operates' – the studio, gallery and museum ... Never before has the inner bearing of the artist been turned so directly into a work of art ... the activity of the artist has become the dominant theme.[70]

In the context of the Caro retrospective particularly, the importance of 'When Attitudes Become Form' was that it legitimated the existence of anti-form and process approaches to the making of art, to which British artists had significantly contributed.[71] Secondly, it demonstrated conclusively that, though most of the work had been conceived against the spirit of the market mechanism, the adventurous commercial galleries (such as the Rowan) were capable of staking an interest in and indeed were already primed to further encourage the influx of avant-gardist attitudes into the viewing space. But pre-eminently, its importance was that it proposed a radical redescription of both the creator and the observer of art: the work's new emphasis on conception, duration and performance positioned the competent viewer as materialist rather than idealist, participant rather than observer, witness and activist rather than judge. And such concepts were all eminently capable of political inflection. Implicitly the 'public' collected by such art would be citizens of a very different kind.

Towards the 'new art'

The conjunction of those two exhibitions implied that for a moment the London public could identify itself through art in numerous ways. In the aftermath of 'Attitudes' in 1969, not one but several alternatives to formalist modernism can be traced, each proposing new valorisations of the art object and its setting, including 'inexpensive' attitudes to the gallery as a social space; a marked drop in the importance of discrimination, fine feeling, empathy or 'good taste'; the generation and deployment of non-aristocratic social networks for artistic gossip and repute; radical attitudes to mental or physical participation in the work; the possibility of linkages with wider social and political ideals; and a new appraisal of what now became widely known as the 'ontology' of the work. All these alternatives were definitive of a series of shifts in the identity of the spectator away from his traditional bourgeois home.

'Participation' was perhaps the key term. Following 'Attitudes', the most aus-
tere form which this concept took was an even greater Duchampian distancing
from crafted physical things and a move towards a paradigm of the work of art as
a primarily mental or theoretical (or at best textual) object. A show called 'Idea
Structures' at the Camden Arts Centre in 1970 and featuring Keith Arnatt, Victor
Burgin, Ed Herring, Joseph Kosuth and a quartet of artist–theorists known as
Art–Language (Terry Atkinson, David Bainbridge, Michael Baldwin and Harold
Hurrell) proposed work whose incarnation was in plans, instructions, and descrip-
tions of physical or mental structures, which demanded of the viewer an ability to
suspend 'normal' visual activity in favour of reassembling the 'work' imaginatively
in the mind alone.[72]

A second concept of 'participation' and an early symptom of the full institu-
tionalisation of alternative art was the 1971 show by the American sculptor Robert
Morris at the Tate Gallery – a show which proposed a sudden and even physi-
cally traumatic redefinition of the Gallery's committed modernist audience. In
New York Morris had already usurped the traditional artist's role by becoming
joint chairman of the Artists' Strike Committee to protest the Cambodian War;
he had established the Peripatetic Artists' Guild with a view to hiring out artis-
tic labour at $25 per hour 'to make explosions, chemical swamps, hanging gar-
dens, and ensembles of curious objects to be seen while travelling at high speeds'.
Morris's London show was no less aggressively conceived. 'Participation, Objects
in Space' presented cumbersome stone blocks, felt and industrial materials, and
– much more controversially – constructed environments in which observers
were invited to walk along a wire, jump on see-saws, climb wooden 'chimneys'
(Figure 109), and swing lumps of concrete against steel plates. In the words of

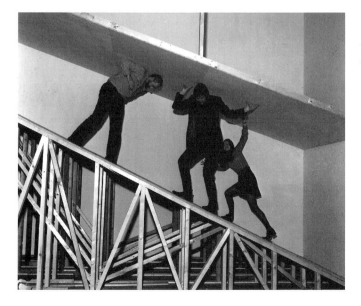

109 Tate Gallery staff
with Robert Morris
sculptures, 1971.

one national newspaper, it made for 'one of the weirdest shows the [Tate] gallery has ever mounted ... the atmosphere suggests a gym'.[73] Morris himself was straightforward enough:

> From the body relating to the space of the Tate via my alteration of the architectural elements of passages and surfaces, to the body relating to its own conditions ... The progression is from the manipulation of objects, to constructions which adjust to the body's presence, to situations where the body itself is manipulated. I want to profile a situation where people can become more aware of themselves and their own experience rather than more aware of some version of my experience.[74]

Moreover bodily physicality was to be elevated over abstracted and disincarnated 'viewing':

> The show is more environmental than object-like, offers more the possibility – or even necessity – of physically moving over, in, around, rather than detached viewing ... We've become blind from so much seeing. Time to press up against things, squeeze around, crawl over – not so much out of a childlish naiveté to return to the playground, but more to acknowledge that the world begins to exist at the limits of our skin ... Personally, I'd rather break my arm falling off a platform than spend an hour in detached contemplation of a Matisse.[75]

As if to take that rhetoric literally, several members of the public suffered minor physical injuries. The Tate Gallery's Director Norman Reid issued a statement that the public had become 'unexpectedly boisterous ... exuberant and excited' in their participation.[76] The participatory part of the show was closed a mere five days after its opening on 4 May 1971.

The year 1971 may even be regarded as the *annus mirabilis* – or *horribilis* – of the participation demand. By that time it was clear that anti-form, conceptual or process art was capable of causing friction on either side of the Atlantic. A show at the Guggenheim Museum in February 1971 containing works by the French artist Daniel Buren ended in chaos when museum officials objected to what they believed was a violation of the sanctity of the museum by non-traditional work. The same institution withdrew a planned exhibition by Hans Haacke in April 1971 on grounds of its critical social content. In London an International Coalition for the Liquidation of Art consisting of Stuart Brisley, Gustav Metzger, John Plant and Sigi Krauss were lobbying for an end to the museum as an arbiter of aesthetic judgement and moral power. One sympathizer with the Coalition, Felipe Ehrenberg, arrived at the Tate Gallery dressed in a brown corduroy suit and a white calico hood with an opening for one eye, claiming that he was a human being but also a work of art: on the steps of the Tate he announced 'I claim Mankind, Man, is a work of Art'. The hapless attendants did not let him pass.[77] Nor were such challenges marginal or eccentric. Signficant of the collapse of one aesthetic order and the gradual evolution of another, and stimulated massively by a crisis of public authority from California to Eastern Europe, it is clear that by 1971 alternative art forms were no

longer the product of a generational conflict but animated tenured professionals in the art institutions too.[78]

In London, the art establishment in the form of the Arts Council, as arms-length disburser of the national arts budget, approached the new art with muted enthusiasm mixed with some scepticism. Its very Charter, devised in 1946 to promote the 'fine arts' but revised as recently as 1967 to cover the 'arts' however fine,[79] required it to 'develop and improve the knowledge, understanding and practice' of the arts but at the same time to 'increase the accessibility [of those arts] to the public'. The implication was that in any show of avant-garde art in its new show-case gallery on the South Bank, the Arts Council would need to adopt an educative as much as a purely proselytising role. At the very least, such a show would have to be neither overtly physically dangerous, nor so cerebral as to be invisible or intellectually strange. Yet it would also have to be as challenging *as art* as had been the recent modernist shows of Caro or Matisse.

Some such institutional logic must have guided the emergence of the Hayward Gallery's 'The New Art' exhibition of the summer of 1972. Yet the same logic would also mark the end of a period of genuine ferment in the visual arts and the incorporation of avant-gardist thinking within the channels of quasi-official culture.

The evolution of 'The New Art' was hesitant and certainly messy. The Arts Council had announced back in 1969 that it wanted an informative and accessible show to inaugurate a series of biennial exhibitions of recent British work, but the plethora of possibilities had made the choice of selector, the number and type of artists, the principles of selection and the title, elusive.[80] Still uncertain towards the end of 1971, the selection was eventually offered to a junior Tate Gallery curator Anne Seymour, who in consultation with David Sylvester put forward plans for a focused display of about 15 'conceptual artists' – the term was by now common parlance – which would show 'the development of attitudes to art outside the traditional view of painting and sculpture which has suddenly accelerated during the past five years or so'.[81] Norbert Lynton, Director of Exhibitions at the Arts Council and immediate recipient of Seymour's proposal, was initially 'not convinced that there would be much to look at'; he feared that the Council might be 'shot down' for being too experimental.[82] 'There are certainly plenty of established artists who regard such work as rubbish', Seymour replied in agreement. Yet strengthened by the support of Richard Hamilton and a committee of artistic advisers,[83] her resolve remained strong. Hamilton urged that

> the exhibition should be for the artist rather than for the consumer … Unless this exhibition made sense to the artist, it was not worth doing … [Seymour] has sounded out the younger artists. Their mood was against exhibitions of all kinds. She has come up with something reasonably acceptable to the younger generation.[84]

Projected first under the titles 'Magic and Strong Medicine' and 'Fifteen Artists', the show finally went ahead in August and September 1972 as 'The New Art',

collecting 14 British artists of the 'younger generation' but excluding both Richard Hamilton and several others initally listed – Ian Breakwell, Roelof Leow, Bruce McLean, Graham Stevens and Roland Brenner. 'The New Art' was an all-British (and all-male) display of anti-form, process and conceptual art which deployed the abstract technical spaces at the Hayward to philosophical-cum-aesthetic ends. Keith Arnatt's *An Institutional Fact* comprised black and white photographs of the gallery's attendants arranged comment-free in a grid-like format near the entrance. Michael Craig-Martin's wall-piece *Assimilation* (Figure 110) consisted of sixteen sets of objects functionally corresponding to each other, for an understanding of which the viewer would have to approach the wall, read, inspect and think analytically. Barry Flanagan contributed a piece called *Hayward II* (Figure 111). Art and Language exhibited filing cabinets and an index of writings. Gerald Newman contributed eight 'light' pieces involving sound loops and switching lamps. Richard Long showed concentric rings of large stone pebbles. David Dye projected films from eight projectors grouped in a circle and working simultaneously. Hamish Fulton exhibited photographs. John Hilliard showed photo-pieces reflexively documenting the process of their own making (Plate 14). John Stezaker displayed a wall text entitled O_a and O_b; and so on.[85] Notwithstanding the Council's educative role, 'The New Art's catalogue presented difficult writings by and about the artists, the majority exhaustively re-examining the philosophical and social assumptions

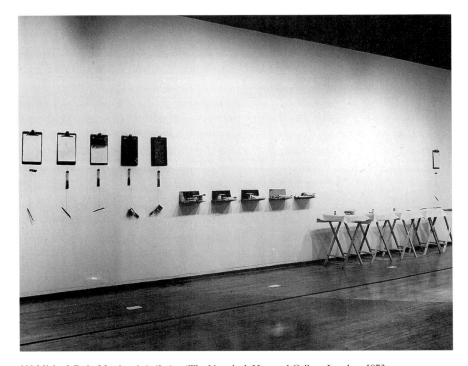

110 Michael Craig-Martin, *Assimilation*, 'The New Art', Hayward Gallery, London, 1972.

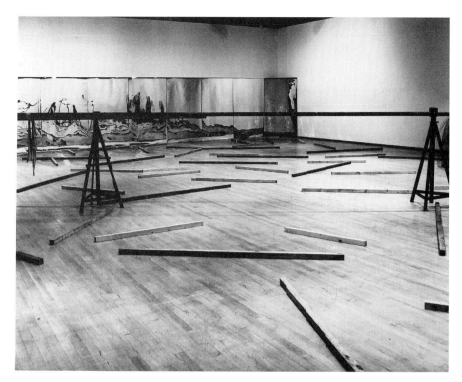

111 Barry Flanagan, *Hayward II*, 'The New Art', Hayward Gallery, London' 1972.

underlying conventional concepts of art, largely by means of techniques deriving from recent analytical philosophy.

The show was the first on British soil to which avant-garde artists and curators from continental Europe flocked in any numbers as a means of measuring the orientation and significance of the British contribution – a fact which alone demonstrates that the new aesthetic was collecting an international following, assisted by rapid magazine communication and cheap air fares. At the other end of the spectrum of sophistication, and despite the fact that Seymour had said in her catalogue text on Keith Arnatt that 'there is no intended element of sending up the audience, or depriving them of their pleasures',[86] there can be no doubt that shock and bewilderment formed the responses of older and more conservative folk. A correspondent from Bury St Edmunds in Suffolk wrote to the Director of Exhibitions expressing 'indignation that public money should be wasted' on such a scandalous exercise:

If the battery of noise and light-emitting objects represent some sort of theatrical experiment, why is that not clearly explained? All that was apparent to the innocent eye, not blinded by the mutual adoration of a social esoteric clique, was a collection of indifferent photographs, a derisory set of 'functional' arrangements glorified by pompous jargon, a clever bit of circus stuff with tin-foil, and the most sickening collection of brochures, written in pretentious and meaningless lingo, viz 'O$_a$, the rela-

tions defining O as the object of reason are the same relations of which O as art entity is compounded'. What does this mean? Do you know? Do they?[87]

This and similar correspondence suggests a widening gulf between advocates of traditional 'expressive' art (in whatever medium) and the cool new philosophical investigations which reframed the containing space, the art object and the habits of self-reflection of the visiting public. At least, the sudden 'suppression' of the traditional bourgeois viewer met with anger and disappointment among many. John Jenney, President of the Delaware Art Museum Trustees on a visit to London, was 'shocked that such tired gadgetry should be given space in a publicly supported gallery ... [he] could not believe that the public would long put up with such an obvious waste of public funds in *our* country, for the benefit of no-one except a group of people who are self-proclaimed artists'.[88] A lady from Cambridge complained that the catalogue was 'gobbledegook and [that she] couldn't understand a paragraph ... If you don't know and your artists can't explain to the public, why have such an exhibition?'[89] Another American visitor sent a copy of Wyndham Lewis's *The Demon of Progress in the Arts* with a note tucked inside: 'I decided that you need this book more than I do: may it promote your earliest possible aesthetic recovery'.[90]

The prominence in such letters of assumptions about what 'the public' wanted and even deserved provides strong evidence that something akin to a traditional viewing posture was still alive on both sides of the Atlantic in 1972: certainly the Arts Council in London, in remaining aware of the sensibilities of traditional viewers, remained divided by the claims of conceptual and process art.[91] Yet there is little doubt that the residue of the traditional London public – including some older modernists – was being forced into a rapid and uncomfortable change of identity for which there were no known guidelines. The 'alienating' languages and 'cerebral' arrangements of the new art were challenging it to renounce well-rehearsed aesthetic pleasures and think critically about the very idea of art as heavily commodified form.[92] At the same time (and paradoxically), art institutions such as the Tate Gallery were collecting works by Flanagan, Craig-Martin, Milow, Arnatt, Burgin and Long with some zeal from 1969 through to 1972 and beyond, implicitly recognising that the 'commodification critique' contained in the new art was a double-edged weapon. Secondly, the identity of the visual arts public as in some sense British and therefore 'national' was decreasingly available in an age of international survey shows, touring exhibitions, and the first glimmerings of global sponsorship for art: the Britishness of the 'New Art' exhibition was significant precisely as a contribution to that wider field.

The internationalisation of art

The sudden and rapid spread of the new art across international boundaries in the late 1960s and early 1970s is important on a number of levels. Although the 'internationalisation' of art was on the one hand an effect of the publishing and

communications revolutions that had occurred in the United States and Europe from the late 1950s on, it was also both a consequence and symptom of the shift of power in the art world from Paris to an English-speaking capital, New York. Partly too, the newer dematerialised forms of art were in themselves easier to reproduce and physically convey.

Further, the suddenly expanding internationalism of the visual-arts world was no longer competitive after about 1965. On the contrary, the Cold War stand-off between America and the Eastern bloc had the effect of underlining the hegemony now increasingly exerted in art by the United States, both in established culture but also in the pattern of activity of the radical avant-garde. National *differentia* within the new art of the Western bloc could still be discerned, even prized; but they counted decreasingly as marks of an artist's origins or as indices of a viewer's self-identification, let alone of the viewer's sense of his or her membership of a national 'public'. By the end of the period 1968-72 the situation is reasonably clear: the 'internationalism' of avant-garde culture had become a value in and of itself. Younger artists not only saw themselves as a community of interests without national borders; their work was actively experienced by its supporters as parts of a transnational conversation about culture and its modern (that is, Westernised) functions. In the aftermath of 1968 younger and radicalised followers could uphold the internationalism of art almost as an end to be pursued: few could gainsay the excitement and interest that it caused.

Even such a sceptical figure as Norbert Lynton, the Arts Council's Director of Exhibitions in London, would defend the new art on the grounds – scarcely comprehensible in 1750, unthinkable in 1850 and very unlikely in 1950 – that 'this kind of art, and almost all the artists included … are of considerable international repute. They were, until now, prophets unhonoured in their own country.' There was 'a good case for letting people see the work that has so frequently featured in international art magazines'.[93]

Global marketing, finally – a process young in 1969 that was destined to change the identity of the viewing public further still – was about to intervene to cement the aspirations of radical artists and international business in a pattern whose consequences no one at the time could foresee. As John A. Murphy, President of the tobacco conglomerate Philip Morris Europe, had written in the catalogue to *When Attitudes Become Form* in 1969:

> Just as the artist endeavours to improve his interpretation and conception through innovation, the commercial entity strives to improve its end product or service through experimentation with new methods and materials … As businessmen in tune with our times, we at Philip Morris are committed to support the experimental … these [sponsorship] arrangements are not adjuncts to our commercial function, but rather an integral part.[94]

On the one hand it can be safely assumed that radical artists of the later 1960s (even the smoking ones) would have been embarrassed by these commercial attentions

in so far as their sympathies were Marxist or otherwise to the left of the political centre. On the other, the apparent contradiction of a commercially sponsored avant-garde was obviously not new. And it would intensify in years to come. By 1972, what had at various times attempted to coalesce as a 'national' public for art was in the process of becoming even further atomised in accordance with the dictates of the market and of ideology alike.

Coda:
Bankside and beyond

THE PERIOD FOLLOWING THE 'DEATH OF THE BOURGEOIS VIEWER' in 1968-72 was complicated by many circumstances, which together would fill another book. The rapidly internationalising art world of the mid- and later 1970s was inevitably dominated by the efforts of the 'new art' to make good on its early radical beginnings. A heavily politicised body of work, reflecting disquiet over the Vietnam War, consumption, housing, and gender inequalities throughout the West, reinforced an earlier tendency to erode boundaries between national publics and consolidated the appearance of an international cultural arena in which aesthetic and political concerns could be expressed. Unlike the mid-eighteenth century when art was promoted as a matter of national identity, in terms of participation in the ethos of the state, the Western system of art from the early 1970s became primarily an informational arena whose participants contested differences (even nuances) of aesthetico-political position across an entire market-oriented geopolity. Of course, empirical individuals continued to attend art exhibitions in increasing numbers; yet my argument is that they did so no longer as Londoners or even as Britons. For the first time it became impossible to characterise an art public in terms of its geography or its nationhood alone.

The reasons for this sudden loss of identity are more or less clear. Redemption from poverty, drunkenness and crime was no longer on the cultural agenda as it had been in the nineteenth century. Nor were other forms of 'virtue' any longer straightforwardly to be associated with participation in the cultural process – as Reynolds and others had urged in the eighteenth. On the other hand, the expanded educational franchise of the 1960s and 1970s were to have complex effects upon the arts. For the younger counter-public identified with social and political change, the capturing of the cultural agenda from the hands of older connoisseurs, critics and dealers resulted in changes in the conditions of spectatorship which were both complementary yet contradictory in kind. First, the best new work aspired to yet higher levels of conceptual sophistication and interpretation across a wide range of experimental genres and types, from land art to body art to feminist, light and installation art. The accompanying publishing boom in radical theories and histories of art meant that gallery-goers of both sexes could no longer disregard their

own status as viewing subjects of a given gender, race and economic status. While popular 'blockbuster' shows of old and modern masters scored spectacular box-office successes at the major museums and galleries of the capital, educated observers of either sex could now stand aloof from all kinds of unreflective enthusiasm for culture, newly aware of the ways in which 'culture' and its implied forms of subjectivity had produced its traditional effects. Most observers of Western society in the 1970s would have had to agree that after Marxism and feminism – not to mention psychoanalysis and post-structuralist forms of theory applied to art – the association of art with old-fashioned forms of 'pleasure' was effectively at an end, not only in London but in the expanded global system to which every Western metropolis now contributed.

That generalisation calls to mind the vast expansion of the international museum infrastructure in the period of the later 1970s through the 1980s and beyond. Museum and gallery-visiting became 'popular' in this period on a scale to rival sporting events, television and the cinema. Especially in the field of contemporary art but also more widely, city bosses across the developed world realised that income from tourism went hand in hand with art; and built accordingly. From Frankfurt to Los Angeles, from Stockholm to St Ives, museums of 'modern and contemporary art' sprang up to cater for a new international audience that has begun to define a second era of the art museum, which is now unfolding. As part of that process, art museums transformed themselves into recreational and educational facilities in addition to being mere containers for physical works of art.[1]

But the major break with the past has been a falling away of an idealised concept of the viewing 'public', a process that began in the nineteenth century, accelerated in the middle decades of the twentieth, and now appears to be all but complete. By the post Second World War era, aesthetics could no longer be defined in terms of male discrimination or the kinds of sensibility appropriate to the administration of the state. At the same time, a falling away of the classical politics of class had by the late 1970s given rise to an acknowledgement of a broad if differentiated 'middle' public whose aspirations and values were now those of an increasingly internationalised consumer world. Few blandishments uttered by politicians or bureaucrats in the name of 'the public' any longer affect the self-identity of this group, and *ipso facto* few idealisations beyond those of the market are any longer put in its path. At the same time, the swing to the right in British (and American) politics after 1979 has had the consequence that principles derived from the marketing sector invaded the management and function of the art museum, from the private collection right up to the national display. The interpenetration of art by business values (and vice versa) that began with Philip Morris's slogan "it takes art to make a company great" became normal practice by about 1985: the effect was to boost the glamour of large art displays in London at the same time as imposing limits of politeness and normality upon what could be seen, when and by whom.

Yet from the perspective of a transitional moment such as the present, change is inevitably mixed with continuity. A feature that achieved striking regularity in the first museum age, and seems set to extend into the second, was a pattern of utopian projection in the art museum, mixed with almost instant redundancy. The Royal Academy in 1768 was already in one sense too late to establish a coherent 'public sphere' free of the corrupting effects of commerce, given that the social forces which had compelled the Academy project had already passed it by. The National Gallery began life in the 1830s simultaneously with the birth of the very image-technology that would threaten to render painting dead – namely photography (Figure 112). The Tate Gallery in 1897 claimed to summarise a late nineteenth-century cultural manner, based upon narrative content and Royal Academy technique, that was itself already under radical threat from 'the modern'. The Tate's first full-scale institutionalisation of modern French art in 1926 occurred at a time when that art was no longer new, but already part of an established 'progressive' taste. The Arts Council and other post-war bodies attempted to extend and popularise rather than to originate the entirely new. In the late 1960s and early 1970s the Hayward Gallery institutionalised, even as it sought to celebrate, a counter-culture that by that time had already passed its radical apogee.

The latest of London's national galleries of art, the Tate Gallery of Modern Art, scheduled to open in the year 2000, looks like repeating several of the contradictions which have given the first age of the public art museum its identity. Bankside is the old area between the Bishop of Winchester's park and Paris Garden, that from the thirteenth to the seventeenth centuries contained amphitheatres for bear-baiting and bull-baiting, and in the Elizabethan period Shakespeare's Globe Theatre, now rebuilt. Paris Garden 'always had an immoral reputation', according to one account, containing a brothel in the old manor, with a moat to keep the constables at bay.[2] The new gallery, close as the crow flies to the site of

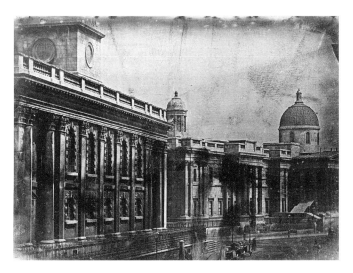

112 M. de St Croix, The National Gallery, daguerrotype, 1839.

Thomas Coram's Foundling Hospital and the first exhibitions across the river in the 1760s, will effectively symbolise the decline of organised religion and the rise of art as the major spiritual and social shift of the past two centuries. Housed in a redundant oil-fired power station designed by Sir Giles Gilbert Scott in two phases between 1947 and 1963 and replacing an earlier coal-fired power station still operative until 1953, its vast bulk will stand as a reminder of the days when major power stations were situated at the city's core, but also of the utopian dreams of the twentieth century's modern movement based on cheaply accessible oil harnessed to streamlined functional architecture on an imposing scale (Figure 113). The Bankside building may be 'architecturally distinguished'[3] in the sense of deriving from the same design office as other behemoths of its time – Waterloo Bridge, Liverpool's Anglican Cathedral and Battersea Power Station, whose great chimneys of 1934–55 are still visible up river to the west. But its position opposite St Paul's Cathedral will make it one of the most challenging juxtapositions of late twentieth-century London; and its bunker-like physical mass of some 4.2 million

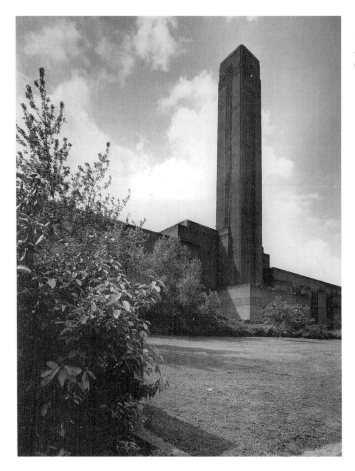

113 *Tate Gallery of Modern Art*, Bankside, during conversion.

bricks and its dominating symmetry on one of the capital's central river frontages will no doubt continue to attract censure as perhaps one of the ugliest edifices of all time. Its redesign at the hands of the Swiss design practice Herzog and de Meuron – under way as this coda is being written – will leave its scale and dominating symmetry intact; will leave, too, its central chimney as a rival to the banking corporations and tower blocks across the river to the north. However, the building's new top storey, made of glass, will irradiate the circulation and display spaces beneath to make it, for all its power-hungry presence, one of the physically largest art museums in the world.[4] Meanwhile, the Millbank 'temple' will revert in the resonant year of 2001 to becoming the home of British art.

But a further effect is likely, as the sheer scale of both projects becomes subject to the major contradictions of the art object in its late twentieth-century guise. For gradually since the cybernetic enthusiasms of the later 1960s and more rapidly following the growth of micro-chip and fibre-optic technology in the 1970s and 1980s, concepts of 'the aesthetic' have been threatened by the rise of new technologies in more or less visual form. Proclaimed by some as a post-modernist symptom capable of supplanting 'modernist' history and culture on a wide scale, screen-based information pathways have already significantly modified the terms upon which public access to the visual arts may be gained. Television has been mentioned. More recently still, major art museums such as the National Gallery, created in 1838 to bring art before 'the people', have acquired interactive touch-screen displays of its most significant (or popular) works which call upon competences mainly bestowed in the classroom or the office. CD-Rom technology already provides access to foreign museum collections to an increasing audience of users of Internet and the World-Wide Web. Works of art themselves have begun to be produced that exist only 'virtually' – that is, can never be embodied in tangible materials and forms.[5]

Thus while traditional concepts of 'public' are left behind, the traditional coupling of prescience and redundancy in the art museum looks set to continue, at least for a while. 'When completed', a recent Bankside press accouncement reads, 'the gallery will be a home for the finest twentieth-century art ranging from Andy Warhol to Rachel Whiteread, from Henri Matisse to Henry Moore [as well as] significantly enchancing Britain's ability to host major exhibitions of modern and contemporary art'.[6] Yet by the time of Bankside's opening, the twentieth century will have ended, and even newer patterns of interaction between individuals and works of art will have begun to evolve.

Notes

Notes to Chapter 1

1 See J. H. Plumb, 'The Commercialisation of Leisure in Eighteenth Century London', in N. McKendrick, J. Brewer and J. H. Plumb, *The Birth of a Consumer Society: The Commercialisation of Eighteenth Century England*, London, 1982, pp. 265–85.

2 See for example G. Beaumont and H. Disney, *Whatever is Curious in the several Counties, Cities, Boroughs, Market Towns, and Villages of Note in the Kingdom ...*, London 1768.

3 For this development, see I. Pears, *The Discovery of Painting: The Growth of Interest in the Arts in England, 1680–1768*, New Haven and London, 1988.

4 See L. Colley, *Britons: Forging the Nation 1707–1837*, New Haven and London, 1992, pp. 1–54.

5 See I. Bignamini, 'The Academy of Art in Britain before the Foundation of the Royal Academy in 1768', in A. Boschloo, E. Hendrikse, L. Smit, G. van der Sman (eds), *Academies of Art between Renaissance and Romanticism*, Leiden, Netherlands, 1989, pp. 434–50; and for greater detail, I. Bignamini, 'The Accompaniment to Patronage: A study of the Origins, Rise and Development of an Institutional System for the Arts in Britain, 1692–1768', unpublished Ph.D. thesis, University of London, 1988.

6 E. Edwards, *Anecdotes of Painters who have resided or been born in England, with Critical Remarks on their Productions*, London, 1808, pp. xx–xxi.

7 W. T. Whitley, *Artists and their Friends in England*, 1700–1799, vol. 1, London and Boston, 1928, p. 163.

8 Edwards, *Anecdotes of Painters*, p. xxiv.

9 R. H. Nichols and F. A. Wray, *The History of the Foundling Hospital*, London, 1935, p. 252; S. Hutchison, *The History of the Royal Academy* , London, p. 35.

10 Colley, *Britons*, p. 85.

11 Colley, *Britons*, pp. 58–9.

12 G. Turnbull, *A Treatise on Ancient Painting, Containing Observations on the Rise, Progress, and Decline of that Art Amongst the Greeks and Romans*, London, 1740, p. 122; cited in D. Solkin, *Painting for Money: The Visual Arts and the Public Sphere in Eighteenth Century England*, New Haven and London, 1992, to which I am indebted in this chapter; quotation, Solkin p. 163.

13 D. Hume, 'Of the Delicacy of Taste and Passion', *Essays*, London, 1741–42, p. 6.

14 See B. Allen, *Francis Hayman*, New Haven and London, 1987, Fig. 36 and pp. 65–6, who suggests the full-scale painting may have been intended for Vauxhall Gardens.

15 K. Rorschach, 'Frederick, Prince of Wales (1707–1751) as Patron of the Visual Arts: Princely Patriotism and Political Propaganda', unpublished Ph.D. thesis, Yale University, 1985. Evidently Frederick was planning to assist in the founding of a Royal Academy through his friendship with Hayman; Vertue records that the Prince spoke to him 'concerning the settlement of an Academy for painting and drawing' (G. Vertue, *Note Books*, I, p. 10); and that according to the *London Advertiser*, 20 March 1751, it would be housed in the Exeter Exchange 'until a House could be built for the purpose' (Rorschach, pp. 117–18).

16 Edwards, *Anecdotes of Painters*, pp. xxii–xxiii, who reproduces the invitation letter to the meeting at the Turk's Head Tavern in Greek Street, Soho, dated 23 Oct. 1753. See also Whitley, *Artists and their Friends*, I, pp. 157–8.

17 Hogarth's antagonism to this plan is pointed out by M. Kitson in his 'Hogarth's "Apology for Painters"', *Forty-First Volume of the Walpole Society, 1966–68*, Glasgow, 1968, pp. 55–9.

18 Edwards, *Anecdotes of Painters*, p. xxiii, who supposes that because the plan came to nothing the St Martin's Lane group remained in that location until 1767. See also L. Cust, *The History of the Dilettanti Society*, London, 1898, pp. 52–5.

19 D. G. Allen, *William Shipley: Founder of the RSA: A Biography with Documents*, London, 1968, p. 20.

20 T. Mortimer (attrib.), *A Concise Account of the Rise, Progress, and Present State of the Society for the Encouragement of Arts, Manufactures, and Commerce ...*, London, 1763; Allen, *Shipley*, pp. 43–4. On the early prize-winners and the sums paid, see D. Hudson and K. W. Luckhurst, *The Royal Society of Arts, 1754–1954*, London, 1954, pp. 5–9.

21 I owe the detail of this reading to R. Paulson, *Hogarth: His Life, Art and Times*, New Haven and London, 1971.

22 Whitley, *Artists and their Friends*, p. 165.

23 For both quotations, see *Minutes of the General Meetings of the Artists for Managing the Public Exhibition*, beginning 12 Nov. 1759 (Royal Academy Archives, London); Paulson, *Hogarth*, II, p. 308 and n. 52, p. 456.

24 Society of Arts minute books, vol. 4, 27 Feb. 1760; Paulson, *Hogarth, vol. III: Art and Politics 1750–1760*, Cambridge, 1993, p. 307.

25 Paulson, *Hogarth*, II, p. 309.

26 *London Chronicle*, 12–15 April 1760, pp. 362-3.

27 *London Chronicle*, 17–19 April 1760, p. 378.

28 Reynolds is defended in something like these terms in the *Imperial Magazine*: his four contributions to the 1760 show display 'a copious and easy invention, the most graceful attitudes, great truth, sweetness, and harmony of colouring; a light bold, mellow and happy pencil; a thorough knowledge of the magic of lights and shadows, with all the parts of the art which constitute a perfect painter'; cited in Whitley, *Artists and their Friends in England*, I, p. 167.

29 The figure is from *Guard Book of the Society of Arts*, I, p. 44. See also Husdon and Luckhurst, *The Royal Society of Arts* , p. 38.

30 J. Gwynn, *London and Westminster Improved, Illustrated by Plans to which is prefixed, A Discourse on Publick Magnificence; with Observations on the State of the Arts and Artists in this Kingdom, wherein the Study of the Polite Arts is recommended as Necessary to a Liberal Education*, London, 1766, pp. 24–5.

31 Paulson, *Hogarth*, II, p. 308, but for reference see vol. I, p. 458; also Hudson and Luckhurst, *The Royal Society of Arts*, p. 37. Shipley referred to 'irregularities committed by the audience'; see *Minutes of the Society of Arts*, cited in Allen, *Shipley*, p. 72.

32 Gwynn, *London and Westminster Improved*, p. 25.

33 Edwards, *Anecdotes of Painters*, pp. xxv–xxvi.

34 Colley, *Britons*, pp. 220–30.

35 *The London Evening Post*, 14–16 May 1761, p. 1.

36 Edwards, *Anecdotes of Painters*, p. xxvi.

37 See the *Catalogue of the Pictures, Sculptures, Models, Drawings, Prints, etc. exhibited by the Society of Artists of Great Britain, at the Great Room in Spring Gardens, Charing Cross, May the 9th 1761. Being the Second Year of their Exhibition*, London, 1761.

38 The exhibition opened on 20 April 1762, 'for four weeks, Wednesdays excepted … from Seven in the Morning till Twelve at Noon'. No person could be admitted without a ticket signed by a member, and the room was opened at one o'clock for members of the Society only. A further condition advertised in the press was that 'No Servant in Livery will be admitted into the Great Room on any Pretence whatsoever'. See *London Chronicle*, 17–20 April 1762, p. 374.

39 Anon., *The Conduct of the Royal Academicians, while Members of the Incorporated Society of Artists of Great Britain*, London, 1771, pp. 12, 13; Paulson, *Hogarth* II, p. 339.

40 'Admittance One Shilling each Person; the Catalogue gratis. The Room will be open from Eight in the Morning till Seven at Night'. See *London Evening Post*, 18–20 May 1762, p. 1.

41 Catalogue of the 1762 exhibition of the Society of Artists of Great Britain, reprinted in Edwards, *Anecdotes of Painters*, pp. xxvii–xxviii, from which all catalogue quotations are taken.

42 Edwards, *Anecdotes of Painters*, pp. xxviii–xxix.

43 Thornton was described as 'a well-known Gentleman … who has in several instances displayed a most uncommon Vein of Humour. His Burlesque-Ode on St Caecilia's Day, his Labours in the Drury-Lane Journal and other Papers, all possess that singular Turn of Imagination, so peculiar to himself', from *London Register*, April 1763, reprinted in *St James's Chronicle*, 29 April–1 May 1762, p. 3.

44 J. Larwood and J. C. Hotten, *The History of Signboards from the Earliest Times to the Present Day*, London, 1867, pp. 18–19. The poem is from *British Apollo*, vol. III, 1710, p. 34; Larwood and Hotten, *History of Signboards* p. 18. Joseph Addison had taken up the tune in his *Spectator* for 1710:

> There is nothing like sound literature and good sense to be met with in those objects, that are everywhere thrusting themselves out to the eye and endeavouring to become visible. Our streets are filled with *blue boars*, *black swans*, and *red lions*; not to mention *flying pigs* and *hogs in armours*, with many creatures more extraordinary than any in the deserts of Africa … My first task, therefore, should be like that of Hercules, to clear the city of monsters. In the second place, I should forbid that creatures of jarring and incongruous natures should be joined together in the same sign.

He asks, almost jokingly, for shops to purvey rational meanings:

> What can be more inconsistent than to see a bawd at the sign of the Angel, or a tailor at the Lion? A cock should not live at the Boot, nor a shoemaker at the Roasted Pig …

The Fox and the Goose may be supposed to have met, but what have the Fox and the Seven Stars to do together?

See Addison, *Spectator*, no. 28, 2 April 1710; Larwood and Hotten, *History of Signboards*, pp. 19-20. For a later complaint along the same lines, see the lecture 'The Microcosm', by William Whim (another pseudonym) and published at the end of the sign-painters' show: 'What right have tavern-keepers to hang out so many heads as they do? – unless it is by way of a savage triumph (as the Indians save scalps) to show what power they have over our heads. But why should a Turk's head be used at a tavern? when by their law the Mahometans are forbid to drink any wine?' *London Evening Post*, 1–4 May 1762, p. 4.

45 Hogarth's sometime assistant Philip Dawes, reported in J. Nichols and G. Stevens, *General Works of William Hogarth*, I, London, 1808, pp. 416–19; Paulson, *Hogarth*, II, pp. 346, and n. 22, p. 513.

46 We know something of Hogarth's attitudes to the technical side of sign painting from the unfinished manuscript known as the 'Apology for Painters', perhaps of 1760–61, in which he notes 'Well painted <&> finely <pencild> and miraculously painted are phrases constantly in the mouths of coach and sign painters merely well painted or pencil is chiefly the effects of much practice with expedition <and> those are often excellent in these particulars but seldom go much further'. See M. Kitson, 'Hogarth's "Apology for Painters"', p. 8.

47 Assuming the persona of one Philip Carmine ('a humble journeyman sign-painter in Harp-alley'), Thornton rehearses the old slogans against variety and contradiction ('would not any one inquire for a hosier at the Leg, or for a locksmith at the Cross Keys? and who would expect anything but water to be sold at the Fountain?') in order cleverly to insert some scathing criticisms of the Church and the monarchy. 'Why must the Angel, the Lamb, and the Mitre be the designations of the seats of drunkeness or prostitution?', he asks at one point;

> Why must Queen Anne keep a ginshop, and King Charles inform us of a skittle-ground? Propriety of character, I think, require that these illustrious personages should be deposed from their lofty stations, and I would recommend … that the comely face of that public-spirited patriot who first reduced the price of punch and raised its reputation Pro Bono Publico, should be set up whereever three penn'orth of warm rum is to be sold.

Thornton, *Adventurer*, no 9, 2 Dec. 1752.

48 In 1771 the Paris police passed an Act requiring signs to be fixed to the wall and to project no more than 4 inches. The following year London followed suit, first in the Parish of Westminster in 1762, and then in St Botolph's, St Leonard, Shoreditch, St Martin's-le-Grand and, by 1770, Marylebone. Henceforward, projecting signs were either replaced by signs fixed to houses, or by a system of 'rational' numbering. The Acts were 2. Geo III, c. 21, explained and amended by 3. Geo III, c. 23 and 4. Geo III, c. 39, and 6. Geo III, c. 24; Larwood and Hotten, *History of Signboards*, pp. 28–9. The same source also says that by that time 'education had now so readily spread, that the majority of the people could read sufficiently well to decipher a name and a number … Though the numbers [became] an established fact, the shopkeepers still clung to the old traditions, and for years continued to display their signs, grand, gorgeous and gigantic, though affixed to the houses' (p 31), and there is little doubt that some hanging signs survived as well. See also Pears, *Discovery of Painting*, pp. 115-7, and W. O.

Englefield, *History of the Painter-Stainers' Company*, London 1922; and J. Larwood and J. C. Hotten, *English Inn Signs*, London, 1951.

49 *St James's Chronicle*, 18–20 March 1762, p. 4; *St James's Chronicle*, 23–5 March 1762, p. 4.

50 The description is from L. Bertelsen, *The Nonsense Club: Literature and Popular Culture, 1749-1764*, Oxford, 1986, p. 119.

51 *London Evening Post*, 22–4 April 1762, p. 4. The article was syndicated in *St James's Chronicle*, 22–4 April 1762, p. 2 – a self-effacement which the latter paper clearly enjoyed.

52 Bertelsen, *Nonsense Club*, p. 139.

53 By the time of the exhibition itself, two kinds of printed response had come to light. One had been to condemn it as a kind of blasphemy: a letter got up artifically in the *Chronicle* had protested 'I shall not cease to contend in some News Paper or other, till the Sign-Painters exhibition is over, that the Act of Painting is attacked, and whoever appears at such a Profanation, deserves to be damned as a Connoisseur; just as my Friend of Tottenham Court denies to every one the Name of a Christian, who sets his foot in a Play House'(*St James' Chronicle*, 3-6 April 1761, p. 4). Another letter, supposedly from a member of the Society of Arts on behalf of 'A Thousand Honest Men', was sent to the *London Evening Post* shortly before the show, avowing that

> A set of *Merry Andrews* may burlesque our honest endeavours as much as their ignorance and affrontery may prompt them to, but they will be treated with that contempt such wretches deserve. They may, indeed, set the ignorant and vulgar gapers after such low fun, a-laughing; but their folly and impudence will be properly taken notice of, and they will receive such treatment from the discerning, as will make them be despised by all the world. (*London Evening Post*, 17-20 April 1762, p. 3).

54 *London Register*, April 1762, pp. 346–7; excerpted in *St James's Chronicle*, 29 April–1 May 1762, pp. 3-4.

55 *London Register*, April 1762, pp. 345–52; reproduced in *St James's Chronicle*, 20–2 April 1762; also in Larwood and Hotten, *History of Signboards*, pp. 520–5.

56 Bertelsen, *Nonsense Club*, p. 114. For the figure of Nobody in contemporary satirical prints, see D. Donald, *The Age of Caricature: Satirical Prints in the Reign of George III*, New Haven and London, 1996, p. 375.

57 *St James's Chronicle*, 29 April–1 May 1762, p. 4.

58 For these and other epithets, see T. Castle, *Masquerade and Civilization: The Carnivalesque in 18th Century English Culture and Fiction*, London, 1986, p. 99 and passim.

59 W. T. Whitley, *Artists and their Friends in England, 1700–1799*, I, London and Boston, 1928, p. 172.

60 For these disputes, see Edwards, *Anecdotes of Painters*, pp. xxx–xxxiv.

61 From *Instrument of Foundation of the Royal Academy*, 1768; reproduced in W. R. M. Lamb, *The Royal Academy*, London, 1935, pp. 196–204.

62 Note that Shipley had on 12 May 1762 proposed to his Society a plan for a 'Repository' or gallery, where artists 'May copy such original pictures and other works of Art as may be deposited for that purpose'. Rooms on the second floor of the Thames-side mansion Essex House had been identified; a scheme of finances had been drawn up; and a plan advanced which would 'especially contribute to the advancement of the Arts

of Painting and Drawing in various branches of the Polite Arts and in consequence improve in many articles the ornamental Manufactures of these Kingdoms'. The Society had turned it down, for unknown reasons; and the link with industry had been lost. See *Minutes of the Committee of the Society of Arts*, 21 May 1762; Allen, *Francis Hayman*, pp. 90–1. Or to go back even further: according to the Welsh landscape painter and pupil of Shipley, Thomas Jones, Shipley had once proposed to the Foundling Hospital 'that the whole Seminary should be converted into an Academy of Art, and all the Foundlings brought up painters'; see T. Jones, 'Memories', *Walpole Society*, vol. XXXII, 1943–44, pp. 7–8; Allen, *Francis Hayman*, p. 127.

63 J. Reynolds, *Discourses on Art* (ed. Robert R. Wark), New Haven and London, 1975, First Discourse, 2 Jan. 1769, p. 15.

64 See J. Reynolds, 'A letter on PAINTING', *The Idler*, 29 Sept. 1759, 20 Oct. 1759 and 10 Nov. 1759; collected in *The London Chronicle for 1761*, 12–14 May 1761, pp. 460–1; as well as generally, *Discourses on Art* (ed. Wark).

65 *Trewman's Exeter Flying Post*, 18-25 March 1768; Rudé, *Wilkes and Liberty*, Oxford, 1962, p. 40. See also Lord Denning, *Landmarks in the Law*, London, 1984, pp. 272–5.

66 Reynolds, *Discourses*, First Discourse, p. 13.

67 Rudé, *Wilkes and Liberty*, pp. 64-5.

68 A third show of 1769 was that of the Free Society of Artists 'at Mr Christie's New Great Rooms next Cumberland House, Pall-mall … open from Seven in the Morning till Eight in the Evening', which ran from 28 April 1769. See, e.g., *Public Advertiser*, 25 April 1769, 1 June 1769 (both p. 1). For the Free Society, see A. Graves, *The Society of Artists of Great Britain 1760–1791, The Free Society of Artists 1761–1783, A Complete Dictionary of Contributors*, London, 1907. Yet a fourth was at Strange's in St Martin's Lane.

69 The latter is no. 258, 'Portrait of a gentleman, composed of human hair', one of two similar pieces by Mrs Denham. See *A Catalogue of the Pictures, Sculptures, Designs in Architecture, Models, Drawings, Prints, &c … exhibited … by the Royal Incorporated Society of Artists, May the 1st, 1769*, London, 1769. The advertisement is from *Lloyd's Evening Post, and British Chronicle*, 3–5 May 1769, p. 435; cited in Solkin, *Painting for Money* p. 267.

70 *The Exhibition of the Royal Academy, the First*, London 1769, p. 2.

71 Whitley, *Artists and their Friends in England* I, p. 258.

72 *Whitehall Evening Post*, 25–7 April 1769, p. 1.

73 A list is contained in *Lloyd's Evening Post, and British Chronicle*, 1–3 May 1769, p. 427; Solkin, *Painting for Money*, p. 267.

74 Reynolds, *Discourses*, no. III, 1770, pp. 51, 50.

75 Solkin, *Painting for Money*, pp. 267, 268.

76 Reported in *London Chronicle*, 3–6 June 1769, p. 534; *Middlesex Journal, or, Chronicle of Liberty*, 3–6 June 1769, p. 3.

77 Colley, *Britons*, pp. 101–5.

78 *London Evening Post*, 4–6 June 1771, p. 1.

79 The information about the conflagration is compiled from a note on the back of Cipriani's design, in his own hand; from a a report in the *Middlesex Journal*, 4–6 June 1771, p. 1; and from reports of the Academy's celebrations in the Academy's own press book for 1774.

80 *The Speeches of John Wilkes*, vol. II, London, 1777, pp. 58–9.

81 Speech of 28 April 1777, in *Speeches*, p. 59.

82 *Speeches*, p. 61.

83 *Speeches*, pp. 61, 67.

Notes to Chapter 2

1 N. Pevsner, 'Museums', in Pevsner, *A History of Building Types*, London, 1976, p. 117.

2 J. Wilkes, parliamentary record for 28 April 1777; *Cobbett's Parliamentary History, comprising the period 29 Jan. 1777 to 4 Dec. 1778*, London, 1814, col. 190–1.

3 See G. Waterfield, *Soane and After: The Architecture of the Dulwich Picture Gallery*, Dulwich, 1987, p. 5.

4 For the Truchsess pictures see 'Truchsess Gallery', *The Times*, 6 June 1803, p. 4, and 23 April 1806, p. 4.

5 I am indebted here to L. Colley, 'Whose Nation? Class and National Consciousness in Britain, 1750–1830', *Past and Present*, 113, Nov. 1986, pp. 106, 108.

6 The citation is from *Catalogue of the Works of British Artists placed in the Gallery of the British Institution, Pall Mall, for Exhibition and Sale*, London, 1811, pp. 11–12. See more generally, P. Fullerton, 'Patronage and Pedagogy: the British Institution in the Early Nineteenth Century', *Art History*, 5: no 1, March 1982, pp. 59–72. For the earlier British School, see J. Gage '*The British School* and the British School', in B. Allen (ed.), *Towards a Modern Art World: Studies in British Art I*, New Haven and London, 1995, pp. 109–20.

7 J. Farington, *The Times*, 1 April 1809, p. 3; Fullerton, 'Patronage and Pedagogy', p. 64 and n. 40, p. 71. On the social appraisal of gallery visitors more generally before 1824 see A. Hemingway, 'Art Exhibitions as Leisure-Class Rituals in Early Nineteenth Century London', in Allen (ed.), *Towards a Modern Art World*, pp. 95–108.

8 J. Britton, *Marquess of Stafford Collection*, London, 1808, preface, p.v; cited in: *Art Galleries in Britain, 1790–1990*, London, 1991, Waterfield, *Palaces of Art*, p. 75.

9 See G. Waterfield, 'The Town House as a Gallery of Art', *London Journal*, 20: 1, 1995, pp. 58–9.

10 J. Carey, *A Descriptive Catalogue of a Collection of Paintings By British Artists in the Possession of Sir John Fleming Leicester, Bart*, London, 1819, p. x.

11 Colley, *Britons*, pp. 322 ff.

12 See P. Bailey, *Leisure and Class in Victorian England: Rational Recreation and the Contest for Control, 1830–1885*, London, 1978, passim.

13 For these, see R. Altick, *The Shows of London*, Cambridge, Mass., and London, 1978.

14 For the evolution of liberalism, see T. A. Jenkins, *The Liberal Ascendency 1830–1886*, London 1994; and for the radicals, W. Thomas, *The Philosophic Radicals: Nine Studies in Theory and Practice, 1817–1841*, Oxford, 1979.

15 The major accounts of the founding of the National Gallery are G. Martin, 'The Founding of the National Gallery in London', *Connoisseur* (nine parts), April to Dec. 1974; C. Trodd, 'Formations of Cultural Identity: Art Criticism, the National Gallery and the Royal Academy, 1820–1863', unpublished Ph.D. thesis, University of Sussex, 1992; and C. Duncan, *Civilizing Rituals: Inside Public Art Museums*, London, 1995, chapter 2.

16 C. Lloyd, 'John Julius Angerstein, 1732-1823', *History Today*, 16:6, June 1966, p. 375.

17 *The Times*, 3 Oct. 1803; cited in Colley, Britons, p. 110.

18 Commons debate, 2 April 1824. There were also advantages to tourism and trade. Agar-Ellis said that one

> consists in the increased affluence of foreigners of all nations to our metropolis, some of whom will become patrons of British art, and all of whom must contribute to the prosperity and riches of the country, by spending a portion of their revenues in it. That this will be the case, we may venture to predict from our experiences of the numbers of travellers who visit the various continental towns which are so fortunate as to possess public collections of pictures. The gallery at Dresden must have repaid to the country many times over what its formation cost Augustus the Third.

For Agar-Ellis's full statement, see the unsigned report 'Catalogue of the celebrated Collection of Pictures of the later John Julius Angerstein, Esq', *Quarterly Review*, 31:61, Dec. 1824, pp. 210–15.

19 Ibid., p. 211.

20 For English artists the qualities are more moral: he referred to the 'truth and humour' of Hogarth, the 'taste, the grace, the facility, the happy invention, and the richness and harmony of colouring' of Reynolds. Agar-Ellis, 'Catalogue', pp. 213, 210.

21 Ibid., p. 213.

22 From the original title of the Mackenzie watercolour, according to *The Royal Watercolour Society: The First Fifty Years, 1805–1855*, London, 1992, p. 183.

23 W. Hazlitt, 'Mr Angerstein's Gallery', in *Sketches of the Principal Picture-Galleries in England*, London, 1824, reprinted as part of vol. 10 of P. P. Howe (ed.), *The Complete Works of William Hazlitt*, London and Toronto, 1930, pp. 1–82, from which the quotation comes, p. 7.

24 Agar-Ellis in his *Quarterly Review* statement claimed that 'In the five months during which the Angerstein collection of pictures has been the property of the public, it has been visited by twenty-four thousand individuals' (p. 214). Admittedly he was arguing that the pictures not be sent to the more inaccessible British Museum.

25 Trollope, cited in Martin, 'Founding of the National Gallery', part 7, Oct. 1974, p. 113.

26 G. F. Waagen, *Works of Art and Architecture in England*, I, London, 1838, p. 183.

27 Lord Farnborough, *Short Remarks and Suggestions upon Improvements now carrying on or under Consideration*, 1826, pp. 39 ff; Martin, 'Founding of the National Gallery', part 7, p. 113.

28 Lord Ashley, debate on Supply: Miscellaneous Estimates, 13 April 1832, *Hansard*, XII, col. 469.

29 C. Dickens, *Sketches by Boz*, London, 1836–37, Oxford, 1957, p. 184. The character of poverty in central London is well covered by C. Trodd, 'Formations of Cultural Identity', chapters 3 and 4.

30 Sir Robert Peel, debate on Supply: National Gallery, 23 July 1832, *Hansard*, XIV, col. 645; see also Martin, 'Founding of the National Gallery', part 7, p. 113.

31 Colley, *Britons*, p. 340.

32 *London and its Environs: or, the General Ambulator and Pocket Companion for the Tour of the Metropolis and its Vicinities, within the Circuit of Twenty-five Miles …*, 12th Edn, London, 1820, p. 35.

33 J. Nash, in *First Report to His Majesty's Commissioners for Woods, Forests and Land Revenues*, London, 1812, p. 90; R. Mace, *Trafalgar Square: Emblem of Empire*, London, 1976, Mace, *Trafalgar Square*, p. 32.

34 R. Mace, *Trafalgar Square*, p. 29; citing Public Record Office, CREST 26/178.

35 Mace, *Trafalgar Square*, p. 37.

36 The building was inscribed 'Giorgio Secundo Rego MDCCXXXII National Repository for the Exhibition of Specimins of a New And Improved Production of the Artisans and Manufacturers of the United Kingdom [Pidcocks] Menagerie now Exeter Change'. The space was briefly given over to the 93-foot skeleton of a whale brought ashore at Ostend, now erected in the centre of what was soon to become Trafalgar Square as an entertainment: the public could climb up to a platform inside the rib-cage and listen to a 24-piece orchestra, while reading copies of Lacépède's *Natural History*, and contribute puns or witticisms to the guest book; R. Altick, *Shows of London*, p. 305.

37 On Wilkins' design process, see Martin, 'Founding of the National Gallery', part 3, June 1974, and part 4, Aug. 1974.

38 7 Geo IV, c. 77; Mace, *Trafalgar Square*, p. 42.

39 *The National Gallery of Pictures by the Great Masters, presented by Individuals or Purchased by Grant of Parliament*, London, n.d., p. iv. Though lacking a printed date, the preface refers to the edifice in Trafalgar Square 'now rising', which suggests a date; yet the frontispiece is an engraving by T. H. Shepherd of a much later date. Also lacking a named author, the catalogue may be a quasi-official government publication. William Young Ottley had already produced two descriptive catalogues to the National Gallery pictures, in 1832 and in 1835. In the first, the paintings are merely described, and in the second the paintings are 'arranged chronologically in one unbroken series'; see W. Y. Ottley, *A Descriptive Catalogue of the Pictures in the National Gallery, with Critical Remarks on their Merits*, London, 1832 and 1835. J. Landseer's *A Descriptive, Explanatory and Critical Catalogue of Fifty of the Earliest Pictures contained in the National Gallery of Great Britain*, London, 1834, is a more philosophical tract on behalf of taste and historical eloquence before pictures. The early 'official' catalogues of the National Gallery, for Pall Mall and Trafalgar Square, are descriptive lists, without critical or aesthetic commentary. The first fully historicised catalogue divided into schools, with provenance and other detail by Ralph Wornum, was published from 1856.

40 *The National Gallery of Pictures by the Great Masters*, p. iii.

41 *Report of the House of Commons Select Committee on Arts and their Connexion with Manufactures, 1835–6*, 1836 (*Minutes of Evidence*, 1835 session, para. 1615, p. 133).

42 1836 *Report*, p. v.

43 1836 *Report*, p. v.

44 1836 *Report*, pp. iii, v and x.

45 Colley, *Britons*, p. 345.

46 For Ewart, Bowring and others, see *Dod's Parliamentary Companion*, 1833; and *Dictionary of National Biography*.

47 *A Return of the Number and Officers, effective and superannuated, connected with the National Gallery, the Amount of their Salaries, etc*, 1835 (598), v. 517. Seguier and Thwaites were paid £200 and £150 per annum respectively.

48 1836 *Report*, p. x.

49 *Minutes of Evidence*, 1836 session, para. 2281, p. 195.

50 *Minutes of Evidence*, 1836 session, paras 2282, 2283, p. 196.

51 *Minutes of Evidence*, 1836 session, paras 1590, 1594, p. 132.

52 *Minutes of Evidence*, 1836 session, paras 1567, 1568, 1571, p. 131.

53 *Minutes of Evidence*, 1836 session, para. 1610, p. 133.

54 *Minutes of Evidence*, 1836 session, paras 1611–12, p. 134.

55 *The Lancet*, 1832, vol. II, p. 796; cited in R. Morris, *Cholera, 1832: The Social Response to an Epidemic*, London, 1976, p. 171.

56 R.Slaney, 21 Feb. 1833, *Hansard*, XV, cols 1052, 1054. On the dangers attendant on the continuing poor health of the labouring classes, see Slaney, *Reports of the House of Commons on the Education (1838) and on the Health (1840) of the Poorer Classes in Large Towns, with Some Suggestions for Improvement*, London, n.d., and *State of the Poorer Classes in Great Towns*, London, 1840, passim, which is a summary.

57 Slaney, *Report … on … Health (1840)*, pp. 33–4.

58 Criminals committed in England and Wales number 4,600 in 1805, 7,800 in 1815, 16,500 in 1821, 19,600 in 1831 and 22,000 in 1838 (Slaney, ibid., p. 52) with the consumption of 'ardent spirits' increasing by 300 per cent over the same period: in 1817, 9.2 million gallons were consumed, in 1827, 18.2 million gallons, in 1837, 29.2 million gallons, although the consumption in England was low (7.1 pints per head) compared with Ireland (13 pints) and Scotland (23 pints).

59 Slaney, 21 Feb. 1833, *Hansard*, XV, cols 1054–5.

60 Select Committee on Drunkenness, 1834, p. viii. In many parts of the country progress in implementing these measures was slow. Bailey goes so far as to suggest that 'recreational reforms failed to command any real priority with the legislators', parliament frequently taking the view that educational and morality 'diffused downwards from the upper class(es)', to cite the words of one MP (Bailey, *Leisure and Class*, p. 39, and *Hansard* XXVII, 2 May 1835).

61 The Act stated that

> all specimins of Art or Science, and articles of every description which may be purchased for or presented to any such Museum … shall be vested in and held upon trust for ever by the Mayor, Aldermen and Burgesses of the Borough … and shall be kept in fit and proper order for the benefit of the inhabitants of the Borough [and that] the Council … may from time to time fix such rates of payment for admission to any such museum as the Council may think expedient; and the amount so raised shall be employed in defraying the salaries of the curators and other persons employed in charge of such Museum, and in lighting, warming, cleaning and otherwise supporting and improving the same; and that the Council may also make such regulations for the preservation of the contents of such a Museum, and for the maintenance or order within it, as may to them seem expedient. (8 & 9 Vict 43 [Clauses 3, 4]).

62 The water-borne origins of cholera were revealed only after John Booth's experiments in Bristol in the early 1850s; see Morris, *Cholera, 1832*, pp. 207–9.

63 *Report of the Select Committee on National Monuments and Works of Art, 1841*, p. iii.

64 Evidence of Mr Edward Hawkins, *Minutes of Evidence*, 1841, para. 3117, p. 164.

65 Evidence of Mr J. Gray, *Minutes of Evidence*, 1841, paras 3130, 3171, pp. 165, 170.

66 Evidence of John Britton, 1841 *Report*, p. vii.

67 Evidence of Allan Cunningham, 1841 *Report*, p. vii.

68 Evidence of Lt Col George Thwaites, *Minutes of Evidence*, 1841, para. 2583, p. 133.

69 Evidence of John Wildsmith, *Minutes of Evidence*, 1841, para. 2640, p. 136.

70 Evidence of William Seguier, *Minutes of Evidence*, 1841, para. 2538, p. 130.

71 1841 *Report*, p. vi.

72 Evidence of George Thwaites, *Minutes of Evidence*, 1841, paras 2585, 2586, 2587, p. 133.

73 Evidence of John Wildsmith, *Minutes of Evidence*, 1841, para 2672, p. 138, and paras. 2642, 2645, p. 136. Reference to the mechanics serves to remind us of the development of the Mechanics Institutes and their exhibitions from the 1840s on. Open until ten o'clock at night and stimulated by the development of the railway system which enouraged day excursions, these exhibitions provided opportunites for the inspection of a bewildering variety of objects, and led indirectly to the formation of the Great Exhibition in Hyde Park in 1851. Similar protocols of decorum were applied: cleanly dressed men particularly became 'an honourable and worthy object' to appear before an exhibition; see *Journal of the Leeds Polytechnic Exhibition*, 30 June 1845, cited in T. Kusamitsu, 'Great Exhibitions before 1851', *History Workshop Journal*, 9, Spring 1980, p. 77.

74 [George Mogridge], *Old Humphrey's Walks in London and its Neighbourhood*, London 1843, p. 70.

75 Charles Kingsley, *Politics for the People*, 6 May 1848; Altick, *Shows of London* p. 416.

76 'Miscellanea', *The Athenaeum*, no. 846, 13 Jan. 1844, p. 44.

77 *The Times*, 6 Sept. 1843, p. 3. More generally, see T. S. R. Boase, 'The Decoration of the New Palace of Westminster 1841–1863', *Journal of the Warburg and Courtauld Institutes*, vol. 17, p. 154, who reports on the popularity of the exhibition, and P. Barlow, 'The Imagined Hero as Incarnate Sign: Thomas Carlyle and the Mythology of the "National Portrait" in Victorian Britain', *Art History*, 17: 4, Dec. 1994, pp. 517–45.

78 Sir Charles Lock Eastlake, *Contributions to the Literature of the Fine Arts*, 2nd series, London, 1870, pp. 173–4. Enthusiasm for the mixture of classes is also expressed in B. Simmons' poem 'Westminster Hall and the Works of Art (On a Free Admission Day)', *Blackwood's Edinburgh Magazine*, vol. LVI, Nov. 1844, pp. 652–53. See also S. C. Hall, *Art-Union Journal*, V, 1842, p. 219.

79 'Substance and Shadow, Cartoon No 1', *Punch*, vol. 5, 8 July 1843, p. 22.

80 For the debate on the Duke of Cumberland, who had become an independent King of Hanover on the death of William IV in 1837, see 'The King of Hanover's Allowance', *Hansard*, LXX, 3rd series, 16 June–28 July 1843, cols 515–33.

81 *Report of a Commission on the State of the Pictures in the National Gallery*, May 1850, compiled by Eastlake, Faraday and William Russell, p. 67.

82 C. Eastlake, *Observations on the Unfitness of the Present Building for its Purpose, in a letter to the Rt. Hon. Sir Robert Peel* , London, 1845, p. 9.

83 May 1850 *Report*, p. 68.

84 *Report of the Select Committee on the National Gallery*, 1850, p. iv.

85 *Minutes of Evidence*, para. 607, p. 40.

86 *Minutes of Evidence*, para. 83, p. 6.

87 *Minutes of Evidence*, para. 82, pp. 5–6.

88 May 1850 *Report*, p. 68.

89 As the Appendix to the May 1850 *Report* stated despairingly, ventilation 'cannot be effected without the introduction of smoke and dust produced externally' (p 68).

90 May 1850 *Report*, p. 68.

91 May 1850 *Report*, p. 68.

92 1850 *Report, Minutes of Evidence*, para. 664, p. 45.

93 *Minutes of Evidence*, 1850, para. 709, p. 48.

94 *Minutes of Evidence*, 1850, para. 681, p. 46, and para. 657, p. 44.

> The sulphurous vapours are in abundance in the atmosphere of London, [Faraday continued hopefully]; they are everywhere present, and I have no doubt that even in this room they could be proved to be present … there are also miasmata, or matters which arise in perspiration, etc, which, when they are decomposed by heat or otherwise, at all events give ammonia and sulphurous productions, and which, therefore, must exist in some form of sulphuretted vapour in their transit or in their ordinary state; we know not always, perhaps, what the actual conditions of the organic miasma which arises is (*Minutes of Evidence*, para. 666, p. 45).

95 *Minutes of Evidence*, para. 690, p. 47. Faraday's solution, which had major consequences for the way pictures were seen, and by whom, was that glass should be placed over the front of the picture and that tin-foil should be placed over the back. The selective glazing of pictures at the National Gallery after 1850 attracted little unanimity, and further discussion on the cleaning and varnishing techniques ran into comparable difficulties: all of them posed dangers to the ideal visibility of the pictures, either through removing the artist's original work, or through adding something he never did.

96 *Minutes of Evidence*, 1836, paras 1697–1702, p. 137, and 1836 *Report*, p. x.

97 *Treasury Minute*, 27 March 1855, p. 3.

98 *Treasury Minute*, 27 March 1855, p. 4.

99 *Treasury Minute*, 27 March 1855, pp. 4, 8. On Eastlake's purchasing activities while Director of the National Gallery, see D. Robertson, *Sir Charles Eastlake and the Victorian Art World*, Princeton, N.J., Princeton University Press, 1978, chapter 8.

100 *Treasury Minute*, 27 March 1855, pp. 6–7.

101 *Report of the Director of the National Gallery to the Lords Commissioners of Her Majesty's Treasury*, dated 5 March 1856, Appendix 4, pp. 17–18.

102 H. Mayhew, *London Labour and the London Poor*, London 1861–62.

103 H. Chadwick, *Report on the Sanitary Condition of the Labouring Population, London, 1842*, p. 423.

104 On the Queen's marriage to Albert, 10 Feb. 1840, the authorities in Manchester threw open at short notice the Botanic Gardens, Old Trafford; the Zoological Gardens, Higher Broughton; the Natural History Smith's Museum, Peter Street; the Manchester Mechanics Institution; the Manchester Athanaeum; and the Salford Royal Mechanics Institution Exhibition, Victoria Bridge. See *Manchester Guardian*, 12 Feb. 1840, p. 2, and also *The Manchester Courier, and Lancashire General Advertiser*, 15 Feb. 1840, p. 6.

105 G. F. Waagen, *Treasures of Art in Great Britain: being an Account of the Chief Collections of Paintings, Drawings, Sculptures, Illuminated MSS, etc*, 3 vols, London, 1854, which annotates 28 collections in and around the capital, 19 elsewhere in England and 7 in Scotland, pp. v,vi.

106 Waagen, *Art Journal*, 1849, p. 202.

107 Chadwick, *Report*, pp. 337, 425.

Notes to Chapter 3

1 The best illustrations are *Dickinson's Comprehensive Pictures of the Great Exhibition of 1851*, 2 vols, London, 1854.

2 On this and the regulation of health and crime generally in mid-nineteenth-century Britain, see R. Corrigan and D. Sayer, *The Great Arch: English State Formation as Cultural Revolution*, Oxford, 1985, pp. 114–65.

3 See *First Report of the Commissioners for the Exhibition of 1851, to the Right Hon Spencer Walpole, Secretary of State*, London, HMSO, 1852. A fascinating mathematical ratio-nalisation of ticket prices across the days of the week is proposed in Charles Babbage, *The Exposition of 1851, or Views of the Industry, the Science and the Government of England*, London, 1951, pp. 26–41.

4 Cited by P. Greenhalgh, *Ephemeral Vistas: The Expositions Universelles, Great Exhibitions and World Fairs, 1851–1939*, Manchester, 1988, p. 30.

5 'Report of Mr Alexander Redgrave on the Visits of the Working Classes', in *First Report of the Commissioners of 1851*, p. 111.

6 Ibid., p. 125.

7 Ibid., p. 121.

8 *Report of a Commission on the Site for a new National Gallery*, Aug. 1851, cited in *Second Report of the Commissioners for the Exhibition of 1851*, London, 1852, p. 35.

9 *First Report of the Department of Practical Art*, 1853, British Parliamentary Papers, vol. iv, p. 2.

10 *Second Report of the Commissioners for the Exhibition of 1851*, p. 35.

11 The origins of the South Kensington Museum as an educational project are surveyed in Louise Purbrick, 'The South Kensington Museum: The Building of the House of Henry Cole', in M. Pointon, *Art Apart*, pp. 69–86. A full account of South Kensington architecture and its decoration is J. Physick, *The Victoria and Albert Museum: The History of its Building*, London, 1982.

12 *Second Report of the Commissioners for the Exhibition of 1851*, p. 40.

13 For the detail of Vernon's early collecting and a full catalogue, see R. Hamlyn, *Robert Vernon's Gift: British Art for the Nation, 1847*, London, 1993.

14 See *The Athenaeum*, no 1530, 21 Feb. 1857, pp. 245–6, and the reference in 'Popular Art Education' (anonymous), *Meliora* , no. 2, July 1858, pp. 171–2.

15 The separation is the more remarkable given Sheepshanks' own original instruction that 'the said pictures and drawings shall be deposited in such gallery with any other pictures or other works of Art that may be subsquently placed there by other contrib-utors, as it is not my desire that my collection of pictures and drawings shall be kept apart, or bear my name as such'; see *A Catalogue of the British Fine Art Collections in the South Kensington Museum*, London, 1870, p. 6. For the 1863 bequest of 189 oil paintings, 174 watercolours, and drawings and other objects, by the Revd Chauncey Hare Townsend (1798–1868), see the same catalogue.

16 Cole, *The Function of the Science and Art Department*, London, 1857, p. 16.

17 Cole, *The Function of the Science and Art Department*, pp. 27, 18.

18 See Cole, *The Function of the Science and Art Department*, pp. 29–30. On the role of Royal Engineers, see R. Cardoso Denis, 'The Brompton Barracks: War, Peace, and the Rise of Victorian Art and Design Education', *Journal of Design History*, 8: 1, 1995, pp. 11–25.

19 *Lloyd's* newspaper, 5 July 1857.

20 Cole, *The Function of the Science and Art Department*, pp. 24, 26.

21 Cole, *The Function of the Science and Art Department*, pp. 25–6.

22 The 1855 Metropolis Management Act chiefly set in train a Metropolitan Board of Works to co-ordinate 'Sewerage, Drainage, and the paving, cleansing, lighting and improvements thereof', and advanced little administratively beyhond the parish structure of the city. See *Act For the Better Local Management of the Metropolis* (18 & 19 Vict), 1855.

23 R. Redgrave, *The Gift of the Sheepshanks collection, with a View to the Formation of a National Gallery of British Art*, London, 1857, pp. 28, 29. Redgrave also argued that the roof light of the Munich Pinakothek was too high, placing the spectators 'in a well where but few rays of light can penetrate' (p 20). A diagram showing a new balance between roof height, spectator's position and the highest reflection-free paintings was published both in this publication and in *The Builder,* 28 Nov. 1857.

24 Redgrave, *The Gift of the Sheepshanks Collection*, p. 30.

25 J. Ruskin, 'Picture-Galleries – Their Functions and Formation', in *Works of John Ruskin*, ed. E. T. Cook and A. Wedderburn, London, 1905, vol. XIII, pp. 539 ff. (first printed in the *Report of the National Gallery Site Commission*, 1857, Questions 2,392–2,504, pp. 92–7), pp. 545, 549.

26 Ruskin, 'Picture-Galleries', p. 553.

27 Ruskin, 'Picture-Galleries', pp. 546–7.

28 J. Ruskin, 'On the Present State of Modern Art, with Reference to the Advisable Arrangements of a National Gallery', *Works of John Ruskin*, vol. XIX, pp. 197, 200–1.

29 Ruskin, 'On the Present State of Modern Art', p. 202.

30 Ruskin, 'On the Present State of Modern Art', p. 216.

31 Ruskin, 'On the Present State of Modern Art', p. 215.

32 Ruskin, 'On the Present State of Modern Art', p. 219.

33 J. Ruskin, 'A Museum or Picture Gallery: Its Functions and Its Formation', *Works of John Ruskin*, vol. XXXIV, p. 250.

34 Ruskin, 'On the Present State of Modern Art', p. 226.

35 Ruskin, 'On the Present State of Modern Art', pp. 227–8.

36 *Report of the Commmission of 1863 on the Royal Academy.*

37 Ruskin, 'On the Present State of Modern Art', p. 223.

38 Ruskin, 'A Museum or Picture Gallery', p. 249.

39 *The Graphic*, 6 Aug. 1870, p. 136.

40 Ruskin, 'On the Present State of Modern Art', p. 219.

41 H. Hannyngton, 'East End Museum', *New Society*, 22 June 1972, p. 633.

42 *Borough of Hackney Express and Shoreditch Observer*, 25 May 1872.

43 Septimus Hansard, letter to *The Times*, 16 March 1874, p. 6.

44 *The Daily Telegraph* commented wryly on the preceding Saturday on some picturesque features of what it called

> A Royal progress ... into the great beehive of furniture-makers. Union Jacks are already flying from lines suspended across the streets. The publicans at the corner houses have been putting St George and the Dragon through their ablutions for festive display ... Two houses in three are placarded with the customary motice of seats to let ... The better class of shopkeepers, who have committed the extravagance of having balconies to their houses, rejoice in the hope of good investment ... Bethnal Green has none of Silas Wegg's proclivity for dropping into poetry. The decorations are strangely free from sentiment of any kind. But two mottoes are visible from one end of the district to the other.

> One welcomes the Prince and Princess in the name of a corner-shop occupied by a loyal bootmaker; the other is a sarcastic intimation, in white and red letters, that the greatest curiosities of Bethnal Green are outside the Museum. (*Daily Telegraph*, 22 June 1872).

45 *The Times*, 25 June 1872.

46 *The Inauguration Ode, Composed on the Occasion of the Visit of their Royal Highnesses the Prince and Princess of Wales, at the Opening of the East London Museum, 24 June 1872*, verses 1 and 3.

47 *Daily Telegraph*, 25 June 1872. The article was acused of 'brutal sarcasm … snobbishness', by *East London Observer and Tower Hamlets and Borough Chronicle*, leader, 29 June 1872, and disputed by the *Borough of Hackney Express and Shoreditch Echo*, 29 June 1892.

48 *Art Journal*, 1972, p. 217.

49 A. Brady, address of 7 March 1866 to Lord President of the Council of the South Kensington Museum, Earl Granville, reproduced in *East London Observer*, 22 June 1872.

50 HRH Prince of Wales, Opening Speech at Bethnal Green, 24 June 1872, reported *inter alia* in *Daily Telegraph*, 25 June 1872.

51 They included pictures from Dulwich Gallery in 1876, the Marquis of Bute's paintings in 1882, the National Collection of Portraits in 1885 (subsequently to transfer to Trafalgar Square as the National Portrait Gallery), and the Chantrey Bequest pictures in 1896, for which see chapters 5 and 6 below.

52 For more on the Grosvenor Gallery, see S. P. Casteras and C. Denny (eds), *The Grosvenor Gallery: A Palace of Art in the Victorian Art World*, New Haven and London, 1996.

53 There is an account of Rossiter and his activities in N. Smith, 'A Brief Account of the Origins of the South London Art Gallery', in Waterfield (ed.), *Art for the People*, pp. 11–17.

54 *The Times*, 26 March 1883

55 Eight days for the 1881 show; two weeks until 1886; three weeks thereafter. See H. Barnett, *Canon Barnett, His Life, Work and Friends*, London, 1918, vol. II, p. 151, and F. Borzello, *Civilizing Caliban: The Misuse of Art, 1875–1980*, London, 1987, p. 53.

56 Canon Barnett in 1893, quoted in Barnett, *Canon Barnett*, p. 168. A further biography is W. F. Aitken, *Canon Barnett*, London, 1902.

57 Barnett, *Canon Barnett*, p. 161.

58 'At the East-End "Academy": A "Private View" at the St Judes' Schools, Whitechapel', *Pall Mall Gazette*, 28 April 1886, pp. 1–2.

59 For this speech see Borzello, 'An Un-noted Speech by William Morris', *Notes and Queries*, Aug. 1978, pp. 314–16; and *Civilizing Caliban*, pp. 78–9 and chapter 9 passim, for other speakers.

60 Barnett, *Canon Barnett*, London, vol. I, p. 216.

61 Barnett, *Canon Barnett*, p. 155.

62 Barnwtt, *Canon Barnett*, p. 153.

63 See the recent study by Seth Koven, 'The Whitechapel Picture Exhibitions and the Politics of Seeing', in D. J. Sherman and I. Rogoff (eds), *Museum Culture: Histories, Discourses, Spectacles*, London, 1994, pp. 22–48.

64 See Borzello, *Civilizing Caliban*, pp. 80–1; and more generally Giles Waterfield, 'Art for the People', in Waterfield (ed.), *Art for the People*. For Horsfall's enterprise, see

T.C.Horsfall, *An Art Gallery for Manchester*, Manchester, 1877, and his 'Painting and Popular Culture', *Fraser's Magazine*, June 1880; more recently M. Harrison, 'Art and Philanthropy: T. C. Horsfall and the Manchester Art Museum', in A. Kidd and K. W. Roberts (eds), *City, Class and Culture: Studies of Social Policy and Cultural Production in Victorian Manchester*, Manchester, 1985.

65 Crane's speech was reported in 'Art for Artisans', *London*, 2 April 1896, p. 318.

66 Ibid.

67 W. Rossiter, *A Summary of the History of the South London Art Gallery, Library and Lecture Hall, from its Foundation in 1868, A Quarter of a Century Ago*, London, 1893, p. 3.

68 N. Smith, 'A Brief Account of the Origins of the South London Art Gallery', in Waterfield (ed.) *Art for the People*, p. 11.

69 For a discussion of the Jewish art exhibition of 1906, see J. Steyn, 'The Complexities of Assimilation in the Exhibition "Jewish Art and Antiques" in the Whitechapel Art Gallery, London 1906', *Oxford Art Journal*, 13: 2, 1990.

70 For the painters, see R. Strong, *And When Did You Last See Your Father? The Victorian Painter and British History*, London, 1978.

71 I am indebted in the following discussion to M.Pointon, *Hanging the Head: Portraiture and Social Formation in Eighteenth Century England*, New Haven and London, 1993, pp. 227–45 and passim.

72 T. Wyse, Commons speech, *Hansard*, 27 June 1845, col. 1,329.

73 T. Wyse, Commons speech, *Hansard*, 27 June 1845, col. 1,331.

74 Viscount Mahon, Commons speech, *Hansard*, 27 June 1845, col. 1,338.

75 N. Desenfans, *A Plan, preceded by a Short Review of the Fine Arts, to preserve among us, and transmit to Posterity, the Portraits of the Most Distinguished Characters of England, Scotland and Ireland, since his Majesty's Accession to the Throne*, London, 1799.

76 Viscount Mahon, *Hansard*, 4 June 1852, col. 10.

77 Earl Stanhope, *Hansard*, 4 March 1856, House of Lords, cols 1,771, 1,772. Carlyle's letter is that of 3 May 1854, to David Laing.

78 Carlyle, letter to Laing, 3 May 1854, also reported by Stanhope in *Hansard*, ibid. For the nature of Carlyle's likely influence on the debate, see his *On Heroes, Hero-Worship and the Heroic in History*, London, 1841.

79 Earl Stanhope, *Hansard*, 4 March 1856, col. 1,774.

80 Earl Stanhope, *Hansard*, 4 March 1856, cols 1,773,1,780.

81 Earl of Ellenborough, House of Lords, *Hansard*, 4 March 1856, col. 1,783.

82 Palmerston, *Hansard*, 6 June 1956, cols 1,119–20.

83 *First Report of the Trustees of the National Portrait Gallery*, 5 May 1858.

84 See *Fifth Report*, 1862; *Sixth Report*, 1863; *Seventh Report*, 1864; and *Ninth Report*, 1866.

85 Director's *Report* for 1870, cited in 'The National Portrait Gallery', *Quarterly Review*, vol. 166, Jan. and April 1888, p. 349.

86 Ibid.

87 Ibid.

88 See Early Stanhope, *Hansard*, 4 March 1856.

89 For example the speech by Mr Spooner, MP for North Warwickshire, *Hansard*, 6 June 1856, col. 1,115.

90 [Scharf], 'The National Portrait Gallery', *Quarterly Review*, vol. 166, Jan. and April 1888, p. 353.

91 I am indebted in this paragraph to Lara Perry for showing me a draft of her D.Phil. thesis 'Facing Femininities: Women in the National Portrait Gallery, 1856–1900', forthcoming 1998.

92 *Quarterly Review*, vol. 166, Jan. and April 1888, pp. 362–3.

93 *General Thoughts as to Requirements for a Permanent National Portrait Gallery in London, 25 May 1889*, n.p., NPG Archives. My thanks to Charles Saumarez Smith and Francesca O'Dell for bringing this to my attention. In fact the possibility of access *was* incorporated by Ewan Christian in his plan for the 1896 building – a door on the principal staircase – but to the best of my knowledge has never been used for regular public access.

94 L. Cust, letter to *The Times*, 3 April 1896. See also 'The Sunday Opening of the Museum', *The Graphic*, 11 April 1896.

95 *First Report of the Trustees of the National Portrait Gallery*, 5 May 1858.

Notes to Chapter 4

1 Churchill calls the period 'the climax of the Victorian era'; see his *History of the English Speaking Peoples*, vol. 4: *The Great Democracies*, London, 1958 p. 303. A less partial account is L. C. B. Seaman, *Victorian England: Aspects of English and Imperial History, 1837–1901*, London, 1973, chapters 13–15.

2 'The proletariat may strangle us', Samuel Smith had written in 1885, 'unless we teach it the same virtues which have elevated the other classes of society'; see S. Smith, 'The Industrial Training of Destitute Children', *Contemporary Review*, vol. xlvii, Jan. 1885, p. 110; G. Stedman Jones, *Outcast London: A Study in the Relations between Classes in Victorian London*, Oxford, 1971, p. 291.

3 Lord Birkenhead, *Rudyard Kipling*, London, 1978, p.186. For 'Recessional', see *The Times*, 17 July 1897. The poem was later saved from imperialism by George Orwell, who described it as a 'denunciation of power politics', especially of German power. See Birkenhead, *Kipling*, p. 188.

4 There are selective accounts of the origins of the Tate Gallery in the Gallery's own publications from 1897, to which must be added K. Cieszkowski, 'Millbank before the Tate', *The Tate Gallery 1984-86: Illustrated Biennial Report* London, 1986, pp. 38–43; R. Hamlyn, 'Tate Gallery', in G. Waterfield (ed.), *Palaces of Art: Art Galleries in Britain 1790-1990*, London, 1991, pp. 113–16. To these must now be added my own 'From Penitentiary to "Temple of Art": Early Metaphors of Improvement at the Millbank Tate', in Pointon (ed.), *Art Apart*, and F. Spalding, *The Tate: A History*, London, 1998.

5 J. A. Watson, *Talk of Many Things: Random Notes concerning Henry Tate and Love Lane*, London, 1985, p. 14.

6 T. Jones, *Henry Tate, 1819-1899: A Biographical Sketch*, London 1960, p. 28.

7 R. H. Blackburn, *Sir Henry Tate*, c. 1937, privately printed, pp. 58–9, Tate Gallery Archive, London.

8 According to a letter from the present Sir Henry Tate to Daphne Hayes-Mojon of the Streatham Society, dated 24 Aug. 1984.

9 For an alleged link between Tate's sugar business and slavery, see David Dabydeen, on Central ITV's *Viewpoint* programme, 22 Sept. 1987, and in 'High Culture based in Black Slavery', *The Listener*, 24 Sept. 1987, pp. 14-15.

10 Letter from Hubert von Herkomer to Mrs Tate, undated, in the possession of the Streatham Society.

11 E. Morris, 'The Formation of the Gallery of Art in the Liverpool Royal Institution, 1816-1819' (unpublished MS).

12 B. Guinness Orchard, *Liverpool's Legion of Honour*, Birkenhead, 1893, p. 689, insinuates that Walker's gifts were instruments of social advancement (Walker received a knighthood and a baronetcy). See also D. Owen, *English Philanthropy, 1660-1960*, Cambridge, Mass., 1965, pp. 453–4. The activities of the merchant aristocracy in Liverpool are partially chronicled in M. B. Simey, *Charitable Effort in Liverpool in the Nineteenth Century*, Liverpool, 1951. For the Rathbones, see E. F. Rathbone, *William Rathbone: A Memoir*, London 1905. Class relations were patriarchal, according to B.D.White's *A History of the Corporation of Liverpool, 1835–1914*, Liverpool, 1951, but were 'slightly tempered by philanthropy' (p 4). Owen, *English Philanthropy*, 1965, pp. 453–468, also gives a brief summary.

13 For lists of bequests, see Jones, *Henry Tate*, pp. 29 ff. Information about the Tate libraries is contained in K.Povey, 'Sir Henry Tate as a Benefactor of Libraries', Presidential Address to the North Western Branch of the Library Association, read at the Annual General Meeting, University of Liverpool, 7 Feb. 1957 (MS in the possession of Daphne Hayes-Mojon, to whom I am again indebted).

14 With the sanatorium at Virginia Water costing £350,000, the total gift was over a million pounds, all from the proceeds of patent medicine.

15 These gifts are inevitably the cause of some critical and historical scepticism. Foucault says gloomily:

> It was no longer a question of leading people to their salvation in the next world but rather ensuring it in this world. And in this context the word 'salvation' takes on different meanings: health, well-being, … security, protection against accidents, [including medicine and welfare]. Sometimes this [pastoral] form of power was exerted by private ventures, welfare societies, benefactors, and generally by philanthropists. ('The Subject and Power', in B. Wallis (ed.), *Art After Modernism: Rethinking Representation*, New York, 1984, p. 421).

More relevant here is the fact that in the 1860s vast sums had been dispensed to the poor of London by the upper classes, much of it little more than the indiscriminate giving away of cash. As Stedman Jones points out (*Outcast London*, pp. 245–7), it was a practice that was heavily criticised for feeding the intemperance of the poor and for making begging more profitable than work.

16 See *The Athenaeum*, no. 1530, 21 Feb. 1857, pp. 245–6; and above, chapter 3, n. 14.

17 *Report of the Commission of 1863 on the Royal Academy.*

18 Orrock's lecture was delivered on 11 March 1890 and was supported by correspondents to *The Times*, 13 March 1890.

19 'Editorial', *Burlington Magazine*, no. 1, 1903, p. 3.

20 C. Arscott, 'Sentimentality in Victorian Paintings', in Waterfield (ed.), *Art for the People*, p. 69.

21 The phrase is from R. V. Holt's *The Unitarian Contribution to Social Progress in England 1930*, p. 13, a book that summarises Unitarian efforts in nineteenth-century reform.

For contemporareous accounts, see *Unitarianism: Its Origins and History*, London, 1890; *Unitarian Christianity: Ten Lectures on the Positive Aspects of Unitarian Thought and Doctrine*, London, 1881; and Mrs Humphrey Ward, *Unitarians and the Future*, London, 1894. For the pattern of Unitarian migration from the northern cities to London, see R. K. Webb, 'Flying Missionaries: Unitarian Journalism in Victorian England', in J. M. W. Bean (ed.), *The Political Culture of Modern Britain: Studies in Memory of Stephen Koss*, London, pp. 11–31.

22 It is not to be supposed that Tate's purchases were exclusively English, or British – a confusion to which I shall return. Tate's 'Foreign' collection, which he did not offer to the nation, is revealing. Here were 49 heterogeneous works by artists from France, Spain, Italy, America and Holland. None is an Impressionist or a member of the 'modern' school. For the complete list, see *Catalogue of the Collection of Pictures of Henry Tate, Park Hill, Streatham Common*, London, 1894, which lists 101 British paintings, 49 'foreign' works and 28 variegated watercolours.

23 For Tate's letter, the Treasury's response and subsequent correspondence, see *Report of the National Gallery to the Treasury*, 1890, pp. 4–5.

24 Unsigned column in *The Times*, 13 March 1890, also supporting the Orrocks lecture at the Royal Society of Arts. Orrocks' claim had been that 'there are probably not a hundred men whose judgement is alive to the merits of the work of some of the our most celebrated master, especially in landscape', and he had supported Ruskin's view at the beginning of *Modern Painters* that English art can rest its claims on colour, 'as well as on its frank, manly, and above all healthy outlook on life and nature' (*Times* article, p. 13).

25 *The Hawk*, 11 March 1890.

26 *The Graphic: An Illustrated Weekly Magazine*, 17 March 1890. The painting appears on the cover of *The Magazine of Art* for March 1890.

27 *The Hawk*, 11 March 1890.

28 Letter from Henry Tate, *The Times*, 21 June 1890.

29 Letter from Henry Tate, *The Times*, 21 June 1890.

30 *The Times*, 23 June 1890. The article pointed out that the *terminus ante quem* of 1750 would ensure that the collection 'would practically include the whole history of British art'.

31 Ibid.

32 *Daily News*, 21 June 1890.

33 The Treasury was slow to respond:

> the proposal to establish such a gallery … on the general lines of the Luxembourg Museum at Paris is not new to my Lords … my Lords are disposed to believe that the eastern and western galleries at South Kensington, now temporarily asigned to other purposes, might be devoted to the establishment of a representative collection of modern British pictures, in which the works that are at present scattered in various institutions might be brought together. My Lords are satisfied that these galleries, which are fireproof and would afford a good light, could be adapted to the purpose – at any rate for a number of years … My Lords regret, however, that it is not possible for them to accept, without reservation, the further condition [i.e. for independent administration] with which your offer is accompanied. (Letter from W. L. Jackson, Financial Secretary to the Treasury, to Henry Tate, published in *The Times*, 27 June 1890).

Tate felt the Treasury proposal was 'makeshift', and turned it down (letter to *The Times*, 27 June 1890). The influential Earl of Carlisle supported the South Kensington

plan, though *The Times* found it 'very far from the ideal solution' (1 July 1890), favouring instead Kensington Palace, with an independent management, as per Tate's proposal. The next day, 2 July 1890, it reported that Sir James Linton, President of the Royal Institution, was attempting to secure the site of Kensington Palace for a new British gallery: it was already Crown property, and the Queen and the Prince of Wales were known to be unfavourable. Sir William Agnew offered £10,000 if the government would act. At this point it became almost routine to put suggestions into the ring. A correspondent to *The Times* (F. H. Jeune) suggested St James's Palace. Offers of money were made. The Sunday Society offered money for a Sunday Gallery, and the *Punch* cartoonist Harry Furness gave a lecture at Toynbee Hall on 'My Gift to the Nation' in which he jokingly offered a collection of 'modern artists' that he had recently exhibited in Bond Street. A Mr Harry Quilter offered £2,000 on condition that a central site could be found. No one took either of them seriously. However, a meeting convened by Goschen a fortnight later and involving the Earl of Carlisle, Sir Henry Layard, Sir Frederick Leighton, Sir F. Burton, Sir John Gilbert and Sir James Linton agreed that a proposed British Art Gallery at South Kensington would not be administered by the Department of Science and Art, but by an indpendent board 'composed, to some extent, if not wholly, of those connected with the national art in this country' ('Parliamentary Report', *The Times*, 15 Aug. 1890). The concept of a separate building had been lost: yet it was proposed that a physical connection with the Imperial Institute would ensure a 'distinguished entrance in harmony with the Imperial Institute (in South Kensington) and with the connecting gallery'. It was further mooted that the Luxembourg 'ten-year rule' for living artists be adopted. Supporters of the Kensington Palace alternative felt that the rug had been pulled. Scepticism about a link with the Imperial Institute was expressed in *The Times*. Lord Leighton and Lord Carlisle were accused of 'acting on their own', of having won over the government 'when better proposals were available' (letter from J. C. Robinson, *The Times*, 10 Sept. 1890). There was a long period of inactivity. In March 1891, a Mr T. Humphrey Ward, following discussions with the Chancellor and clearly at Tate's behest, published a letter to the Chancellor in *The Times* explaining that 'a friend of mine (whose name I have given you in confidence, his earnest wish being that it should not be made public) authorises me to propose … to build at his own expense and at a cost not exceeding £80,000, a gallery for British art'. The conditions were that the government should give a plot of land at the south-eastern corner of Imperial Institute Road, having a frontage of 300 feet to Exhibition Road and 180 feet to Imperial Institute Road; that the government reserve an extra piece of land up to 200 feet westwards up Imperial Institute Road, and that the 'organisation of the gallery be entirely separate from the Science and Art Department' (letter dated 12 March 1890 from Ward to Goschen, published in *The Times*, 21 March 1891, p. 10). The Chancellor felt that the scheme 'will meet with general approval'. Yet he vacillated: the site was 'not entirely vacant at the present time', £80,000 might not be enough; the site might need reducing; its future extension could not be guaranteed. In other respects Goschen found the plan a good alternative to the east and west galleries (letter from the Chancellor also published in *The Times*, 21 March 1891). Ward showed the reply to Tate, who was 'happy to regard [Goschen's letter] as an acceptance of his offer (also *The Times*, 21 March 1891). Yet the site discussed turned out to be also destined for a new Science Museum:

'Science is indignant with Art in the matter', said the *Pall Mall Gazette* (21 March 1891); with Sir Henry Roscoe and E. J. Poynter intervening on behalf of the science lobby. Simultaneously, a proposal came up that the Corporation of London might contribute a site on the Embankment between the Temple and Sion college. *The Times* supported the idea (21 July 1891). Tate was reported in the later part of 1891 to be reluctant to insist upon the South Kensington land in the face of opposition from the science lobby. Yet the problem with the Embankment site was that the Corporation of London was not in favour of giving away the land, and in any case was being made a handsome offer for it by the Salvation Army. The debate was stalemated.

34 *Society*, 20 Feb. 1892.

35 J. Rothenstein, *The Tate Gallery: The National Collection of British Painting and of Modern Foreign Art*, London, 1947, p. 6.

36 S. R. J. Smith (d. 1913) is a forgotten figure. He was an eclectic architect who opened an independent practice in 1879 and whose buildings include public libraries at Norwood, South Lambeth Road, Brixton, Kennington, Streatham, Balham, Greenwich, Hammersmith; additions to All Saints Church, south Lambeth, All Saints' Institute, the Cripplegate Polytechnic Institute, Golden Lane, the library of New Bedford College, Regent's Park, and of the picture gallery at Park Hill, Streatham. There is a short obituary in the *Journal of the Royal Institute of British Architects*, 12 April 1913, p. 412.

37 Letter from Edward Goschen to Henry Tate dated 29 Feb. 1892, published in *The Times*, 5 March 1892, p. 10.

38 Letter from Henry Tate to Edward Goschen dated 3 March 1892, *The Times*, 5 March 1892, p. 10.

39 Letter from E. F. DuCane, *The Times*, 17 March 1892. DuCane was the author of *The Punishment and Prevention of Crime*, 1885.

40 A. Griffiths, *Memories of Millbank, and Chapters in Prison History*, London, 1884, pp. 1–2. The building of the penitentiary was supervised by Sir Robert Smirke, architect of the British Museum (1823–47).

41 See R. Evans, *The Fabric of Virtue: English Prison Architecture 1750–1840*, Cambridge, 1982, pp. 346–87.

42 C. Dickens, *David Copperfield*, London, 1850. Some other references can found in Cieszkowski, 'Millbank before the Tate', to which I am again indebted.

43 On the inside, Miss Pynsent and Hyacinth formed a

> confused impression of being surrounded with high black walls, whose inner face was more dreadful than the other, the one that overlooked the river; of passing through gray courts, in some of which dreadful figures, scarcely female, in hideous brown, misfitting uniforms and perfect frights of hoods, were marching round in a circle; or sqeezing up steep, unlighted staircases at the heels of a woman who had taken possession of her at the first stage, and who made incomprehensible remarks to other women, of lumpish aspect, as she saw them erect themselves, suddenly and spectrally, with dowdy untied bonnets, in uncanny corners and recesses of the draughty labyrinths. (Henry James, The Princess Casamassima (1886), Harmondsworth, 1977, 1986, pp. 79, 82).

44 J. Stowe, *A Survey of London*, London, 1598.

45 Griffiths, *Memories of Millbank*, pp. 22–3.

46 *Daily News*, 3 Nov. 1892.

47 E. DuCane, *The Times*, 17 March 1892.

48 Ruskin, 'On the Present State of Modern Art', pp. 227–8.

49 *The Times*, 18 March 1892.

50 *Magazine of Art*, June 1893, p. 264.

51 *Art Journal*, Sept. 1897, where the building is described as 'Italian renaissance with Grecian motives', p. 287. See also *Art Journal*, Dec. 1894, p. 373. *The Graphic* later had it as 'pseudo-classical in style, dignified in elevation and simple in plan', 17 July 1897. The *Daily Chronicle* expressed relief that it wasn't Gothic; that it 'has returned to the classic models that served for the National Gallery and British Museum', in the issue for 15 July 1897. See also *The Builder*, 2 Jan. 1897, p. 17 for a summary of the changes to the design.

52 *The Times*, 15 July 1897.

53 *The Sunday Times Short Guide to the Tate Gallery of Contemporary Art*, London 1897, p. 8.

54 *The Spectator*, July 1897, p. 113.

55 H. Heathcote Statham, 'Notes on Architecture in 1897', *The Year's Art*, London, 1898, p. 14–15.

56 Alain-Fournier, *Towards the Lost Domain: Letters from London, 1905* (ed. and trans. W. J. Strachan), Manchester, 1986, p. 129.

57 Anne Ritchie, 'Alfred Stevens', *Contemporary Review*, April 1912, p. 487.

58 At 4 o'clock in the afternoon, the Prince and Princess of Wales, the Duke and Duchess of York, Princess Victoria of Wales and Princess Louise, Marchioness of York, arrived at the bottom of the steps leading up to the National Gallery of British Art. Awaiting the arrival of the Royal Party were Leader of the House of Commons Arthur Balfour, leader of the Liberal opposition Sir William Harcourt and First Commissioner of Works Mr Akers-Douglas. The royal party were first received by the Trustees and Officers of the National Gallery (named as the Marquis of Lansdowne, Mr Alfred Rothschild, the Earl of Carlisle, Mr P. Heseltine, Earl Brownlow, Mr M. J. Murray Scott, Sir Charles Tennant, Sir Edward Poynter, Charles Eastlake, G. E. Ambrose and Charles Holroyd). Henry Tate handed the Prince of Wales a solid gold key of 15 ounces (also designed by Smith) and invited him to unlock the Gallery. Mrs Tate offered the Princess of Wales a bouquet of orchids in the shape of the Prince's ceremonial feathers: the Princess of Wales wore a dress of pearl gray silk trimmed with petunia velvet and gray chiffon, and a toque of deep mauve poppies with a black plume. The royal party passed through the entrance hall, past a goldfish fountain, through a Chantrey Bequest room to the left and a small octagonal room devoted to works by Watts, into Gallery 3, where Tate's collection was hung. Their Royal Highnesses mounted the dais in front of Millias's *And the Sea Shall Give Up Its Dead*. Tate handed the deeds of the Gallery to the Prince of Wales, who then handed them to Mr Akers-Douglas. Among the other invited guests were Lady Burne-Jones, Sir William Agnew, Mr and Mrs Alma Tadema, Alfred Waterhouse, Mr and Mrs Luke Fildes, the Herkomers, the Norman Shaws, and some 20 members of the Tate family of different generations, in addition to Henry and his wife.

59 *The Times*, 22 July 1897.

60 *The Times*, 23 July 1897. See also *Daily News*, 22 July 1897, p. 2, and the report in *Daily Graphic*, 22 July 1897, pp. 1, 3.

61 *Daily News*, 2 Dec. 1893.

62 *Daily Graphic*, 22 July 1897, p. 7. The contrast between the worlds of crime and art was again drawn, some three months later, by Lord Herschell in his opening speech at Reading Art Gallery:

> We all passed much of our time in the midst of what was calculated rather to depress than to elevate us, surroundings that were sordid, mean and unlovely. And this was the case none more than those who were engaged in the profession of the law. It must do us all good to come for a time from these surroundings to look upon pictures which depicted acts of heroism or self-sacrifice, or a quiet reposeful piece of nature which reminded us that our worries did not bulk so mightily in the arrangement of the world as we were apt to suppose. Those who came to this gallery would find not only enjoyment but would go away with their better selves refreshed and strengthened, and might carry away also a very real love of nature itself by seeing that nature depicted in works of art. (*The Daily Graphic*, 20 Oct. 1897, p. 8.)

63 *Daily News*, 22 July 1897, p. 5.

64 Tate himself had made it clear that he did not want his name attached. 'I do not wish it to bear my name, and I most certainly object to its being called "The New Tate Gallery". I have recommended the Government to call it "The National Gallery of British Art", and I hope it will be known by that name for all time'; H. Tate, letter to *Daily News*, 4 Dec. 1893.

65 The suggestions are all from *Truth*, 16 Sept. 1897. The next issue of *Truth* (30 Sept. 1897, p. 861) admitted that

> It is quite clear that the public intend to call the new building at Millbank the Tate Gallery, so that it is useless to expect any of the suggestions made by the competitors to this competition to be adopted. To withhold the prize, however, on that account, is not my intention, and it will therefore be divided between [those who suggested]...'The British Art Gallery'.

66 *Westminster Gazette*, 26 July 1897.

67 Associations between the prison and the gallery have been frequent in recent art history, proposing a Foucauldian reading of the art museum that underscores the interpellation of an unsuspecting mass in regimes of surveillance and social control, before the spectacle of official culture. See for example D. Preziozi, *Rethinking Art History*, Berkeley, Cal., 1989, and my own 'Displays of Power: With Foucault in the Museum', *Circa*, 59, Sept–Oct. 1991, pp. 22–7. In the present case it would be perverse not to mention a certain geographical continuity between Foucault's 'carceral archipelago' and the gallery at Millbank. A London guide of 1820 says that

> the plan of this edifice [the Millbank Penitentiary] was principally founded on the *Canopticon* [sic] of that illustrious philanthropist, Mr Jeremy Bentham. The external walls form an irregular octagon ... this vast space is intended to comprehend seven distinct ... masses of building, the centre being a regular hexagon, and the others branching from its respective sides. By this means, the governor or overseer may, at all times, from windows in the central part, have the power of overlooking every division of the prison; [the aim of the establishment being to] try to effect a system of imprisonment founded on humane and rational principles, in which the prisoners should be separated into classes, and be compelled to work; and their religious and moral habits properly attended to, as well as those of industry and cleanliness. (*London and its Environs*, London, 1820, p. 117).

It can safely be asserted that Bentham's inspection principle, in various forms, became the unifying principle of early nineteenth-century prison architecture (for a similar assessment see Evans, *Fabric of Virtue*, p. 228). Built between 1812 and 1816 and finally finished in 1821 to a design of Messrs Williams, Hardwicke and Braithwaite, Millbank nevertheless contained several non-panoptic features that made it something other than a pure 'iron cage, glazed'. It is ironic that it was at Millbank, or to be precise at nearby Tothill Fields in Pimlico, that Bentham had wanted his 'Panopticon, or Inspection House' built – the scheme was finally vetoed by the Home Secretary in 1811. But the penitentiary never fulfilled its reforming function in anything like Bentham's terms. By the 1890s it was precisely its reputation as unbeautiful and disease-ridden that suggested the metaphors of cleanliness and enlightenment that became installed in representations of the new gallery. The gallery's foundations were built from the bricks of the old prison – that too made for a certain poignancy in the 'transformation'. Yet the argument that art museums are 'panoptic' in Foucault's terms would require different premises: our literary fragments from the 1890s represent a complete inversion of the Foucauldian thesis, suggesting the kinds of positive valuations that one part of the art audience of 1897 wanted the experience of art to be accorded. For a Foucauldian argument as it might be applied to the very different architecture of the nineteenth-century fairs and international expositions, see T. Bennett 'The Exhibitionary Complex', *New Formations*, 4, Spring 1988, pp. 73–102.

68 See for example *Penny Illustrated Paper*, 24 July 1897, p. 56.

69 See for example the diagram of the park on the Millbank site in *Pall Mall Gazette*, 31 March 1892, p. 2; proposed on the grounds that 'the park and the gallery would be within eight minutes' easy walk from the Houses of Parliament. There is a steam-boat pier near, and Victoria Station is only a few minutes distant' (p 2).

70 *Daily Graphic*, 21 Oct. 1897, p. 11.

71 A proposal that the area be populated by 'clerks, and others of a similar standing' had been published in *Daily News*, 2 Dec. 1893: 'the eight or nine acres of land might thus be converted into a residential colony of a class somewhat superior to the "artisan" neighbourhood, and a little more in keeping ... with the vicinity of this splendid national institution'. A plan which resembles the scheme eventually built was published in *Daily Graphic*, 21 Oct. 1897, p. 11. For the concept of the 'residuum', see Stedman Jones, *Outcast London*, passim.

72 The names affixed were those of Reynolds, Morland, Maclise, Mulready, Millais, Ruskin, Rossetti, Hogarth, Stubbs, Turner, Gainsborough, Leighton, Landseer, Lawrence and Wilkie.

73 *Norwood Press*, 21 Aug. 1897.

74 'Sunday Evening at a South London Picture Gallery', *Pall Mall Gazette*, 14 Oct. 1889.

75 *Daily Graphic*, 17 Aug. 1897; reproduced in Waterfield (ed.), *Art for the People*, London, 1994, p. 82.

76 *Daily Graphic*, 24 Aug. 1897.

77 See *Penny Illustrated Paper*, 24 July 1897, p. 56.

78 For this and other detail on the interior, see Hamlyn, 'The Tate Gallery', in Waterfield (ed.), *Palaces of Art*.

79 *Descriptive and Historical Catalogue of the Paintings and Sculptures in the National Gallery*, London, 1897, p. 42.

80 *The Sunday Times Short Guide to the Tate Gallery of Contemporary Art*, London, 1897, p. 28.

81 *Sunday Times Short Guide*, p. 6.

82 *Sunday Times Short Guide*, p. 5. For a residual confusion between 'modern' and 'contemporary' see the letter from Lord Leighton to *The Times*, 21 May 1891. I am indebted to Edward Morris for this reference.

83 As reported for instance in *Illustrated London News*, 24 July 1897, p. 129.

84 Lionel Cust, 'A National Gallery of British Art' in *Catalogue of the National Gallery of British Art (Tate Gallery)*, London, 1898 p. 5.

85 Cust, 'A National Gallery of British Art', p. 6.

86 Cust, 'A National Gallery of British Art', pp. 6–7.

87 Cust, 'A National Gallery of British Art', p. 7.

88 Cust, 'A National Gallery of British Art', p. 8.

89 Cust, 'A National Gallery of British Art', p. 10.

90 B. Doyle, 'The Invention of English', in R. Colls and P. Dodds (eds), *Englishness in Politics and Culture 1880–1920*, London, 1986, pp. 89–115. See also H. T. Buckle, *History of Civilisation in England*, vol. I, London, 1902.

91 Other changes were afoot which undercut a simple thesis of criminal decline. Crime had, in one sense, decreased: the number of persons committed to prison between 1871 and 1901 shows a steady decline (see *Returns of Numbers of Commitals for Crime in England and Wales*, 1884, 1887, 1897, 1899). At the same time, prison sentences were being used less by magistrates for petty crime, and reformatories and industrial schools were being used increasingly for juvenile offences. Shorter-term sentences actually *increased* over the period. A shift was also observable in the discourse of crime from a traditional terminology of 'error' and 'sin' to a set of overtly psychiatric terms: thus the incidence of 'insanity' was rising rapidly, particularly for women, as a method of classifying behaviour (see *Census* returns, 1881, 1891, 1901, London, HMSO).

92 Reported in, for example, *The Sketch*, 28 July 1897, p. 3.

93 The mood of the empire in 1897 is well summarised in J. Morris, *Pax Britannica: The Climax of Empire*, London, 1968.

Notes to Chapter 5

1 P. Corrigan and D. Sayer, *The Great Arch: English State Formation as Cultural Revolution*, Oxford, 1985, pp. 166 ff.

2 For details of the residual sympathy for German culture as represented in *The Art Journal* though *The New Age* to *Art News*, *Rythm* and Wyndham Lewis's *Blast*, see M. Paraskos, 'English Expressionism', unpublished M.A. thesis, University of Leeds, 1997.

3 E. Wake Cook, *Anarchy in Art and Chaos in Criticism*, London, 1904, p. 7. The book originated in a series of articles in *Vanity Fair*, 1903–4.

4 F. Wedmore, 'The Impressionists', *Fortnightly Review*, Jan. 1883, xxxiii; in K. Flint (ed.), *Impressionists in England: The Critical Reception*, London, 1984, pp. 48, 50, 51.

5 First published as R. A. M. Stevenson, *Velázquez*, London, 1895; revised second edition published as *Velázquez*, London, 1899, from which this quotation comes, p. 92.

6 F. Rutter, *Art in My Time*, London, 1933; quoted in Flint (ed.), *Impressionists in England*, pp. 197–8. Konody (1872–1933) was art critic of *The Observer* and the *Daily*

Mail, and in 1903 published an English translation of Camille Mauclair's *The French Impressionists*.

7 Rutter, 'Art in My Time', p. 198.

8 The reference is to Degas's *L'Absinthe*, first shown in Brighton in 1876 and eventually exhibited at the Grafton Galleries in 1893. For the controversy, see Flint (ed.), *Impressionists in England*, pp. 8–10.

9 The book was based on earlier articles in *Pall Mall Gazette*, *The Artist* and *Studio*. The quotation is from *Impressionist Painting*, pp. 3–4; Flint, *Impressionists in England*, p. 190.

10 D. S. MacColl, *Nineteenth Century Art*, Glasgow, 1902, p. 2.

11 MacColl, *Nineteenth Century Art*, p. 16, in a discussion of Millet.

12 MacColl, *Nineteenth Century Art*, p. 164.

13 MacColl, *Nineteenth Century Art*, p. 3.

14 From 'Extracts from the Will of Sir Francis Chantrey, R.A., D.C.L., dated 31 Dec. 1840', reproduced in W. R. M. Lamb, *The Royal Academy: A Short History of its Foundation and Development to the Present Day*, London, 1935, pp. 188-193. This quotation, p. 192.

15 D. S. MacColl, *The Administration of the Chantrey Bequest; Articles Reprinted from 'The Saturday Review' with Additional Matter, including the Text of Chantrey's Will and a List of Purchases*, London, 1904; the statement from Chantrey's will trust is from pp. 73-4. See also the leaflet 'The Chantrey Bequest', by W. R. M. Lamb, 1937, rev. 1951. Lamb was secretary to the Royal Academy and to the Chantrey Trustees. For the House of Lords Report, see *Report from the Select Committee of the House of Lords on the Chantrey Trust; together with Proceedings of the Committee, Minutes of Evidence and Appendices*, 1904. House of Lords papers, vol. VII, 1904. There is also a *Memorandum by the Royal Academy on the Report of the House of Lords Committee on the Chantrey Trust*, House of Lords Papers, no. 166, 1905, in which the Academy agrees in principle to establish the two committees for selection – one for painting and one for sculpture.

16 MacColl, *The Administration of the Chantrey Bequest*, p. ix.

17 MacColl, *The Administration of the Chantrey Bequest*, p. 14. The Dicksee painting was purchased in 1900. MacColl pointed out that Whistler's *Portrait of his Mother* had gone to the Luxembourg 'at a price beggarly compared with the standard of the Chantrey Trustees' (p 12) – it had cost the Luxembourg £160, in 1892.

18 R. Fry, 'The Chantrey Bequest', *The Athenaeum*, 2 July 1904, and 'The Chantrey Bequest', *The Athenaeum*, 20 Aug. 1904. They are reprinted in C. Reed (ed. with introductory essay), *A Roger Fry Reader*, Chicago and London, 1996, pp. 252, 255-8. Reed also plausibly identified the unsigned 'Fine Art Gossip', *The Athenaeum*, 23 May 1903 and 'The Chantry Bequest', *The Athenaeum*, 7 Nov. 1903, and the review of MacColl's *Administration of the Chantrey Bequest* in *The Athenaeum*, 9 April 1904 as being by Fry.

19 See *List of Works purchased under the Terms of the Chantrey Bequest, 1877–1952* Royal Academy of Arts, n.d. (Royal Academy Archives). The later controversy over the Chantrey Bequest is taken up again in chapter 6 below.

20 For Harcourt's budget see R. C. K. Ensor, *England, 1870–1914*, Oxford, 1936; and Sir Edward Walter Hamilton, *The Destruction of Lord Roseberry* (ed. and intr. David Brooks), London, 1988, chapter 1 passim.

21 *Report of the Committee of Trustees of the National Gallery appointed by the Trustees to inquire into the Retention of Important Pictures in this Country and Other Matters connected with the*

National Art Collection, London, 1915. Appendix V lists some 500 works which had recently been sold in America or Europe, including 4 Botticellis, 6 Constables, 29 Van Dykes, 32 Gainsboroughs, 25 Frans Hals's, 12 Hobemmas, 12 Holbeins, 22 Raeburns, 4 Raphaels, 54 Rembrandts, 33 Reynolds, 22 Rubens's, 14 Turners, 7 Velázquezs, 7 Vermeers, 4 Van der Weydens, etc. – the overwhelming majority to the USA.

22 *Report of the Committee of Trustees of the National Gallery*, p. 26.

23 *Minutes of Evidence of the Committee of Trustees of the National Gallery.*

24 *Report of the Committee of Trustees of the National Gallery*, p. 26.

25 *Report of the Committee of Trustees of the National Gallery*, p. 64.

26 *Report of the Committee of Trustees of the National Gallery*, p. 26.

27 See D. S. MacColl, 'The Future of the National and Tate Galleries', *The Nineteenth Century and After*, June 1915, p. 1,404.

28 Interestingly, MacColl's objection to further purchase of Old Masters was that it would turn Trafalgar Square into a 'museum' in the sense of 'an unlimited number of examples of painting in every degree of imaginative force, but claiming a place because they are authentic illustrations of human activity … in every country and period … a scientific (shall we say German?) ideal … opposed to the ideal of choice and rejection': MacColl, 'The Future of the National and Tate Galleries', p. 1392. MacColl felt that in the Turner collection there was a 'vast superfluity, much more than he intended us to have'. He recommended that 'the superfluous Turner drawings' be sold (p 1,397).

29 A sociological description has been attempted in two recent articles by Gordon Fyfe, 'The Chantrey Episode; Art Classification, Museums and the State, c. 1870–1920', in S. Pearce (ed.), *Art in Museums: New Research in Museum Studies*, vol. 5, London, 1995, pp. 5–41, and 'A Trojan Horse at the Tate: Theorizing the Museum as Agency and Structure', in S. Macdonald and G. Fyfe (eds), *Theorizing Museums: Representing Identity and Diversity in a Changing World*, Oxford 1996, pp. 203–28.

30 *Report of the Committee of Trustees of the National Gallery*, p. 27. This was more or less the line taken in the inquiry by Robert Witt, its secretary:

> If you erected buildings on the Tate Gallery site and temporarily filled them with foreign pictures, subsequently at a later period, when you wanted to, I agree, you could move the whole of the modern foreign pictures to a separate place, when it has become important enough. But you cannot justify it at present because you have not enough pictures to put in it. (*Minutes of Evidence*, p. 41)

31 For the letter of bequest see T. Bodkin, *Hugh Lane and his Pictures*, Dublin, 1956, p. 31; for the Oct. 1913 letter, see p. 37.

32 The codicil is reproduced in Bodkin, *Hugh Lane and his Pictures*, p. 43.

33 For further accounts of the case, see Bodkin, *Hugh Lane and his Pictures*; the pamphlet *Sir Hugh Lane's French Pictures* (A. Gregory and others), London, 1917; the correspondence columns of *The Times*, *Morning Post*, *Observer* and other London papers, Dec. 1916 and Jan. 1917; D. S. MacColl, 'The National Gallery Bill, and Sir Hugh Lane's Bequest', *The Nineteenth Century and After*, Feb. 1917; the anti-Irish articles in the *Burlington Magazine*, Sept. 1926 (p 148) and Jan. 1927; D. S. MacColl, 'The National Gallery Bill' and J. Reynolds (ed.), *Statement of the Claim for the Return to Dublin of the 39 Lane Bequest Pictures Now at the Tate Gallery, London*, Dublin, 1932, which lists other newspaper articles on both sides of the argument.

34 S. N. Behrmann, *Duveen*, London, 1952, chapter 2.

35 Two accounts of Joe Duveen as a 'personality' and dealer – two roles that were insep-
 arably united in him – are Behrmann, *Duveen*, and E. Fowles, *Memories of Duveen
 Brothers* (intr. E. Waterhouse), London, 1976, to which may be added L. Wright,
 'Joseph Duveen, Benefactor of the Arts', *Antique Collector*, Nov. 1989, pp. 120–6. An
 account of the early history of the Duveen dynasty is J(ames) H(enry) Duveen, *The
 Rise of the House of Duveen*, London, 1957, which is supplemented by the latter
 author's reminiscencies of his own business, *Collections and Recollections of an Art
 Dealer: A Century and a Half of Art Deals*, London, 1934. Duveen's profitable rela-
 tionship with Bernard Berenson is described in C. Simpson, *The Partnership: The
 Secret Association of Bernard Berenson and Joseph Duveen*, London, 1987. Kenneth
 Clark's later description of Duveen rings true: a man of

 > charm and generosity ... controlled solely by instinct and appetite ... His bravura and
 > impudence were infectious, and when he was present everyone behaved as if they had
 > had a couple of drinks. He worked entirely by instinct and was incapable of writing a
 > letter or making a coherent statement; and he had rightly seen that, whereas in America
 > it paid him to be very grand, in England he could get further by bribing the upper classes
 > and playing the fool. (K. Clark, *Another Part of the Wood: A Self-portrait*, London, 1974
 > (1985), pp. 265, 227)

36 Letters from J. Duveen to Lord D'Abernon, 8 Aug. 1916, and from Duveen to the
 National Gallery Board, 3 Nov. 1916; both Tate Gallery Archive, London. It is hard
 to tell why Duveen should have wanted the Germans out of Flanders and Normandy
 before the new gallery was associated with his name. Was he waiting for trading con-
 ditions to return to normal before resuming his patronage in London? Did he regard
 French culture as spoiled by the German presence? Or was he setting the terms for an
 eventual triumphal celebration of Allied Culture?

37 *The Modern Foreign Gallery* (First Schedule), undated MS, Tate Gallery Archive. The
 German artists are Max Klinger, Wilhelm Leibl, Franz von Lenbach, Max
 Liebermann, Adolf Menzel, Moritz Schwind, Skarbina, Hans Thoma, Fritz von
 Uhde, Anton von Werner.

38 Press statement by the Tate Gallery, not dated but presumably 1918; Tate Gallery
 Archive, London.

39 These are *Tahiziens*, 1891, and *Faa Iheihe*, 1898.

40 S. Courtauld, 'Art Education' (1943), in *Ideals and Industry*, Cambridge, 1949, p. 53.

41 Courtauld, 'Art Education', p. 45.

42 Quoted by A. Blunt, 'Samuel Courtauld as a Collector and Benefactor', in Douglas
 Cooper, *The Courtauld Collection: A Catalogue and Introduction*, with a memoir of
 Samuel Courtauld by Anthony Blunt, London, 1954, p. 3.

43 Letter to Charles Aitken, 25 June 1923, Tate Gallery Archive; the original list of names
 from the Trust Deed is published in M. Korn, 'The Courtauld Gift – Missing Papers
 Traced', *Burlington Magazine*, 138: 1,117, April 1996, p. 256. Further French paint-
 ings from the collection of the German dealer Paul Cassirer were also offered to the
 Tate in 1923, but turned down. See S. Malvern, 'Narrating Modernism, Imaging
 Nations: Museums of Modern Art at the end of the Millennium', *Collapse*, 3,
 Vancouver, 1997, pp. 119–31.

44 Relations between Courtauld and the Bloomsbury group are very usefully discussed
 by A. Stephenson, 'An Anatomy of Taste: Samuel Courtauld and Debates about Art

Patronage and Modernism in Britain in the Inter-War Years', in J. House (ed.), *Impressionism for England: Samuel Courtauld as Patron and Collector*, London, 1994, pp. 35–46.

45 Courtauld, 'Art Education', p. 54. Courtauld was also opposed to international modernist architecture with its 'stark simplicity … its rigid lines and hard angles, and the occasional rudimentary curve'. To him, this was mere 'packing-case architecture' that rigorously obstructed the 'growth and variety' that the human spirit required. A proclivity in Courtauld for classical art must also be recognised: on return from a trip to Greece in September 1927 he wrote to Manson at the Tate of his 'very vivid impression of Greek art and mentality, all the more strange because what remains is very fragmentary. I certainly recognise clearly – which I never did before – that the Greeks are my real spiritual ancestors. All that came since is more foreign to me': letter from Courtauld to James Manson, 19 Sept. 1927; Tate Gallery Archive, London.

46 The major period of Courtauld's buying as a collector reached a peak in 1926-7 with the stock-market valuation of his company, only to fall off in the slump years; a tendency deepened by the death of his wife in 1931, the donation of his painting collection to the Courtauld Institute of Art in Portman Square in 1932, and the onset of a more introspective phase of his life. See J. Murdoch, 'The Courtauld Family and its Money' in House (ed.), *Impressionism for England*, pp. 47–56.

47 W. S. Meadmore, *The Crowing of the Cock: A Biography of James Bolivar Manson*, unpublished MS, undated, Tate Gallery Archive, p. 101.

48 Clark, *Another Part of the Wood*, p. 78.

49 C. Aitken, 'Preface', in J. B. Manson, *Hours in the Tate Gallery*, London, 1926. Aitken expressed the conventional view that the Millbank collection completed 'a thorough representation of British art from Hogarth to the present day'. He also believed that 'pictures with a story usually appeal to the British public, and, though aesthetic qualities must not be sacrificed to story-telling, there is no reason why, if the subject appeals to a literary artist, a literary subject should not be a work of art', (pp 7, 8).

50 Manson (b. 1879) wrote *Rembrandt* (London, 1923), *The Life and Work of Edgar Degas* (London, 1927) and translated T. Klingsor's book *Cézanne*. He also wrote criticism. See Dictionary of National Biography and Manson's obituary, *The Times*, 4 July 1945. For Manson's later career, see chapter 5 below.

51 Manson, *Hours in the Tate Gallery*, p. 48.

52 Manson, *Hours in the Tate Gallery*, pp. 83, 97, 100–1.

53 Manson, *Hours in the Tate Gallery*, pp. 109, 110.

54 For these further citations see J. B. Manson, *The Tate Gallery* London, 1929, pp. 8, 150, 13, 6.

55 See *National Gallery Millbank. List of Loans at the Opening Exhibition of the Modern Foreign Gallery, June to Oct. 1926*, London, 1926. The opening was postponed from 8 to 26 June apparently because the King felt it was inadvisable to open the galleries while the Lane pictures were still under dispute – though this cannot have been the true reason. A House of Lords Committee of Inquiry had been announced on 14 July 1924 under the chairmanship of J. W. Wilson 'to consider the arguments advanced by the Irish Free State and the Trustees of the National Gallery in London' on Lane's codicil (see Bodkin, *Hugh Lane and his Pictures*, p. 52). The Wilson inquiry report was signed on 28 Jan. 1925, but not immediately published: an evasive answer was given

by Mr Amery on 26 April 1926 as to the delay in publication. When published later in 1926, the Wilson committee *Report* concluded that Lane's codicil was intended – but they were not unanimous, and tried to justify their evasiveness with the argument that had Lane lived to see Duveen's new gallery, he would surely have preferred the Millbank gallery (the Irish duly responded by saying that the Commission had not been invited to speculate upon the hypothetical). The further argument that Duveen had donated the extension only on the assurance that Lane's pictures would be in it also failed to impress the Irish – the building had after all been begun in June 1923, before the Wilson Committee was appointed: a press release merely referred to Duveen's gift as a 'thanksgiving for peace'. The British government decided a mere ten days after the Tate opening that it would be 'improper to alter Lane's will by legislation', and provided for a Bill to offer the Lane pictures to Ireland on loan after ten years (Bodkin, *Hugh Lane and his Pictures*, p. 53). For the opening itself the official addresses were quickly redrafted to remove reference to the Lane pictures and to highlight the munificence of Duveen and Courtauld only. The Irish remained – and remain – disgruntled.

56 *National Gallery of Modern Art, Millbank: Description of the New Wing added by Sir Joseph Duveen which is shortly to be opened*, Tate Gallery press release 1926 (Tate Gallery Archive, London).

57 *National Gallery Millbank: Programme of Ceremonies to be observed at the Opening, 26 June 1926*, Tate Gallery Archive, London.

58 'The King and Queen watched with interest Sir John Lavery at work on a picture which is to be a record in paint of their Majesties opening the new galleries. Sir John the day before had painted in the background, and during the ceremony he had roughed in the figures of the King and Queen with notes of the colours so as to get the right tones for the subsequent finished canvas': *The Times*, 28 June 1926, p. 11.

59 Lord D'Abernon, speech at the opening of the Modern Foreign Galleries, 1926, Tate Gallery Archive, London.

60 Speech of H. M. The King at the opening of the Modern Foreign Galleries, 1926, Tate Gallery Archive, London. For a report of the event, see *The Times*, 28 June 1926, p. 11.

61 *Oxford English Dictionary*.

62 Tate Gallery extension opened by the King', *The Times*, 28 June 1926, p. 11.

63 *National Gallery, Millbank: A Record of Ten Years, 1917–27*, Glasgow, 1927, p. 17.

64 *National Gallery, Millbank: A Record of Ten Years*, p. 18, and *National Gallery Millbank: Illustrated Guide, British School*, Glasgow, 1926–7, p. v.

65 The evolutionary language deployed in this description echoes the Tate Gallery's own: for example

> The pictures are hung, for the most part, in chronological sequence, beginning with the eighteenth century paintings in Gallery I, and the visitor may follow the course of British art from Hogarth to the present day by passing through Galleries I, II, III, IV, V, XV, XIX, XX, XXI, XXII, XXIII, XXIV, and XXV in sequence, these galleries being arranged in a continuous outer line round the Central Sculpture Hall … The Turner Wing, Galleries VI to X, opens out of Gallery V; and beyond the Turner wing, opening out of Gallery VII, are the Modern Foreign Galleries XI – XIII and the Sargent Gallery XIV. (*National Gallery Millbank: Illustrated Guide, British School*, p. v).

66 'Tate Gallery: The New Building', *The Times*, 26 June 1926, p. 10.

67 See J.–B. Duroselle, 'Entente and Mésentente', in J. Johnson, F. Crouzet and F. Bedarida (eds), *Britain and France: Ten Centuries*, Kent, 1980, pp. 274–80.

68 Viscount D'Abernon, *Portraits and Appreciations*, London, 1931, pp. 25–32.

69 D'Abernon, *Portraits and Appreciations*, p. 95.

70 See for example, Earl of Ronaldsway, *The Life of Lord Curzon: being the Authorized Biography of George Nathaniel Marquess Curzon of Kedleston*, London, 1928, pp. 163–6; or J. Biggs-Davidson, *George Wyndham: A Study in Toryism*, London, 1951, p. 46. Wyndham is described in The *Dictionary of National Biography* as

> an English Tory in the best sense; his love of England, which was intense, was bound up with a belief in the monarchy, the church, and the landed gentry, as the best institutions in England. He was an imperialist, and he was not a believer in democracy. But his ideal for the nation, as for the class which he thought called to the function of government, was so high that he grieved less at the gentry's loss of power than at any manifestation of their abandoning their traditions.

71 Lord D'Abernon, *An Ambassador of Peace*, London, 1929, vol. I, pp. 6–14, vol. II, pp. 11–20. On the other hand the Russians were 'fanatical communists, animated by hatred of all political organisations that stood in the way of a world-victory of the Soviet creed' (p 20), against whom a brave Anglo-French mission had been launched.

72 *Morning Post*, 16 Aug. 1923.

73 *Morning Post*, 14 June 1923, p. 8.

74 E. Wake Cook, *Retrogression in Art, and the Suicide of the Royal Academy*, London, 1924, p. 37. The Royal Academy election of Augustus John in 1921 was for Cook the final straw. 'The Bolshevistic dictum that a picture is finished when the painter becomes bored by it, is the last word in artistic demoralisation', Cook wails. Following the signs of decay in Whistler, the 'ruck that followed' brought art in London 'down to the deepest depths of degradation ever seen in its eventful history ... the enthroning of incompetence, now endorsed by the Academy, is a devastating blight which prevents London being the centre of the art world, which M. Rodin declared it to be'. For more in the same vein, see H. Hugh Higginbottom, *Frightfulness in Modern Art*, London, 1928, or his earlier satirical *King of Kulturia*, London and Felling-on-Tyne, 1915.

75 F. Dicksee, *Discourse, delivered to the Students of the Royal Academy on the Distribution of the Prizes, 10 Dec. 1925*, London, 1925, pp. 16, 14, 13.

76 Dicksee, *Discourse, delivered to the Students of the Royal Academy on the Distribution of the Prizes, 10 Dec. 1927*, London, 1927, pp. 14–15.

77 F. Dicksee, toast to 'Guests', Royal Academy Dinner, 30 April 1927 (Royal Academy Archives).

78 G. Santayana, *Soliloquies in England, and Later Soliloquies*, London, 1922, p. 30; S. Baldwin, *On England and other Addresses*, 1926; J. B. Priestley, *Good Companions*, London, 1929, and *English Journey*, London, 1934. Towards the end of the 1920s another genre sprang up, that of reflection on the English countryside and the threat to it from 'crass' commercialism and the spread of the towns. An early instance of this genre is J. V. Morton, *In Search of England*, London 1927, followed by C. B. Ford, *The Landscape of England*, London, 1932, and Thomas Burke, *The Beauty of England*, London 1933. They are discussed by A. Potts, '"Constable Country" between the Wars', in Raphael Samuel (ed.), *Patriotism. The Making and Unmaking of a British National Identity*, vol. III: *National Fictions*, London, 1989, pp. 160–86.

79 S. Baldwin, 'England', in *On England, and other Addresses*, London, 1926, pp. 9, 7.

80 S.Baldwin, 'Among Sculptors', speech delivered at the Dinner of the Royal Society of British Sculptors, 25 Feb. 1926, in *Our Inheritance: Speeches and Addresses by the Rt. Hon. Stanley Baldwin, MP*, London, 1928, p. 244.

81 S.Baldwin, 'England', p. 2.

82 A. St John Adcock's 'Editor's Introduction', in A. St John Adcock (ed.), *Wonderful London: The World's Greatest City described by its Best Writers and Pictured by its Finest Photographers*, London, 1926–27, vol. I, p. 1, and picture caption.

83 Adcock (ed.), *Wonderful London*, pp. 4, 9.

84 Adcock (ed.), *Wonderful London*, p. 9. H. V. Morton's essays 'The Heart of London', 'The Spell of London' and 'The Nights of London', published in June 1925, Feb. 1926 and Nov. 1926 respectively, should also be consulted. They were reissued in one volume as *H. V. Morton's London*, London, 1940.

85 See *National Gallery Millbank: A Record of Ten Years, 1917–1927*, p. 17. The Tate had been slow to reopen, the Gallery having been used during the war as an office of the Ministry of Pensions; the pictures were only gradually redisplayed, a minority of rooms opening in 1920 and the majority not admitting visitors until the following spring.

86 Charles Aitken, letter to Lord D'Abernon, 12 March 1918; Tate Gallery Archive, London.

87 *National Gallery of Modern Art, Millbank: Description of the New Wing.*

88 *National Gallery, Millbank: Catalogue, Modern Foreign School*, 1st edn, London, 1926, pp. 51, 50.

89 E. Fagg, *Modern Foreign Masters: An Introduction and Complete Handbook to the Modern Foreign Work in the National Collection*, London, 1930, pp. 55–6.

90 *National Gallery, Millbank: Catalogue*, p. 66.

91 Fagg, *Modern Foreign Masters*, p. 80. In E. Wake Cook's angry remonstration Van Gogh comes out as a lunatic or worse:

> The Directorate [of the National Gallery] has just acquired for the nation two bad works by Van Gogh ... His works are the *delirium tremens* of art; the poor fellow tried frantically to express himself in pigment, but he never got much above the pavement level ... Many innocents abroad have been fooled by them, but the trick is being found out, and people are eager to get rid of the rubbish foisted on them, and are dumping them on our defenceless market ... Van Gogh seems to infect his admirers with some of his own malady. That *The Yellow Chair* should have been bought for the nation is the greatest insult to our intelligence yet offered. It is simply an old rush-bottomed chair, badly drawn, badly painted, standing on a floor which looks like a sloping roof ... The memory of this amazing transaction will hang about the Directorate as the dead albatross hung about the neck of the Ancient Mariner. (E.Wake Cook, *Retrogression in Art*, p. 50).

92 Fagg, *Modern Foreign Masters*, p. 82.

93 The oral answer was given in the Commons on 9 Feb. 1928 by the Financial Secretary to the Treasury, the MP for Putney Mr Samuel Samuel, in reply to a question from Leslie Hore-Belisha (See *Hansard*, 1928, vol. 213, col. 246).

94 *National Gallery, Millbank: Review of the Acquisitions during the years July 1927–December 1929*, Glasgow, 1930, p. 23.

95 Manson, *Hours in the Tate Gallery*, p. 50.

96 For some detail of the role of the BBC and the contrary motion of the We Won't Go To Wembley Society, see J. MacKenzie, 'In Touch with the Infinite: The BBC and the Empire, 1923-53', in J. MacKenzie (ed.), *Imperialism and Popular Culture*, Manchester, 1986, pp. 165–91. For the main art event of the Wembley Exhibition, see *Illustrated Souvenir of the Palace of the Arts*, British Empire Exhibition 1924, and the corresponding *Souvenir* for 1925, London 1924 and 1925.

Notes to Chapter 6

1 J. Rothenstein, 'The War and After', in Rothenstein, *The Tate Gallery*, London, 1962, pp. 42, 43.

2 M. Sorrell, *Queen*, 3 Feb. 1947.

3 'Enormous and enthusiastic', according to the *Hastings Evening Argus*, 9 April 1948, on the occasion of the '100 Contemporary British Paintings' exhibition, at that moment in Brighton.

4 C. Gordon, 'London Commentary', *Studio*, vol. 131, Feb. 1946, p. 94.

5 The reader should consult 'Is Modern Art a Sham?', editorial, *Studio*, 112: 523, Dec. 1936, p. 295, which itself glosses A. Layman, 'Modern Art is a Sham', ibid., pp. 315–6; followed by 'Is Modern Art a Sham? The Editor sums up', *Studio*, 115: 527, Feb. 1937, and 'Is Modern Art a Sham: Correspondence', ibid., pp. 74, 203, 280, which sought to express both sides of the argument but also distinguished between 'false' and 'true' modernity, in the end proposing to 'separate truth from sham, to set up civilized ideals … to put forward construtive criticisms and suggestions' (Feb 1937, p. 55).

6 Gordon, 'London Commentary', p. 94.

7 J. B. Manson, untitled lecture MS, dated 1936, pp. 2, 7, 13. Tate Gallery Archive, London.

8 For the Ashington Group, see W. Feaver, *Pitmen Painters: The Ashington Group, 1934–84*, London, 1988. For additional detail see *Bensham Grove Educational Settlement, Gateshead-on-Tyne, Annual Report and Statement of Accounts*, 1938-39, pp. 5–7; D. R. O. Thomas, 'Unprofessional Painting', *British Journal of Adult Education*, June 1939, pp. 269–73; and the record of the Mass-Observation Archive, University of Sussex.

9 H. Read, *Art Now: An Introduction to Painting and Sculpture*, London, 1933, pp. 124, 115, 137. Picasso had had a small following in England since the time of his Leicester Galleries exhibition of 1921, and had received endorsements by critics of the order of Frank Rutter, Charles Marriott and Anthony Bertram. See F. Rutter, *Evolution in Modern Art*, London, 1926 and *Since I was Twenty-two*, London, 1927; C. Marriott, *Modern Art: A Collection of Writings on Modern Art*, 2 vols, London, 1918, and *Modern Movements in Painting*, London, 1920; A. Bertram, *Paul Gauguin*, London, 1930, *Matisse*, London, 1934.

10 J. Rothenstein, *Summer's Lease: Autobiography 1901–1938*, London, 1965, p. 196.

11 The BBC had broadcast discussions on art since at least 1939, for example the 12 talks in the 'Artist in the Witness Box' series of that year, edited by Eric Newton, and the BBC booklet *The Artist in the Witness Box*, London, 1939. A detailed study of the WAAC is B. Foss, 'Message and Medium: Government Patronage, National Identity and National Culture in Britain, 1939–45', *Oxford Art Journal*, 14:2, 1991, pp. 52–72.

12 See A.Sinclair, *Arts and Cultures: The History of the 50 Years of the Arts Council of Great Britain*, London, 1995, pp. 28–9.

13 See F. M. Leventhal, '"The Best for The Most": CEMA and State Sponsorship of the Arts in Wartime, 1939-45', *Twentieth Century British History*, vol. 1: 3, 1990, pp. 289-317. For Keynes, see Keynes's letter dated 22 Jan. 1942, Keynes Papers, King's College Cambridge, Sinclair, *Arts and Cultures*, p. 36.

14 W. Emrys Williams, 'The Pre-history of the Arts Council', in E. M. Hutchinson (ed.), *Aims and Action in Adult Education, 1921–71*, London, 1971, p. 22.

15 Kathleen Box, 'The Jones Exhibition', organised by Graham Bell and Tom Harrisson, Storran Gallery, 12 Nov. 1938, Art Box 1/g. Typed MS. Mass-Observation Archive, University of Sussex.

16 Kathleen Box, Tate Gallery, 1 Dec. 1938, Box 1/G. Mass-Observation Archive, University of Susssex.

17 'JA', National Gallery Report, 12 Sept. 1941, TC: Art 3/A, handwritten MS., Mass-Observation Archive, University of Susssex.

18 'JA', Report on Leicester and Leger Galleries, 12 Sept. 1941, TC: Art 3/A, hand-written MS., Mass-Observation Archive, University of Sussex.

19 Clark's words were reported in 'Art Shows for the Citizen', *Liverpool Daily Post*, 15 May 1945.

20 Both Bevin and Emmanuel are reported in The *Daily Telegraph*, 11 April 1946. I have not been able to locate the text of Bevin's address – according to Bevin's biographer Sir Alan Bullock, it may have been impromptu (correspondence to the author, 19 July 1993).

21 *The Visual Arts* (The Arts Inquiry), PEP Publications Oxford, 1946, p. 113.

22 *The Visual Arts*, p. 121.

23 *The Visual Arts*, p. 148.

24 *The Visual Arts*, p. 149.

25 H.Read, *Education through Art*, London,1943, p. 141.

26 *The Visual Arts*, p. 152.

27 Lord Keynes, 'The Arts Council: Its Policy and Hopes', *The Listener*, 12 July 1945, pp. 31, 32, 31–2, 32.

28 *The Charter of Incorporation Granted by His Majesty the King to the Arts Council of Great Britain*, 9 Aug. 1946, p. 3.

29 R. Williams, 'The Arts Council', *Political Quaterly*, Spring 1979, p. 166.

30 A. A. Longden, *British Art Exhibitions at Home and Abroad. A Report for the British Council for Relations with Other Countries*, 1935, PRO, BW 78/1, 1935-45, pp. 2-3. More general background on the Council is to found in P. Taylor, *The Projection of Britain: British Overseas Publicity and Propaganda, 1919-36*, Cambridge, 1981, chapter 4; and Frances Donaldson, *The British Council: The First Fifty Years*, London, 1984. It is revealing that Longden (who became the first Director of Fine Art at the Council) emphasised that Britain was merely doing what other 'more self-assertive' nations were already doing, particularly the French, whose propaganda 'is so skilful that there is hardly a country that is not persuaded to believe that France leads the world in every known art', and in which the Germans had cultivated a myth of scientific progress. 'It is one of the finest duties of any country enjoying a leading place in the world to express her national ideals and character through art and through other media, on all occasions when other nations are energetically expressing theirs',

Longden had written. British art, and in particular modern art, had qualities of 'delicacy, honesty and reserve that are bound, if made known, to win us friends abroad as our literature has already done'. Longden, *Report*, 1935, p. 4.

31 Ms Ward, 'Report on the Picasso–Matisse Exhibition in Manchester', 25 Feb. 1946, PRO, BW 31/21.

32 British Council, 'Some Facts about the Picasso–Matisse Exhibition', *Monthly Overseas Bulletin Supplement*, 31 Dec. 1945, p. 2.

33 A. A. Longden, letter to T. J. Honeyman, Glasgow City Museum and Art Gallery, 4 March 1946, PRO, BW. 31/21.

34 Gordon, 'London Commentary', p. 93. For an earlier but comparable claim, see M. Ayrton, 'The Black Magic of Picasso', *The Listener*, 5 April 1945, pp. 382–3.

35 *The Times*, 6 Dec. 1945, p. 6. See also P. James, 'Picasso and Matisse', *The Listener*, 13 Dec. 1945, pp. 697–8; R. Marvell, *New Statesman and Nation*, 15 Dec. 1945; E. Newton, *Picture Post*, 22 Dec. 1945, pp. 26–7, 29. For Hendy's statement, see *Daily Telegraph*, 1 Jan. 1946.

36 M. Sorrell, *Queen*, 3 Feb. 1947. Next after the Victoria and Albert show came Constable; here Sorrell spoke of 'the eloquent silence of the spectators when drinking in [sic] the glories of Constable's tumultuous heavens'. The Klee show at Trafalgar Square followed; 'delirious doodles, elfin winds and flowers dancing (what did it matter?)'.

37 'Picasso and Matisse', *Tatler*, 12 Dec. 1945. *Tatler*'s correspondent made no attempt to disguise her desire to own selected examples of French modernist art; she refers to 'the lovely *nature morte* [by Picasso] which I began to buy on the instalment plan' [from Rosenberg's gallery in Paris before the war] and comments that Matisse provided a 'graceful surprise … I would give a very great deal to own his *Deux Femmes aux Canapés*'.

38 *Illustrated London News*, 19 Jan. 1946, p. 76.

39 *The Sketch*, 9 Jan. 1946, p. 18.

40 See the selection of letters 'Must We Tolerate Ugliness in Art?', *Daily Telegraph*, 22 Dec. 1945.

41 'Picasso art "Monstrous"', *Daily Telegraph*, 28 Dec. 1945.

42 J. Howard Whitehouse, 'Picasso Works criticised by Headmaster', *Daily Telegraph*, 1 Jan. 1946.

43 Joint letter to *The Times*, 17 Dec. 1945, p. 5.

44 *The Times*, 15 Dec. 1945, p. 5.

45 *The Times*, 15 Dec. 1945, p. 5.

46 *The Times*, 18 Dec. 1945, p. 5.

47 *The Times*, 19 Dec. 1945.

48 See *The Times*, 21 Dec., 22 Dec. 1945, 8 Jan. 1946. It is perhaps predictable that members of the mandarin class should have joined battle with the traditionalists towards the end of the exhibition. MacColl, now cast as a conservative, was roundly condemned by Herbert Read (see *The Times*, 4 Jan. 1946, p. 5). Both Picasso and Klee were eloquently defended by the young Douglas Cooper (*The Times*, 9 Jan. 1946); the occasional student or enthusiast wrote to point out that Picasso was searching for 'new values', or was expressing his horror at the darkness of war, or commenting on the state of the cosmos. There was a rough geographical division: dissenters who wrote from Salisbury or somewhere in Gloucestershire were often countered by metropolitan voices.

49 Sir E. Benn, *Daily Telegraph*, 10 May 1947.

50 See E. Benn, *Confessions of a Capitalist*, London, 1925; *Letters of an Individualist to 'The Times', 1921-1926*, London, 1927; and *Manifesto on British Liberty*, Aug. 1942, reproduced in D. Abel, *Ernest Benn: Counsel for Liberty*, London, 1960, pp. 110-12, from which the quoted phrases are taken.

51 *Daily Telegraph*, 1 Jan. 1946.

52 H. T. Massingham, *The Times*, 22 Dec. 1945, p. 5.

53 F. Topolski, *The Times*, 29 Dec. 1945, p. 5.

54 *The Times*, 18 Dec.; *The Times*, 19 Dec.; *Daily Telegraph*, 28 December; *Sevenoaks News*, 3 Jan. 1946.

55 This in the *Sevenoaks News*, 3 Jan. 1946 again, in which reference is made to majority opinion which is that of the 'virile general public'.

56 C. Asquith, *The Times*, 8 Jan. 1946, p. 5.

57 See the *Evening News* advertisement in *Newspaper Press Directory and Advertisers' Guide*, London, 1948, p. 321.

58 *Newspaper Press Directory and Advertisers' Guide*, 1948, p. 80

59 Advertisement in *Newspaper Press Directory and Advertisers' Guide*, London, 1946–47, p. 324.

60 Advertisement in *Newspaper Press Directory and Advertisers' Guide*, London, 1940, p. 325.

61 Feaver, *Pitmen Painters*, pp. 133, 134.

62 See 'Museum of Modern Art Scheme' in Minutes of first meeting held on 30 Jan. 1946; ICA Archives, London.

63 H. Read, letter to *The Times*, 26 June 1947, p. 5. The letter was sent simultaneously to several other newspapers and journals.

64 *The Institute of Conptemporary Arts: A Statement of Policy and Aims of the Proposed Institute by Members of the Organising Committee*, 1947, p. 3, ICA Archives, London.

65 *Arts Council Paper 298*, 15 Feb. 1951. As Philip James of the Arts Council was to write later, 'They [the ICA] ... arrange their own exhibtions, many of which relieve the Arts Council of a certain responsibility; especially in the field of avant-garde art'; cited in A. Massey, *The Independent Group: Modernism and Mass Culture in Britain*, Manchester, 1995, p. 25 and n.6, p. 32.

66 H. Read, 'Introduction' on the occasion of '40 Years of Modern Art', ICA, 9 Feb. 1948, n.p., ICA Archives, London.

67 See 'What's Up in Oxford Street?', *Architectural Design*, March 1948, p. 47.

68 P. Strauss, letter to Mr Powe of the LCC, 15 May 1946.

69 Reported in a Note to the Chair of the Parks Committee, 26 July 1946.

70 Assistant Clerk to the LCC, letter to Philip James, 3 April 1947.

71 More pervasive tension between the two councils is emphasised in M. Garlake, '"A War of Taste": The London County Council as Art Patron, 1948-65', *The London Journal*, 18: 1, 1993, pp. 49–51.

72 The Travel Association refused to use the figure on their poster for overseas use; note from Mr Hartman of the Travel Association, 8 Dec. 1947.

73 Parks Committee, LCC, Minutes, 5 Dec. 1947, item 45.

74 Letter to Eric Newton, (Assistant Clerk to the LCC), 14 Jan. 1948.

75 Minutes of the Working Party, 28 Jan. 1948, and letter from Mr W. E. Jackson Assistant Clerk to the LCC, to Eric Newton, 28 Jan. 1948.

76 Letter from Eric Newton to the LCC, 29 Jan. 1948.

77 E. Newton, 'Sculpture', *Open Air Exhibition of Sculpture*, LCC, 1948, pp. 6,9.

78 M. Wright, *Lecturer's Report for Mr Philip James*, 17–28 May 1948.

79 B. Naish, *Lecturer's Report*, 28 Aug.–16 Sept. 1948.

80 G. Mayer-Marton, *Lecturer's Report*, 16 June–5 July 1948.

81 G. Mayer-Marton, *Lecturer's Report*, 28 Aug. 1948. Evidently the idea caught on, in so far as Moore's group was proposed for renaming as 'Enemy Overhead' in mid-1949 during LCC discussions of the resiting of the work. See the 'note for R. R. Tomlinson' (signed O.W.H), 25 May 1949.

82 H. Read, 'Introduction', '40 Years of Modern Art', ICA, 9 Feb. 1948, ICA Archives, London.

83 *Report of the Committee on the Functions of the National Gallery and Tate Gallery and, in respect of Paintings, of the Victoria and Albert Museum, together with a Memorandum thereon by the Standing Commission on Museums and Galleries*, HMSO, London, May 1946 (Cmd 6827), p. 8.

84 The Committee could hardly have produced a different result. Massey himself had been a Tate Trustee from 1942 to 1946, and for the last three of those years Chairman of the National Gallery Trustees under whom the Tate was still nominally administered. Alongside Jasper Ridley, Massey was John Rothenstein's most trusted colleague; both Rothenstein and Ridley were also members of the Massey Committee, with (by now Sir) Kenneth Clark, Leigh Ashton (Director of the V & A), and Sir Eric Maclagan (recently retired from the V & A).

85 Letter from A. J. Munnings to Sir Desmond MacCarthy, 13 Sept. 1946; cited in R. Pound, *The Englishman: A Biography of Sir Alfred Munnings*, London, 1962, p. 166.

86 J. Rothenstein, *Brave Day, Hideous Night: Autobiography 1939–1965*, London, 1966, pp. 174–5. Most of Munnings' work was nevertheless anathema to Rothenstein. Munnings' picture *Their Majesties' Return from Ascot* of 1926 had been acquired by Manson for the Chantrey Bequest in 1928 – the price was £850 – but Rothenstein refused to hang it when he arrived at the Tate the following year (Pound, *The Englishman*, p. 102).

87 J. Rothenstein, *Brave Day, Hideous Night*, p. 208. On another occasion at the Garrick Club, he loudly accused Rothenstein of being 'a bloody Jew' and alleged that that was the reason he staged the Chagall exhibition. Munnings was rebuked by the club (see J. Goodman, *What A Go! The Life of Alfred Munnings*, London, 1988, p. 239).

88 Rothenstein says that Ridley made the suggestion 'in order that the whole issue [of the Bequest] be brought into the open', *Brave Day, Hideous Night*, p. 208.

89 G. Grigson, 'The Scandal of the Chantrey Bequest', *Picture Post*, 22 Jan. 1949, pp. 23–6.

90 Grigson, 'Scandal', p. 25. A small number of exceptions only strengthened Grigson's point: of the Chantrey's 305 pictures, Grigson found nine of them had been bought 'either rightly or pardonably', three being reproduced approvingly in *Picture Post* (Charles Keene's *Self-Portrait*, Walter Greaves' *Hammersmith Bridge on Boat-Race Day*, Sargent's *Carnation, Lily, Lily, Rose*). Yet other illustrations gave a hint of Grigson's objections to the genre.

91 Munnings tells us that Churchill encouraged him to resume the tradition of the dinners. 'All right', said Munnings, 'If you'll come and made a speech, we'll have

the dinner.' 'Of course', replied Churchill according to this account, 'Let's have a rag' (words he subseqently denied), See Munnings, *The Finish*, London 1952, p. 141.

92 F. C. Stoop died on 10 July 1933 and offered a bequest of modern paintings to the Tate. Manson is said to have baulked at the bequest on the grounds that it contained two Picassos and two Matisses, at least according to Clark, *Another Part of the Wood*, p. 233. One Picasso was *Femme à la Chemise*, 1905, which had been exhibited at the Leicester Galleries exhibition in 1921; the other was *Seated Woman* of 1923, already on loan to the Tate since 1931. The Matisses were *(Trivaux Pond) La Forêt* of 1916, and *Nude Study in Blue*, c. 1899–1900. The Tate Trustees must have won Manson over, for the Stoop Bequest is reported as being accepted by a meeting of the Tate Gallery Board, 11 Dec. 1933.

93 The speech is available from the BBC Sound Archive, *The National Sound Archive*, London. The text is reproduced in Munnings, *The Finish*. Churchill later denied the story about Picasso. According to Rothenstein, Churchill said to him, 'Quite untrue. I was angry. I wrote to Sir Alfred. All quite untrue, and besides, I never walk in the street'. See Rothenstein, *Time's Thievish Progress: Autobiography*, vol. 3, London, 1970, p. 130 (and p. 140 for another disclaimer).

94 The mail apparently continued for a week. A selection is published in Munnings, *The Finish*, pp. 148–72.

95 Reported in R. Fogg, 'An Interview with Sir Alfred Munnings: Art and the Common Man', *East Anglian Times*, May, 1949.

96 Fogg, 'An Interview with Sir Alfred Munnings'.

97 J. Habermas, *The Structural Tranformation of the Public Sphere: An Inquiry into a Category of Bourgeois Society*, 1962, English translation by Thomas Berger, Cambridge, 1992, p. 164.

Notes to Chapter 7

1 Habermas's stern view was that 'Today the conversation itself is administered ... the rational debate of private people becomes one of the production numbers of the stars in radio and television ... The world fashioned by the mass media is a public sphere in appearance only', *The Structural Transformation of the Public Sphere*, pp. 164, 171; compare the qualifications entered in C. Calhoun (ed.), *Habermas and the Public Sphere*, Cambridge, Mass., 1991.

2 For an overview of Duveen's magnanimity see L. Wright, 'Joseph Duveen, Benefactor of the Arts', *Antique Collector*, Nov. 1989, pp. 120–6.

3 *Second and Final Report*, Unhealthy Areas Committee, Ministry of Health 1921 (reprinted 1928).

4 *Thames South Bank Scheme, made on behalf of and sponsored by "The Star"*, LCC Archives London, LCC/AR/TP/5/7, n.d., pp. 8,3.

5 *"The Star" South Side Plan*, leaflet, n.d., LCC Archives.

6 See the summary and statistics in *Administrative County of London Development Plan – 1951: Analysis*, LCC, London, 1952, p. 276.

7 *County of London Plan*, 1943, by J. H. Forshaw and P. Abercrombie; *Greater London Plan*, 1944, by P. Abercrombie, HMSO, London, 1945.

8 *Adminstrative County of London Development Plan – 1951: Statement*, LCC, 1951, p. 27.

9 See A. Forty, 'Festival Politics', in M. Banham and B. Hillier (eds), *A Tonic to the Nation: The Festival of Britain, 1951*, London, 1976, p. 27.

10 Forty, 'Festival Politics', p. 35.

11 R. Banham, 'The Style: "Flimsy … Effeminate"?', in Banham and Hillier (eds), *A Tonic to the Nation*, p. 193.

12 Six artists could for various reasons not exhibit. See Philip James's foreword to *Sixty Paintings for '51*, Arts Council, London, 1951.

13 The Times, 10 Aug. 1949. For confirmation of the prowess of musical life in the capital in the post-war years, see the speech by Felix Aprahamian at the foundation-stone laying ceremony at the Royal Festival Hall, 12 Oct. 1949 and reported in *LCC: Laying the Foundation Stone of the Concert Hall, 12 October 1949*, file LCC/CL/CER/3/8, LCC Archives, London.

14 For instance in the management of the Festival exhibitions themselves; see Massey, *The Independent Group*, pp. 29–30.

15 G. S. Sandilands, 'London County Council as Patron of Art, I', *Studio*, vol. 159, Jan. 1960, p. 8.

16 Summary from *LCC Minutes*, 3 Nov. 1953, p. 471.

17 Summary from *LCC Minutes*, 3 Nov. 1953, p. 472.

18 *Note of a Meeting on 19.7.56 at 4 St James' Square with Members of the "Housing the Arts" Committee of Inquiry*, LCC Archives, London. LCC/CL/GP/2/123, p. 1.

19 A hotel was also felt at this stage to be 'an essential part of the layout of the South Bank' and a site for an opera house was considered. *Note of a Meeting on 19.7.56*, p. 2.

20 *Housing the Arts in Great Britain: Report by the Arts Council of Great Britain*, London, 1959, pp. 50–1.

21 The list is given in *Housing the Arts in Great Britain*, p. 17. Arts Council exhibitions at the Tate for the same year comprised 'Paintings from the Solomon R Guggenheim Museum', 'Wilhelm Lehmbruck', 'Constant Permeke', 'Kandinsky', and 'Paintings from the Musée Nationale d'Art Moderne', Paris, at the RIBA Galleries.

22 *LCC Housing the Arts: South Bank Development. Note of a discussion on 24 January 1958*, p. 3, file LCC/CL/GP/2/123; *Housing the Arts in Great Britain*, p. 52.

23 Minutes of a meeting between LCC and representatives of the Arts Council, 18 May 1960, pp. 1–2.

24 *LCC General Purposes Committee. Report 14 January 1963 of the Special Development and Arts Sub-Committee.*

25 *Minutes of the LCC*, 6 Dec. 1960, p. 738.

26 *Minutes of the LCC*, 18 June 1963, pp. 419–20.

27 *General Purposes Committee, Special Development and Arts Sub-Committee: Completion Date for New Elizabeth Hall and Hayward Exhibition Gallery, on South Bank, Waterloo*, Report, 22 Feb.1965, by the architect.

28 For example *On the Balcony* (1955–57) or the use of the Union Jack as a badge in Blake's *Self-Portrait with Badges* (1961). An anthology of further examples is D. Mellor, *The Sixties Art Scene in London*, London, 1993.

29 The statement by Charles Wheeler, President, at the Royal Academy dinner, 1 May 1957, that 'in National politics, as in International policies, [the art world] is split into

two halves. Speaking broadly, one half is "representational" and the other "abstract"' betrays little awareness of the changes that were about to engulf the Academy. For the whole of this retardataire speech, see Wheeler, 'My Ladies and Gentlemen', *Studio*, vol. 154, 1957, pp. 74–5, 83.

30 But see the letter of 20 Dec. 1960 from the Secretary of the Royal Fine Arts Commission to the LCC, baulking at the use of pre-cast slabs and fairface concrete. They were modified to 'reconstructed granite slabs finished with a smooth texture'. LCC file CL/GP/2/174. LCC Archives, London.

31 *South Bank Arts Centre*, Greater London Council, London, n.d., pp. 46–7.

32 According to the remark by R. Denison, General Manager of the Royal Festival Hall, reported in the meeting of 31 July 1968 on the question of South Bank Sculpture; item 3, GLC/DG/GP/01, 23–4.

33 The latter decision is recorded in *Minutes of the LCC* for 1 Dec. 1964, p. 997; a GLC opening ceremony in honour of Sir Isaac Hayward took place on 20 Dec. 1967.

34 HM the Queen's speech, Hayward Gallery, 8 July 1968, text from the Queen's archives, Buckingham Palace, London.

35 M. Webb, 'The Arts Council's New Gallery', *Country Life*, 11 July 1968, p. 70.

36 See G. Brett, 'Lessons of our New Gallery', *Saturday Review*, 27 July 1968. The quotation is from J. Gainsborough, 'London's New Public Gallery', *Arts Review*, 11 Nov. 1967, p. 410.

37 L. Gowing, 'Introduction', *Matisse*, London, 1968.

38 'Concrete facts about an £800,000 gallery', *The Guardian*, 10 July 1968.

39 P.Lewis, *Daily Mail*, 22 July 1968.

40 Robin Campbell, quoted in 'Matisse at the Hayward', *Newsweek*, 2 Sept. 1968, p. 41.

41 G. Brett, 'Lessons of our New Gallery'.

42 B. Robertson, 'Space, Time and Matisse', *The Spectator*, 19 July 1968.

43 J. Russell, 'Southward Ho!', *Sunday Times*, 14 July 1968.

44 N. Lynton, 'The Freer Alternative', *The Guardian*, 11 July 1968.

45 Robertson, 'Space, Time and Matisse'. Only Denys Sutton, in the *Financial Times*, sounded a negative note in referring to Matisse's 'limitations'. 'His error, for instance, is telling at a distance but when seen close to, a fundamental lack of vitality is apparent. Matisse … has been compared to Titian; but the point about this great 16th century Venetian was that each portion of the canvas exists in its own right as a source of delectation. Matisse remains an enjoyable but superficial artist whose dexterity does not altogether mask a touch of emptiness', *Financial Times*, 16 July 1968.

46 For the link between Matisse and French tradition, see J. Russell, 'Everything Most Pleasant in Life', *Sunday Times Magazine*, 30 June 1968, p. 24.

47 R. Leenders, 'Reflection of a Face in my Eye', *Silâns*, 2, St Martin's School of Art, London, Oct. 1964, n.p.

48 B. Flanagan, in Rowan Gallery catalogue, London, Aug.–Sept. 1968.

49 M. Kustow, *Tank: An Autobiographical Fiction*, London, 1975, p. 74. See also Students and Staff of Hornsey College of Art, *The Hornsey Affair*, Harmondsworth, Middlesex, 1969, p. 171.

50 'Art Transplant', 5–14 July 1968, ICA, London. The Hornsey sit-in itself ended on the night of 8 July 1968. It is commemorated in the film *The Hornsey Film* (Metro Cinema for the Other Cinema), Dir. Patrick Holland, 1970.

51 Kustow notes that Hornsey only agreed to the exhibition 'after initial suspicions that his offer [of the ICA space] was an attempt by the Establishment to take over their revolt', lamenting after the event that 'the art-school uprising was absorbed into the time-honoured British machinery of a commission of inquiry and the production of a report', *Tank*, pp. 74, 75.

52 'KH', 'Against the Art Object', *The Hornsey Affair*, pp. 70, 71.

53 Editorial in the *Wood Green, Southgate and Palmer's Green Weekly Herald*, 27 Sept. 1968; cited in *The Hornsey Affair*, p. 206, and by T. Nairn 'On the Subversiveness of Art Students', *The Listener*, 17 Oct. 1968, p. 491.

54 J. Sparrow, 'Revolting Students', *The Listener*, 4 July 1968, p. 1.

55 Other examples are legion. The eccentric pop idol Tiny Tim would conduct half a million people in a parodic rendition of 'There'll Always Be An England' at the Isle of Wight Pop Festival, 1970.

56 Sparrow, 'Revolting Students', p. 2.

57 M. Fried, *Anthony Caro*, catalogue, Hayward Gallery, London, 1968, p. 12. The argument was substantially that of the same author's 'Art and Objecthood', *Artforum*, June 1967, a text that was known and read in art circles in London.

58 M. Fried, *Anthony Caro*, pp. 14, 15.

59 N. Gosling, 'International Father', *The Observer*, 26 Jan. 1969.

60 R. Melville, 'Turner's Only Rival', *New Statesman*, 7 Feb. 1969.

61 D. Thompson, 'Art', *Queen*, Feb. 1969.

62 E. Mullins, 'Removing the Barriers', *Sunday Telegraph*, 26 Jan. 1969

63 G. Brett, 'Elegance of Caro's Sculpture', *The Times*, 27 Jan. 1969.

64 D. Thompson, 'Art'.

65 N. Lynton, 'Sculpture on the Table', *The Guardian*, 17 Feb. 1967.

66 E. Mullins, 'Removing the Barriers', *Sunday Telegraph*, 26 Jan. 1969.

67 P. Overy, 'Anthony Caro', *Financial Times*, 4 Feb. 1969.

68 S. Burton, 'Notes on the New', in *When Attitudes Become Form*, catalogue, ICA, London, 1968, n.p.

69 C. Harrison, 'Against Precedents', in *When Attitudes Became Form*.

70 H. Szeemann, 'About the Exhibition', in *When Attitudes Become Form*. The Bern show is the subject of chapter 13 of B. Altshuler, *The Avant-Garde in Exhibition: New Art in the 20th Century*, New York, 1994; see also 'Mind Over Matter: Hans Obrist talks with Harald Szeemann', *Artforum*, Nov. 1996.

71 See 'Op Losse Schroeven', Stedelijk Museum, Amsterdam, March 1968; 'When Attitudes Become Form', Kunsthalle, Bern, March 1968; 'Arte Povera', Galleria La Bertesca, Genoa, Sept. 1967; 'Language', Dwan Gallery, New York, 1967; 'Earthworks', Dwan Gallery, New York, 1968. See also L. Lippard, *Six Years: The Dematerialisation of the Art Object from 1966 to 1972*, London, 1973, chapters 1 and 2.

72 The contribution to this and other early shows by the Art–Language community are described in detail by Charles Harrison in his more recent *Essays on Art and Language*, Oxford, 1991.

73 N. Gosling, *The Observer*, 2 May 1971.

74 Robert Morris, letter to Michael Compton, 5 March 1971, Tate Gallery Archive, London. The essay of Morris's which corresponds closest to the conception of the Tate show is 'The Art of Existence. Three Extra-Visual Artists: Work in Progress',

Artforum, 9: 5, Jan. 1971, pp. 28-33; reprinted in Morris, *Continuous Project Altered Daily*, Cambridge, Mass., 1993, pp. 95–118.

75 Robert Morris, letter to Michael Compton, 19 Jan. 1971; Tate Gallery Archive, London, File 121.1.1.

76 Various memoranda and a press release by Norman Reid dated 7 May 1971; Tate Gallery Archive, London. An explanatory note to Michael Compton by a member of the gallery staff dated 5 May 1971 stated:

> As far as I can ascertain 16 members of the public required first aid or hospital treat-ment. The two most serious casualties were a schoolboy who it was suspected had bro-ken a finger but in fact had only sprained it … The other serious casualty was Miss D. Brooke who appeared to have torn a leg muscle and although an ambulance was called appears to have gone straight home. The other 14 casualties received first aid treatment on the premises. These included minor abrasions, cuts and splinters and one case of a damaged toe-nail caused by the stone roller. (Tate Gallery Archive, London).

Several press reports noticed the aggressive masculinity of Morris's hefting of stone and steel, the severity, even the 'mildly authoritarian' character of his constructions; see M. Vaizey, *Financial Times*, 11 May 1971. G. Brett in *The Times* felt that the museum itself was trying to impose an 'absolute authority' on a less than original (28 April 1971).

77 See 'Date With Fate at the Tate', *Studio International*, March 1971, p. 92.

78 Michael Compton wrote to Robert Morris with a candid account of his reactions:

> (1) The noise, particularly of the steel piece, caused people to lose their inhibitions and behave rashly. (2) the 'museum' location evidently did nothing to influence people to be more meditative in their approach to the objects - a fact which might argue against the view … that 'museums' sterilized works of art. (3) I entirely underestimated the effect of social interaction. I think people responded a great deal to each other, rather than to the objects, to their relationship to the latter or their awareness of their own physical processes … they made up group games, competed, acted out their aggression and showed off, etc … (4) In most exhibitions the amount of sensory input is more or less fixed. In this one it is clear that, because it was variable, many people tried to maximise it … I am convinced that … it posed in a particularly succinct and explicit manner some of the important issues of art; the way it is conceived and made; the social role of the museums; the notions of freedom and responsibility in art. (Letter from Compton to Robert Morris, 13 May 1971, Tate Gallery Archive, London)

'I do regard the experience of working with you on the show and of being in it when completed as one of the very few events which have truly altered my consciousness', he continued, 'A great many people who saw the exhibit have said the same'.

79 *The Charter of Incorporation Granted by Her Majesty the Queen to the Arts Council of Great Britain, 7 February 1967*, para 3.

80 Michael Compton had already curated 'Six at the Hayward' late in 1969, comprising works by six artists who, 'owing to their size, cost or impermanence, could be unlikely to be shown in the commercial galleries': they were Stephen Buckley, Barry Flanagan, Keith Milow, Victor Newsome, Michael Sandle, Ian Stephenson ('Six at the Hayward', ACGB press notice, 1969, Hayward Gallery Archives). In practice that statement was not even applicable to Barry Flanagan's *in situ* work known as *Light on Light on White on White* which, though impermanent and though interfered with by members of the

public who thought its appearance could be 'improved', nevertheless was supported by the Rowan Gallery. The work survives in photographic documentation.

81 Anne Seymour, letter to Norbert Lynton, 7 Jan. 1972, p. 3; Hayward Gallery Archives, London.

82 Statements attributed to a letter from Norbert Lynton in Anne Seymour's letter of 7 Jan. 1972.

83 The committee, appointed on 8 Oct. 1971 and disbanded by mutual agreement in Jan. 1972, had comprised Hamilton, William Tucker, Adrian Heath, Joe Tilson, Keith Milow and Victor Burgin.

84 Notes of a meeting of the Art Panel Exhibitions Sub-Committee, 12 Jan. 1972, p. 1, Hayward Gallery Archives, London. Hamilton's voice at the meeting was not unopposed. Older members doubted Seymour's competence (Sir John Pope Hennessy) and her apparent inclination towards 'trends' (Sir Norman Reid). Both David Sylvester and Alan Bowness endorsed Seymour's plans.

85 See J. Hilliard, 'Notes from 1970-71', in *Beyond Painting and Sculpture*, catalogue, Arts Council of Great Britain, London, 1974. For an account of how Hilliard made *Sixty Seconds of Light*, see *The Tate Gallery 1972-4*, London, 1975, pp. 167–8. The other artists in 'The New Art' were Victor Burgin, Gilbert and George, John Hilliard, Keith Milow and David Tremlett.

86 A. Seymour, 'Keith Arnatt', in *The New Art*, catalogue, London, 1972, p. 66.

87 Letter from Beatrice Curtis to Norbert Lynton, 25 Sept. 1972, Hayward Gallery Archives, London.

88 Letter to Norbert Lynton from John Jenney, President of the Trustees of the Delaware Art Museum, 26 Sept. 1972, Hayward Gallery Archives, London.

89 Letter to Norbert Lynton from Eileen Simmons, 15 Sept. 1972, Hayward Gallery Archives, London.

90 Letter to Nora Meninsky from C. J. Fox, 2 Sept. 1972, Hayward Gallery Archives, London.

91 'It is not my kind of art either', Lynton replied sadly to Beatrice Curtis: 'I decided, for my own comfort, that all the words and formulae on the walls and in filing cabinets did not need to be understood, and perhaps were not even meant to be understood, except in terms of a kind of poetic effect' (Norbert Lynton, reply to letter from Beatrice Curtis, 29 Sept. 1972).

92 There is some irony therefore in the fact that those languages themselves derived partly from the later writings of Ludwig Wittgenstein, particularly the *Philosophical Investigations* (1947) and a tradition of Anglo-American analytical philosophy, both of which were iconoclastic with respect to metaphysics and, in their non-formal parts, non-technical and therefore accessible, particularly the writings of J. L. Austin and John Searle on speech–acts. It was precisely this accessibility that had made the interface between art and its theory a malleable one. Only in the writings of Art–Language did the use of those philosophical instruments become mannered and self-mocking – and again, for identifiable ends.

93 Norbert Lynton, letters to Beatrice Curtis, 25 Sept. 1972, and to John Jenney, 26 Sept. 1972, respectively, Hayward Gallery Archives, London.

94 John A. Murphy, foreword, *When Attitudes Become Form*, London, 1969. Subsequently Philip Morris Inc. adopted the slogan 'It takes art to make a company great'; see

Business Week, 24 Nov. 1980. For the latter information I am indebted to Chin-tao Wu, 'Privatising Culture: Aspects of Corporate Intervention in Contemporary Art and Art Institutions during the Reagan and Thatcher Decade', unpublished Ph.D. thesis, University of London, 1997, p. 104.

Notes to Chapter 8

1 For an account of this development, see my own *The Art of Today*, London, 1995, pp. 118–29.
2 See A. J. C. Hare, *Walks in London*, vol. I, London, 1878, p. 460.
3 *Tate Gallery of Modern Art*, booklet, London, 1997.
4 The longer story of British art will remain at Millbank. Funding for both parts of the project is from the gambling system beloved of lower-income Britons, the National Lottery: £18.75 million for Millbank and £50 million through the Millennium Commission for Bankside. Private benefactions and sponsorship schemes have been generated by the gallery's fund-raising office: the largest to date is the £7 million given anonymously in 1994 by Sir Edwin Manton for developments at Millbank. Sir Edwin, born in Essex in 1909 and for most of his working life an employee of the American International Corporation insurance company in New York, becoming chairman before his retirement in 1975, was knighted in the year of his gift for 'charitable services to the Tate Gallery'. Three years later he pledged a further £7 million and a recently discoverd fourth version of Constable's *The Glebe Farm* dated after 1830.
5 The first virtual work of art to be sold at auction was *Parcelle/Reseau* by French university teacher Fred Forest, sold in Paris to Antoine Beaussant and Bruno Chabal who paid FF58,000 for the right to access (and subsequently print copies of) the work. See the report in *Independent on Sunday*, 20 Nov. 1996.
6 'Channel 4 follows Bankside into the Next Millennium', Channel 4 Press Release, 17 Sept. 1996.

Bibliography

Unpublished sources

Bignamini, I., 'The Accompaniment to Patronage: A Study of the Origins, Rise and Development of an Institutional System for the Arts in Britain, 1692–1768', Ph.D. thesis, University of London, 1988.

Cowdell, T., 'The Role of the Royal Academy in English Art, 1918–1930', Ph.D. thesis, University of London, 1980.

Lord D'Abernon, speech at the opening of the Modern Foreign Galleries, 1926, Tate Gallery Archive, London.

Dicksee, F., toast to 'Guests', RA Dinner, 30 April 1927, Royal Academy of Arts Archives, London.

Burton, Anthony, 'The Department of Science and Art and the Bethnal Green Museum', lecture MS, n.d., Bethnal Green Museum Archive, London.

Flanagan, B., and others, *Silâns*, 16 issues, St Martin's School of Art, London, Sept. 1964–June 1965. Tate Gallery Archive, London.

General Purposes Committee, Special Development and Arts Sub-Committee: Completion Date for New Elizabeth Hall and Hayward Exhibition Gallery, on South Bank, Waterloo, Report, 22 Feb. 1965, by the architect.

General Thoughts as to Requirements for a Permanent National Portrait Gallery in London, 25 May 1839, National Portait Gallery Archives, London.

The Institute of Contemporary Arts: A Statement of Policy and Aims of the Proposed Institute by Members of the Organising Committee, 1947, ICA Archives, London.

LCC General Purposes Committee. Report 14 January 1963 of the Special Development and Arts Sub-Committee.

LCC Housing the Arts: South Bank Development. Note of a Discussion on 24 January 1958, file LCC/CL/GP/2/123, LCC Archives, London.

LCC: Laying the Foundation Stone of the Concert Hall, 12 October 1949, file LCC/CL/CER/3/8, LCC Archives, London.

List of Works purchased under the Terms of the Chantrey Bequest, 1877–1952, Royal Academy of Arts, n.d., Royal Academy Archives, London.

Longden, A. A., *British Art Exhibitions at Home and Abroad. A Report for the British Council for Relations with Other Countries*, 1935, Public Record Office, BW 78/1, 1935–45.

Longden, A.A., letter to T. J. Honeyman, Glasgow City Museum and Art Gallery, 4 March 1946, Public Record Office, BW. 31/21.

Manson, J. B., untitled lecture MS, 1936, Tate Gallery Archive, London.

Mass-Observation Archive, University of Sussex, Art Exhibitions 1941–49, Boxes 1-3.

Meadmore, W. S., *The Crowing of the Cock: A Biography of James Bolivar Manson*, unpublished MS, undated, Tate Gallery Archive, London.

Minutes of the LCC, 1960-63.

Minutes of a Meeting of 31 July 1968 on the Question of South Bank Sculpture, GLC/DG/GP/01.

The Modern Foreign Gallery (First Schedule), undated MS, London, Tate Gallery Archive.

Morris, E., 'The Formation of the Gallery of Art in the Liverpool Royal Institution, 1816-1819', unpubished MS.

Museum of Modern Art Scheme, in Minutes of First Meeting, held on 30 Jan. 1946, ICA Archives, London.

National Gallery Millbank: Programme of Ceremonies to be observed at the opening, 26 June 1926, Tate Gallery Archive, London.

Note of a Meeting on 19.7.56 at 4 St James' Square with members of the 'Housing the Arts' Committee of Inquiry, LCC/CL/GP/2/123, LCC Archives, London.

Paraskos, M., 'English Expressionism', M.A. thesis, University of Leeds, 1997.

Perry, L., 'Facing Femininities: Women in the National Portrait Gallery', Ph.D thesis, University of York, 1998.

Povey, K., 'Sir Henry Tate as a Benefactor of Libraries', Presidential Address to the North Western Branch of the Library Association, read at the Annual General Meeting, University of Liverpool, 7 Feb. 1957 (MS in the possession of Daphne Hayes-Mojon).

Public Record Office (PRO), CREST, 26/178.

Read, H., 'Introduction', *40 Years of Modern Art*, ICA, 9 Feb. 1948, ICA Archives, London.

Rorschach, K., 'Frederick Prince of Wales (1701–1751) as Patron of the Visual Arts: Princely Patriotism and Political Propaganda', Ph.D. thesis, Yale University 1985.

Speech of HM the King at the opening of the Modern Foreign Galleries, 1926, Tate Gallery Archive, London.

'The Star' South Side Plan, leaflet, n.d., LCC Archives, London.

Thames South Bank Scheme, made on behalf of and sponsored by 'The Star', LCC/AR/TP/5/7, n.d., LCC Archives, London.

Trodd, C., 'Formations of Cultural Identity: Art Criticism, the National Gallery and the Royal Academy, 1820–1863', D.Phil. thesis, University Sussex, 1992.

Ms. Ward, 'Report on the Picasso–Matisse Exhibition in Manchester', 25 Feb. 1946, PRO, BW/31/21.

Wu, Chin-tao, 'Privatising Culture: Aspects of Corporate Intervention in Contemporary Art and Art Institutions during the Reagan and Thatcher Decade', Ph.D. thesis, University of London, 1997.

Parliamentary papers and Acts of Parliament

Act for Paving, Cleansing and Lighting the Squares, Streets and Lanes of London (2 Geo III, c. 21), 1762.

Act for Paving the Streets and Lanes within the Town and Borough of Southwark (6 Geo III, c. 24), 1766.

First Report to His Majesty's Commissioners for Woods, Forests and Land Revenues, London, 1812.

Report of the Select Committee on Drunkenness, 1834.

A Return of the Number and Officers, effective and superannuated, connected with the National Gallery, the Amount of their Salaries, etc., 1835.

Report of the House of Commons Select Committee on Arts and their Connexion with Manufactures, 1835–6 (with Minutes of Evidence Collected in the Select Committee on Arts and Manufactures, and Minutes of Evidence Collected in the Select Comittee on Arts and Principles of Design, February–August 1936), 1836.

Report on Free Admission to Museums, 1837–38.

Return of Number of Visitors to the National Gallery, 1839.

Report of the Select Committee on National Monuments and Works of Art, 1841.

Act for Encouraging the Establishment of Museums in Large Towns (8 & 9 Vict., c. 43), 1845.

Return of Numbers of Visitors to the British Museum and National Gallery, 1843–45, 1846.

Report of the Select Committee on Works of Arts, London, 1847–48.

Report of a Commission on the State of the Pictures in the National Gallery, May 1850.

Report of the Select Committee on the National Gallery (with Minutes of Evidence), 1850.

Public Libraries Act (13 & 14 Vict, c. 65), 1850.

Report of a Commission to consider the Site for a new National Gallery, Aug. 1851.

First Report of the Commissioners for the Exhibition of 1851, to the Right Hon Spencer Walpole, Secretary of State, London, 1852.

Second Report of the Commissioners for the Exhibition of 1851, London, 1852.

Report of the Select Committee on the National Gallery (with Minutes of Evidence), 1853.

First Report of the Department of Practical Art, 1853, British Parliamentary Papers, vol. IV.

Return of Number of Visitors to the Tower of London, Hampton Court, Westminster Abbey, St Paul's Cathedral, British Museum, and National Gallery, 1850–53, 1854–55.

Return of Number of Visitors to the National Gallery and Royal Academy, 1846–54, 1854–55.

Act for the Better Local Management of the Metropolis (18 & 19 Vict), 1855.

Bill to provide Site for new National Gallery, 1856.

Report of the Director of the National Gallery to the Lords Commissioners of Her Majesty's Treasury, dated 5 March 1856.

Report of the National Gallery Site Commission, 1857.

Royal Commission on Site for National Gallery (with Minutes of Evidence), 1857, session 2.

Return of Number of Visitors to the South Kensington Museum, Marlborough House, 1854–56, 1857–58.

First Report of the Trustees of the National Portrait Gallery, 5 May 1858.

Letters and Memorials on Admission of the Public in the Evening to Turner and Vernon Gallery of Pictures, 1859, session 2.

Return of Number of Visitors, Whitsun 1863, at the British Museum, National Gallery, National Portrait Gallery, South Kensington Museum, Patent Museum, East India Museum, Naval Models at Somerset House, Kew Gardens, Hampton Court, Tower of London, Soane Museum, Greenwich Hospital, Crystal Palace and Polytechnic Institution, 1863.

Report of the Commission of 1863 on the Royal Academy.

Report of the Commissioners on the Present Position of the Royal Academy, 1863–64.

Bill to provide for Acquisition of Site for Englargement of the National Gallery, 1866.

Returns of Numbers of Commitals for Crime in England and Wales, 1884, 1887, 1897, 1899.

Report of the National Gallery to the Treasury, 1890.

Report from the Select Committee of the House of Lords on the Chantrey Trust; together with Proceedings of the Committee, Minutes of Evidence and Appendices, House of Lords papers, vol. VII, 1904.

Memorandum by the Royal Academy on the Report of the House of Lords Committee on the Chantrey Trust, House of Lords Papers, no. 166, 1905.

Report of the Committee of Trustees of the National Gallery appointed by the Trustees to inquire into the Retention of Important Pictures in This Country and Other Matters connected with the National Art Collection, London, 1915.

Second and Final Report, Unhealthy Areas Committee, Ministry of Health, 1921 (reprinted 1928).

Royal Commission on National Museums and Galleries, Interim Report, London, 1928 (Cmd 3192).

Report of the Committee on the Functions of the National Gallery and Tate Gallery and, in respect of Paintings, of the Victoria and Albert Museum, together with a Memorandum thereon by the Standing Commission on Museums and Galleries, London, May 1946 (Cmd 6827).

National Gallery and Tate Gallery Act (2 & 3 Elizabeth 2), 1954.

Published sources

Abel, D., *Ernest Benn: Counsel for Liberty*, London, 1960.

Lord D'Abernon, *An Ambassador of Peace*, 3 vols, London, 1929.

Lord D'Abernon, *Portraits and Appreciations*, London, 1931.

Adam, P., *A Book about Paris*, London, 1927.

Administrative County of London Development Plan, 1951: Statement, LCC, London, 1951.

[Agar-Ellis, G. W. W.], 'Catalogue of the Celebrated Collection of Pictures of the late John Julius Angerstein', *Quarterly Review*, 31:61, Dec. 1824, pp. 210–11, 213.

Aitken, W. F., *Canon Barnett, Warden of Toynbee Hall: His Mission and its Relation to Social Movements*, London, 1902.

Alain-Fournier, *Towards the Lost Domain: Letters from London, 1905*, ed. and trans. W. J. Strachan, Manchester, 1986.

Allen, B., *Francis Hayman*, New Haven and London, 1987.

Allen, B. (ed.), *Towards a Modern Art World: Studies in British Art, I*, New Haven and London, 1995.

Allen, D. G., *William Shipley: Founder of the RSA: A Biography with Documents*, London, 1968.

Altick, R., *The Shows of London*, Cambridge, Mass., and London, 1978.

Altshuler, B., *The Avant-Garde in Exhibition: New Art in the 20th Century*, New York, 1994.

[anonymous], *The Conduct of the Royal Academicians, while Members of the Incorporated Society of Artists in Great Britain*, London, 1771.

[anonymous], 'Popular Art Education', *Meliora*, 2, July 1858, pp. 171–2.

Arte Povera (catalogue), Galleria La Bertesca, Genoa, Sept. 1967.

The Arts in Wartime: A Report on the Work of CEMA, 1942 and 1943, CEMA, London, n.d.

Arts Council Paper 298, 15 Feb. 1951.

The Arts Inquiry, PEP Publications, Oxford, 1946.

Bailey, P., *Leisure and Class in Victorian England: Rational Recreation and the Contest for Control, 1830–1885*, London, 1978.

Baldwin, S., *On England, and Other Addresses*, London, 1926.

—— *Our Inheritance: Speeches and Addresses by the Rt. Hon. Stanley Baldwin, MP*, London, 1928.

Banham, M. and Hillier, B. (eds), *A Tonic to the Nation: The Festival of Britain, 1951*, London, 1976.

Banham, R., 'The Style: "Flimsy ... Effeminate?"', in M. Banham and B. Hillier (eds), *A Tonic to the Nation: The Festival of Britain*, London, 1976, pp. 190–8.

Barlow, P., 'The Imagined Hero as Incarnate Sign: Thomas Carlyle and the Mythology of the "National Portrait" in Victorian Britain', *Art History*, 17:4, Dec. 1994, pp. 517–45.

Barnett, H., *Canon Barnett, His Life, Work and Friends*, 2 vols, London, 1918.

Barrell, J., *The Political Theory of Painting from Reynolds to Hazlitt: 'The Body of the Public'*, New Haven and London, 1986.

Bean, J. M. W. (ed.), *The Political Culture of Modern Britain: Studies in Memory of Stephen Koss*, London, 1987, pp. 11–31.

Beaumont, G. and Disney, H., *Whatever is Curious in the Several Counties, Cities, Borough, Market Towns, and Villages of Note in the Kingdom...*, London, 1768.

Behrman, S. N., *Duveen*, London, 1952.

Bell, Clive, *Landmarks of Nineteenth Century Painting*, London, 1929.

Benn, E., *Confessions of a Capitalist*, London, 1925.

—— *Letters of an Individualist to 'The Times', 1921–26*, London, 1927.

Bennett, T., 'The Exhibitionary Complex', *New Formations*, 4, Spring 1988, pp. 73–102.

Bensham Grove Eductional Settlement, Gateshead-on-Tyne Annual Report and Statement of Accounts, Gateshead-on-Tyne, 1938–39.

Bertelsen, L., *The Nonsense Club: Literature and Popular Culture, 1749–1764*, Oxford, 1986.

—— 'Have at You All: or, Bonnell Thornton's Journalism', *Huntington Library Quarterly*, 44:4, 1981, pp. 263–82.

Bertram, A., *Paul Gauguin*, London, 1930.

—— *Matisse*, London, 1934.

Bickerstaffe, I., 'The National Gallery', *The Field: The Country Gentleman's Newspaper*, 10 April 1924.

Biggs-Davidson, J., *George Wyndham: A Study in Toryism*, London, 1951.

Bignamini, I., 'The Academy of Art in Britain before the Foundation of the Royal Academy in 1768', in A. Boschloo, E. Hendrikse, L. Smit and G. Van der Sman (eds), *Academies of Art between Renaissance and Romanticism*, Leiden, Netherlands, 1989, pp. 434–50.

Blackburn, H., *Sir Henry Tate*, c. 1937, privately printed, Tate Gallery Archive, London.

Blunt, A., 'Samuel Courtauld as a Collector and Benefactor', in Douglas Cooper, *The Courtauld Collection: A Catalogue and Introduction*, with a memoir of Samuel Courtauld by Anthony Blunt, London, 1954.

Boase, T. S. R., 'The Decoration of the New Palace of Westminster, 1841-1863', *Journal of the Warburg and Courtauld Institutes*, vol. 17, 1954, pp. 319–58.

Bodkin, T., *Hugh Lane and his Pictures*, Dublin, 1956.

Borzello, F., 'An Un-noted Speech by William Morris', *Notes and Queries*, Aug. 1978, pp. 314–16.

—— *Civilizing Caliban: The Misuse of Art, 1875–1980*, London, 1987.

Brewer, J., *The Pleasures of the Imagination: English Culture in the Eighteenth Century*, London, 1997.

British Council, 'Some Facts about the Picasso–Matisse Exhibition', *Monthly Overseas Bulletin Supplement*, 31 Dec. 1945.

Britton, F., *A Chronological History and Graphic Illustration of Christian Architecture in England*, vol. 5 of *The Architectural Antiquities of Great Britain*, London, 1827.

Britton, J., *Catalogue Raisonné of the Pictures belonging to the Most Honourable the Marquis of Stafford, in the Gallery of Cleveland House. Comprising a List of the Pictures, with Illustrative Anecdotes, and Descriptive Accounts of the Principal Paintings*, London, 1808.

Brown, J., *Collecting Art in Seventeenth-Century Europe*, New Haven and London, 1995.

Buckle, H. T., *History of Civilisation in England*, vol. 1, London, 1902.

Buckman, D., *James Bolivar Manson: An English Impressionist, 1875-1945*, London, 1973.

'Building Illustrated: Hayward Gallery Appraisal', *The Architectural Forum*, CXLVIII, no. 28, 10 July 1968, pp. 56–60.

Bullen, J. B. (ed.), *Post-Impressionists in England: The Critical Reception*, London, 1988.

Burke, Thomas, *The Beauty of England*, London, 1933.

Burton, S., 'Notes on the New', catalogue to *When Attitudes Become Form*, ICA, London, 1968.

Calhoun, C. (ed.) *Habermas and the Public Sphere*, Cambridge, Mass., 1991.

Carey, W., *A Descriptive Catalogue of a Collection of Paintings by British Artists, in the Possession of Sir John Leicester, Bart*, London, 1819.

Casteras, S. P. and Denny, C. (eds), *The Grosvenor Gallery: A Palace of Art in the Victorian Art World*, New Haven and London, 1996.

Castle, T., *Masquerade and Civilization: The Carnivalesque in 18th Century English Culture and Fiction*, London, 1986.

A Catalogue of the British Fine Art Collections in the South Kensington Museum, with Part of the Bequest of the Rev. Chauncey Hare Townshend, London, 1870.

Catalogue of the Collection of Pictures of Henry Tate, Park Hill, Streatham Common, London, 1894.

A Catalogue of the Pictures, Sculptures, Designs in Architecture, Models, Drawings, Prints, &c ... exhibited ... by the Royal Incorporated Society of Artists, May the 1st, 1769, London, 1769.

Catalogue of the Works of British Artists placed in the Gallery of the British Institution, Pall Mall, for Exhibition and Sale, London, 1811.

Caygill, M., *The Story of the British Museum*, London, 1981.

Chadwick, H., *Report on the Sanitary Condition of the Labouring Population*, London, 1842.

Chalmers, H. (ed.), *The British Essayists*, London, 1817.

'Channel 4 follows Bankside into the Next Millennium', Channel 4 Press Release, London, 17 Sept. 1996.

Chantrey and His Bequest; a Complete Illustrated Record of the Purchases of the Trustees, with a Biographical Note, Text of the Will, etc., London, 1904.

The Charter of Incorporation Granted by His Majesty the King to the Arts Council of Great Britain, London, 9 Aug. 1946.

The Charter of Incorporation Granted by Her Majesty the Queen to the Arts Council of Great Britain, 7 February 1967.

Churchill, W., *History of the English Speaking Peoples*, vol. 4: *The Great Democracies*, London, 1958.

Cieszkowski, K., 'Millbank before the Tate', *The Tate Gallery 1984-86: Illustrated Biennial Report*, London, 1986, pp. 38–43.

Clark, K., *Another Part of the Wood: A Self-portrait*, London, 1985.

Cobbett's Parliamentary History, comprising the period 29 January 1777 to 4 December 1778, London, 1814.

Cole, H., *The Function of the Science and Art Department*, London, 1857.

Colley, L., *Britons: Forging the Nation, 1707–1837*, New Haven and London, 1992.

—— 'Whose Nation? Class and National Consciousness in Britain, 1750-1830', *Past and Present*, 113, Nov. 1986, pp. 97–117.

Cook, E. Wake, *Anarchy in Art and Chaos in Criticism*, London, 1904.

Cook, E. Wake, *Retrogression in Art, and the Suicide of the Royal Academy*, London, 1924.

Cooper, Douglas, *The Courtauld Collection: A Catalogue and Introduction*, with a Memoir of Samuel Courtauld by Anthony Blunt, London, 1954.

Corrigan, R. and Sayer, D., *The Great Arch: English State Formation as Cultural Revolution*, Oxford, 1985.

County of London Plan by J. H. Forshaw and P. Abercrombie, London, 1943.

Courtauld, S., *Ideals and Industry*, Cambridge, 1949.

Cust, L., *The History of the Dilettanti Society*, London, 1898.

—— 'A National Gallery of British Art', in *Catalogue of the National Gallery of British Art (Tate Gallery)*, London, 1898.

Dabydeen, D., 'High Culture based in Black Slavery', *The Listener*, 24 Sept. 1987, pp. 1–15.

[unsigned], 'Date with Fate at the Tate', *Studio International*, March 1971.

Denis, R. Cardoso, 'The Brompton Barracks: War, Peace, and the Rise of Victorian Art and Design Education', *Journal of Design History*, 8:1, 1995, pp. 11–25.

Desenfans, N., *A Plan, preceded by a Short Review of the Fine Arts, to preserve among us, and transmit to Posterity, the Portraits of the Most Distinguished Characters of England, Scotland and Ireland, since his Majesty's Accession to the Throne*, London, 1799.

Dewhurst, W., *Impressionist Painting*, London, 1904.

Dickens, C., *David Copperfield*, London, 1850.

—— *Sketches by Boz*, London, 1836–37, Oxford Edn, 1957.

Dickinson's Comprehensive Pictures of the Great Exhibition of 1851, 2 Vols, London, 1854.

Dicksee, F., *Discourse, delivered to the Students of the Royal Academy on the Distribution of the Prizes, 10 December 1925*, London, 1925.

—— *Discourse, delivered to the Students of the Royal Adacemy on the Distribution of the Prizes, 10 December 1927*, London, 1927.

Donald, D., *The Age of Caricature: Satirical Prints in the Reign of George III*, New Haven & London, 1996.

Donaldson, F., *The British Council: The First Fifty Years*, London, 1984.

Doyle, B., 'The Invention of English', in R. Colls and P. Dodds (eds), *Englishness in Politics and Culture 1880–1920*, London, 1986, pp. 89–115.

DuCane, E. F., *The Punishment and Prevention of Crime*, London, 1885.

Duncan, C., *Civilizing Rituals: Inside Public Art Museums*, London, 1995.

Duncan, C. and Wallach, A., 'The Universal Survey Museum', *Art History*, 3, Dec. 1980, pp. 447-69.

Duroselle, J.-B., 'Entente and Mésentente', in J. Johnson, F. Crouzet and F. Bedarida (eds), *Britain and France: Ten Centuries*, Kent, 1980, pp. 274–80.

Duveen, J(ames) H(enry), *The Rise of the House of Duveen*, London, 1957.

—— *Collections and Recollections of an Art Dealer. A Century and a Half of Art Deals*, London, 1934.

—— *Secrets of an Art Dealer*, London, 1937.

Eastlake, C., *Observations on the Unfitness of the Present Building for its Purpose, in a Letter to the Rt. Hon. Sir Robert Peel*, London, 1845.

'Editorial', *Burlington Magazine*, no. 1, 1903, p. 3.

Edwards, E., *Anecdotes of Painters who have resided or been born in England, with Critical Remarks on their Productions*, London, 1808.

Englefield, W. O., *History of the Painter-Stainers' Company*, London, 1922.

Ensor, R. C. K., *England, 1870–1914*, Oxford, 1936.

Evans, R., *The Fabric of Virtue: Engish Prison Architecture 1750–1840*, Cambridge, 1982.

The Exhibition of the Royal Academy, the First, London, 1769.

Exhibition of Paintings by Picasso and Matisse (catalogue), Victoria and Albert Museum, London 1945–46.

Fagg, E., *Modern Foreign Masters: An Introduction and Complete Handbook to the Modern Foreign Work in the National Collection*, London, 1930.

Lord Farnborough, *Short Remarks and Suggestions Upon Improvements now carrying on or under Consideration*, London, 1826.

Feaver, W., *Pitmen Painters: The Ashington Group, 1934–84*, London, 1988.

Flint, K. (ed.), *Impressionists in England: The Critical Reception*, London, 1984.

Fogg, R., 'An Interview with Sir Alfred Munnings: Art and the Common Man', *East Anglian Times*, May, 1949.

Ford, C. B., *The Landscape of England*, London, 1932.

Forty, A., 'Festival Politics', in M. Banham and B. Hillier (eds), *A Tonic to the Nation: The Festival of Britain, 1951*, London, 1976.

40,000 Years of Modern Art: A Comparison of Primitive and Modern, ICA, London, 1948–49.

Foss, B., 'Message and Medium: Government Patronage, National Identity and National Culture in Britain, 1939–45', *Oxford Art Journal*, 14:2, 1991, pp. 52–72.

Fowles, E., *Memories of Duveen Brothers* (intr. E. Waterhouse), London, 1976.

Fried, M., 'Art and Objecthood', *Artforum*, June 1967.

—— *Matisse*, Hayward Gallery catalogue, London, 1968.

Fullerton, P., 'Patronage and Pedagogy: the British Institution in the Early Nineteenth Century', *Art History*, 5:1, March 1982, pp. 59–72.

Fyfe, G., 'Art Museums and the State', Working Paper no. 2, Department of Sociology and Social Anthopology, Keele University, Keele, 1993.

—— 'Art Exhibitions and Power during the Nineteenth Century', in J. Law (ed.), *Power, Action and Belief*, London, 1986, pp. 20–45.

—— 'The Chantrey Episode: Art Classification, Museums and the State, c. 1870–1920', in S. Pearce (ed.), *Art in Museums: New Research in Museum Studies*, vol. 5, London, 1995, pp. 5–41.

——— 'A Trojan Horse at the Tate: Theorising the Museum as Agency and Structure', in S. Macdonald and G. Fyfe, *Theorising Museums: Representing Identity and Diversity in a Changing World:*, Oxford, 1996, p. 203–28.

Gage, J., '*The British School* and the British School', in B. Allen (ed.), *Towards a Modern Art World : Studies in British Art I*, New Haven and London, 1995, pp. 109–20.
Gainsborough, J., 'London's New Public Gallery', *Arts Review*, 11 Nov. 1967.
Garlake, M., '"A War of Taste": The London County Council as Art Patron, 1948–65', *The London Journal*, 18:1, 1993, pp. 45–65.
Goodman, J., *What A Go! The Life of Alfred Munnings*, London, 1988.
Gordon J., *Modern French Painters*, London, 1923.
Gordon, C., 'London Commentary', *Studio*, vol. 131, Feb. 1946.
Gowing, L., 'Introduction', *Matisse*, Hayward Gallery, catalogue, London, 1968.
Graves, A., *The Society of Artists of Great Britain 1766–1791, The Free Society of Artists 1761–1783, A Complete Dictionary of Contributors*, London, 1907.
Greater of London Plan, 1944, by P. Abercrombie, London, 1945.
Greenberg, R., Ferguson, B., and Nairne, S. (eds), *Thinking about Exhibitions*, London, 1996.
Greenhalgh, P., *Ephemeral Vistas: The Expositions Universelles, Great Exhibitions and World Fairs, 1851–1939*, Manchester, 1988.
Gregory, A. and others, *Sir Hugh Lane's French Pictures*, London, 1917.
Griffiths, A., *Memories of Millbank, and Chapters in Prison History*, London, 1884.
Gwynn, J., *The Plan of an Academy for the Better Cultivation, Improvement and Encouragement of Painting, Sculpture, Architecture, and the Arts of Design in General: The Abstract of a Royal Charter as propos'd for establishing the same; And a short Introduction*, London, 1755.
——— *London and Westminster Improved, Illustrated by Plans to which is prefixed, A Discourse on Publick Magnificence; with Observations on the State of the Arts and Artists in this Kingdom, wherein the Study of the Polite Arts is recommended as necesary to a liberal Education*, London, 1766.

Habermas, J., *The Structural Transformation of the Public Sphere: An Inquiry into a Category of Bourgeois Society*, 1962, English translation by Thomas Berger, Cambridge, 1992.
Hamilton, E. W., *The Destruction of Lord Roseberry*, (ed. and intr. D. Brooks), London 1988.
Hamlyn, R., 'Tate Gallery', in G. Waterfield (ed.), *Palaces of Art: Art Galleries in Britain, 1790-1990*, London, Dulwich Picture Galleries, 1991, pp. 113–6.
——— *Robert Vernon's Gift: British Art for the Nation, 1947*, Tate Gallery, London, 1993.
Hannyngton, H., 'East End Museum', *New Society*, 22 June 1972, p. 633.
Hare, A. J. C., *Walks in London*, vol. 1, London, 1878.
Harris, J., 'English Country House Guides, 1740–1840', in J. Summerson (ed.), *Concerning Architecture: Essays on Architectural Writers and Writing Presented to Nicholaus Pevsner*, London, 1968, pp. 58-74.
Harrison, C., 'Against Precedents', in *When Attitudes Become Form*, ICA, London, 1969.
——— *Essays on Art and Language*, Oxford, 1991.
Harrison, M., 'Art and Philanthropy: T. C.Horsfall and the Manchester Art Museum', in A. Kidd and K. W. Roberts (eds.), *City, Class and Culture: Studies of Social Policy and Cultural Production in Victorian Manchester*, Manchester, 1985.
Hazlitt, W., *Sketches of the Principal Picture-Galleries in England*, London, 1824.

Heal, A., *London's Tradesmen's Cards of the 18th Century*, London, 1925.

—— *The Signboards of Old London Shops: A Review of the Shop Signs employed by the London Tradesmen during the XVIIth and XVIIIth Centuries, compiled from the Author's Collections of Contemporary Trade-cards and Billheads*, London, 1947.

Hemingway, A., 'Art Exhibitions as Leisure-Class Rituals in Early Nineteenth Century London', in Allen, B., (ed.), *Towards a Modern Art World, I*, pp. 95–105.

Hermann, F., *The English as Collectors: A Documentary Chrestomathy*, London, 1972.

Higginbottom, H. Hugh, *Frightfulness in Modern Art*, London, 1928.

—— *King of Kulturia*, London and Felling-on-Tyne, 1915.

Holt, R. V., *The Unitarian Contribution to Social Progress in England*, London, 1938.

The Hornsey Affair, Students and Staff of Hornsey College of Art, Harmondsworth, Middlesex, 1969.

Horsfall, T. C., *An Art Gallery for Manchester*, Manchester, 1877.

—— 'Painting and Popular Culture', *Fraser's Magazine*, June 1880.

House, J. (ed.), *Impressionism for England: Samuel Courtauld as Patron and Collector*, London, 1994.

Housing the Arts in Great Britain: Report by the Arts Council of Great Britain, London, 1959.

Hughes, P., *The Founders of the Wallace Collection*, Trustees of the Wallace Collection, London, 1981.

Hume, D., *Essays Moral, Political and Literary*, London, 1741–42.

Hutchison, S., *The Homes of the Royal Academy*, Royal Academy of Arts, London, 1956.

—— *The History of the Royal Academy, 1768–1968*, London, 1968.

Illustrated Souvenir of the Palace of the Arts, British Empire Exhibition 1924, London, 1924.

Impey, O. and McGregor, A. (eds), *The Origins of Museums: The Cabinet of Curiosities in Sixteenth and Seventeenth Century Europe*, Oxford, 1985.

The Inauguration Ode, Composed on the Occasion of the Visit of their Royal Highnesses the Prince and Princes of Wales, at the Opening of the East London Museum, 24 June 1872.

James, Henry, *The Princess Casamassima* (1886), Harmondsworth, 1977, 1986.

Jameson, A., *Handbook to the Public Galleries in and near London*, London, 1842.

—— *Companion to the Most Celebrated Private Galleries of Art in London*, London, 1844.

Jenkins, T. A., *The Liberal Ascendency 1830–1886*, London, 1994.

Stedman Jones, G., *Outcast London: A Study in the Relations between Classes in Victorian London*, Oxford, 1971.

Jones, T., *Henry Tate, 1819-1899: A Biographical Sketch*, London, 1960.

Journal of the Leeds Polytechnic Exhibition, 30 June 1845.

Lord Keynes, 'The Arts Council: Its Policy and Hopes', *The Listener*, 12 July 1945, pp. 31–2.

Kingsley, Charles, *Politics for the People*, 6 May 1848.

Kitson, M., 'Hogarth's "Apology for Painters"', *Forty-First Volume of the Walpole Society, 1966-68*, Glasgow, 1968.

Klingsor, T., *Cézanne* (trans. by J. B. Manson), London, 1925.

Korn, M., 'The Courtauld Gift - Missing Papers Traced', *Burlington Magazine*, 138:1, 117, April 1996, p. 256.

Koven, S., 'The Whitechapel Picture Exhibitions and the Politics of Seeing', in D. J. Sherman and I. Rogoff (eds.), *Museum Culture: Histories, Discourses, Spectacles*, London, 1994, pp. 22–48.

Kusamitsu, T., 'Great Exhibitions before 1851', *History Workshop Journal*, 9, Spring 1980.

Kustow, M., *Tank: An Autobiographical Fiction*, London, 1975.

Lamb, W. R. M., *The Royal Academy: A Short Hgistory of its Foundation and Development to the Present Day*, London, 1935.

Landseer, J., *A Descriptive, Explanatory and Critical Catalogue of Fifty of the Earliest Pictures contained in the National Gallery of Great Britain*, London, 1834.

Larwood, J. and Hotton, J. C., *The History of Signboards from the Earliest Times to the Present Day*, London, 1867.

—— *English Inn Signs*, London, 1951.

Leenders, R., 'Reflection of a Face in My Eye', *Silâns*, 2, St Martin's School of Art, London, Oct. 1964.

Leventhal, F. M., '"The Best for The Most": CEMA and State Sponsorship of the Arts in Wartime, 1935-45', *Twentieth Century British History*, 1:3, 1990, pp. 289–317.

Lillywhite, B., *London Signs: A Reference Book of Signs from Earliest Times to about the Mid Eighteenth Century*, London, 1972.

Lippard, L., *Six Years: The Dematerialisation of the Art Object from 1966 to 1972*, London, 1973.

Lloyd, C., 'John Julius Angerstein, 1732-1823', *History Today*, 16:6, June 1966, pp. 373–90.

London and its Environs: or, the General Ambulator and Pocket Companion for the Tour of the Metropolis and its Vicinity, within the Circuit of Twenty-five Miles, descriptive of the Objects most Remarkable for Grandeur, Elegance, Taste, Local Beauty and Antiquity illustrated by Anecdotes, Historical and Biographical, Sixteen Elegant Engravings, and a Correct Map, 12th edition, greatly impoved and much enlarged, with an Appendix containing Lists of Pictures in the Royal Palaces and Principal Mansions round London, London, 1820.

Luckhurst, K. W., *The Royal Society of Arts, 1754–1954*, London, 1954.

MacColl, D. S., *Nineteenth Century Art*, Glasgow, 1902.

—— *The Administration of the Chantrey Bequest; Articles reprinted from 'The Saturday Review' with Additional Matter, including the Text of Chantrey's Will and a List of Purchases*, London, 1904.

—— 'The Future of the National and Tate Galleries', *The Nineteenth Century and After*, June 1915.

—— 'The National Gallery Bill, and Sir Hugh Lane's Bequest', *The Nineteenth Century and After*, Feb. 1917.

—— *Confesssions of a Keeper and Other Papers*, London, 1931.

Macdonald, S. and Fyfe, G. (eds), *Theorizing Musems: Representing Identity and Diversity in a Changing World*, Oxford, The Sociological Review, 1996.

Mace, R., *Trafalgar Square: Emblem of Empire*, London, 1976.

MacKenzie, J. (ed.), *Imperialism and Popular Culture*, Manchester, 1986.

Manson, J. B., *Rembrandt*, London, 1923.

—— *Hours in the Tate Gallery*, London, 1926.

—— *The Life and Work of Edgar Degas*, London, 1927.

—— *The Tate Gallery*, London, 1929.

Marriott, C., *Modern Art: A Collection of Writings on Modern Art*, 2 vols, London, 1918.

—— *Modern Movements in Painting*, London, 1920.

Martin, G, 'The Founding of the National Gallery in London', *Connoisseur*, April 1974, pp. 280–7; May 1974 pp. 24–31; June 1974, pp. 124–8; July 1974, pp. 200–7; Aug. 1974, pp. 272–80; Sept. 1974, pp. 48–53; Oct. 1974, pp. 108–13; Nov. 1974, pp. 202–5; Dec. 1974, pp. 278–83.

Massey, A., *The Independent Group: Modernism and Mass Culture in Britain*, Manchester, 1995.

Massey, V., *What's Past is Prologue*, London, 1962.

Mauclair, C., *The French Impressionists, 1860–1900*, (trans. P. G. Konody), London, 1903.

—— *The Great French Painters and the Evolution of French Painting from 1830 to the Present Day* (trans. P. G. Konody), London, 1903.

Mayhew, H., *London Labour and the London Poor*, London, 1861–2.

Mellor, D., *The Sixties Art Scene in London*, London, 1993.

'Mind over Matter: Hans Obrist talks with Harald Szeemann', *Artforum*, Nov. 1996.

Minihan, J., *The Nationalisation of Culture*, London, 1977.

[Mogridge, George,] *Old Humphrey's Walks in London and Its Neighbourhood*, London, 1843.

Morris, J., *Pax Britannica: The Climax of Empire*, London, 1968 (Harmondsworth, Middlesex, 1979).

Morris, R. J., *Cholera, 1832: The Social Response to an Epidemic*, London, 1976.

Morris, R., 'The Art of Existence. Three Extra-Visual Artists: Work in Progress', *Artforum*, 9:5, Jan. 1971, pp. 28–33.

Mortimer, T. (attrib.), *A Concise Account of the Rise, Progress and Present State of the Society for the Encouragement of Arts, Manufacture and Commerce*, London, 1763.

Morton, H. V., *In Search of England*, London, 1927.

Morton, H. V., *H. V. Morton's London*, London 1940.

Munnings, A. J., 'The President of the Royal Academy Replies', *Picture Post*, 5 Feb. 1949, pp. 24–5, 37.

—— *The Finish*, London, 1952.

Murdoch, J., 'The Courtauld Family and its Money', in J. House (ed.), *Impressionism for England: Samuel Courtauld as Patron and Collector*, London, 1994, pp. 47–56.

Nairn, T., 'On the Subversiveness of Art Students', *The Listener*, 17 Oct. 1968.

[unsigned,] 'The National Portrait Gallery', *Quarterly Review*, vol. 166, Jan. and April 1888.

National Gallery, Millbank: Catalogue, Modern Foreign School, 1st ed, London, 1926.

National Gallery, Millbank: Illustrated Guide, British School, Glasgow, 1926–27.

National Gallery, Millbank. List of Loans at the Opening Exhibition of the Modern Foreign Gallery, June to October 1926, London, 1926.

National Gallery, Millbank: A Record of Ten Years, 1917–27, Glasgow, 1927.

National Gallery, Millbank: Review of the Acquisitions during the years July 1927–December 1929, Glasgow, 1930.

National Gallery of Modern Art, Millbank: Description of the New Wing added by Sir Joseph Duveen which is shortly to be opened, Tate Gallery press release, 1926, Tate Gallery Archive, London.

The National Gallery of Pictures by the Great Masters, presented by Individuals or Purchased by Grant of Parliament, London, n.d.

Nevill, R., *Paris of Today*, London, 1924.

The New Art, Hayward Gallery catalogue, London 1972.

[unsigned,] 'The New Director of the ICA', *Vogue*, April 1968.

Newspaper Press Directory and Advertisers' Guide, London, 1940.

Newspaper Press Directory and Advertisers' Guide, London, 1946–47.

Newspaper Press Directory and Advertisers' Guide, London, 1948.

Newton, Eric (ed.), 'The Artist in the Witness Box', BBC Radio, London, 1938.

Newton, E., 'Sculpture', *Open Air Exhibition of Sculpture*, LCC, London, 1948.

Nichols, R. H. and Wray, F. A., *The History of the Foundling Hospital*, London, 1935.

Op Losse Schroeven: Situaties en Crypostructuren, Stedelijk Museum Amsterdam, 15 March–27 April 1969.

Orchard, B. Guiness, *Liverpool's Legion of Honour*, Birkenhead, 1893.

Ottley, W. Y., *A Descriptive Catalogue of the Pictures in the National Gallery, with Critical Remarks on their Merits*, London, 1832 and 1835.

Owen, D., *English Philanthropy, 1660–1960*, Cambridge, Mass., 1965.

'Papers of the Society of Artists of Great Britain', *Walpole Society*, 6, 1917–18, pp. 113–30.

Paulson, R., *Hogarth: His Life, Art and Times*, 2 vols, New Haven and London, 1971.

—— *Hogarth, vol. 3: Art and Politics, 1750–1760*, Cambridge, 1993.

Pearce S. (ed.), *Art in Museums: New Research in Museum Studies*, vol. 5, London 1995.

Pears, I., *The Discovery of Painting: The Growth of Interest in the Arts in England, 1680–1786*, New Haven and London, 1988.

Pearson, N., *The State and the Visual Arts: A discussion of State Intervention in the Visual Arts in Britain, 1760–1981*, Milton Keynes, 1982.

Pevsner, N., 'Museums', in Pevsner, *A History of Building Types*, London, 1976, pp. 111–138.

Physick, J., *The Victoria and Albert Museum: The History of its Building*, London, 1982.

Plumb, J. H., 'The Commercialisation of Leisure in Eighteenth Century London', in N. McKendrick, J. Brewer and J. H. Plumb, *The Birth of a Consumer Society: The Commercialisation of Eighteenth Century England*, London, 1982, pp. 265–85.

Pointon, M., *Hanging the Head: Portraiture and Social Formation in Eighteenth Century England*, New Haven and London, 1993.

—— (ed.), *Art Apart: Art Institutions and Ideology across England and North America*, Manchester, 1994.

Potts, A., '"Constable Country" between the Wars', in Raphael Samuel (ed.), *Patriotism. The Making and Unmaking of a British National Identity*, vol. 3: *National Fictions*, London, 1989.

Pound, R., *The Englishman: A Biography of Sir Alfred Munnings*, London, 1962.

Preziozi, D., *Rethinking Art History*, Berkeley, Cal., 1989.

Priestley, J. B., *The Good Companions*, London, 1929.

—— *English Journey*, London, 1934.

Pye, J., *Patronage of British Art*, London, 1845.

Rathbone, E. F., *William Rathbone: A Memoir*, London, 1905.

Read, H., *Art Now: An Introduction to Painting and Sculpture*, London, 1933.

—— 'Picasso and the Marxists', *London Mercury*, 31 Nov. 1934.

—— *Art and Society*, London, 1936.

—— *Education through Art*, London, 1943.

Redgrave, R., *The Gift of the Sheepshanks Collection, with a View to the Formation of a National Gallery of British Art*, London, 1857.

—— 'The Construction of Picture Galleries', *The Builder*, 28 Nov. 1857.

Reed, C. (ed. and intr.) *A Roger Fry Reader*, Chicago and London, 1996.

Reynolds, J. (ed.), *Statement of the Claim for the Return to Dublin of the 39 Lane Bequest Pictures Now at the Tate Tallery, London*, Dublin, 1932.

Reynolds, Joshua, *Discourses on Art* (ed. Robert R. Wark), New Haven and London, 1975.

Robertson, D., *Sir Charles Eastlake and the Victorian Art World*, Princeton, N.J., 1978.

Earl of Ronaldsway, *The Life of Lord Curzon: being the Authorized Biography of George Nathaniel Marquess Curzon of Kedleston*, London, 1928.

Rossiter, W., *A Summary of the History of the South London Art Gallery, Library and Lecture Hall, from its Foundation in 1868, A Quarter of a Century Ago*, London, 1893.

Rothenstein, J., 'Forward', *A Selection from the Tate Gallery's War-Time Acquisitions*, CEMA, London, 1942-43.

—— *The Tate Gallery: The National Collection of British Painting and of Modern Foreign Art*, London, 1947.

—— *The Tate Gallery*, London, 1962.

—— *Summer's Lease, Autobiography 1901–1938*, London 1965.

—— *Brave Day, Hideous Night: Autobiography, 1939–1965*, London, 1966.

—— *Time's Thievish Progress: Autobiography*, vol. 3, London, 1970.

The Royal Watercolour Society: The First Fifty Years, 1805–1855, London, 1992.

Rudé, G., *Wilkes and Liberty*, Oxford, 1962.

Ruskin, J., 'On the Present State of Modern Art, with Reference to the Advisable Arrangements of a National Gallery', in *Works of John Ruskin*, ed. E. T. Cook and A. Wedderburn, vol. 19, London, 1905.

—— 'Picture-Galleries – Their Functions and Formation', in *Works of John Ruskin*, ed. E. T. Cook and A. Wedderburn, vol. 13 (first printed in the *Report of the National Gallery Site Commission*, 1857, Questions 2, 392–504, pp. 92–7).

—— 'A Museum or Picture Gallery: Its Functions and Its Formation', *Works of John Ruskin*, vol. 34.

Rutter, F., *Evolution in Modern Art*, London, 1926.

—— *Since I was Twenty-two*, London, 1927.

—— *Art in My Time*, London, 1933.

Sadler, M., *A Memoir*, London, 1949.

Sandby, W., *The History of the Royal Academy, from its Foundations to the Present Day*, vol. 1, London, 1862.

Sandilands, G. S., 'London County Council as Patron of Art, I', *Studio*, vol. 159, January 1960.

Santayana, G., *Soliloquies in England, and Later Soliloquies*, London, 1922.

Schiff, G. (ed.), *Picasso in Perspective*, Englewood Cliffs, N.J., 1976.

Seaman, L. C. B., *Victorian England: Aspects of English and Imperial History, 1837–1901*, London, 1973.

Selig, H., 'The Genesis of the Museum', *Architectural Review*, no 840, vol. CXLI, Feb. 1967, pp. 103–14.

Seymour, A., 'Keith Arnatt', *The New Art*, Hayward Gallery catalogue, London, 1972.

Sherman, D. J. and Rogoff, I. (eds), *Museum Culture: Histories, Discourses, Spectacles*, London, 1994.

Simey M. B., *Charitable Effort in Liverpool in the Nineteenth Century*, Liverpool, 1951.

Simpson, C., *The Partnership: The Secret Association of Bernard Berenson and Joseph Duveen*, London, 1987.

Sinclair, A., *Arts and Cultures: The History of the 50 Years of the Arts Council of Great Britain*, London, 1995.

Six At the Hayward, Hayward Gallery catalogue, London, 1969.

Slaney, R., *Reports of the House of Commons on the Eduction (1838) and on the Health (1840) of the Poorer Classes in Large Towns, with Some Suggestions for Improvement*, London, n.d.

—— *State of the Poorer Clases in Great Towns*, London, 1840.

Smith, N., 'A Brief Account of the Origins of the South London Art Gallery', in G. Waterfield (ed.), *Art For the People*, London, 1994, pp. 11-17.

Smith, S., 'The Industrial Training of Destitute Children', *Contemporary Review*, vol. 47, Jan. 1885.

'S. R. J. Smith' [obituary], *The Journal of the Royal Institute of British Architects*, 12 April 1913, p. 412.

Solkin, D., *Painting for Money: The Visual Arts and the Public Sphere in Eighteenth Century England*, New Haven and London, 1992.

South Bank Arts Centre, Greater London Council, London, n.d.

Spalding, F., *The Tate: A History*, London, 1998.

Sparrow, J., 'Revolting Students', *The Listener*, 4 July 1968.

The Speeches of John Wilkes, vol. 2, London, 1777.

St John Adcock, A. (ed.), *Wonderful London: The World's Greatest City described by its Best Writers and pictured by its Finest Photographers*, 3 vols, London, 1926–27.

Statham, H. Heathcote, 'Notes on Architecture in 1897', *The Year's Art*, London, 1898, pp. 14–15.

Stephenson, A., 'An Anatomy of Taste: Samuel Courtauld and Debates about Art Patronage and Modernism in Britain in the Inter-War Years', in J. House (ed.), *Impressionism in England: Samuel Courtauld as Patron and Collector*, London, 1994, pp. 35–46.

Steyn, J., 'The Complexity of Assimilation in the Exhibition "Jewish Art and Antiquities" in the Whitechapel Art Gallery, London 1906', *Oxford Art Journal*, 13:2, 1990, pp. 44–50.

Stevenson, R. A. M., *Velázquez*, London, 1895.

Stowe, John, *A Survey of London*, London, 1598.

Strong, R., *And When Did You Last See Your Father? The Victorian Painter and British History*, London, 1978.

The Sunday Times Short Guide to the Tate Gallery, London, 1897.

Szeemann, H., 'About the Exhibition', *When Attitudes Become Form*, ICA catalogue, London 1969.

Tate Gallery Illustrated Guide, 1928, London, 1928.

Tate Gallery of Modern Art, booklet, Tate Gallery, London, 1997.

Taylor, B., 'Displays of Power: With Foucault in the Museum', *Circa*, 59, Sept.–Oct. 1991, pp. 22–7.

—— 'From Penitentiary to "Temple of Art": Early Metaphors of Improvement at the Millbank Tate', in M. Pointon (ed.), *Art Apart: Art Institutions and Ideology Across and North America*, Manchester, 1994, pp. 9–32.

—— *The Art of Today*, London, 1995.

Taylor, P., *The Projection of Britain: British Overseas Publicity and Propaganda, 1919–36*, Cambridge, 1981.

Taylor, W. B. S., *Origins, Progress and Present Condition of the Fine Arts in Great Britain*, 2 vols, London, 1841.

Thomas, D. R. O., 'Unprofessional Painting', *British Journal of Adult Education*, June 1939, pp. 269–73.

Thomas, W., *The Philosophic Radicals: Nine Studies in Theory and Practice, 1817–1841*, Oxford, 1979.

Unitarian Christianity: Ten Lectures on the Positive Aspects of Unitarian Thought and Doctrine, London, 1881.

Unitarianism: Its Origins and History, London, 1890.

Vertue, G., *Note Books*, 6 vols, *The Walpole Society*, 18, 20, 22, 24, 26, 30 (1930–55).

The Visual Arts (The Arts Inquiry), PEP Publications, Oxford, 1946.

Waagen, G. F., *Works of Art and Architecture in England*, vol. I etc., London, 1838.

—— *Treasures of Art in Great Britain: being an Account of the Chief Collections of Paintings, Drawings, Sculptures, Illuminated MSS, etc*, 3 vols, London, 1854–70.

Walpole, H., *Anecdotes of Painting in England, 1760–1795*, New Haven, 1937.

Ward, Mary Augusta [Mrs Humphrey], *Unitarians and the Future*, London, 1894.

Waterfield, G., *Soane and After: The Architecture of the Dulwich Picture Gallery*, Dulwich, 1987.

—— (ed.), *Palaces of Art: Art Galleries in Britain, 1790–1990*, Dulwich Picture Gallery, London, 1991.

—— 'Picture Hanging and Gallery Decoration', in Waterfield (ed.), *Palaces of Art*, Dulwich, 1991.

—— (ed.), *Art for the People: Culture in the Slums of Late Victorian Britain*, London, Dulwich Picture Gallery, 1994.

—— 'The Town House as a Gallery of Art', *London Journal*, 20:1, 1995, pp. 47–66.

Watson, J. A., *Talk of Many Things: Random Notes concerning Henry Tate and Love Lane*, London, 1985.

Webb, M., 'The Arts Council's New Gallery', *Country Life*, 11 July 1968.

[unsigned], 'What Our Readers Think', *Picture Post*, 5 Feb. 1949.

When Attitudes Become Form, Kunsthalle, Bern, 1968, and ICA, London, 1969.

White, B. D., *A History of the Corporation of Liverpool, 1835–1914*, Liverpool, 1951.

Whitley, W. T., *Artists and their Friends in England, 1700–1799*, 2 vols, London and Boston, 1928.

Williams, R., 'The Arts Council', *Political Quarterly*, Spring 1979, pp. 157–71.

Williams, W. Emrys, 'The Pre-history of the Arts Council', in E. M. Hutchinson (ed.), *Aims and Action in Adult Education, 1921–71*, London, 1971.

Wright, L., 'Joseph Duveen, Benefactor of the Arts', *Antique Collector*, Nov. 1989, pp. 120–6.

Young, J., *The Celebrated Collection of Pictures of J. J. Angerstein*, London, 1923.

Index

Notes: References to plates and figures are given in italics. Titles of works appear under the name of the artist. 'n.' after a page reference indicates the number of a note on that page.

Act for Encouraging the Establishment of Museums in Large Towns (1845), 51, 100
Act of Settlement (1701), 2
Act of Union (1707), 2
Addison, Joseph, 244–5n.44
Agar-Ellis, George, 34–5, 36–7
Agnew, Sir William, 127, 261n.33
Aitken, Charles, 91, 139, 146–7, 161, 165
Alain-Fournier, 117
Alexander, W. H., 96—7
Alexandria, Queen (earlier Princess of Wales), 83, 117
Alwyn, William, 191
Ancoats Hall, 90
Andre, Carl, 227
Angerstein, John Julius, 34, 35, 104
Armitage, Edward, 57
Armstrong, Sir Walter, 139–40
Arnatt, Keith, 233
Arscott, Caroline, 106
Art and Language, 229, 232
Arts Council of Great Britain, xiii, 209, 231, 234, 239
 foundation, 175–6
 and Hayward Gallery, 216, 218
 and Institute of Contemporary Arts, 190
 and LCC sculpture exhibitions, 192, 193
 South Bank policy, 211–12, 213
Arts Inquiry, 174–5
Arts Lab, 222
'Art Transplant' exhibition, (1968), 223
Ashington Group, 185–6, 186
Ashley, Lord, 39

Asquith, Sir Cyril, 182, 195
Association Française d'Action Artistique, 176
Atkinson, Terry, 229
Attlee, Clement, 196
Austin, J. L., 284n.92

Bainbridge, David, 229
Baird, John Logie, 158
Baldwin, Michael, 229
Baldwin, Stanley, 158–9, 166
Balfour, Arthur, 117, 118, 119
Banham, Reyner, 208
Bankside, 239–41
Barnett, Henrietta, 88–9, 91
Barnett, Samuel, 88–9, 91, 169
Barry, E. M., 80
Barry, James
 Temptation of Adam, 26, 26
Bartok, Bela, 191
Battersea Park sculpture exhibitions, 192–4, 209–10
Beaumont, Sir George, 37, 104
Bedford, Michael, 193
Bell, Clive, 146, 177
Bell, Jacob, 71
Belsky, Franta, 212
Benn, Sir Ernest, 180–1
Bennett, Hubert, 215
Benson, Robert H., 138
Bentham, Jeremy, 32, 104, 264–5n.67
Bentinck, Lord Henry, 155
Berg, Alban, 19
Bertelsen, Lance, 19

Bethnal Green Museum, 82–8, *83*, *86*, *95*, 95–6
Benys, Joseph, 227
Bevin, Ernest, 173
Blake, Peter, 214
Bloomsbury Group, 146
Blunt, Anthony, 198
Board of Trade, 71, 176
 Department of Practical Art, 71
 Department of Science and Art, 71, 73, 74
Bodkin, Thomas, 180, 202
Boer Wars, 101, 131
Bolus, Michael
 Bowbend, 221
 January, 221
 September, 221
Booth, John, 251n.62
Boudin, Eugène, *The Entrance to Trouville Harbour*, 134
Bowles, T., *17*
Bowring, Dr, 45, 46
Brabazon, Lord of Tara, 180
Brady, Sir Antonio, 80, 85
Bramley, Frank, *Sacred*, 108, 109
Brandoin, Charles (Michel-Vincent Brandouin), *The Exhibition of the Royal Academy of Painting in the Year 1771*, *26*, 26–7
Braque, Georges, 191
Brett, Guy, 216, 218
Brewtnall, E. J., *81*
Brisley, Stuart, 230
British Apollo, 14
British Broadcasting Corporation (BBC), xv, 158, 166, 170, 178
British Council, xv, 176–7, 178
British Gallery, 30, *31*
British Institute of Adult Education, 169, 170
British Institution, 93
British Institution for Promoting the Fine Arts in the United Kingdom (*see* British Gallery)
British Museum, 27, 52, 70, 79
Britton, John, 52
Brobyn, Stanley, 220
Brooke, Humphrey, 192, 196, 202
Brotherton, Thomas, 45
Brown, Frederick, 135
Buchanan, William, 30

Buckler, John Chessell, *The Picture Gallery of Sir John Fleming Leicester*, 31, *32*
Burdett-Coutts, Baroness, 89, 104
Buren, Daniel, 230
Burgin, Victor, 227, 229
Burne-Jones, Sir Edward, 151
Burton, Sir F., 261n.33
Bute, Earl of, 15–16
Buthe, Michael, 227
Butler, Mildred, 137

Cadbury, George, 104
Cage, John, 225
Calderon, P. H., 137
Camden Town Group, 133, 138
Carey, John, 31
caricature, 180–8
Carlisle, Earl of, 260n.33, 261n.33
Carlyle, Thomas, 92, 95
Caro, Anthony, 220, 221, 225–6, 228
 Eyelit, 225
 Hopscotch, 225
 Horizon, 225
 Red Splash, 225
 Source, 225
Carr, Holwell, 37, 104
Cassali, Andrea, *The Story of Gunhilda*, 8
Cassirer, Paul, 269n.43
Catherine the Great, 29
Chadwick, Henry, 65, 66
Chagall, Marc, 185–8
Chambers, Sir William, 20
Chantrey Bequest, 105, 109, 117, 136–8, 139, 195, 196
Chantrey, Francis, *see* Chantrey Bequest
Chartist movement, 55, *56*
Chéron, Louis, 3
Chirico, Giorgio de, 191
cholera, 48–9, 51, 58
Christian, Ewan, 97
Churchill, Charles, 19, 21–2
Churchill, Winston, 197, 198–9
Cipriani, Giovanni Battista, 24
 'The Arts': Illumination for the King's Birthday, 24–6, 25
Cizek, Frank, 175
Clark, Joseph, 137
Clark, Kenneth, 147, 172, 173, 177, 269n.35
cleanliness, 52, 58–9, 60, 61
Clutton-Brock, Arthur, 139

Cockram, G., 137
Cole, Henry, 67–8, 80, 82, 91
 and South Kensington Museum, 70, 71,
 73–6, 100
Colley, Linda, 4, 11, 40
Colman, George, 16
Colvin, Sir Sidney, 139
Compton, Charles, *A Study in the National
 Gallery*, 55, *56*
Compton, Michael, 283n.78
Conder, Charles, 172
Connington, William, 61
Conrad, Joseph, 101
Constable, John, 72, 276n.36
Contemporary Art Society, 144
Cook, Ebenezer Wake, 133, 155–6, 157,
 272n.74
Cooper, Douglas, 276n.48
Cope, C. W., 57
Coram, Thomas, 4
 see also Foundling Hospital
Corbett, David Peters, xvii
Cosway, Richard, 11
Council for the Encouragement
 of Music and the Arts (CEMA), 170–2
Country Life, 131
Courtauld, Samuel, 144–6, *145*, 149–50
Cozens, John Robert, 8
Craig-Martin, Michael, *Assimilation*, *232*, 232
Crane, Walter, 90–1
Crewe, Lord, 136
crime, 50, 65–6, 70, 111–22, 266n.91
Crimean War, 74
Cumberland, Duke of, 57
Cunningham, Allan, 52
curatorial profession, 61–5, 66
Curzon, Lord, 138, 153, 154
Curzon Committee and *Report*, 138–41, 143
Cust, Lionel, 97, 129–30

D'Abernon, Lord (Sir Edgar Vincent), 138,
 143, 149, 153–5
Dali, Salvador, 191
Dallapiccola, Luigi, 190
Dalton, Richard, 7
Dance, Nathaniel, 24
Dance, Sir Henry, 172
Dashwood, Sir Francis, 21
Davis, Henry, *Mother and Son*, 105
death duties, 138

Degas, Edgar, 134–5
 The Ballet from Robert the Devil, 134
 L'Absinthe, 135
Delaroche, Paul, 165
Denham, Mrs, *Portrait of a Gentleman*, 22
Department of Overseas Trade, 176
Department of Practical Art, *see* Board of
 Trade
Department of Science and Art, *see* Board of
 Trade
Desenfans, Noel, 29–30, 93
Dewhurst, Wynford, 135
Diary for Timothy, A, 171
Dibbets, Jan, 227
Dickens, Charles, 39, 92, 113
Dicksee, Frank, 156–7, *157*
 Two Crowns, 137, *138*, 196
Dictionary of National Biography, 131
Direction Générale des Relations Culturelles,
 176
disease, 46, 48–9, 51, 58
Dodgson, Campbell, 177
Douglas, Edwin, *Alderneys (Mother and
 Daughter)*, 105, *106*
Doyle, Richard, 54, *54*
Drucker Bequest, 144
DuCane, Sir Edward, 111, 114
Duchamp, Marcel, 224–5, 227
Dulwich College Picture Gallery, 30, 33
Duncan, Carol, xiii
Durand-Ruel, Paul, 132–3, 134, 136,
 141
Duveen, Elsie, *142*
Duveen, Sir Joseph, 141–4, *142*, 152, 159–61,
 271n.55
Duveen, Joseph Joel, 142–3
Dye, David, 232

Earlom, Richard, *26*, 26–7
Eastlake, Sir Charles Lock, 51, 57, 58, 59, 62,
 63
 on portraiture, 94
 and Vernon donation, 73
Eastlake, Charles Lock, 108
East London Museum, *see* Bethnal Green
 Museum
Ede, Jim, 165
Edward VII (Prince of Wales), 83, 85, 91
 National Gallery of British Art, 102, 117,
 118, 121

Edwards, Edward 10, 11, 14
Ehrenberg, Felipe, 230
Elgin Marbles, 44
Eliot, T. S., 191
Elizabeth II, 215–16, *217*
Ellenborough, Earl of, 94
Emmanuel, Frank, 173, 174
Empire Day Movement, 166
Epstein, Jacob, 191, 193
Ernst, Max, 191
Esher, Lord, 142
Etty, William, 72
Ewart, William, 45–6, 62
Exhibition Branch, Board of Trade, 176
Exhibition Division, Department of Overseas
 Trade, 176

Faed, Thomas, *The Highland Mother*, 105
Fagg, Edwin, 163–4
Faraday, Michael, 51, 60–1
Farnborough, Lord, 39
Fawkes, Sir Walter, 32
Festival of Britain, *plate 13*, 206–8, *208*, 209,
 214
Fildes, Luke, *The Doctor*, 105
Fine Arts Commission, 94
Fisher, Archbishop, 208
Flanagan, Barry, 220, 221, 227
 Hayward II, 232, *233*
 Light on Light on White on White,
 283–4n.80
 ring n, 221, *222*
Forest, Fred, *Parcelle/Reseau*, 285n.5
Foucault, Michel, 259n.15, 264n.67, 265n.67
Foundling Hospital, *plate 1*, 3–5, *5*, 7, 247n.62
France
 collections of fine art, 32
 comparisons with British art, 30
 D'Abernon on, 154
 diplomatic relations with Britain,
 153
 King's Library, 27
 Luxembourg Gallery, 108, 109–10,
 260n.33, 267n.17
 'modern' art, xiv, 132–3
 reactions to, 133-40
 'supplement', France as a, 148–55
 Musée Français/Louvre, 29, 37,
 38
 signs, public, 245n.48

Franco-Prussian War, 132
Frankel, Benjamin, 191
Frederick, Prince of Wales, 5, 11
Free Society of Artists associated for
 the Relief of Distressed Brethren, their
 Widows and Orphans, 13, 247n.68
Freud, Sigmund, 170
Fried, Michael, 225–6
Froude, J. A., 92
Fry, Roger, 133, 137, 139, 146
Fulton, Hamish, 232
Furness, Harry, 261n.33

Gainsborough, Thomas, 3, 11
Gallery of National Portraits, *see* National
 Portrait Gallery
Garrick, David, 16
Gauguin, Paul, 163–5
General Strike, 158
George I, 11
George II, 4, 11
George III, 11–13, 22, 23, 32
 Royal Academy of Arts, xiv, 20, 21, 22, 23,
 24–6
George IV, 32
George V, 149, 150
George VI, 176, 206, *208*
Germany, 29, 47, 133, 140, 153, 154
Gilbert, Sir John, 261n.33
Gill, Eric, 193
Gilpin, Sawrey, *Darius Obtaining the Persian
 Empire*, 22
Glasgow International Exhibition, 135
glazing, 64, 253n.95
Godard, Jean-Luc, *Weekend*, 223
Gordon, Cora, 168, 179
Goschen, Edward, 110, 111, 115, 261n.33
Gowing, Lawrence, 217–18
Grand Tour, 1
Gray, J., 52
Great Exhibition, 67–70, *68*, 252n.73
Green, J. R., 92
Gregory, Lady, 141
Grey administration, 39
Griffiths, Arthur, 113–14
Grignion, Charles, *12*
Grigson, Geoffrey, 196, 199–200
Gritten, Henry, *View of the National Gallery
 and the Royal Academy*, 55, *55*
Grosvenor, Earl, 31

Guggenheim Museum, 230
Gwynn, John, 10

Haacke, Hans, 227, 230
Habermas, Jürgen, 202
Hacker, A., 137
Hamilton, Richard, 231, 232
Hampton Court Palace, 79
Hansard, Revd Septimus, 80, 83
Harcourt, Lewis, 142
Harcourt, Sir William, 111, 117, 119, 138, 143
Hardinge, Viscount, 96
Harrison, Charles, 227
Hawkins, Edward, 52
Hayland cartoon, 184, *185*
Hayman, Francis, 3, 4, 5–6, 7, 8, 13
 The Artists presenting a Plan for an Academy
 to Frederick, Prince of Wales and Princess
 Augusta, 5, 6
 The Finding of Moses in the Bullrushes, 4, *5*
Haytley, Edward, 3, 8
Hayward, Sir Isaac, 211, 215
Hayward Gallery, xiii, xvi, 203–4, 239
 architecture, 214–20, *216*
 'New Art' exhibition, 225–6, 231
Hazlitt, William, 37
Hellfire Club, 21
Hendy, Phillip, 177, 179
Henges, Heinz, 193
Hepworth, Barbara, 193, 202, 214
Herkomer, Hubert von, *plate 9*, 103
Hermes, Gertrude, 193
Herschell, Lord, 91, 264n.62
Hertford, Marquis of, 85
Hess, Myra, 171
Hesse, Eva, 227
Highmore, Joseph, 3, 4, 8
 The Angel Appearing to Hagar and Ishmael,
 4, *5*
Hilbery, Sir Malcolm, 195
Hilliard, John
 Sixty Seconds of Light, plate 14, 232
 Ten Runs past a Fixed Point (3), plate 14,
 232
Hockney, David, 214
Hogarth, William
 Analysis of Beauty, 15
 Beer Street, 16
 'British School', 130
 Foundling Hospital, 3, 4

The Loggerheads, 19
A Man loaded with Mischief, or Matrimony,
 plate 2, 15
Moses Brought Before Pharoah's Daughter,
 4, *5*
national academy of art scheme, 6
Nonsense Club, 16–17
The Painter and his Pug, plate 6
and public signs, 15, 16
Reynolds on, 24
royal patronage, 11–13
Signboards Exhibition, 18, 19
Society of Artists of Great Britain, 11–12,
 12, 13
Society of Arts, 7
South Kensington Museum, 71
St Martin's Lane teaching academy, 3
The Times, 22
Holloway, Thomas, 104
Holroyd, Sir Charles, 138, 142
Honeyman, T. J., 178
Hook, James, *Home with the Tide*, 105
Hornsey College of Art, 222, *223*
Horsfall Museum, 90
Houghton collection, 29
Hoven, A., *A Room hanging with British*
 Pictures, plate 6, 55
Hullmandel, Charles, *The Louvre or the*
 National Gallery Paris, and No. 100
 Pall Mall or the National Gallery of
 England, 37, *38*
Hume, David, 4
Hunt, Charles, *Cross Readings at Charing Cross,*
 plate 5
Hunt, Walter, 137
Hunt, William Holman, 89, 148
Hunter, Dr William, *plate 3*, 25
Hurrell, Harold, 229

Imperial collections, Vienna, 29
Imperial Institute, 261n.33
Impressionism, xiv, 132–8, 149
 Aitken, 147
 Courtauld, 145, 146
 Manson, 147, 148
Incorporated Society of Artists of Great
 Britain, 20
Institute of Contemporary Arts (ICA),
 xv, 188–91, 195, 196, 211, 222,
 226–7

International Coalition for the Liquidation of
 Art, 230
internationalisation of art, 234–6
International Society exhibition (1908), 138
Italy, 1, 27, 29

Jackson, Alastair, 220
Jackson, John, *Portrait of William Seguier*, 36
Jagger, Mick, 224
James, Henry, 113
James, Philip, 179
Jenney, John, 234
Jennings, Humphrey, 171
John, Augustus, 191, 272n.74
John, W. Goscombe, *Boy At Play*, 127, *128*
Johnson, Samuel, 13
Jones, Thomas, 171–2

Kauffman, Angelica, 24
Kemp-Smith, Lucy, 137
Kennington, Thomas, *Orphans*, 105
Kew Gardens, 79
Keynes, John Maynard (Lord), xiv, 172, 175,
 176
Kingsley, Charles, 54
King's Library, Paris, 27
Kipling, Rudyard, 101–2, 131
Klee, Paul, 179, 191, 276n.36, 276n.48
Klenze, Baron von, 47
Kneller, Sir Godfrey, 3, 130
Knott, Ralph, 205
Konody, Paul, 134, 266–7n.6
Krauss, Sigi, 230
Kustow, Michael, 222–3

Laing, David, 93
Lambe, Aaron, 22
Landlord and Tenant Act (1954), 213
Landseer, Edwin, 72, 165
Landseer, J., 250n.39
Lane, Hugh, 139, 141, 144, 149
Lascelles, Sir Alan, 195
Lavery, John, 271n.58
 *King George accompanied by Queen Mary at
 the Opening of the Modern Foreign and
 Sargent Galleries at the Tate, plate 11*,
 149
law and order, 50, 65–6, 70, 266n.91
Lawrence, Sir Thomas, *Portrait of John Julius
 Angerstein*, 34, *35*

Layard, Sir Henry, 261n.33
Lee cartoons, 183, *183*, 186–7, *188*
Leech, John, 57, *58*
Leeds, 170
Leenders, Rudy, 220
Léger Gallery, 173
Leicester, Sir John, 31, *32*, 32
Leicester Galleries, 173
Leighton, Sir Frederick, 103, 148, 165,
 261n.33
 Bath of Psyche, 196
Lennon, John, 224
Lewis, Wyndham, 191, 234
lighting conditions
 Hayward Gallery, 216
 National Gallery, 47, 59, 60
 Tate Gallery, 161
Lilliput, 184–5
Linton, Sir James, 261n.33
Lipchitz, J., 193
 Figure, 196, *198*
Listen to Britain, 171
Liverpool, 104
Liverpool, Lord, 33
Lloyd's Patriotic Fund, 34
Locke, John, 104
Loew, Roelof, 227
London
 centralisation of culture in, xv
 inter-war period, 159, *160*
 in eighteenth century, 1–2,
 reform process, 40–3, *42*
 signs, public, 15–16, *17*
 writings on, 159
London Chronicle, 9
London County Council (LCC), 188, 191–2
 establishment, 76
 Hayward Gallery, 215, 216
 open-air sculpture shows, xv, 191–4,
 209–10
 South Bank policy, 206, 210–11, 212–13
London Group, 133
London Register, 18
Long, Richard, 222, 232
 A Line Made by Walking, 222
Longden, A. A., 176, 178
Lord's Day Observance Society, 89
Louvre, 29, 37, *38*
Low, David, 199, *201*
Lucas, John Seymour, 92

Lusitania, 141
Lutyens, Elizabeth, 191
Luxembourg Gallery, 108, 109–10, 260n.33, 267n.17
Lynton, Norbert, 231, 235, 284n.91

Macaulay, Thomas, 92
MacCarthy, Sir Desmond, 195
MacColl, Dugald S., 134, 135–7, 139, 140, 142, 149, 180
Mackenzie, Francis, *plate 4*, 37
Macmillan, Lord, 172
Mahon, Viscount (Earl Stanhope), 93–4, 95–6, 97
Maillol, Aristide, 193
Manchester, 65–6, 90
Manet, Édouard
 Homage to Manet (Sir William Orpen), *plate 10*, 141
 La Servante de Bocks, 146
Mannheim, 29
Manson, James Bolivar, 147–8, 166, 168–9
 Self Portrait, 147
Manton, Sir Edwin, 285n.4
Marc, Franz, 191
Marchand, André, 149
Marlow, William, 22
Martin, Leslie, 206, 211
Marvell, Roger, 179
Massey, Vincent, 195, 196
Matisse, Henri, 181, 191
 Hayward Gallery exhibition, 216, *217*, *218*, 219–20
 Trivaux Pond (*La Forêt*), 198, *200*
 V & A scandal, 176, *177*, 177–8, 180
Matthew, Robert, 206
Maundrell, Chas., 137
Mavrogordato, John, 202
Mayhew, Henry, 65
McCartney, Paul, 224
McLean, Bruce, 227
McWilliam, F. E., 193
 Head in Green and Brown, 210
 Kneeling Woman, 191, *191*
Mechanics' Institute movement, 41, 252n.73
Medici collections, 29
Mesens, E. L. T., 189
Metropolis Management Act (1855), 255n. 22
Metzger, Gustav, 230

Mill, John Stuart, 68
Millais, Sir John, 103, 108, 129
 And the Sea Shall Give Up Its Dead, 263n.58
Minihan, Janet, xiii
'modern foreign' art, 132–3
 audience, 155–66
 Duveen, Sir Joseph and, 141–4
 cannon of, 144–8
 and Germany, 133, 140
 Lane, Hugh, 141
 See also France, 'modern' art
Modigliani, Amedeo, 191
Mondrian, Piet, 214
Monet, Claude, 134, 135, 136
 Beach at Trouville, 162
 Vétheuil: Sunshine and Snow, 162, 163
Moore, George, 110
Moore, Henry, 191, 193, 226
 Madonna and Child, 198
 Reclining Figure, 192
 Three Standing Figures, *194*, 194
Morley, Samuel, 104
Morris, Edward, 110
Morris, Robert, *229*, 229–30
Morris, William, 89, 161
Morrison, Herbert, 206
Moser, George, 22
Mulready, William, *Interior with Portrait of John Sheepshanks*, *plate 7*, 73
Mündler, Otto, 62–3
Munich Pinakothek, 47, *48*, 255n.23
Munnings, Alfred, 195–9, 200–2
 Does the Subject Matter?, *plate 12*, 202
 The Racehorse Hyperion, 196
Murdoch, John, xvii
Murphy, John A., 235
Museum Français *see* Louvre
Museum of Manufactures, 71
Museums Association, 170

Nash, John, 41, 42
National Film Theatre, 214
National Gallery, xiii, 38
 curatorial imperatives, 46–8
 curatorial profession, 61, 62–5, 66
 extension (1876), 80
 founding, 34–5
 government reports, xiv
 Lane bequest, 141

Massey Committee, 195
and National Portrait Gallery, 97
Pall Mall premises, 35–40, *38*
and photography, 239
'public', redefinition of, 50, 61, 64–6
and public health debate, 51
Robert Vernon collection, *72, 73*
Second World War, 170
Select Committee reports, 51–3, 58–61,
 62–3
Site Commission (1857), 77
and South Kensington Museum, 71, 73,
 76, 100
and Tate Gallery, 136
Trafalgar Square, 37, 40, 41–3
visitors and class, 53, 59–61, 70, 76, 79,
 81–2, 172–3
see also Tate Gallery
National Gallery of British Art, *see* Tate
 Gallery
National Lottery, 285n.4
National Portrait Gallery, *plate 8*, 79, 92–9,
 95, 97, 100
National Portrait Gallery Dublin, 99
National Repository, 41, *42*
National Trust for Places of Historic Interest
 and Natural Beauty, 131
'New Art' exhibition (1972), 228–34
New Critics, 133–8, 143–4
New English Art Club, 133–4
'New Generation' exhibition (1965), 221
Newman, Gerald, 232
New Romanticism, 209
Newton, Eric, 179, 192–3
Newton, Francis, 7–8
Nigg, Serge, 190
Nollekens, Joseph, 11
Nonsense Club, 16–17, 18, 19
Nordau, Max, 133
Noyes, Alfred, 159

Orage, Alfred, 133
Orchardson, William, 148
 Her Mother's Voice, 105
Orleans, Duke of, 27
Orpen, Sir William, *Homage to Manet, plate
 10*, 141
Orrock, James, 105, 260n.24
Ottley, William Young, 250n.39
Oxford English Dictionary, 131

Palmerston, Viscount, 94
Paris
 collections of fine art, 32
 King's Library, 27
 Luxembourg Gallery, 108, 109–10,
 260n.33, 267n.17
 Museum Français, 29
 Louvre, 29
 public signs, 245n.48
Patriotic Fund, Lloyd's, 34
patronage
 Arts Council of Great Britain, 176
 George III, 11–13
 initiatives to generate, 5–6
 Insitute of Contemporary Arts, 188
 London County Council, 188
 Prince Albert, 67
Paxton, Joseph, 67
Peace of Amiens (1802), 30
Peacock, Thomas Love, 68
Pearson, Nicholas, xiii
Peel, Sir Robert, 39–40, 48
Penrose, Roland, 189, 213
People's Palace, 90
Phillip Morris Europe, 235
Picasso, Pablo, 170, 181–2, 191, 213, 274n.9
 Les Demoiselles d'Avignon, 196
 Munnings' *Does the Subject Matter?*, 202
 V & A scandal, 176, 177–80, *178*
 Woman with a Fish Hat, 182, *182*
Picture Post, 184
Pine, Robert, 7, 8
 *The Surrender of Calais to Edward the
 Third*, 8
Piper, John, 191
Pissarro, Camille, 134, 135
Pissarro, Lucien, 137–8, 147, 148
 All Saints' Church, Hastings, 137
 April, Epping, 137
Plant, John, 230
'play–discipline', 33
Pointon, Marcia, xiii, xvii
Pollock, Jackson, 214
pollution, 58–9
Post-Impressionism, xiv, 133, 138, 145, 147,
 149
Poynter, Sir Edward J., 127, 262n.33
Priestley, J. B., 158
Prince Albert, 65–6, 67, 71
Prinsep, Val, 137

private teaching academies, 3
Public Hall, Canning Town, 90
Public Libraries Act (1850), 100
Punch, 57, 120, *120*, 183–4, *184*

Quilter, Harry, 133, 261n.33

Ramsay, Allan, 7
Raphael, 27
Rathbone, William, 104
Rawnsley, H. D., 122
Read, Herbert, 170, 175, 177, 189, 190, 195,
 196, 276n.48
Reading Art Gallery, 264n.62
Redgrave, Alexander, 70
Redgrave, Richard, 72, 73, 76, 100
Reform Act (1832), 33, 39, 46
Reform Act (1867), 80
Reid, Norman, 196, 230
Reid Dick, William, 193
Rembrandt, *Portrait of Margaretha de Geer*,
 171
Renoir, Pierre Auguste, 134
Rexroth, Kenneth, 191
Reynolds, Sir Joshua, 7, 20, 22, 23, 30
 Agar-Ellis on, 249n.20
 Royal Academy of Arts, 21, 24
 Society of Artists of Great Britain, 11, 13
 Society of Arts exhibitions, 8, 11, 243n.28
Richardson, Marion, 175
Ridley, Jasper, 196, 278n.84
Rivière, Briton, 106, 110
 Polar Bear, 129
Robertson, Bryan, 214, 219, 220
Robinson, Frederic Cayley, *Pastoral*, 196
Rootes, W. E., 176
Roscoe, Sir Henry, 262n.33
Roscoe, William, 104
Roseberry, Lord, 89
Rossetti, Dante Gabriel, 151
Rossiter, William, 88, 90, 91
Rothenstein, John, 110, 167–8, 170, 177, 196,
 202, 278n.84
Rouault, Georges, 191
Roubiliac, Louis, 8
Rowan Gallery, 228
Rowntree, Joseph, 104
Royal Academy of Arts, xiii, xiv, 21–3, 26–7,
 30, 70, 174, 239
 exhibitions, 22–4, 26–7, 30, 157

foundation, 20–1
 Instrument of Foundation, 20–1
 King's authority and, xiv, 21
 'modern foreign' art, 136, 137
 and National Gallery, 41
 Old Somerset House premises, 25
 Pall Mall premises, 22, *23*
 and Tate Gallery, 136
 Tate's connections with, 103, 105
Royal Festival Hall, 206, 214
Royal Incorporated Society of Artists
 of Great Britain, 22
Royal Picture Gallery, Berlin, 47
Royal Society of Arts, xv
Royal Watercolour Society, xv
Ruskin, John, 77–80, 88, 89, 114, 260n.24
Russell, William, 51
Rutter, Frank, 134
Ryland family, 104

Sadler, Dendy, *Thursday, 107*
Sadler, Sir Michael, 155
Salisbury, Lord, 110
Salting Bequest, 144
Sandby, Thomas, 8
Sandby, W., *23*
Santayana, George, 158
Sargent, John Singer, 152
Scharf, G., *plate 8*, 94–5, 96, 97
Schools of Design, 71
Schwarz, Arturo, 225
Scott, Sir Giles Gilbert, 195, 240
Scottish National Portrait Gallery, 99
Scully, William, *204*
sculpture, xv, 191–4, 209–10, 221, 225–8
Seager, S. Hurst, 161
Searle, John, 284n.92
Second World War, 167–72
Seguier, William, 35, *36*, 46, 47–8, 52
select committees
 on Arts and Their Connexion with
 Manufactures (1836), 67
 on Drunkenness (1834), 51
 on National Monuments and Works of Art
 (1841), 51, 52, 53
 on the National Gallery
 (1850), 52, 58–61
 (1853), 52, 62–3
 on the State of the Pictures
 in the National Gallery (1850), 52

on Works of Art (1847–48), 51

Selous, Henry, *Opening of the Great Exhibition by Queen Victoria on 1 May 1851*, 67, *68*

Serle, Humphrey, 191

Settled Lands Act (1882), 96

Seurat, Georges, *Bathers at Asnières*, 146, *146*

Seven Years' War, 25

Seymour, Anne, 231, 233

Shaftesbury, 3rd Earl of, 4

Sharkey, John, 220

Sheepshanks, John, *plate 7*, 71–3, 74, 75, 76, 105, 131

Sheffield, Sir Charles, 27

Shell Building, 214

Shepherd, R., *The King's Mews, Charing Cross*, *42*

Shepherd, T. H., 250n.39

Shipley, William, 6–7, 11, 246–7n.62

Sickert, Walter, 110, 141

Signboards Exhibition (1762), 14, 15, 16, 17–19

signs, public, 14–16, 17–19

Silâns, 220

Sisley, Alfred, 134

Slaney, Robert, 49–50, 51

Smirke, Sir Robert, 262n.40

Smith, George, *Landscape*, 8, *8*

Smith, John, *Landscape*, 8

Smith, Sidney R. J., 111, 114–15, 121

social class

 and Great Exhibition, 70

 and National Gallery of British Art, 124, 125–7

 Second World War, 172–3

 see also working class

Society for the Encouragement of the Arts, Manufactures and Commerce, *see* Society of Arts

Society of Artists of Great Britain, 11–12, 13–14, 16, 20, 22

Society of Arts, 6–10, 11, 12, 20, 246–7n.62

Society of Dilettanti, 6

Solkin, David, 4

Sorrell, Mary, 168, 179

Soukop, Willi, *The Pied Paper*, 212

'Souls, the', 154

South Bank policy, 204–13

South Kensington Museum, *plate 8*, 71–6, *72*, 78–9, *80*, 95, 100

 see also Victoria and Albert Museum

South London Art Gallery (later South London Gallery), 91, 124–5

South London Working Men's College, 88

Sparrow, John, 224

Spender, J. A., 133

Stafford, Marquess of, 30, 31

Stanhope, Earl, 93–4, 95–6, 97

Stanhope–Forbes, A., 129

statistics, 68–9

Stephanoff, F. P., *The British Institute in 1816*, 30, *31*

Stephanoff, James, *The British Institute in 1816*, 30, *31*

Stephens, F. G., 133

Stevenson, R. A. M., 134

Stezaker, John, 232

St James's Chronicle, 16, 17, 18

St John Adcock, A., 159

St Jude's Schools, 88–9, 90

St Martin's Lane group, 5–6

Stockley, Henry, *169*

Stoop Bequest, 198

Storran Gallery, 172

Stowe, John, 114

Strauss, Patricia, 191–2

Stravinsky, Igor, 190

Strube, *201*

Strutt, Edward, 45

Studio International, 227

student movement, 222–4

Sunday opening, 86–7 *86*, *87*, *90*, 90, 97

Sunday Society, 86, 261n.33

surrealism, 170

Sutherland, Graham, 191

Sutton, Denys, 281n.45

Sylvester, David, 231

Szeemann, Harald, 227–8

Tate, Lady Amy, 103, 143

Tate Gallery, xiii, 100, 101, 109–10, *128*

 bomb damage, 170, *171*

 flood, 165, *166*

 gallery for the nation, 129–31

 Massey Committee, 195

 metaphors of improvement, 117–22

 Millbank site, 111–17, *113*, *115*, *116*, *118*

 'modern foreign' art, 136, 139, 140–1, 143, 144, 155

 opening, 117–19, *119*

plans, *151*, *153*
Second World War, 170
site proposals, 110–11, *111*
visitors and class, 122–4, 125–9, 172
Tate, Henry, 89, 100, 102–4, *112*, *plate 9*
 building programme, 129
 collection as cultural gift, 104–8
 naming of Tate Gallery, 264n.64
 offer, 108–11
 opening of Tate Gallery, 117
 Park Hill collection, 103, *103*
 plaque, 131
 see also National Gallery
Tate, Phyliss, 190
Tate Gallery of Modern Art, 239–41,
 240
Tchelitchev, Pavel, 191
temperance movement, 50
Tenniel, Sir J., *74*
Thomas, Dylan, 191
Thomas, Havard, 193
Thornhill, Sir James, 3, *3*
Thornton, Bonnell, 14, 15, 16
Thurloe, John, 96
Thwaites, George, 46–7, 52, 53, 70
Tiny Tim, 282n.55
Tomlinson, R. R., 192
Topolski, Felix, 181
Town and Country Planning Act (1947),
 206
Townsend, C. Harrison, 91
Toynbee Hall, 89–90
Trollope, Anthony, 37
Truchsess, Joseph Count, 30
Turner, J. M. W., 71, 72, 73, 105, 142, 150–2,
 268n.28
 Dido building Carthage, *plate 6*
 Ulysses deriding Polyphemus, *plate 6*
Tuke, H, S., 129

Udney, Robert, 30
Underwood, Leon, 193
Unitarianism, 103–4
 Courtauld, Samuel, 144
 Tate, Henry, 103, 105, 106, 107
United States of America, 138, 235
'Unprofessional Painting' exhibition
 (1938–39), 169, *169*
Utrillo, Maurice, 191
Uwins, Thomas, 59–60

Vanderbank, John, 3
Van Gogh, Vincent, 163–4, 168
 The Yellow Chair, 163, *164*, 168
Vatican, 27
Vauxhall Gardens, 4
ventilation
 Hayward Gallery, 217
 National Gallery, 60
 Tate Gallery, 161
Vernon, Robert, 71, 72, 73, 76, 105, 117
Victoria, Queen, 65–6, 67, *68*, 89, 101, 131
Victoria and Albert Museum, 134, 170, 176–80
 see also South Kensington Museum
Vienna, 29
Vincent, Sir Edgar, *see* D'Abernon, Lord
virtual works of art, 241
von Klenze, Baron, 47

Waagen, Dr G. F., 37, 59
 Treasures of Art in Great Britain, 66
Wale, Samuel, 3, 7
Walker, Andrew Barclay, 104
Walker, Emery, 95
Walker, W. H. Romaine, 161
Walker Art Gallery, 104
Wallace, Sir Richard, 85, 86
Walpole, Horace, 29
Walpole, Sir Robert, 27
War Artists' Advisory Committee, 170
Ward, T. Humphrey, 261n.33
Warren, Robert Penn, 191
Waterhouse, John, 129
Watts, George Frederick, 57, 89, 103, 117
Watts, Mrs, 143
Waugh, Evelyn, 180
Webb, Sir Aston, 156
Wedmore, Frederick, 134
Wembley Empire Exhibition, 166
Wertheimer, Alfred, 152
West, Benjamin, *Departure of Regulus from
 Rome*, 23, 24
Wheeler, Charles, 192, 280–1n.29
 Spring, 193
Whim, William, 245n.44
Whinnom, Arthur, 186
Whistler, James, *Portrait of his Mother*, 267n.17
Whitechapel Art Gallery, xv, 91–2
Whittle, Jack, 215
Wignall, Jane, 103
Wilde, J. W., 82, *83*

Wildsmith, John, 52, 53
Wilenski, R. H., 178
Wilkes, John, 21–2, 23, 27–8, 29
Wilkins, William, 41, 114, 115
Wilkinson, Norman, 180
William IV, 44
Williams, Raymond, 176
Williams, (Sir) William Emrys, 169, 172, 213
Wills, James, 3, 4
 Little Children Brought Unto Christ, 4, *5*
Wilson, Harold, 204
Wilson, J. W., 270–1n.55
Wilson, Richard, 3, 7, 8
 View of the Foundling Hospital, plate 1
Witkin, Isaac
 Dawn, 221
 Nagas, 221
 Volution, 221
Witt, Sir Robert, 165, 268n.30
Wittgenstein, Ludwig, 284n.92
Woods, Henry, 110
Woolf, Virginia, xiv
working class
 access to private art collections, 33
 Bethnal Green Museum, 82, 84
 declining support for, 173
 French and British, comparison, 144–5
 Great Exhibition, 70
 National Gallery, 53, 79, *81–2*
 National Gallery of British Art, 124, 125
 Rossiter's gallery, 88
 South Kensington Museum, 75
 South London Gallery, 124–5, 126
 St Jude's exhibitions, 88–9, 90
Working Men's Club and Institute Union, 79
Wornum, Ralph, 62, 63, 250n.39
Wright, Joseph, 22
Wyndham, George, 272n.70
Wyse, Thomas, 45, 92–3

Yeames, William Frederick, 92
Yeats, W. B., 141
Yeo, Richard, 8

Zadkine, Osip, 193
Zoffany, Johann, *Dr William Hunter
 delivering a Lecture on Anatomy at the
 Royal Academy, plate 3*, 25